Semi-Detached

Semi-Detached

THE AESTHETICS
OF VIRTUAL
EXPERIENCE
SINCE DICKENS

John Plotz

Princeton University Press

Princeton and Oxford

To Lenny and Daria

detached or attached

near or far

our joy forever

Contents

Illustrations

Acknowledgments

These thanks begin with a wince at the thought of omitting many people whose kindness and acumen palpably shape this book ("Think where man's glory most begins and ends / And say my glory was I had such friends"). No choice but to press on, regardless: Steve Biel, Alex Ross, and Phil Joseph (who got caught in a hailstorm with me on the way to Red Cloud, Nebraska) helped me understand Cather. The chapter on short fiction would be inconceivable without Penny Fielding's collegiality, counsel, and camaraderie, and Jonathan Grossman's Dickensian wit and wisdom. My ideas about Mill and Victorian liberalism owe much to Elaine Hadley, Rachel Ablow, Deborah Cohen, Elaine Freedgood, and Mary Jean Corbett. For tutelage and counsel on all things Victorian, I thank Elaine Scarry, Philip Fisher, Anna Henchman, Deb Gettelman, Nick Dames, Rae Greiner, Ian Duncan, Catherine Gallagher, and the two splendid Victorianist groups in Boston, generously overseen by Martha Vicinus, Laura Green, and Kelly Hager. Jed Esty and Sarah Cole shared their thoughts on Wells, science fiction, and much more; Andrew Miller and Sharon Marcus did the same when it came to Buster Keaton. In correspondence and highly delightful conversation on art history topics ranging from Millais to Alma-Tadema to William Morris, Beth Helsinger, Tim Barringer, Jennifer Roberts, Kate Flint, and Pamela Fletcher have been kindness personified. For research on Morris and in other archival forays, I am particularly indebted to Elizabeth Miller and Florence Boos, and to Anne Woodrum and Sarah Shoemaker at Brandeis, and the thoughtful staff at Harvard's Widener and Houghton Libraries. At Princeton, Anne Savarese and her editorial team were terrific.

Then I come to those whose fingerprints are simply all over the book: old friends like Vanessa Smith, Ivan Kreilkamp, Daniel Itzkovitz, and Sean McCann; new ones like Sanjay Krishnan, Eugene Sheppard, and the Time-Lapse group—Gina Turrigiano, Elizabeth Ferry, Tory Fair, Sharon Grimberg, Rahul Mehrotra, and Erik Noyes. Friends outside the academy

who long ago won my love also earned my thanks for tough questions and unquestioning support during the long years of writing: Liberty Aldrich, Alex Star, Robert Glick. Finally, this book is entirely permeated by the generosity, wisdom, and patience of the Maple Ave. gang—Yoon Lee, Leah Price, Amanda Claybaugh, and Deidre Lynch. They richly deserve this book's dedication—but will forgive me when they see who replaced them.

My grandmothers, Helen Plotz and Helen Abrams, are gone now but unforgotten. It makes me smile to think of my brother David, his wife Hanna, their Noa, Jacob, and Gideon. My parents Paul Plotz and Judith Abrams Plotz are a cold refreshing spring; what a joy that their grand-children can drink from the same source David and I did growing up. Lisa Soltani: same as last time, nothing more to say and never less, on this earth or in it.

Semi-Detached draws on various earlier pieces, substantially reworked and revised. Portions of chapter 1 are adapted from "The Short Fiction of James Hogg" in *The Edinburgh Companion to James Hogg*, edited by Douglas Mack and Ian Duncan (Edinburgh University Press, 2012); and from "Victorian Short Stories" in *Cambridge Companion to the English Short Story*, edited by Ann-Marie Einhaus (Cambridge University Press, 2016). Portions of chapter 2 are adapted from "Antisocial Fictions: Mill and the Novel," *Novel* 43:1 (2010): 38–46; and "Reading as a Resonant Cavity: John Stuart Mill's Mediated Involvement," 69–92 in *The Feeling of Reading*, edited by Rachel Ablow (U. Michigan Press, 2010). Portions of chapter 4 are adapted from "The Semi-Detached Provincial Novel," *Victorian Studies* 53:3 (Fall 2011): 405–16; and from "The Provincial Novel," 360–72 in *A Companion to the English Novel*, edited by Stephen Arata, J. Paul Hunter, and Jennifer Wicke (Blackwell, 2015). Portions of chapter 5 are adapted from "Two Flowers: George Eliot's Diagrams and the Modern Novel," 76–90 in *A Companion to George Eliot*, edited by Amanda Anderson and Harry Shaw (Blackwell, 2013); and from "Henry James's Rat-tat-tat-ah: Insidious Loss, Disguised Recovery and Semi-Detached Subjects," *Henry James Review* 34 (2013): 232–44. Portions of chapter 6 and the conclusion are adapted from "Materiality in Theory: What to Make of Victorian Things, Objects, and Commodities," 522–38 in *The Oxford Handbook of Victorian Literary Culture*, edited by Juliet John (Oxford University Press, 2016). Portions of chapter 8 are adapted from "Overtones and Empty Rooms: Willa Cather's Semi-Detached Modernism" *Novel* 50:1 (2016):56–76, and "Partial to Opera: Sounding Willa Cather's Empty Rooms" in *Sounding Modernism: Rhythm and Sonic Mediation in Modern Literature and Film*, forthcoming, edited by

Julian Murphet, Helen Groth, and Penelope Hone (Edinburgh University Press, 2017). Portions of the conclusion are adapted from "This Book is 119 Years Overdue" *Slate* (November 17, 2011). I gratefully acknowledge generous support from the Guggenheim Foundation and the Radcliffe Institute for Advanced Study, as well as a Senior Faculty Research Leave from Brandeis University. Thanks are also due to the National Humanities Center for funding, and to my generous colleague Maurie Samuels for co-organizing, "The Virtual Nineteenth Century," a 2011 conference about semi-detachment. Portions of this work were presented at Victoria University (NZ), University of Otago, Wesleyan, Yale, Durham University, Chicago, University of British Columbia, Harvard, University of Sydney, University of Edinburgh, University of Sussex, Stanford, SUNY Buffalo, Indiana University, University of Alabama, Brandeis, Boston College, Tufts, SUNY Binghamton, University of Wisconsin, University of Connecticut, Dickens Universe, and Notre Dame. I am grateful to audiences and colleagues there for their questions, comments, and subsequent correspondence.

Introduction: Through Bright Glass

When you half lose yourself in a work of art, what happens to the half left behind? The critical vocabulary to describe that sensation is lacking, but it is a familiar feeling, nonetheless. When most carried away, audiences of even the most compelling artwork remain somewhat aware of their actual situation. Ideas about this kind of semi-detachment play a crucial and generally unrecognized role in shaping a wide range of nineteenth- and twentieth-century fiction. In such works, the crux of an aesthetic experience is imagined, or depicted, or understood as residing neither in complete absorption in an artwork nor in critical detachment from it, but in the odd fact of both states existing simultaneously.

In George Eliot's *The Mill on the Floss*, for instance, the first chapter moves suddenly from an account of the young Maggie Tulliver at play to a description of the "really benumbed" arms of the narrator who has been watching her:

> It is time the little playfellow went in, I think; and there is a very bright fire to tempt her: the red light shines out under the deepening gray of the sky. It is time, too, for me to leave off resting my arms on the cold stone of this bridge. . . .
>
> Ah, my arms are really benumbed. I have been pressing my elbows on the arms of my chair, and dreaming that I was standing on the bridge in front of Dorlcote Mill, as it looked one February afternoon many years ago. [1]

Eliot's doubled elbow-rest (bridge and chair-arm both) offers a way to think about the reading of the novel itself: not only am I here reading, I am also there watching. The narrator turns into a simulacrum of the reader, whose dream-like entry into Maggie's world is bodied forth in the narrator's ellipsis-marked discovery that his or her arms have been pressing

onto bridge and armchair simultaneously. That dual experience of being both at home in one's own study and at the same time immersed in an invented world is intimately linked to Eliot's sense that novels themselves may become testing grounds for universal laws of ethics and of sociability. Novels help Eliot to explore how little you grasp of the other minds at work around you and to chart some of the ways in which their own wavering, flickering attention misunderstands you in just the same degree that you misunderstand them.

Take another example, a moment at the end of Henry James's *The Ambassadors*. A minor character, Marie Gostrey, proposes to our hero Lambert Strether—only he is too busy thinking about the proposal's impossibility, and how he will refuse her, to notice that she continues to talk to him. James brings his cognitive glitch to the reader's attention with a wry aside about Strether's serene thoughts on how well his refusal will be received: "That indeed might be, but meanwhile she was going on." That sense of the ongoing—we might call it the novel's version of "parallel processing"—puts into view the discrepancy between one's actual position and one's conceptual location. The Jamesian novel becomes a seismograph of the divergence between experience and event, showing where the mind goes when it wanders.

James's little joke about Marie "going on" while Strether mentally sketches out her future responses is a register of the novel's capacity to register twists and turns of experience that James himself calls "disguised and repaired losses" and "insidious recoveries."[2] A novel (or a painting or a film) that generates in its audience the sensation of semi-detachment is in some ways replicating and holding up for examination an experience familiar to the real world. Late nineteenth- and early twentieth-century readers are so interested in the ways that a novel's free indirect discourse *half*-enters into a character's mind because of their interest in how well or how poorly they are able to predict and understand the actions and the thoughts of other human beings in everyday social settings—human beings who are, each and every one, partially absorbed in their social situation and partially detached from it.

One April morning, biking over the Mass Pike listening to my iPod—traffic noise in one ear, the Carter family in the other—I suddenly saw that moment in James as a fact of life, not art. Holding two things in my head at once—"Cabin in the Pines" and the pile of broken glass I'd have to dodge at the end of the footbridge—suddenly struck me less as a quirk of the Jamesian narrator and more as a record of something that had been happening to me all my life, but only happening in the most evanescent

unsatisfactory way: happening, then immediately vanishing again because I lacked the vocabulary to make sense of it, to give it a name and attributes. The title of Sherry Turkle's jeremiad about overly virtual lives—*Alone Together*—began to strike me less as an indictment of our present social condition than a description of our perennial residence in a state of mental *quasi*-abstraction. I biked straight off that bridge and into the library. Sometimes it seems I haven't left since.

MINDS SOMEWHERE QUITE ANOTHER

> It is, I mean, perfectly possible for a sensitized person, be he poet or prose writer, to have the sense, when he is in one room, that he is in another, or when he is speaking to one person he may be so haunted by the memory or desire for another person that he may be absent-minded or distraught. . . . Indeed, I suppose that Impressionism exists to render those queer effects of real life that are like so many views seen through bright glass—through glass so bright that whilst you perceive through it a landscape or backyard, you are aware that, on its surface, it reflects a face of a person behind you. For the whole of life is really like that: we are almost always in one place with our minds somewhere quite another.
>
> Ford Madox Ford, "On Impressionism"

In recent years, the concept of virtuality has emerged as one important way to think about the interplay between actuality and aesthetic mimesis.[3] *Semi-Detached*'s distinctive approach to the concepts of the actual and the virtual results in part from its attention to what we might call artisanal questions—on what it means for writers (and other artists) to take note of and reflect on the partial nature of such experiences of aesthetic dislocation as practical problems related to getting their work done. Semi-detachment, as a concept, helps shed light on how writers understood what it meant for readers to experience the world of a book as if it were real, while nonetheless remaining aware of the distance between such invention and one's tangible physical surroundings.

I came to Ford's essay very late in the writing of this book: How many hours, or even minutes, did it take him to jot down the telling image ("real life . . . seen through bright glass") I'd spent almost a decade *not* coming up with? So many of the examples I'd been setting aside for further thought—Buster Keaton's double take when he realizes that his beloved

has overheard his practice proposal of marriage; my own discovery that my computer was burning my thighs while my on-screen avatar roamed some virtual world—were imperfect approximations of that doubled "impression" Ford so elegantly sketches. Ford presumably proposes a half-reflective, half-transmissive piece of glass as an apt metaphor for impressionism because that bright glass creates an unsettling double exposure, leaving the gazer uncertain which view has priority.

Ford's image offered me a new way to think about those elbows in Eliot, the ones that rested simultaneously on a cold, stone bridge and a warm armchair. It also offered traction on other examples: Robert Lowell's account in "For the Union Dead" of pressing himself (in memory) against the long-gone glass of the South Boston aquarium and also (in the present day) against the construction fence that has replaced it. I liked the way that in Ford's account it was not the *mind* that split in two, but something that came between mind and world. That piece of bright glass—refractive or translucent or reflective—conjures up a world in which a coherent consciousness has to make a choice about its relationship to the world it finds around itself. Do I wake or sleep? becomes a different kind of puzzle: What kind of wakefulness is this? That is, what sort of waking dream or dreamy wakefulness can leave me looking out at a world that itself splits, offering me a view ahead of myself but also, simultaneously, a view over my shoulder into the house behind me, mirrored there on the bright glass? If the brave new world of movie cameras was likely on Ford's mind as he wrote, so too was Plato's cave.

That double vision aligns Ford's piece in some ways with the more famous account of impressionism that Conrad offers up in the preface to *The Nigger of the Narcissus*: "the motions of a labourer in a distant field," whose actions and object become momentarily legible, before "we forgive, go on our way—and forget."[4] But Ford's image of the doubled glass also contains a second notion: the odd feeling that in looking through the glass into an invented world, you are also looking back into reflections that may be coming from right behind you. Implicitly, then, gazing into a made-up realm also means entering your own world, your own life, in a different way (that could be your very own reflection you see on the glass). An 1869 poem by Swinburne offers a subtly torqued account of experiences that lie *neither* in the world out there, *nor* in the mind that takes in that world: "Deep in the gleaming glass / She sees all past things pass."[5] This deep glass allows the viewing subject to inhabit a space of reflection and inward contemplation at once within and without our actual world. Conscious awareness itself may be something that takes place not so much inside one's mind as *within* that gleaming glass.[6]

Ask a Brickmaker

Different academic disciplines have over the years variously approached the problem raised by such "deep glass" moments. It would be hard to think of a scholarly field that does not require some paradigm to account for unexpected sorts of cultural or cognitive recombination that take place in a way that fails to fit neatly into an established order of knowledge. The English psychoanalytical theorist Donald Winnicott sketched out a "third area," a realm of play neither precisely part of the everyday world nor entirely removed from it; the renowned medievalist Johan Huizinga's *Homo Ludens* anatomizes the realm of "serious play" in which ludic rule-following rehearses the right life; anthropologist Victor Turner theorized a notion of threshold or "liminal" moments of cultural transition; Roland Barthes created a suggestive category of "the neutral" that also points toward similarly suspended zones. The possibility of such problematic overlaps even informs recent developments in the history of science, as for example in Lorraine Daston and Peter Galison's compelling account of the nineteenth-century rise of "objectivity" as a crucial scientific desideratum. Their influential *Objectivity* (2007) charted the rise of an aesthetic "willed willfulness" that in reaction makes the arts home to an explicitly antiscientific subjectivism. That analysis implicitly opened up for investigation a turbulent in-between zone, a range of situations neither entirely aesthetic nor entirely scientific, in which objectivity and subjectivity collide and collaborate.

James's anatomy of the way the mind wanders, decides things, then returns to actuality with a jolt ("that might be, but meanwhile she was going on") suggested that a closer look at narrative arts might help make sense of the various "third areas" social scientists have diagrammed. Over the centuries, ideas about semi-detachment have been emerging, developing, waning, and waxing in the practice of those who rely on the concept most: novelists, painters, designers, and filmmakers. So I focus my attention on artists who throughout their working lives were pressed by the constraints and possibilities of their respective media to explore the curious aesthetic states not accounted for in sociological, philosophical, and anthropological approaches to the space between absorption and distraction.

The first fruits of this project were a pair of articles about how semi-detachment was imagined in twentieth-century America. One started by remarking on the ways that Edmund Wilson and others of his milieu started to think about suburbia as a semi-detached space, and ended with the Ang Lee's vision of chilly Nixon-era Connecticut in *The Ice Storm*. The other made the case for thinking of social life as inherently semi-detached, in part by exploring how David Riesman's mid-twentieth-century denunciation

of "other-directed" sociability in *The Lonely Crowd* had given way fifty years later to Robert Putnam's celebrated attack on atomized America in *Bowling Alone*.[7] In its final form, though, *Semi-Detached* focuses on the ways novelists, painters, and filmmakers between 1815 and 1930 understand and make use of the state of dual awareness that an artwork produces: to share and not to share a world with an artwork's fictive beings. On the one hand (for reasons I explore in some detail in the conclusion), this project aims to make sense of artworks as they work their way through time, affecting different audiences in different ways, and appealing to (or appalling) present audiences for reasons that have everything to do with present-day situations. On the other hand, I have striven to take a serious look at how artists (novelists, painters, filmmakers) understood the constraints and the possibilities that aesthetic semi-detachment afforded: if you want to understand bricks, ask a brickmaker. Chapter 5, on the experimental novel, looks at James's dictation notes for his late novels, which attest to his evolving ideas about the relationship between a novelist's voice and the reader's experience. In chapter 7, Conrad's acute diagnosis of his friend H. G. Wells's scientific romances helps me frame an argument about Wells's use of the legacy of the realist novel to open up a brave new world of speculative fiction.

A colleague recently proposed thinking about semi-detachment as a new aesthetic *technology*. Although semi-detachment is a concept, rather than a set of tools, the "brickmaker" principle does shed some light on the impulse to see this as a story about emerging technologies: technological advances can be shaped by the demands of aesthetic forms; in turn, new technical possibilities ("affordances") can shift ideas about the capacities of art.[8] Buster Keaton used trick shots, sight gags, and unforeseen properties of the newfangled "story film" in ways that were shaped by how he imagined his audience's semi-detached reaction to his storytelling. In order to know what to invent next, it helps to know what you are trying to convey to your audience: a principle that applies as much to the rise of free indirect discourse in the early nineteenth century as to modernist experiments (in prose or on film) a century later.

How Historical?

The project began with a twenty-first-century "eureka" moment on a scruffy overpass. Unsurprising, then, that its early days involved slightly feverish attempts to link Victorian ideas about reverie directly to iPhones,

Facebook addiction, and virtual reality thought-experiments of the *Neuromancer* variety. In the years that followed, my approach grew more synchronic, asking what early nineteen-century Scottish writers James Hogg and John Galt thought about the rise of the short story, what effect Eliot's experiments with satirical verisimilitude in *Theophrastus Such* might have had on Henry James or even H. G. Wells. In fact, one virtue of focusing on the end of the nineteenth century and the first decades of the twentieth has been to clarify the historical antecedents for the current upheaval in thinking about states of partial absorption.

So how historicist does this book aim to be? Is *Semi-Detached* anatomizing a durable mental state and the artworks that record its nature; or is this a systematic register of formal techniques, committed Quentin Skinner–style to strictly delimited, historically contingent registers of possible meaning?[9] Much more the latter than the former—though I explain in the conclusion why that is a harder question to answer than it initially appears. *Semi-Detached* aims to map the range of "actor categories" that help explain the choices, even the compositional strategies of nineteenth- and early twentieth-century writers and other narrative artists—the logic that makes those artists deliberately turn to certain forms, techniques, and storytelling strategies that generate, or that represent, the state of semi-detachment. It tracks an unfolding conversation, sometimes explicitly marked, between Victorian and early modernist artists who understood their work as somehow tapping into, amplifying, or giving shape to a suspended duality of experience: the kind of duality Eliot depicts with elbows on bridge and armchair both, that James captures with his dialogue of the deaf between Marie Gostrey and Ralph Strether, that Ford Madox Ford describes by way of his double-layered glass, and that H. G. Wells approaches by way of "extra-dimensional worlds" at the very edge of tangibility and plausibility.

My presumption throughout has been that tracing semi-detachment as it materializes in past and present aesthetic forms does not prevent making contextual distinctions and exclusions. In Jane Austen's *Persuasion*, for example, Wentworth writes Anne a note while he is listening to her talking with Harville about woman's constancy in hopeless love. Is this a moment of involuted semi-detachment like that experienced by the *Mill on the Floss* narrator, whose arms rest on a stone bridge and his chair simultaneously? No. The crux in Eliot is not so much that a character is shown multitasking, but that the novel reflects on what it feels like to be *partially* drawn into a represented or imagined world while partially remaining at home in one's own actual surroundings. The logic of selection turns on that question of how explicitly and overtly problems of doubled consciousness

come to the fore. Austen notes the bifurcation—Wentworth is writing and listening both—but it does not lead her to the kind of speculation about here-and-thereness that becomes an overt topic of concern in novels like *Mill on the Floss*.

Still, historically minded genealogy should not become a sterile exercise in conjuring up a definitive past-as-it-must-have-been. Scott invented Dr. Jonas Dryasdust so readers could laugh at pedantic antiquarianism and academics might heed the warning: *go thou and do otherwise*. Presented only as a slideshow of a century's worth of potentially semi-detached aesthetic moments, the chapters that follow would be of little help in constructing a general sense of the concept and its wider implications. Even the most dogged historicism should aim to shed light on a concept's relevance outside a single era. The first time I saw Caravaggio's 1595 *The Musicians*, I was struck by how its central figure seems to be gazing directly out at the viewer—but also blindly tuning, listening to the unheard music of his mandolin (Fig. 0.1).

What good would my genealogy be if it left no space for such disturbances and anomalies, for speculation about semi-detachment in

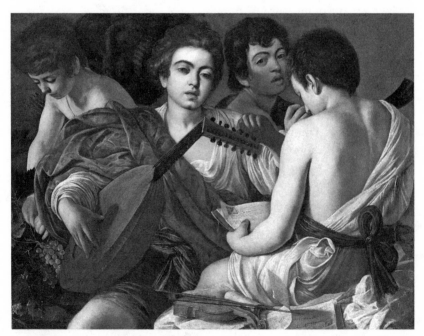

FIGURE 0.1. Caravaggio, *The Musicians* (c. 1595, Metropolitan Museum of Art, New York). Courtesy of Bridgeman Images.

Shakespeare's reverie-laden *Winter's Tale*, or in *Le Roman de la Rose*, or Virgil's *Eclogues*? Not to mention the games with partial absorption that Cervantes's *Don Quixote* plays: Quixote the dreamer seeing giants, and Sancho Panza by his side seeing windmills, with the result that readers are gifted with a kind of second sight and can see both at once.

How Literary?

That kind of untimely meditation ultimately made it easier for me to think about looking farther afield for a general explanation of the doubling of experience, the two-in-one sensation, betokened by those *Mill on the Floss* elbows. The experience of semi-detachment is neither categorically nor exclusively a fictional one, and its attempts to think through its implications are not confined to a single genre, form, or medium. David Summers's recent notion of the "double distance" produced by paintings, for instance, offers one fascinating way into the problem of semi-detachment. By his account, paintings implicitly instruct their viewers to respond to them both as material objects in actual space and as representations of a virtual world. The doubleness of the painting (it occupies actual space and creates virtual space) thus becomes an indispensable part of the conceptual encounter that viewers will have with it. Summers's argument helped me to understand why I found the sightless gaze of Caravaggio's musician so compelling. I saw him at the painting's center, at once soliciting my gaze and gazing past me, as it were, staring at the (invisible and inaudible) music his fingers made. But I also saw something that could never, by definition, meet my gaze: pigments arranged on canvas by a long-dead painter. In short, I felt like that narrator from *Mill on the Floss*, thinking that my elbows were one place, only to give myself a shake and discover that I and my elbows were actually in another room altogether. Nothing but paint on canvas all along. And yet that gaze, and those tuning fingers, call into being a moment of intense intimacy. The moment Caravaggio's musician acknowledges he is on one side of the pictorial divide and we are on the other is also the moment that heightens our sense of what kind of intimacy could exist between us.

Semi-Detached aims to imitate Caravaggio: to slow things down, to offer a complex account of what might otherwise be categorized in a way that captured only one side of an innately double experience.[10] Thinking about the twin effects of Caravaggio's painting helped me appreciate that Summers's notion of "double distance" aligns with the Kantian notion of the aesthetic as a site where reflection and reception necessarily converge

(which is at issue as well in John Stuart Mill's conception of mediated involvement with his correspondents, readers, and collaborators). All three Visual Interludes benefited from the realization that it was not only novel readers who experienced an artwork's capacity to make actuality partially recede. The doubleness that artworks produce in their deliberately imperfect virtuality was central to my exploration of Pre-Raphaelite struggles in a photographic age, to paint a not-always-objective "truth to life," as well as to my account of William Morris's efforts to turn his Kelmscott books into not-quite-self-contained little universes; central as well to making sense of Buster Keaton's semipermeable film-world, which somehow seems simultaneously to exist up on a screen and in the viewer's actual experience.

"Double Visions: Pre-Raphaelite Objectivity and its Pitfalls" moves into the mid-nineteenth century, examining a range of mid-Victorian paintings that explicitly or implicitly take semi-detached states of attention as their subject. The chapter explores what it means to be drawn into a painting's world, and yet also to remain apart from that world—to be critically detached and immersed simultaneously. It begins with controversial Pre-Raphaelite paintings of the 1850s, which angered Dickens and others by insisting on changing the rules by which their realism was established. Such paintings, John Everett Millais's 1850 *Christ in the House of His Parents* prominent among them, locate their putative actuality at one special moment in time—yet also openly acknowledge and reflect upon their dislocation from that time, the painting's role as an artificial moment. The way that paintings by Millais and by Lawrence Alma-Tadema explore that tension sheds light on a problem that runs through nineteenth-century narrative art, as well.

"This New-Old Industry: William Morris's Kelmscott Press" begins on November 15, 1888, when William Morris went to a "lantern lecture" by the skilled typographer Emery Walker, who screened a series of brilliantly colored photographs of books from the early days of movable type. Understanding why Morris was inspired that night to found the Kelmscott Press requires grasping what we might call Morris's emergent residualism. Morris's aesthetic practice in the 1890s, especially at the Kelmscott Press, bespeaks his commitment to creating innovative aesthetic experiments by recapturing long-lost artisanal practices that in their own day had been innovations that looked backward for inspiration. Recent work by Isobel Armstrong, Leah Price, and Elizabeth Miller on what might be called Victorian "materiality in theory" offers insight into the relationship between those glowing lantern slides of letter-forms and the solidly ink-and-paper books Morris brought into being. Those new accounts of how materiality was theorized in the nineteenth century also shed light on the tension

woven into Morris's work between what he called the "epical" and the "ornamental" aspects of a printed book.

Finally, "The Great Stone Face: Buster Keaton, Semi-Detached" traces the rapid emergence in the 1920s of semi-detachment in a new medium: building on theatrical, fictional, and painterly antecedents but strikingly original. Postmodern critical accounts highlight Keaton's Borgesian games with film—and who could forget the moment in *Sherlock Jr.* in which Buster leaps out of a darkened movie theater *into* the film he is watching, taking on a new persona in the process? Yet such accounts underestimate the persistent complexity of the ways that Keaton's characters essentially move in and out of touch with the world around them, attending and disattending to its actuality. Like Henry James's notion of "disguised and repaired losses" and "insidious recoveries," Keaton's way of locating himself within "worlds not realized" offers his audience members insight into the yawning differences between what they initially grasp of the world around them and what may actually be going on just beyond their attention's edge—unperceived but nonetheless real.

Visual Interludes and post-Kantian struggles with aesthetic judgment notwithstanding, the weighting of the chapters that follow signals the centrality of the genre of the novel and the formal possibilities afforded by fiction. However, proportional page weighting does not tell the whole story. The capacities of various visual media—from Pre-Raphaelite painting to silent film—to narrate is a key element in explaining how their audiences remain at once absorbed and critically detached. Conversely, works of fiction have a spatial as well as a temporal dimension, and that doubleness is decodable; indeed, it is part of the story that novels themselves tell about their own formal status.

The crucial overlaps come into sharp focus only when the elective affinities between the novel and the experience of semi-detachment are mapped. For that, two recent accounts of realism in fiction prove exceptionally helpful: Catherine Gallagher's idea of novels arising in the eighteenth century as "believable stories that do not solicit belief"[11] and Franco Moretti's proposal that we think of the realist novel as ineluctably constituted out of sequences of *episodes*.

Believable and Invented

Catherine Gallagher's influential work, from *Nobody's Story* to a recent summative piece on "The Rise of Fictionality," stresses the importance of eighteenth-century market conditions (a worldview shaped by "disbelief,

speculation, and credit") in shaping novels into "believable stories that do not solicit belief."[12] Gallagher proposes that "readers attach themselves to characters because of, not despite their fictionality. . . . Consequently we cannot be dissuaded from identifying with them by reminders of their nonexistence."[13] Another way to put Gallagher's claim is to say that the very thing that makes the experience of characters especially congruent to us as readers—that we can overhear or learn of their thoughts, especially via free indirect discourse—is also what makes clear their dissimilarity from us. With believability their benchmark and inventedness their given, novels do two seemingly discordant things simultaneously. On the one hand, they allow for a form of imaginative escape, a release into the pleasures of an invented world—the travails of a fictional character require no direct action on the reader's part. On the other, they trigger experiential attentiveness to the way the world is.

Readers of realist novels principally respond to fictional characters in their innately doubled roles as simultaneously plausible inhabitants of a world just like ours, and as thoroughly airy products of mere textuality. Compare this account of fictionality's dual nature to Michael Saler's recent *As If*, which makes the case that we should understand realist fiction as an imperfect way station on the path toward fully immersive art.[14] Saler argues that full-on dream worlds—modern-day virtual gaming worlds and in series like Tolkien's *Lord of the Rings*—achieve the fondest hopes of past fictional realism: Sherlock Holmes ushered his readers into an era of "disenchanted enchantment" or of "animistic reason," so that the late nineteenth and early twentieth century became a golden age for the plausible invented universes that Tolkien labeled "secondary worlds."[15] If Saler reads fiction as an attenuated version of fully immersive fantasy ("subcreation"), Gallagher makes clear the benefits that accrue to novels precisely from the doubleness of fictionality. Semi-detachment marks just that doubleness.

What looks like a contradiction between the novel's commitment to capturing social reality and its interest in the experience of psychological depth is actually productive complementarity.[16] Like characters, we have inward thoughts and experiences that do not directly appear in the world outside us; unlike us, they do not truly have such thoughts because they are characters and not persons. Think of Jane Eyre, reading for life in a window seat, screened from and yet connected to a cold world beyond the glass: she is also cousin Jane, aware that at any moment the red curtain will be thrown back and her book turned into another weapon in a daily domestic war. The Jane who contemplates the glories of the world of

Roman history opened up in the talk (and inside the glowing temples) of Helen Burns and Miss Temple is also the Jane blissfully aware of what it is like to be well-fed and ensconced within the only "temple" to be found in profane Lowood. In the world Brontë envisions, books can as readily turn into a missile to strike her readers as they can serve as an escape hatch to another world.[17]

Semi-Detached spends considerable time tracing the implications of Gallagher's model of cognitive suspension and fictionality. "Experiments in Semi-Detachment" charts ways that realist novelists—Dickens, Eliot, and James especially—modify formal techniques such as free indirect discourse in an effort to make sense of the way that consciousness, in life as in fiction, can be located in more than one place simultaneously. The flickering, moving center of consciousness charts novelists' efforts to understand that fraught and ironic capacity to see one's life from one's own perspective and also from outside. Henry James, for example, aims to render an unstable equipoise between—to borrow terms Lukacs uses to distinguish between realism's interest in narrating subjective interiority and naturalism's attachment to the "mere facts" of the world—the world as *event* and as *experience*. James sees the novel's distinctive capacity in its movement between what he calls "dramatic" (event-oriented) and "representational" (experience-oriented) prose.

"H. G. Wells, Realist of the Fantastic" follows the same line of thought, arguing that Wells's decade of experiments with the genre of "scientific romance" signals a fin-de-siècle turn away from many of the normative assumptions of Victorian realism; he does so by examining curious cases in which characters undergo extreme experiences, while simultaneously remaining anchored enough in the actual world that their stories can somehow be recovered and transmitted. Conrad's label for Wells—"O Realist of the Fantastic"—is a useful reminder that Wells profited from the elaborate unfolding of new formal capacities in late Victorian realist fiction. Wells's experiments in double exposure speak not to a broken world, but to a glitch in how that world enters into consciousness. Between the wars, a range of writers from Dunsany to Kipling to Forster to Stella Benson—practitioners of what Adorno disparages as "moderate modernism"—produce speculative fiction made possible by those formally simple but conceptually innovative stories of Wells.

By the same token, "Overtones and Empty Rooms: Willa Cather's Layers" sets out to track Cather's idiosyncratic movement away from antecedents ranging from Norris's naturalism to James's novels of consciousness toward a "moderate modernist" form of semi-detachment. Her

fiction between *O Pioneers!* (1913) and *The Professor's House* (1927) turns away from the possibilities explored by Lawrence, Hemingway, Woolf, Proust, Joyce, Faulkner, and Fitzgerald, seeking instead moments of aesthetic translucence, the overlay of one image, or one sound, on top of another. Such moments of overlay (or overtone) encapsulate the problem, as well as the promise, involved in turning one's readers simultaneously into participants and critical witnesses to one's story. Cather's distinctive form of modernism hinges on the way that she postulates a dichotomy between the world of aesthetic dreaming and the world of hard facts—then asserts fiction's capacity to inhabit both simultaneously.

Episodes as (and against) Plot

Gallagher's account of fictionality elucidates one key component of the experience of semi-detachment: readers' knowing embrace of artifice as if it were real. Her account highlights the ways in which fictionality implicitly works to separate the experience of reading fiction from the experience of actuality: of life lived inside the real world rather than in the pages of a book. Yet the link between Gallagher's concept of fictionality and the experience of semi-detachment does not foreclose ties with other critical accounts of the realist novel, among them Franco Moretti's argument about the "episodic" nature of fiction. The "episodic" is by Moretti's account both that which interrupts the flow of important events inside the European nineteenth-century realist novel—and also as, mirabile dictu, the actual substance out of which those events are constituted: "Small things become significant, without ceasing to be small; they become *narrative*, without ceasing to be everyday."[18] Moretti sees the novel representing actual life, that is, by capturing the way that any such life is built out of a series of single events or scenes. Taken each on their own, such episodes are trivial. When a character or a narrator looks back seeking order, however, those little pieces of almost-nothing can be sequenced together—strategically or arbitrarily excised, or newly arranged and ordered in the retelling—to add up to something much larger.[19]

The capacity to go back into the past to resurrect old occurrences and recognize their new significance in light of the present may not seem at first blush much like the capacity to feel oneself at home within a fictional world and actuality simultaneously. But—as modernist novels influenced by Henri Bergson's ideas about involuntary recall explored in exquisite detail—the discovery that one's past accompanies one in the present

may manifest itself as the experience of living inside two worlds at once. For a novel to be made up of episodes, aggregated actions that may or may not matter in the grand scheme (or that matter at one point and then cease to matter) has the odd effect of creating an immanent semi-detachment. Because every event in one's life is important not only as it occurs but also as it is retrospectively called up and made part of a series or pattern of events, the very fact of one's present experiences is itself shot through with a sense of absent events: the facts of the past or of the future that will make this event *sequentially* significant.

Novels, then, are constituted out of episodes agglomerated into a plot that nonetheless retains its contingent relationship to those disaggregated episodes. This opens the door for readers to understand their own relationship to their actual past similarly. Saler's notion of fiction as normatively aspiring to create a "secondary world" (a self-contained fantasy space apart) misses just such inklings, which are woven into Gallagher's account of fictionality's cognitive complexity. The looseness in the relationship between any given episode and the overall plot of a novel is a crucial form of semi-detachment.[20] Just as the impressions that Ford describes seeing in a half-darkened glass are double, so too do episodes, in this laminated account of the dialectic between past and present, loom into view as bygone events that are brought back into a kind of significant pastness by events of the present. Fiction's episodic nature—which allows the narrative partially to pull away from present surroundings to recollect the past—allows it to be mimetic of the real-world experience of discovering oneself overcome by what's bygone. Bulstrode's hidden nefarious past in *Middlemarch*, a past that will destroy him once known, is only revealed by actions occurring in the novel's present. Revealed, it becomes part of the novel's present—but as something long gone, present and absent both, evident in its very evanescence.

"Pertinent Fiction: Short Stories into Novels" relates crucial developments in nineteenth-century British fiction—the decline of the romantic tale, the rise of the short story, and the short story's subsequent shadow-life *within* realist novels—to changing ideas about semi-detachment. The relationship between the "real"—circumstantially vivid, experientially centered and particularized—and the "true"—the timeless, incontrovertible, and generalizable—changed markedly in both short- and long-form fiction in ways that have everything to do with new ways of thinking about readers' absorption, or partial absorption, into a fictive world. The chapter tracks the hybrid and disruptive form that tales and stories took in romantic-era writers such as James Hogg, as well as the rise of the sketch

and the short story (exemplified by John Galt's late work) in 1830s Britain. When short stories are absorbed into the "baggy" long-form Victorian realist novel, what might seem like narrative detours, digressions, or pure interpolations are instead made *pertinent* to the novel's characters.

The uneasy relationship between episode and whole—and analogously between the local and the universal—plays a similarly important role in "Virtual Provinces, Actually." That chapter asks how novelists from Gaskell to Trollope to Margaret Oliphant think about provincial subjects as existing both on the margins of a society centered elsewhere, and also as necessarily centered in the delimited sphere of their own experience: thus, a life that is simultaneously peripheral and central. At the heart of the provincial novel lies not a triumph of the local over the cosmopolitan (Little-Englandism), but a fascinating version of *magnum in parvo*, whereby provincial life is desirable for its capacity to locate its inhabitants at once in a trivial (but chartable) Nowheresville and in a universal (but strangely ephemeral) everywhere. Margaret Oliphant's searching accounts of irritation and envy as provincial vices, in such undervalued works as *The Rector's Family* and *The Perpetual Curate*, chart that Nowheresville's boundaries.

Between Worlds: The Advantages of Fuzziness

There are organizational disadvantages to a book about an idea with as many edges as semi-detachment: genre boundaries, historical periodization, and even disciplinary logic all potentially militate against any cohesion. Describing this project as aligned with Gallagher on believability or with Moretti on the episodic is not the same as claiming for it a thoroughgoing historicism, or a consistent commitment to mapping decade-by-decade change. Moreover, the book concludes by reflecting on the inevitable influence of present conditions on any scholarly account of the past, this one very much included. Yet the aim is unitary: to examine across genres, decades, and disciplines a single phenomenon, albeit one with fuzzy borders. My hope is not so much to dispel as to examine that fuzziness, to explain (rather than explaining away) semi-detachment as a phenomenon that artists reflect upon and represent in their works, and as something audiences experience at the moment of aesthetic encounter.[21]

In "Apparitional Criticism," I conclude by turning the lens of semi-detachment on the scholarly undertaking itself. Historically informed scholarship strives to avoid, on the one hand, antiquarianism (the past as a

world viewed with precision and certainty through a telescope) and, on the other, pure presentism (conceiving of the past as always knowable only on the present's terms). However, a problem that already preoccupied writers like Scott and Browning persists today: what is the relationship between our own conception of the past as past and what that past must actually have been like *as a present*? My own effort at "reading like the dead" (detailed in the conclusion) helped me understand both the pitfalls and the promises of any backward leap. Semi-detachment proves a vital concept in making sense of the gulf, neither imaginary nor impassable, that yawns between ourselves and what has gone before.

In *The Four-Dimensional Human*, Laurence Scott reports on the humiliation of being caught texting in a bar while pretending to listen to his tablemates. He repents "my puncturing of our sociability, the bleeding away of presence." Yet he also discovers the pleasures of "shimmering between two places, living simultaneously in a 3d world of tablecloths and elbows, and also in another dimension, a lively unrealizable kind of nowhere, which couldn't adequately be thought about in the regular terms of width, depth and breadth."[22] Scott ends his book with a call for "refreshing two-mindedness . . . a spacious habit where the unknown parts of ourselves and others are allowed to shimmer in their uncertainty, a humane, unmappable multi-dimensionality."[23]

This book makes the case that unmappable multi-dimensionality has been available for quite some time. In the 1890s, the "slow print" movement of the day was declaring the high-speed printing press a force every bit as terrifyingly revolutionary as the iPhone seems today; and H. G. Wells was not the only writer to conjure up worlds of n-plus-one (or n-minus-one) dimensions in which everyday rules went out the window. John Stuart Mill's agonized correspondence with Carlyle about his failure at face-to-face intimacy compared to the bliss he finds in print; George Eliot's account of the way that Dorothea's mind wanders away as she contemplates insect parliaments: when have we not been semi-detached? iPhones may electronically amplify our ways of being, but "shimmering in uncertainty," or "entering a lively unrealizable nowhere"? Eliot's been there, Buster Keaton's done that.

As a kid, I was fascinated by a forest glade, filled with shallow pools, that appeared midway through C. S. Lewis's *The Magician's Nephew*. It kept me up at night not by its *other*-worldliness, but by what you might call its *quasi*-worldiness: it was "the wood between the worlds." The book's protagonists, Diggory and Polly, appear there when they touch his evil uncle's magic rings; when they master the wood's secret, they can reach Narnia.

What enthralled and terrified me was Polly and Diggory's dazed, stumbling progression from shallow pool to shallow pool—especially the fact that they almost forgot to mark the one from which they had emerged, the one and only way back home to their own world.

The fascination of that wood between the worlds may seem to have a name that comes straight from Coleridge's idea of the "suspension of disbelief": absorption. Not quite. In *The Magician's Nephew*, Diggory's uncle thinks of the yellow ring as what takes you out of the actual world and the green ring as what brings you back. But the children understand a crucial distinction: a yellow ring actually takes you to the wood between the worlds, while a green ring sends you back out into any of the myriad available worlds. The wood's appeal to me (or its terror) lay in the idea of a between space, where both reality and fantasy were held temporarily in abeyance.

We should not underestimate the halfway-thereness that aesthetic experiences allow us to approach, explore, and comprehend. Even in a world of play-anywhere online gaming and "continuous partial attention," a world in which tirades about cyber-dependency compete with the allure of augmented reality, entering imaginatively into virtual worlds remains a complex undertaking with both payoffs and pitfalls that have to do with far more than leveling up, or tuning out. What I loved as a child was not losing myself; it was being at once lost and found. I went out and back in again, treating every world like a shallow pool: reality included. This is a book about such in-and-out experiences—and what difference they should make to our ideas about aesthetics.

1

Pertinent Fiction:

Short Stories into Novels

Walter Allen's magisterial 1981 *Short Story in English* begins with his version of the Mikado's little list.

> Everywhere in the world, whenever the short story is discussed, a handful of names crops up, Chekhov and Maupassant always, then Poe and Kipling and Joyce, and probably Katherine Mansfield and Hemingway as well.[1]

Allen presumably means to refer to the tastes of modern middle-class readers, tastes shaped by the standards that Edgar Allan Poe enumerated in 1842: a story ought to be *unitary*, *compact*, and achieve an *effect of immediacy* on the reader.[2] Franco Moretti argues that it is a rare form or genre that outlasts thirty years, but those criteria held good in Poe's own day, and from Chekhov to the present, they have also held sway.[3] So perhaps only a Victorianist would fault Allen for omitting the heyday of British realist fiction from his list. Measure realism's golden age from Charles Dickens's *Pickwick Papers* in 1837 to George Eliot's *Daniel Deronda* in 1876—or even stretch the era a bit to include quasi-naturalist novels like Thomas Hardy's *The Mayor of Casterbridge* (1886)—and only Kipling even comes close.

Allen is not alone in skirting the British's novel's heyday when compiling a short story pantheon. This missing half century is not mere happenstance, but a clue about the gap between Poe's criteria for short fiction's success and the formal attributes Henry James had in mind when he at once praised and disparaged his novelistic predecessors for writing "large loose baggy monsters, with their queer elements of the accidental and the arbitrary."[4] And when Somerset Maugham agrees that the "long, unwieldy shapeless novels of the Victorian era" are England's chief contribution to world literature, he adds a revealing corollary: that "English writers on the whole have not taken kindly to the art of the short story."[5]

Scholars who agree with the Poe litmus test have often subscribed to the *delay* hypothesis, evident for example in Korte's proposal that "the short story 'proper' emerged in Britain with considerable delay, not until the *late* nineteenth century."[6] Dean Baldwin argues, along related lines, that "the rise and fall of the British short story is intimately connected to the economics of writing and publishing" and that "between 1880 and 1950 [but not before] the market for short fiction became sufficiently broad, deep[,] varied and flexible to accommodate all writers of talent and many of very limited abilities."[7] By his reckoning, it was only from the 1880s onward that "art and commerce . . . existed in creative tension, and [a surprising range of authors] turned the short story to their financial and artistic advantage."[8] Taken together, the delay theory and Baldwin's economics-of-publishing argument seem to militate against praising or even perhaps studying with too much attention the short stories of the early and mid-Victorian era.[9]

I propose a different way of thinking about the place of the short story in the changing shape of nineteenth-century British fiction, a way perhaps more in keeping with Tim Killick's recent argument about the generic categorization of short fiction in the early nineteenth century: "Short fiction does not fit into a single overarching agenda. . . . The position and credibility of short fiction was by no means established. Consequently the boundaries of the genre had to be negotiated at every stage."[10] Stories, tales, sketches (even interpolated tales within longer fiction) by James Hogg, John Galt, Charles Dickens, and others reveal nineteenth-century short fiction as an art form that both represents and reflects upon readerly semi-detachment—albeit in changing ways as the century wears on.

This chapter covers writers in three different historical moments: James Hogg from 1810 to 1830; John Galt, Dickens, and Poe from 1830 to 1840; Dickens alongside Eliot and others from 1840 to 1875. The conditions for the production of short fiction and the dominant form such short fiction took varied enormously in those three periods—not least because of the rise of the sketch in the second period and the cultural dominance of the novel in the third. In each period, however, the possibility of semi-detachment, and the question of what it means for someone to become partially absorbed into the world of the story, shaped the writing of short fiction in subtle but ultimately crucial ways. My argument for the generic specificity of semi-detachment in British short fiction aims to accomplish three things: first, to shed light on overlooked features of the tales and stories of the romantic era; second, to offer a new way of thinking about the concurrent emergence in the 1830s of the long-lived genre of the

short story and relatively short-lived genre of the sketch; finally, to replace the "delay hypothesis" about the British short story during the heyday of the Victorian realist novel with the hypothesis that we should think of the British short story as flourishing within the novel itself, taking the form of *pseudo*-interpolated tales.

JAMES HOGG: STRATEGIC UNDECIDABILITY

If we begin the history of the British short story not in 1880 as Baldwin proposes, nor even in 1842 with Poe's genre-shaping review, but back in the era of the romantic tale, we are immediately faced with the problem of short fiction defined not by singleness but by incompletion, rupture, and uncertainty.[11] In the story of the rise of the short story, James Hogg has perpetually found himself out of place, out of time, and surprisingly out of luck. Poe's acolyte Brander Matthews speaks for a surprising congeries of critics when he proclaims the short story "is one of the few sharply defined literary forms. It is a genre . . . a species as a Naturalist might call it, as individual as the Lyric itself."[12] For nearly two centuries, a remarkably durable consensus, critical and creative alike, has coalesced around the insistence that, in Poe's terms, "a certain unique or single effect" is the acme of the author's ambition and that "the immense force derivable from totality" should be understood as an unmistakable impression produced on the reader by a single event.[13]

Compression, psychological penetration, and above all singleness of effect have been at the heart of every generic taxonomy since Poe.[14] True, Goethe influentially described the short story as presenting an eruption of the fantastical into the everyday—"a singular or unprecedented event which occurs as part of everyday reality."[15] Even there, though, the singular has its place, as the moment of fantastical disruption around which all explanations, and all of the story's actions, must coalesce. Small wonder that few people have trumpeted the short-fictional credentials of James Hogg, even though his acme in the 1820s coincides with the triumph of many of the short story's godfathers: Walter Scott, Washington Irving, Edgar Allan Poe, and Alexander Pushkin.

It is worth noticing, though, that Poe's criteria, enshrined by Matthews and virtually every successor in the field, actually rule out a range of formal possibilities—many of them essential components of the realist novel. Oscillation between detachment and absorption seems to be ruled out by Poe's recipe for the short story—as do the temporal unfolding,

the episodic contingency, and the experiential accumulation that Ian Watt and Franco Moretti (in somewhat different ways) singled out as crucial to the novel's brand of fictive realism. Realist novels of the era can succeed by varying or combining different temporal schemes, so that effects are spread out through flashback, concentrated to a sensation, or understood only retrospectively. Stories are denied that luxury, and therein lies a serious problem for Hogg's reputation.

Poe's categories have been rethought in a number of productive ways recently.[16] Recent attention to the role that *The Thousand and One Nights* played in shaping emerging conceptions of fiction in early modern Europe provides a welcome alternative to a straightforward history that walks dutifully through *Spectator* sketches (of the "Inkle and Yarico" variety) and the performative arabesques that structure Eliza Haywood's *Fantomina* to arrive, by a kind of motiveless teleology, at Maria Edgeworth's moral and national tales.[17] The various pre-genres to the modern short story—among them the fabliaux, dirty jokes, and shaggy dog stories that crop up in Aesop and migrate in various ways from *The Thousand and One Nights* to *The Decameron* and Chaucer—offer a much more varied set of contributing antecedents to nineteenth-century short fiction.

To that revisionist work I want to add consideration of the unique formal properties of short fiction that lend themselves to new ways of approaching the readerly experience of semi-detachment. Doing so helps lay bare some of the fascinating formal possibilities opened up by Hogg's experimental short fiction—possibilities that also reappear, albeit in a somewhat tamed and controlled form, in novels later in the century. Thinking about how semi-detachment operates in Hogg's stories and tales, that is, helps clarify short fiction's role as a kind of proving ground, during the romantic era, when Poe's rules about singularity of effect were not yet gospel for some of the most interesting features of the later realist novel— among them, the pseudo-interpolation of stories into the larger diegetic frame of the novel.

James Hogg's quarter century of fiction writing began in 1810 with *The Spy* ("one of the places the modern short story was born")[18] and eventually spread to the scores of tales, stories, elaborate jokes, sketches, records of local customs, melodramatic vignettes, and linked story cycles constituting the core of *Winter Evening Tales*, *The Shepherd's Calendar*, *Altrive Tales*, and *The Three Perils of Man*. Although André Gide excavated and effectively recanonized Hogg's remarkable novel, *The Private Memoirs and Confessions of a Justified Sinner* as a proto-modernist masterpiece, the relationship between Hogg's short fiction and his era's debates about

textuality, fictionality, and literary authority is interesting enough in its own right. Hogg's commitment to the staging of conflict between narrative frames—not simply shifting focalization but actively disrupting it—is not absolutely unique in his own day: links abound to the long-form fictions of his friend and rival Walter Scott. However, when it comes to tracing a through-line in the ways that effects of semi-detachment can operate in short fiction, Hogg stands almost alone. His works make cunning use of central mysteries that lend themselves to various sorts of explanation—Satanic possession, individual madness, collective delusion, or simply the distorting lens of history—but which finally resist the triumph of any one explanatory schema over its alternatives. The consistent effect of such explanation-production and explanation-denial is to leave readers in much the same state that Ford describes with the half-reflecting pane of glass: peering deeply into a world that they suspect of being merely an illusion. Yet by a strange reversal, it is the possibly illusory quality of that world that makes them gaze so deeply, so attentively.

Critics have noted Hogg's attachment to disputation and undecidable problems.[19] To take those observations a step further: Hogg's short fiction practices what we might want to call (on the model of Bakhtin's "polyglossia") *polydoxy*. Hogg addressed the reader's own doubts about the plausibility of the fictional world—the reader's feeling of being at once within and without this invented world—by staging the intersection of profoundly disjunctive belief systems within that world itself. The reader is accordingly faced with some of the same problems that will return to characterize long-form Victorian fiction: about the relationship between divergent perspectives on a single event, sequentiality, and the nature of the episode—that is, the question of what constitutes a significant action or event within a world where narrative significance unfolds contingently rather than being foreordained or authorially sculpted.

Consider what Hogg's short fiction is *not*. Walter Allen once declared Scott's "The Two Drovers" to be "the story that I recognise as the first modern short story in English."[20] David Cecil, praising Scott's short stories over his novels, revealingly claimed that Scott lacked the "sense of form" but was saved in such short works as "The Two Drovers" because "a short story is the record of an isolated incident."[21] Both critics understand Scott's mastery of short fiction to consist of the gradual winnowing out of alternative possibilities for understanding a given incident, until what stands revealed is what Poe called "the single effect." "The Two Drovers" highlights Scott's use of a gathering effect, a movement toward definitive singularity. In it, the murder of an Englishman by a Highlander

and the latter's execution at the Carlisle Assizes serve to reconcile all divergent worldviews under a single, universally acknowledged justice—a justice explicitly recognized by the man doomed to die under it: "'I give a life for the life I took,' he said, 'and what can I do more?'"[22]

The judicial ending of Scott's story puts every character into a single interpretive frame and thus secures the narrator's footing. In Hogg's fiction, however, there are no fair cops. Instead his stories end with sudden dilations, shifts in speech, and closing paragraphs that shift to other forms entirely: "An Old Soldier's Tale," for example, ends with a loosely germane stanza of a Scots song.[23] In Hogg, there is always one further document to be unearthed, one further mystery to puzzle out, and one further genre to be dropped onto the page.

In Hogg's fiction, polydoxy can be found at the level of incident, plot, character, or motive—even in the question of what makes a given occurrence into a story at all. (To look ahead: in the Victorian novel, that question of pertinence or digression develops into a crucial question of what constitutes an episode, and whether episodes themselves constitute digressions *from* the plot of the novel, or instead, when appraised and ordered retrospectively, the embodiment of the novel's plot.) In "An Old Soldier's Tale," rival interpretive communities (Highland rebels and Lowland loyalists) can occupy the same space without acknowledging one another's existence—or they can decide to duel about what sorts of tales will survive from a particular period of war. A Lowland Scots soldier who claims to have done great duty for the government forces at Culloden is "drowned" (shouted down) and "overpowered" by a Jacobite loyalist who gives him hospitality for the night. Yet when his hostess has out-sung him, as compensation for his defeat, she lets him turn the tables and embark on a gory and largely incredible tale: how he was besieged, bungled his use of civilian hostages, and used a heroic handcuffed backflip to throttle his would-be executioner and win the admiration of his enemies.

In this story and others, Highland and Lowland Scots fail (and pretend to fail, and fail to pretend, and even fail to pretend to fail) to understand one another's words. Meanwhile, bemused or smugly obtuse outsiders—English tourists or local stuffed shirts—keep popping up, presenting themselves as authoritative voices with definitive explanations of fundamentally unparsable phenomena. Paranormal and dryly scientific accounts of lightning strikes coexist, and narrators pop up to declare various pieces of local knowledge impossible—yet irrefutable.

Hogg's commitment to shifting frames of believability jibes well with Maureen McLane's recent work on the ways that the various sorts of

poetic authority interact, and resonates with recent investigations of the ways in which Victorian narrative strategies depend on a kind of magisterial "ethnographic authority."[24] In Hogg's stories, the shifts are sudden, striking, and seem designed to alert the reader to the fact that the grounds for trust in the narrative's reliability have shifted. Such games are everywhere in Hogg's oeuvre, an irrepressible habit or imp of the perverse that sends his fictions teetering sideways into a condition of suspect textuality. Consider, for instance, the variety of authoritative claims embedded in just the title of one of Hogg's volumes of stories—*Altrive Tales: Collected among the Peasantry of Scotland and from Foreign Adventurers by the Ettrick Shepherd*—in which the "by" does double duty as a claim to have collected and to have composed the tales.

Hogg works by juxtaposing plausible alternative explanatory schema for a single set of events. Time and again in his stories, a fully coherent account of events is replaced in the final few paragraphs with an equally plausible but incompatible alternative explanation. Hogg's attraction to stories with incompatible beliefs about seemingly straightforward events frequently means that demonic intervention emerges as the only explanation left standing that seems to cover all the facts. Accordingly, supernatural explanations are often offered to the reader with a shrug of disbelief, because the most reasonable interlocutors within the stories are dissatisfied with their veracity but can find no alternative standpoint from which to deny them. A line describing the Devil's presence at the death by lightning of "Mr. Adamson of Laverhope"—"It was asserted and pretended to have been proved"—might be taken as the key to all Hogg's mythologies.[25]

There is no degree-zero in Hogg's stories. "Mr. Adamson of Laverhope" ends not with the death by lightning of Adamson himself, but instead detours fifty-one years forward to another death by lighting, that of Adam Copland of Minnigess. This second death occupies only about a twentieth of the story as a whole, but the narrator's sober scientific explanation for it—freak lightning from the ground—seemingly undermines the conclusion of the previous 19/20ths of the story: that Adamson was slain by the Devil using lightning. Why would Hogg attach this odd demiquaver of a tale to the vivid account of how Adamson's sins against his neighbors—recollected with crystal clarity seventy years later—brought about his doom? He is experimenting with what it might mean to achieve what he knows to be impossible: a neutral ground where various possible explanations hang in equipoise with one another. It should not surprise us, then, that the calm, linguistically neutral account of Adam Copland's death is itself immediately undermined in a variety of ways: the

one witness present cannot actually remember the precise moment of the strike, even the narrator cannot provide the moral exhortation that is to be found carved on Copland's tomb, and so on.

Such turns toward irrelevancy mean that even the events, persons, causes, and effects in any story—the very components that allow it to appear to be a story at all—are perpetually at issue. It is often unclear why a given piece of prose ends where it does, whether the last few pages were an afterthought, the motive for the whole piece, or simply the gateway to another tale told from a different perspective. The in medias res that Hogg pursues, rather than gesturing at an Auerbachian epic totality, lends to his stories the feel of deliberate fragments, made to be appreciated precisely for their fractured, and their fractal, quality.

Even when Hogg's stories seem to aim for the complete package, the full-throated comprehensiveness that a *Spectator* tale (or one of Dickens's *Sketches by Boz*) manages effortlessly, the effect is oddly labored. "The Long Pack," for instance, is a perfectly self-contained squib about a peddler's pack that bleeds when fired on (because a thief is tucked inside, waiting for nightfall). Hogg centers the story on Edward, who becomes a hero by firing into the pack (as he does many other things) "without hesitating one moment."[26] This is a Poe story in the making: Edward's nature is perfectly unfolded in the action itself: he is the ardent defender whose unthinking action saves the day. Why then does Hogg end the story, a good two thousand words further on, by running through Edward's later life, from his career in the army to his death? There is some undercurrent of what McLane calls "experiential authority" here, as the narrator reveals that he had heard the story from this same Edward, but the detour to that effect, away from the focused sensation of the original instance, is deliberately odd.

Hogg's endings are memorable for the ways in which they deny or undo the potential energy that by Poe's logic should be building toward a climactic discharge. Hogg's stories linger in the mind as much for the effects they refuse as those they produce. That makes him worth comparing to his contemporary Heinrich von Kleist, whose formal gyrations are on display in the deliberate irresolution and the teasing half-turns toward magical explanations in works such as "Michael Kohlhaas" and "The Beggarwoman of Locarno."[27] Both Hogg and Kleist succeed by generating an often uneasy sense of between-ness: a solution between magic and science, a world between our own and the past, a character between rationality and inexplicable depths.

The Coleridgean notion of "suspension of disbelief" is ill-suited to explain such fluctuating effects: semi-detachment is a better explanation

of the aesthetic effect here because the sensation of movement between possible worlds is exactly the point. Like the story's befuddled, or suddenly disillusioned characters, readers must grapple with a set of facts that cannot simply be empirically accepted. Semi-detachment as it applies to Hogg, then, is an explanation for how Hogg works on his reader's capacity to receive empirical impressions of a world (the actual world, or a story world) and then, by reflecting upon what they have received, to realize that their impressions are neither complete nor convincing.

Hogg is right, therefore, to insist that there are significant differences between his tales and Scott's genre-shaping short stories. The success of a story like "The Two Drovers" lies in its ability to plaster over just the formal cracks that Hogg loves exploring. Scott sets a model for future short fiction by directing the reader confidently to the moment where the view of the law, the guilty party, and the reader all find themselves in agreement on the events that have just transpired: Poe's "singular effect." Hogg's fiction by contrast aims at disrupting the smooth fit between frames of reference within the story—and, accordingly, the fit between viewpoints expressed within the story and the stance toward the story that the reader can be expected to take. Hogg has often been understood as striving to master one role or another or to manage his transitions from one kind of authority claim to another. However, a great deal of his work strives not to paper over or to excuse a given story's between-ness (between groups, between dialects, between forms) but to celebrate it. Hogg creates a repository that fails to contain the voices that populate it, that ultimately resigns the task of uniting the divergent forces within it into anything resembling an agreeable and agreed-upon outcome.

A significant number of writers after Hogg, in short and long form both, explored the fictional propensity to induce reflection upon "the plural constitution of our experience in general." However, the debt such writers owe to Hogg, or to related experiments of the Romantic era, has been overlooked. Hogg's polydoxy, like that torqued historicism of Scott's novels, hinges on the reader's uneasy movement between immersion and critical detachment—between reception and reflection in a Kantian sense—so that the fiction must be resisted and swallowed at once. Judgment always entails both absorption and detachment.

This chapter concludes by tracing the formal logic of the not-quite inclusion of the short story within the Victorian novel. It is worth pausing here to note an underlying homology—despite surface differences—between Hogg's incomplete, fractured, and inconclusive stories and such Victorian pseudo-interpolation of stories into novels. The multiple deaths

by lightning, multiply explained, in "Mr. Adamson of Laverhope" are just as much a version of incomplete detachment between the world of fiction and of fact as are the stories that in Victorian novels hover somewhere between the actual world and the world of fable. Hogg's underappreciated achievement was to produce a kind of apparitional poetics that functioned within the limited confines of the woolly romantic tale. As norms for tales and stories shifted rapidly in the 1830s, though, the narrow spaces for such inventive genre-bending changed with equal rapidity. How striking then that another half-in, half-out denizen of the Edinburgh/*Blackwood's* scene began an entirely different set of experiments in the 1830s, experiments that cast a revealing side-light on the earliest years of the Victorian publishing world, in which short stories and sketches together rose to prominence.

Story and Sketch

> Miss Peerie, the schoolmistress, was, about sixty years ago, the most beautiful young woman in our town; her father was headmaster of the grammar school, and she excelled every young lady far and near in accomplishments.
>
> John Galt, "The Mem"

In the August 1834 number of *Fraser's*, just after James Hogg's "Domestic Manners of Walter Scott" and preceding the third installment of Thomas Carlyle's *Sartor Resartus*, appears "a sad and simple tale" by the Scottish jack-of-all-genres, John Galt (1779–1839).[28] Its brevity (five pages in *Fraser's*, about 3,500 words) is somewhat belied by its complex, Walter-Scottish title: "The Mem, or Schoolmistress. From the Papers of the Late Micah Balwither, of Dalmailing." It covers Miss Peerie's early promise and accomplishments as well as her financial and romantic disappointments after the death of her father, and briskly disposes of a couple of late suitors who court her when she has become a tutor of everything from Hebrew to table manners and household chores.

On display in this story are many features that also characterize Galt's earlier novels-of-sketches, most famously, his 1821 *Annals of the Parish* ("theoretical histories," he called them, embarrassedly disavowing the novel).[29] From its beginnings around 1812 to his novel writing acme in the early 1820s, his brief, unhappy transplantation to Canada, and his illness-marred writings of the mid- to late 1830s, Galt's writing is marked by

sardonic wit and playful but profound linguistic somersaults.[30] From 1820
(still Hogg's heyday) to the end of his productive fiction career around
1836 (when the new regime of the short story has just begun), Galt stands
out among his peers for compact, powerfully vivid characterization that
turns his often underplotted fiction in a variety of fascinating directions.[31]

Galt was an avid experimentalist ("poetry, biography, travelogue,
drama, and prose fiction in both three-volume and one-volume format"[32])
and his perennial problem with debt was especially troubling in the early
1830s. So it should not be a shock that adaptable, almost protean Galt
turned—with a three-volume collection, *Stories of the Study* (1833)—to
the short story.[33] The way that he approaches that new form is, however,
worth closer attention. It merits remark, for instance, that the very end of
"The Mem" is a striking departure from his earlier work.

When "The Mem" dies, Galt writes,

> Great was the lamentation that ensued. Mothers wondered what
> they would do with their daughters, and really were in as great an af-
> fliction as if they had all been marriageable. However, their grief was
> not of a durable nature, and was soon forgotten when Miss Peerie
> was laid in the churchyard.[34]

Thus far we are in familiar short fiction territory: the sad fact of the death
immediately larded with a little Austenian joke about the nature of the
maternal grief—principally, irritation at the problem of disposing of their
daughters now that Miss Peerie's school is shut. These are sentences that
could have been written by dozens of the writers who shared column
space in *Fraser's* with Hogg, Carlyle, and Galt. The narrator's own grief,
though, suddenly supervenes:

> Miss Peerie was laid in the churchyard. But still she has been a mys-
> tery to me. For what use was knowledge and instruction given to
> her? I ponder when I think of it, but have no answer to the question.[35]

We have been told nothing about the narrator while he charted Miss
Peerie's sad trajectory from accomplished young lady to bitter and stingy
schoolmarm. Suddenly the reader encounters this new voice musing on
the mystery that—after all this sketch-work—still lies at the heart of "The
Mem." This striking effect is almost Beckett-like.[36] Its impact depends not
so much on what the story has to tell as what it admits to leaving out: any
underlying explanation of who Miss Peerie really was, or where we would
go to read the solution to her puzzling life. These final sentences notate the
failure to denote—a failure that is in some odd way also a success.

Galt's definitive biographer, Ian Gordon, describes "the outburst of stories" right after Galt's 1832 stroke as the author's "Indian summer," in which he "abandoned the facile and easily written yarn of his earlier days for a tightly constructed genre."[37] Galt had written stories earlier: "The Gathering of the West" was an 1822 success, and the *Annals of the Parish* could be read as a set of bundled stories whose strength comes more from their compression than any overarching unity.[38] Critics, though, have astutely identified Galt's attention in those earlier works to problems of national belonging and to synchronic cohesion: to the anchors that link characters to their own space and time, and thus, to interpretable, knowable worlds.[39]

Let this story stand for Galt's fiction, circa 1833–36, in which he sought a foothold in a changed publishing environment, in which editors prized singularity and affecting concision (in fact, Galt was dropped by *Blackwood's* in 1836).[40] On the one hand, we might notice its residual (in a Raymond Williams sense) features: the clunky, overly elaborated title and the proliferation of digressive anecdotes within the story (e.g., a litany of failed suitors in the style of a "catalogue of ships") that align "The Mem" with the earlier tale tradition. Also visible, however, is what Williams would label an emergent impulse, a sketch-like impulse in fact, toward classificatory completeness: this is what a "Mem" looks like.

Most remarkable of all, however, is this out-of-nowhere voice, making the reader suddenly aware of a narrator trying and failing to make complete and adequate sense of the focalizing character and her story. With that phrase, Galt aims to do something that he doesn't quite know how to do. We might say that Galt is moving toward an experiential account of what it means to make sense of story or a life—and that experiential quality also requires him at key moments to make the feeling of mystery or imponderability part of the experience of the story. We might think of the polydoxy in Hogg as lateral (i.e., hinging on discrepancies in belief among characters in the story translated into readerly unease). Here, the discrepancy arises from a sudden shift of diegetic level: the focalization is no longer with the suffering "Mem" but with the befuddled narrator, whose existential unease jumps straight into the reader's own mind.

How should Galt's late turn be explained? Ina Ferris's recent account of how the norms for classing historical writing as persuasive or compelling evolved in early nineteenth-century Britain sheds an interesting light on the late transformation in Galt's fiction. After the Napoleonic wars, Ferris argues,

> "Remains" achieved new prominence as classical models of history
> were destabilized both by a scientific turn towards documentary

"sources" (heralded by the emergence of the modern discipline of history) and by a "sentimental" turn, which sought for a more intimate and affective relationship to life as experienced in the past.[41]

Rather than presenting a persuasive overall account of the world (the "classical model" of generally logical truth rising above ephemeral details), persuasive writers had to produce material evidence—and somehow generate among readers a sentimental connection, a *we were there* experience.

By Ferris's account,

> No matter how opposed in other ways, both the scientific and sentimental turns agreed in valorizing the witness-narrative, and understood historiography less as a synthetic mode of explanation and evaluation than as the collection and collation of primary documents through which access to the lived past could be gained. In an important way, history's business was coming now to be seen to be the "real" as much as the "true."[42]

One implication of the dual importance of the scientific and the sentimental as pathways to a "touch of the real"[43] is that any form of writing that can claim to be both scientific and sentimental—by way, that is, both of direct testamentary evidence and also of experiential plausibility—will gain a new kind of credibility in a world where the "real" is valued on both scientific and sentimental grounds. Think of how "The Mem" ends: both with sharp, incisive observations about the micro-fallout of Miss Peerie's death and with the narrator's own marked, experiential aporia—that is, with the narrator's feeling that he has failed to comprehend this highly local but abiding mystery. Fiction's claim to appear realist depends on the dual use that it makes of what Ferris calls *science* and *sentiment*, twin impulses toward the "real" that are working *together* in crucial ways in the short fiction that builds upon the ethnographic impulse of sketches.

This linkage between particular knowledge achieved via empirical observation and via sentiment has fascinating implications. For the fiction of the 1830s, typical knowledge (of the sort the sketch offers to deliver compactly) is not the enemy of moments of mystery, but mystery's handmaid. There is much more to be said here about a new worldview that in the later romantic era rejects the Enlightenment division between a clear, truthful, universal knowledge and mere materiality, suggesting instead that it is *via* materiality alone that any kind of universality can be attained.[44] We might think, for instance, of Carlyle's 1828 claim that to be recognized as universal, "the thing written" must nowadays (in contradistinction to the heyday of the Scottish Enlightenment) bear "the mark of place." Or Hazlitt's

remark in his 1825 *Spirit of the Age*: that Scott, in his effort to make his novels "real" is "like a man who having to imitate the squeaking of a pig upon the stage, brought the animal under his coat with him."[45] Carlyle praises and Hazlitt disparages this turn toward material authenticity; both however discern a shift in how fiction grounds its claim to believability.[46]

Concurrent with the rise of a post–French Revolution commitment to theoretical equality, there also arises a new kind of Aristotelian taxonomical impulse toward fixity of social roles: mid-Victorian writers, such as Mayhew and Trollope, are committed to the idea of deeply embedded vocations that define individual identity in profound, existential ways. But a point Hannah Arendt makes in *The Human Condition* bears stressing: that such relentless socializing of all scales by which human action is to be appraised lends itself to a desire to "only connect" that can obstruct other ways of imagining and understanding the nature of one's political world.

The readily assayable knowledge that Galt provides in stories like "The Mem" (alongside the sense of mystery with which it concludes) sheds valuable light on a distinct "rise of fictionality" in the 1830s, as conceptions of thoroughly embodied persons locked into their social roles pushed novelists and short story writers to come up with new definitions of sympathy and of the conditions for mutual knowledge between strangers and other sorts of writers, as well. The increasingly persuasive power of material evidence is signposted by the influential role a new prose genre comes to play in the 1830s and 1840s.

The Story of the Sketch and a Sketch of the Story

To use a diachronic comparison to Hogg's polydoxy is one approach to Galt's early 1830s pivot toward new kinds of publishable short stories, but his alteration also provokes some synchronic questions about the relationship between the novel, the tale, the newfangled short story—and the sketch. Killick argues that "for short fiction, in broad terms, the watchword during the 1830s was expansion": twice as many short story collections appeared between 1830 and 1836 as during the entire 1820s.[47] This development also spawns quirky by-blows like "The Rioters," an illustrative story dropped into Harriet Martineau's 1832 *Illustrations of Political Economy*.

In fact, boundary-riders like Martineau should prompt us to look more closely at the larger cultural field into which the era's short fiction emerges. That exploration might begin by asking what differentiated short stories from the more loco-descriptive or bio-descriptive work of the sketch. It

turns out that what happened during the subsequent half century, when realist novels ruled Britain's fictional roost, has everything to do with the changes heralded by the 1830s, a decade in which romantic-era tales of Hogg and Scott gave way not only to the short story as a recognizable category of fiction but also to urban sketches—brief impressionistic or analytic descriptions of the city's physical and social geography.

Recent work by Martina Lauster and Amanpal Garcha has described the sketch as a crucial new form of short prose writing straddling the boundary between fiction and nonfiction, displacing the tale and shaping the new Victorian realist novel. Lauster focuses principally on French and German iterations of sketch publication, emphasizing what she calls its "cognitive" work.[48] Garcha, stressing the importance of the sketch's "descriptive" work, focuses primarily on British novelists who began as sketch writers before eventually importing its descriptive logic into long-form fiction.[49] Both see the sketch as an informative genre, one that foregoes experiential interiority in order to convey important aspects of the physical landscape or (Lauster's special emphasis) the social array of people one would likely meet on the streets of a city.[50] For Garcha, the sketch is a gateway to descriptive totality in novels, whereas for Lauster the sketch itself allows readers to watch their own society's cultural classification apparatus at work.[51] The sketches and stories of the 1830s and 1840s are united in their desire to depict (mainly urban) types playing their customary roles—wearing "character masks" in Lauster's useful formulation. Lauster and Garcha open up new ways of thinking about the direct influence of the sketch upon the fictional forms that flourish alongside it, and one of the first new questions they allow us to ask is what the fiction writers of the day made of the enlarged possibilities afforded by the sketch's existence.

The first theoreticians of the sketch's power and its aesthetic possibilities were such writers as Galt, Poe, and Dickens. Yet their response moved fiction *away* from the descriptive or cognitive logic of the sketch. Think of the odd recessive moment that ends "The Mem": that disorienting appearance of the mystified narrator instantly engenders a more complex "cognitive system" (to borrow Lauster's phrase) than the sketch itself permits. In stories that build on the conventions of the sketch but also veer away from them, characters can be classed as social types, but readers are also licensed to feel with characters—and such stories make use of forms of sympathy that often work most fully when characters are presented in the most incomplete, potentially frustrating ways. Such stories rebut an overly neat taxonomic division—sketches depict types, stories focus on

affecting individuals. Rather, it was just such a conjunction the stories of the day provided.

Edgar Allan Poe's unsettling "Man of the Crowd" (1840), for example, brings in its "man" only after the narrator has finished describing dozens of urban types who rush past him on a typical London afternoon. The story begins with the narrator seated "at the large bow-window of the D—Coffee-House in London," smoking a cigar and thinking about Leibniz, looking at the rushing masses outside with a "calm but inquisitive interest in every thing":

> At first my observations took an abstract and generalizing turn. I looked at the passengers in masses, and thought of them in their aggregate relations. Soon, however, I descended to details, and regarded with minute interest the innumerable varieties of figure, dress, air, gait, visage, and expression of countenance.[52]

Poe then whips through two "tribe of clerks " ("junior" and "old") before disposing rapidly of pickpockets, gamblers, dandies, and (shyster) military men; then he runs rapidly through Jew pedlars, professional street beggars, invalids, factory girls, and six varieties of "women of the town" before ending his classificatory work with a crescendo: "beside these, pie-men, porters, coal-heavers, sweeps; organ-grinders, monkey-exhibitors, and ballad-mongers, those who vended with those who sang; ragged artizans and exhausted laborers of every description."[53] All this sketching of types occurs before that one unforgettable face swims into view:

> I was thus occupied in scrutinizing the mob, when suddenly there came into view a countenance (that of a decrepid [sic] old man, some sixty-five or seventy years of age)—a countenance which at once arrested and absorbed my whole attention, on account of the absolute idiosyncrasy of its expression.[54]

Lauster primes us to notice that even in a story that has become the Platonic type for the "singular effect" of the newfangled short story, Poe, in a lapidary fit of Mayhew-like ethnography, sets up scores of people who fit into one category or another.

Nor do we have to look eastward to Nikolai Gogol ("Nevsky Prospect" in 1835, "The Nose" in 1836) to see that Poe's is not a distinctively American approach. In fact, the same duality that makes Poe's "Man of the Crowd" so strikingly able to convey both typical knowledge about urban dwellers and also an abiding unease-inducing sense of mystery is also strikingly present in Charles Dickens's *Sketches by Boz* (1833–36).

Even the earliest of those sketches demonstrate Dickens's dual commit-
ment—on the one hand, to detailed empirical knowledge of city life and,
on the other, to the shadowy spaces of individual feeling, site of the sort of
lapidary "effect" Poe singles out as essential to the story.

For example, "Our Next-Door Neighbour" begins as a catalogue of the
various types who live on Boz's street and ends three pages later with Boz
sitting at the deathbed of his newest neighbor, a boy recently arrived rosy-
cheeked from the country. The sketch begins with a meditation on door-
knockers and how well or poorly they describe the people who live behind
them—which leads to a metonymic analysis of the avuncular hosts to be
found behind "the jolly face of a convivial lion" and the "spare priggish"
government clerk invariably found living at the house with a "little pert
Egyptian knocker."⁵⁵ This is typological reading at its quickest and crud-
est (Boz even compares himself wryly to a phrenologist), which offers an
overly simplified and hence readily undermined form of urban legibility.

The arrival of a new next-door neighbor signals a shift, but the story
still remains in the sketch world of types and their quirks. The landlord
next door quickly proves incapable of reading typical urban cads—a task
that Boz evidently views as indispensable for any physiognomically literate
Londoner. First, the landlord chooses to rent to a cheery young man who
turns out to be a convivial drunk given to loud parties. Making a compen-
satory lurch, the landlord then rents to "a serious man"—who promptly
makes off with all the movables in the house on the first dark night.

The simple, reliable world where residents matched their knockers has
been replaced by a shadowy (though still "type"-ridden) zone where land-
lords are duped, because young men of the new generation are so good at
giving off misleading clues that their exteriors don't match their conduct.
As readers ready themselves for a third laughable urban type, however,
another more substantial narrative shift occurs: Boz unveils the pathetic
tale of a dying young man and his solicitous mother. Like Poe's man of the
crowd, and Galt's decision to turn the end of "The Mem" into an explo-
ration of the narrator's own feelings, this terminal character (terminal in
more ways than one) alters the emotional and the cognitive burden of the
story instantly. Within a page, we are listening to the son's heartfelt plea:

> "Mother! Dear, dear, mother—bury me in the open fields—anywhere
> but in these dreadful streets." . . . He fell back, and a strange expres-
> sion stole upon his features; not of pain or suffering, but an inde-
> scribable fixing of every line and muscle.
> The boy was dead.⁵⁶

The boy's final moments likely struck readers as too lapidary to be truly moving—readers of Dickens's novels get to spend far more time with Jo and Little Nell before they expire, and the existence of that "time passing" is a crucial feature of long-form Victorian realism.

It is nonetheless significant that Dickens is already working out ways to combine the distinct kinds of direct representations of "the real" that Ferris labels the scientific and the sentimental; at the same time, he is toggling between scientific and sentimental forms of knowledge. In doing so, he (like Galt and Poe) is not simply borrowing from the sketch, he is pointedly borrowing from it in order to mark fiction's distance from the merely descriptive task the sketch is presumptively assigned. In Galt, I pointed to the turn toward felt mystery at the story's conclusion: everyday knowledge about a local life is suddenly turned into an affecting account of the narrator's effort to make sense, to comprehend the purpose of, Miss Peerie's life. Here Boz (who may initially seem to resemble the mid-Victorian journalist-turned-urban-ethnographer, Henry Mayhew) moves us away from stock, "legible" city types to a deathbed where everyday urban experience is replaced by a "you had to be there" kind of poignancy.

The key point connecting Galt, Poe, and Dickens at this moment is not that fiction thrives by choosing particular details in preference to general or abstract knowledge (Watt's account of what produces the novel's dominance in the early eighteenth century). Rather it is that both the Dickensian deathbed and Galt's invocation of the sense of mystery hovering over the life of "the Mem" are predicated upon a productive conceptual doubleness *within* the world of particular knowledge. Empirical details go one way, and sentimental responses to moments of great feeling go another. Both, though, are, in Hazlitt's terms, pigs dragged squealing onto the stage (in Ferris's terms, both are Real rather than True). By providing empirical detail and particular feeling, both these pieces of short fiction have the potential to offer what may seem like a new kind of comprehensive totality, one that leaves abstraction out of the mix altogether.

Coming on the heels of Hogg's polydoxic tales of the prior generation, these pieces by Galt, Poe, and Dickens suggest that the stories of the 1830s, even in their quest for that singular effect Poe articulates, draw heavily on the kind of evidentiary moves Lauster associates with the sketch, the story's seemingly much drier and more soberly analytical cousin. The tendency to classify and the tendency to produce in the reader a sympathetic impulse toward a particular focalizing subject are not as distinct as we tend to assume. Read "The Man of the Crowd" or "Our Next-Door Neighbor" as a sketch, and each has a lot to say about the urban array. Read it as

a story according to the usual understanding of Poe's idea of "effect," and the opening pages of outer classification are mere background thrown in to heighten the final tingling of the spine. The challenge is to parse works like this (even a work that overtly marks itself as a "sketch by Boz") as doing both things at once. Each sets in place a "typical" reading whereby all these characters in their well-ordered classes are put into place—and also offers a sublimely unsettling approach, whereby a single shape-shifter (associated with all the chaos that crowds bring) has the capacity to unsettle that typology.

In making sense of an era where Scott's novels stand accused by Hazlitt of writing-as-live-pig-waving, Galt's little-read short stories shed some light on developments also at work in Poe (and later in Hawthorne, Melville, and others) and Dickens as it flows into the realist fiction tradition. "The Mem" and similar Galt stories of the 1830s (e.g., "The English Groom") suggest how deeply the short story's origins are bound up with what Lauster and Garcha have shown is the "cognitive system" of the emerging genre of the sketch and its commitment to the "descriptive," whether that description apply to place or to persons. They also demonstrate that alongside such commitments to empirical informativeness lies a devotion to sensibility that is directly manifest in Poe's notion that the platonic shape of a story lies in its singular effect upon the reader—but a devotion to sensibility that also lines up with realist fiction's newfound commitment in the nineteenth century to prose fiction as particularly experiential.

Where Have All the Stories Gone?
Pseudo-Interpolation and Pertinence

This chapter has argued thus far for a close study of the importance of the sketch in grasping the impact of moments of disorienting semi-detachment in short fiction of the 1830s—moments when the story seems partially a sketch and partially something altogether stranger and more affecting. But there are other contexts to explain the diverse forms of short fiction that flourished at the onset of the Victorian era, and the distance they generally traveled from the sort of stunning (but almost instantly forgotten) polydoxy Hogg deployed in romantic tales.[57] An equally crucial question, though, is how the novelty of the short story should be understood in relationship to concurrent alterations underway in the novel. Korte's remark that "the short story 'proper' emerged in Britain with considerable

delay, not until the *late* nineteenth century"[58] can be taken as a reminder that there are also *improper* stories to be found in the mid-Victorian era, and not just tucked into Harriet Martineau's textbooks. If the short story "proper" failed to thrive in mid-Victorian Britain, readers were nonetheless treated to many stories within the very genre that ostensibly put the short story into eclipse: the novel itself.

Perhaps the easiest way to start making sense of semi-detachment's contribution to the short story as it thrives alongside (and sometimes inside) the Victorian novel is to ask how much the realist novel seems to change its form and function during the early nineteenth century. In the introduction, I stressed the importance of Gallagher's account of fiction as made up of "believable stories that do not solicit belief."[59] Fiction both fantastically escapes from the world-as-is and demands the reader's strict attention to the rules of the world-as-represented. It follows from Gallagher's account that fiction's believability is reinforced rather than undermined by moments when the narrator hits a limit. Think, for instance, of the curious final sentences of "The Mem": "For what use was knowledge and instruction given to her? I ponder when I think of it, but have no answer to the question."

Hogg's and Galt's stories, as I have been reading them, argue for making more than Gallagher does of the differences between fiction and the novel per se; they also argue for putting more stress on the differences between fiction of the romantic and the Victorian era.[60] The boundary-troubling presence of short fiction helps to remind us of how much (to invoke Kantian categories) reflection coexists with reception: how much the turn toward immersion in a fictional world is always accompanied by a set of cognitive calculations about that world and reasoned observations about that world's relationship to the reader's own.[61]

Pratt proposes considering the modern short story a permanently "minor" genre, defined by its relationship (subordinate, contestatory) to the major prose fiction genre, the novel. What if we inverted Pratt's paradigm, however, and considered the realist novel, in all its bagginess, all its multiplottedness, not so much as the short story's enemy but its (symbiotic) engulfer? The post–*Pickwick Papers* disappearance of the interpolated tale from the novel offers a very good clue for when that period of engulfment begins. Around 1837 (the year Victoria ascended the British throne), the realist novel starts to function as a repository of short stories. Although those stories that get woven in novels by Dickens, Trollope, Thackeray, Brontë, and others may lose one formal feature by no longer operating as stand-alone narratives, they retain many other key attributes

of the short story. Incorporated into the larger form, we might say that such stories "go viral."

Critics describe a mid-Victorian interregnum following the era of Poe's apogee and the sketch's triumph.[62] And it is true enough that Anthony Trollope's "Mrs. Brumby"—a vitriolic and blunt attack on a female writer published as a stand-alone story in May 1870—has little in common with the complex character study of the novelist Lady Carbury in *The Way We Live Now* (1875).[63] That Trollope-to-Trollope comparison suggests, however, there may be a different way to locate, classify, and analyze the short stories of the mid-Victorian era—attending to ways that writers of the day are exploring and meditating on the possibilities fictional semi-detachment raises. That way begins by noting that Dickens's 1836 preface to the volume publication of *Sketches by Boz*—"should they be approved of, he hopes to repeat his experiment with increased confidence, and on a more extensive scale"—proved prophetic in an unexpected way.[64] The extensive scale on which the experiment was to be repeated, it transpired, was the realist novel itself.

Stories have always been at home within novels. The interpolated tale is a time-honored novelistic device, predicated on the capacity of one fiction to contain another. Related to its container precisely by disjunction, such a tale is, if you like, an image of the novel within the novel itself: the romance or fancy or tale that offers its characters just the same kind of interlude from their own reality that readers themselves enjoy by picking up a novel. The insertion of such tales implies three ontological levels: our extradiegetic world, the world of the depicted characters (Scheherazade as the storyteller), and the world of the stories that they tell (Scheherazade's characters: e.g., the fisherman who caught a genie). Characters from the nested tales (inhabitants of Genette's "metadiegetic" level) from the age of Aesop through Boccaccio down to *The Pickwick Papers* are generically barred from moving into the world the storyteller inhabits.[65]

In *The Pickwick Papers*, old-school interpolation reigns, from "the Stroller's Tale" in chapter 3 down to chapter 49, "Containing the Story of the Bagman's Uncle."[66] Even if readers were momentarily tempted to believe that the "bagman's uncle" was a real person rather than a convenient fiction, the story itself is cast as a dream, existing only inside the head of the (presumably nonexistent) uncle. At the climax of its action, "my uncle gave a loud stamp in the boot in the energy of the moment and—found that it was gray morning, and he was sitting in the wheelwright's yard."[67] This sort of interpolated tale links Dickens circa 1837 not only to the woolly "tale" tradition of the romantic era but also to a century of formal

realism.[68] Jeffrey Williams even argues, apropos of *Joseph Andrews*, that such interpolated stories have long seemed to critics to function as interruptions that, in Ian Watt's words, "break the spell of the imaginary world represented in the novel."[69] Little wonder that Williams's own defense of these tales argues not for their reintegration into the diegetic universe of the characters, but rather celebrates the disjuncture between world and interpolated tale.[70]

After *The Pickwick Papers*, however, the interpolated tale vanishes almost entirely—not just from Dickens but from Victorian realist fiction almost entirely.[71] Already early on in the serialization of *Oliver Twist* (August 1837, before *Pickwick*'s serialization itself had concluded), Dickens's chapter titles signal his intention to keep every story told on the same diegetic level. "XIII. Some new Acquaintances are introduced to the intelligent Reader; connected with whom various pleasant Matters are related, appertaining to this History" introduces Bill Sykes and Miss Nancy—and though the matters related are anything but pleasant—they do fulfill the pledge of *pertinence* to the story.[72]

Oliver Twist not only discards interpolated stories, it also offers up some significant early versions of a literary device that speaks volumes about Victorian notions of the role and place of the short story. From *Oliver Twist* on, Dickens makes liberal use of the pseudo-interpolated story. That is, a story introduced as if it were an interjection from another world instead proves to be a story directly linked to the novel's characters (you might think of "Wandering Willie's Tale" in *Redgauntlet* [1824]), often reprinted separately as if it were the straightforward "specimen of . . . tales of superstition"[73] that Darsie Latimer takes it as, rather than as *both* an implicative glance backward to Redgauntlet's own ancestors *and* a proleptic warning about future action within the world of the novel).[74] The simplest such story is the kind of embarrassing anecdote that begins "I have this friend who . . ." In the hands of Dickens and other mid-Victorian novelists, the pseudo-interpolated story is anything but simple.

In *Oliver Twist*, Dickens uses pseudo-interpolation briefly, and awkwardly, to disclose Oliver's familial connections. Monks reveals Oliver's connection to Rose Maylie (she is his aunt) in a rambling, seemingly pointless story that temporarily omits names—"The child," replied Monks, "when her father died in a strange place, in a strange name, without a letter, book or scrap of paper"—before suddenly restoring pertinence to a story about a nameless girl by demanding, "Do you see her now?" The reply tumbles this story back into the mimetic frame: "Yes, leaning on your arm."[75]

Deixis is the handmaiden of pseudo-interpolation. What seems to be a story from another world is suddenly made pertinent by a pointing finger: there stands the story's subject. Critics then and now have chided Dickens for the "related after all!" logic of such moments of pseudo-interpolation. Yet the popular success of such revelations of relation attests to the centrality of the idea that every story told inside a novel must in some way "appertain" to the characters who tell or hear it.

There are certainly instances of such pseudo-interpolation in earlier novels: In Ann Radcliffe's *The Italian* (1797), a character more than once discovers that a particular story is not only "concerning" but also "concerned you"; or that a story he hears narrated contains himself as a character within the story.[76] In contradistinction to earlier novelists (not to mention his own earlier novels), from *Oliver Twist* onward, Dickens persistently uses such pseudo-interpolations to allow characters to reveal direct (damning, exonerating, delightful, dreadful) knowledge of others. Stories are, for example, told by one character to signal a threat to another—the threat being that one may reveal who the characters are in this seemingly anonymous tale. In *Bleak House*, for instance, when Tulkinghorn wants to signal to Lady Dedlock that he knows her secrets, he tells her the story of her own shaming past in the presence of Lord Dedlock—but in such a way that her own identity as protagonist of the story remains (temporarily) hidden.

Dickens also shares with his peers the tendency to disparage sorts of stories that propose a different way of imagining the relationship between tale and world. When Pip is given the nickname Handel by his friend Herbert, Herbert explains that he dislikes the name Philip because

> it sounds like a moral boy out of the spelling-book, who was so lazy
> that he fell into a pond, or so fat that he couldn't see out of his eyes,
> or so avaricious that he locked up his cake till the mice ate it, or so
> determined to go a birds'-nesting that he got himself eaten by bears
> who lived handy in the neighborhood.[77]

That joke turns on the failure of the moral tale (a rival genre) to be realistic—that is, its failure to tell a story that can be convincingly linked back to *this* real world, inhabited by these particular characters, who can see out of their own eyes, who don't lock up their cake, and who live in neighborhoods without handy bears. The realist novel, then, is predicated not on conquering the short story but on *assimilating* it, showing that any such story actually belongs to the same world within which it is told. The

girl I spoke of is standing before you now; you yourself are the sinning young lady in my story.

Pseudo-interpolation should also help us recognize another key aspect of storytelling in Dickens: that characters make sense of their mundane lives by framing stories, frequently mistaken stories, about themselves and those around them. If "storytelling and fiction-making are endemic to the entire world of the novel," then the pseudo-interpolation whereby what had initially seemed to be fiction turns out to be fact marks sites of semi-detachment.[78] Pip's irrepressible tendency to invent stories that might explain his career and his desire for Estella, for example, lies at the heart of *Great Expectations*. Hence the crisis when Pip's fantasies—in which his wealth connects him to Miss Havisham and his beloved Estella—give way to the cold, hard reality that he owes everything to a convict.

The seeming rebuke to storytelling that is encoded in that revelation about Magwitch's unexpected centrality has, however, a couple of ironic twists. First, Dickens proves Pip's fantasy genealogy right, after a fashion. On Magwitch's deathbed, Pip re-sutures the plot through an unexpected byway, linking himself, via Magwitch, back to Estella. ("You had a child once, whom you loved and lost. . . . She is a lady and very beautiful. And I love her!"[79]) The story holds—but only because it is confirmed in the unlooked-for byways of life, rather than conforming to the banal clichés on which Pip had built his original storybook love for Estella.

The second twist is that when the time comes to reveal that Pip had been immersed in make-believe, Dickens turns to a story out of *The Arabian Nights*.

> In the Eastern story, the heavy slab that was to fall on the bed of state in the flush of conquest was slowly wrought out of the quarry, the tunnel for the rope to hold it in its place was slowly carried through the leagues of rock, the slab was slowly raised and fitted in the roof, the rope was rove to it and slowly taken through the miles of hollow to the great iron ring. All being made ready with much labor, and the hour come, the sultan was aroused in the dead of the night, and the sharpened axe that was to sever the rope from the great iron ring was put into his hand, and he struck with it, and the rope parted and rushed away, and the ceiling fell.[80]

Dickens spurns storybook moral tales for their unreality—but he welcomes an "Eastern story" when it perfectly aligns with Pip's own life and experiences (*The Arabian Nights* plays a surprisingly large role in the imaginative life of an era ruled by realist novels). By the same token,

Herbert Pocket's "airy pictures of himself conducting Clara Barley to the land of the Arabian Nights, and of me going out to join them (with a caravan of camels, I believe), and of our all going up the Nile and seeing wonders"[81] are delightfully vindicated in the book's final chapters, when Pip joins Pocket's business in Cairo—camels and Nile wonders included in the package.

Pseudo-interpolation, then, lies at the heart of a series of strategies that do not expel stories from the Dickensian novel, but instead restore all stories to the ontological plane on which the characters themselves reside. This incorporation of stories into novels via their application to the protagonists' situation—the swallowing up of stories—helps to explain some of the most distinctive features of the baggy, multiplotted Victorian realist novel. Even elements that seem to fly outside of the novel's universe are eventually unmasked as elements of the lives, rather than the confabulating imaginations, of the novel's characters.

Even granting certain formal differences in how interior stories are framed and related, Victorian realist novels can be usefully compared not only to eighteenth-century forebears like Defoe and Richardson but also to the extensive story collections of earlier centuries: *Aesop's Fables*, *One Thousand and One Nights*, *The Decameron*, *Canterbury Tales*. Their *Flatland*-like qualities (that is, a story you thought was two-dimensional actually rises off the page and into one's own universe; this is an idea to which chapter 7 returns) are an invitation to think about this fiction's forays into semi-detachment.

Other mid-Victorian novelists made equally avid use of pseudo-interpolated tales, weaving multiple plots together rather than setting embedded stories off as interjections from another world. This sort of all-inclusive fictional *pertinence* is precisely the basis of the distinction that George Eliot (in a famous passage from *Middlemarch*) draws between herself and Fielding. That eighteenth-century novelist, writes Eliot

> glories in his copious remarks and digressions as the least imitable part of his work, and especially in those initial chapters to the successive books of his history, where he seems to bring his armchair to the proscenium and chat with us.[82]

"We belated historians must not linger after his example," Eliot continues, because in our own day we must focus on a limited social world.

> I at least have so much to do in unraveling certain human lots, and seeing how they were woven and interwoven, that all the light I can

command must be concentrated on this particular web, and not dis-
persed over that tempting range of relevancies called the universe.[83]

The famous "web" metaphor is often understood as a claim for the novel's
immense scope, but the distinction Eliot draws between her "particular
web" and Fielding's "digressions" suggest that the key point about the
web is that *restriction* in scope is what leads to the productive examination
of unexpected relations between different parts of the restricted domain.
To Fielding, in Eliot's metaphor, the whole world seemed fair game, while
she, by contrast, is limiting herself to the sticky gossamer threads of "this
particular web."

In *Middlemarch*, accordingly, even the furthest flung and most trivial
seeming anecdotes, moments of apparently pure interpolation, are eventu-
ally plucked in such a way that they resonate through the web. Take this
forgettable early moment, when the young Doctor Lydgate and the Rev.
Farebrother are getting acquainted. Farebrother informs Lydgate they
have a mutual friend:

> "You remember Trawley who shared your apartment at Paris for
> some time? I was a correspondent of his, and he told me a good deal
> about you." . . .
>
> "By the way," [Lydgate] said, "what has become of Trawley? I
> have quite lost sight of him. He was hot on the French social sys-
> tems, and talked of going to the Backwoods to found a sort of Pytha-
> gorean community. Is he gone?"
>
> "Not at all. He is practising at a German bath, and has married a
> rich patient."
>
> "Then my notions wear the best, so far," said Lydgate, with a
> short scornful laugh. "He would have it, the medical profession was
> an inevitable system of humbug. I said, the fault was in the men—
> men who truckle to lies and folly."[84]

Trawley appears no more in the novel, and it would be easy to think for
the subsequent seven hundred pages that he is introduced only as an oc-
casion for Farebrother and Lydgate to establish their acquaintance with
one another.

In the novel's final pages, however, readers discover that Lydgate

> died when he was only fifty, leaving his wife and children provided
> for by a heavy insurance on his life. He had gained an excellent prac-
> tice, alternating, according to the season, between London and a
> Continental bathing-place; having written a treatise on Gout, a dis-
> ease which has a good deal of wealth on its side.[85]

Though readers cannot be certain Lydgate's "bathing-place" is in Germany, the application of Trawley's story is evident, and not at all what Lydgate had thought at age twenty-five. Eliot remarks, "The story . . . [of] men who once meant to shape their own deeds . . . coming to be shapen after the average and fit to be packed by the gross, is hardly ever told even in their consciousness."[86] Trawley's story is not traced in his own consciousness, but readers nonetheless get glimpses enough of Lydgate's to register the irony of that superior scorn he had earlier heaped on Trawley.

Eliot's web of stories, then, works by showing Trawley and Lydgate alongside one another, and even showing us Lydgate looking at Trawley (future, sad sellout gazing at the present, successful sellout). Eliot needs such quasi-interpolated tales not only to give the reader a wide array of possible choices but also to show us the mundane process whereby we, hearing the stories of others, try to find the application to our own lives — try, and sometimes, like the scornful Lydgate, fail to guess what sort of pertinence the future will actually reveal.

Conclusion: Semi-Detached Polydoxy, Inconclusiveness, Pertinence

Williams has linked overtly interpolated tales in eighteenth-century fiction to a Burkean aesthetics that sees delight in novelty as superior even to mimesis as a grounding for aesthetics: "For Burke, novelty and its affective power — that which makes us run to see it (such as a fatal accident or a public execution, as he notes, rather than a well-done play) — supplant the interest in and take priority over sheer imitation."[87] This Victorian turn toward *pseudo*-interpolation evinces a taste for the complications that ensue when the artwork's artifice and its suasive fictionality are both recognized simultaneously. This is what happens when a tale is brought forward as if it were an extradiegetic interjection (not in the fictional realm at all, hence delight in its novelty), only for the frame to break and the story to fall back into our own world (fictionality and hence mimesis all the way down).

If there were a joke about how Victorian novels got their bagginess, the punch line might be: by swallowing short stories. During the half century in which the Victorian realist novel held sway, short stories lived on (to steal a phrase from Orwell) inside the whale. Moretti parses the episodic nature of nineteenth-century realist novels as a product of bourgeois sensibility: by his account, the interweaving of mundane digressions and detours toward minor characters works to reduce every action to a merely aleatory set of occurrences, burying significance within trivia.[88]

Pseudo-interpolation, with the fluctuating relationship between story and actuality that it engenders inside Victorian novels (is that a mere story, or is it potentially *the* story of my own life to come?) offers a different way of thinking about the relationship between episodes and overall "plotted-ness." If we take seriously the notion that the realist novel engulfs short stories and puts them to work within a larger multiplotted structure, then Eliot's aims in incorporating stories like Trawley's becomes clearer: to depict a world in which every story has a potential application to every person, even if how the story "appertains" is presently obscure. Rather than being ways to forestall truly heroic action, as Moretti proposes, episodes and the stories of minor characters contained within those episodes mark ways in which daily life is not simply a backdrop to momentous events, but in some odd way actually comprises those moments of greatness, which are thereby revealed as essentially mundane, as well.[89]

Some critics have located stories and novels as essentially subsets within the operative category of fiction.[90] Others (following Poe) have defined the two as distinct genres, governed by distinct rules. The interweaving of stories within the Victorian novel offers a third way of understanding the relationship: stories are forms of fiction that, by virtue of their capacity to appear *within* longer fictions, are at once part of and distinct from the novel.

This is neither a one-body nor a two-body solution: you might call it *one-and-a-half*, because it depends upon a novelist's awareness that the pertinence problem (does this story relate to *me*?) is an intriguing version of the general problem posed by fiction: what should I think and feel about this believable and yet patently invented world? Stories then must be akin to novels because both partake of fictionality, but they must also be different—because what novels represent is the movement of stories through the actual world, which is not a form of circulation that novels themselves can have. Pratt asserts the minor status of the short story when compared to the novel's dominance; by contrast, this chapter explores a crucial asymmetry: a story can be engulfed by a novel, but not vice versa. The result—in a publishing environment in which the short story is defined by singularity, and hence by the gap between its form and that of novelistic pseudo-interpolation—is that novels and stories are united in their difference, divided by their identity.

The ways that seemingly interpolated stories in mid-Victorian novels are eventually folded into the baggy world of the novel itself (but only after existing autonomously for what may feel like a very long time) serves as the same kind of reminder of what the novel's episodic structure does:

that fictionality is not sheer invention so much as it is a deeply convoluted representation of a social world that is also itself constructed upon interlocking worlds of characters and stories that stand always in an indeterminate and perhaps indeterminable relationship to one another. The principle of fictional pertinence that governs the relationship of story and actuality in an Eliot or a Dickens novel, then, works precisely because any given story may turn out to lack pertinence (to be impertinent). The indefinite relationship that subsists between story and actuality (between that earlier spa doctor and one's own life) is in fact the way in which the novel succeeds at representing life itself.

In Hogg's polydoxy and Galt's frame-breaking experiments with narrative focalization is evidence of the ways that short fiction in the early nineteenth century explored the reader's oddly doubled relationship to fiction, as both artifice and potential slice of life. The turn to pseudo-interpolation by writers such as Dickens and Eliot establishes a relationship both of identity and of difference between short stories and the novel. The chapters that follow explore some of the unexpected implications of such uncertain fictionality.

2

Mediated Involvement: John Stuart Mill's Partial Sociability

> The peculiarity of poetry appears to us to lie in the poet's utter unconsciousness of a listener. Poetry is feeling confessing itself to itself in moments of solitude, and embodying itself in symbols which are the nearest possible representations of the feeling in the exact shape in which it exists in the poet's mind.
>
> John Stuart Mill, "Thoughts on Poetry and Its Varieties"

> Though direct moral teaching does much, indirect does more.
>
> Mill, *Autobiography*

REFLECTION, RECEPTION, IMAGINATION

This chapter explores the underpinnings of John Stuart Mill's notion of the forms of sociability available to the ideal liberal subject, focusing on the debt that even the most autonomous form of reasoning owes, by his account, to an imaginative faculty that conceives of other minds in various imperfect ways. Mill's central liberal tenets inhere in his conception of aesthetic judgment—and in his notion of what it means to read works of literature. The model of sociability Mill proposes involves a new way of conceptualizing how one's ideas and judgments are transformed by the immediate or the mediated presence of other minds; in effect, we are defined by our semi-detached relationship to those around us. We might call this a theory of *mediated involvement*. That idea of mediated involvement is rooted in Mill's conception of the powers of art and of the aesthetics of reading. The underpinnings of Mill's ideas about political communities are laid bare in his accounts of the ways in which aesthetic experience make human beings available to one another, graspable and tangible.

Mill's uncertainties about his relationship to Benthamite utilitarianism and Coleridge's romanticism lead him to experiment with new models for

understanding how social interaction and subjective experience shape any individual's grasp of universal truths. To see why this is so requires the examination of antecedents crucial to his conceptions of aesthetic judgment and the capacity of imagination: Kant and post-Kantian romantics. Woven through his career is an innovative approach to a set of problems about aesthetic judgment inherited from Kant, but crucially filtered through romantic historicism.

The role aesthetic judgment has to play in the Kantian pathway between the sensuous (Lockean empiricism) and the purely categorical or conceptual (Leibnizian idealism) has long been in dispute. At stake in that debate is the question of how aesthetic judgment—or aesthetic experience generally—shapes received sensations; what role reflection plays in turning that initial reception into an experience.[1] The answer to that question depends in part upon whether imagination is understood as one self-contained aspect of a larger cognitive capacity that subsumes it, or whether it is a reflective pathway all its own, productive of a qualitatively distinct form of knowledge.

Fiona Hughes stresses the distinctive role Kant assigns to imagination in the *Critique of Judgment*:

> We are complex beings bound to the world by a sensory or aesthetic capacity to take things in, namely receptivity. But we are also able to stand back from our environment in a reflective capacity. That which joins aesthetic receptivity with reflection is a third capacity, Kant tells us, imagination. Imagination makes possible a unification of what is ineliminably different—that is, our capacity to be affected and our capacity to reflect on the world.[2]

For Hughes, the crux of Kantian imagination is the role it plays in making sense of receptivity (the sensuous, empirical apprehension of the world) and reflection, which understanding brings to bear on that sensory data. The imagination forms the basis of aesthetic judgment, which "allows us to reflect on the process of synthesis" between reception and reflection. According to Hughes, "We can only be receptive, and we can only be reflective insofar as we are both at one and the same time. Aesthetics allows for an insight into the plural constitution of our experience in general."[3] Hughes emphasizes what it means to recognize immanent plurality in our sensory and cognitive natures: that recognition is achievable via aesthetics because the aesthetic experience helps us to recognize that our sensory (receptive) and cognitive (reflective) capacities are at once distinct from and reliant upon one another.

In exploring the same congeries of problems around the distinctiveness of aesthetic judgment, Hannah Arendt stresses the *absence* of the world at the moment that the imagination goes to work.

> Imagination, that is, the faculty of having present what is absent, transforms an object into something that I do not have to be directly confronted with but that I have in some sense internalized, so that now I can be affected by it as though it were given to me by a non-objective sense. [4]

Arendt understands Kant's aesthetics as the implicit basis for his political conception of enlightenment by virtue of an aesthetic "enlarged mentality." Whatever we feel about that secondary turn, Arendt is right to stress the importance of the role that imagination has to play in grounding aesthetic judgment in Kant. The crux of the aesthetic operation in Kant, argues Arendt, is to hold in mind a representation that both is and is not the object it represents. The object itself is gone: hence the materiality that a purely empirical account would demand no longer obtrudes, but the representation is in some profound sense determined by that original object. This is not mere idealism, nor a subjectivism that reads the impression as a purely psychological projection, a Paterian account of insulated subjectivity that exists apart from the empirical impressions that intermittently reach it but cannot be verifiably linked to the actual outside world. That tack away from both idealism and empiricism charts the course that Mill, too, follows.

Sentimental Dreams

The evolution of Mill's distinctive idea of intimacy via mediated involvement is the result of developments in the four decades between the appearance of Kant's *Critique of Judgment* and Mill's 1833 "What Is Poetry?" Perhaps the quickest way to trace developments in romantic thought germane to the Millian uptake of Kantian conceptions of judgment is, first, via Schiller's 1795 *On the Naïve and Sentimental in Literature*, and then through a Charles Lamb piece in which both Kant's and Schiller's ideas are refracted in a British milieu.[5]

Schiller's conception of the aesthetic diverges in many ways from the Kantian conception of a judgment that partakes of an aesthetic *sensis communis*, but like much of his thought, his conception of "modern" (as opposed to "classical") poetry has Kantian roots. *On the Naïve and Sentimental in Literature* argues that while the poetry of the ancients "moves

us through nature, through sensuous truth, through living presence the [poetry of the moderns] move[s] us through ideas." The modern (senti-mental) poet differs from the ancient (naïve) in the capacity not simply to *receive* but also to *reflect* upon impressions:

> Since the naïve poet only follows simple nature and simple emo-tions and restricts himself solely to the imitation of nature, so can he only have a single relationship with his subject-matter. . . . Things are quite different with the sentimental poet. He *reflects* on the im-pression which objects make on him, and the emotion into which he himself is transposed and into which he transposes us is based only on that reflection.[6]

Schiller therefore credits the modern with an awareness of the distinction between reflection and reception: "The sentimental poet therefore is con-stantly dealing with two opposing concepts and emotions, with reality as boundary and with his idea as the infinite."[7]

By Schiller's account, the sentimental poet is capable of abiding with the uncertainty of the line that divides the *actual* from the *true*. Modern poetry offers us thought, but with a tremendous price to be paid: uncer-tainty, yearning, and abstraction understood as the failure of that empirical and sensuously rooted materiality that the naïve, ancient poet could have provided. Poetry becomes modern by abiding with thought—infinitely in-complete, perennially dissatisfying but potentially limitless—rather than with the sensuous world, which is tangible, satisfying, and innately limited.

Schiller departs from the logic of Kantian aesthetic judgment because what in Kant had been a simple positive attribute of imagination—that it can take place, as Arendt puts it, in the absence of its object—has become an almost paradoxical quandary. The completion of any imaginative act hinges on aporia and absence, a mourning that is integral to the aesthetic experience. In Kant, imagination functions even in absence, because it dwells in the mind's capacity to make sense of reception and reflection alike and to make sense of the doubled quality of cognition that follows from that mental doubleness. In Schiller, however, absence has become a new kind of conceptual presence, one that is historicized and made the harbinger of modernity itself. To be the offspring of abstractedness, from the perspective of semi-detachment, is to understand any moment of pres-ence as shot through with the possibility of absence—which also makes moments of absence potentially replete with this other, abstracted sort of presence.

Mill's classification of poetry according to its capacity to spur feeling, or thought, or finally "thought mixed with feeling," bears traces of Schiller's

insistence on sentimental modern poetry's relationship to thought in contradistinction to naïve ancient poetry. The way in which absence turns into a stronger kind of conceptual presence continues to ramify in the romantic era. It proves central to one of Charles Lamb's most memorable Elia essays, "Dream Children: a Reverie" (1822). That essay begins with its speaker, Elia, seemingly mourning his beloved wife, Alice. Though grieving, Elia still takes solace in the ways that, though absent, she yet remains present in their still living children, Alice and John. Thus far, the essay seems to be an elegy, but with a physical memento (the children) replacing the grave or cenotaph where mourning might be expected to take place. Elia has been telling the children "some stories about their pretty dead mother."[8] In the essay's much elongated final sentence (a sentence interrupted by interpolated speech), however, a striking inversion occurs:

> suddenly, turning to Alice, the soul of the first Alice looked out at her eyes with such a reality of re-presentment, that I became in doubt which of them stood there before me, or whose that bright hair was; and while I stood gazing, both the children gradually grew fainter to my view, receding, and still receding till nothing at last but two mournful features were seen in the uttermost distance, which, without speech, strangely impressed upon me the effects of speech: "We are not of Alice, nor of thee, nor are we children at all. The children of Alice call Bartrum father. We are nothing; less than nothing, and dreams. We are only what might have been, and must wait upon the tedious shores of Lethe millions of ages before we have existence, and a name"—and immediately awaking, I found myself quietly seated in my bachelor armchair, where I had fallen asleep, with the faithful Bridget unchanged by my side—but John L. (or James Elia) was gone forever.

Solidity and evanescence suddenly switch places: the dream children are revealed as only a visionary glimpse of "what might have been"—had Elia married Alice rather than losing her to Bartrum. It is easy to overlook, though, a slightly earlier moment of unease, when the solidity of the reveries first starts to tremble: "the soul of the first Alice looked out at her eyes with such a reality of re-presentment, that I became in doubt which of them stood there before me, or whose that bright hair was." This too is an account of absence encoded in presence, albeit a more conventional one: the speaker glimpsing the older Alice looming spectrally through a solid personage, the younger Alice. It is a familiar Shakespearean trope: your essence in your offspring, with the implication that those who knew the older generation well can be forgiven if their reception of the physical

attributes of the younger generation activate a process of reflection, making those nostalgic viewers think of an earlier generation peeping through.[9]

The essay's peripety is the discovery that rather than the child Alice sparking a thought of the now-absent mother Alice, it is the other way around; Elia's still unquenched thought of unattainable Alice (happily married to someone else) has generated this evanescent dream child. The reader has been forced initially to think of this scene as a more conventional sort of mourning and substitution where a younger generation stands in for the past one. That substitution of substitutions directs readerly attention to the commonness of this kind of absence-in-presence as a part of ordinary life. (Chapter 9 explores Buster Keaton's deployment of a similar strategy.) Think of the effect Eliot produces with the narrator's forearms in *Mill on the Floss*, making them present on both the bridge and the armchair. The "soul" of Lamb's first Alice, glimpsed through the eyes of that wholly imaginary second Alice, resembles the elbows that actually exist on the actual armchair back in the narrator's study—they are the anchor that connects the (fictional) actual world of the narrator to his reverie world, where Alice has left behind her a second Alice to make an (imaginary) actual residue after her death.

The regress between dream and actuality may seem dizzying or infinite; perhaps it is enough to say the essay summons up a "true" world that contains both imagination and actuality. Or even, in Schiller's terms, with "two opposing concepts and emotions, with reality as boundary and with his idea as the infinite."[10] Lamb's conception of the way in which imaginative truth intersects with actuality raises, in romantic form, the same problem that Hughes identifies as central to Kant's conception of the imagination: that making sense of the dual presence of reception and reflection also involves identifying a capacity (the imagination) whereby we can grapple with the tension, or confusion, or the spectral, oneiric overflow that those double cognitive capacities create. And just as the Kantian quandary endures, so too does the need for an account of the imagination that explains how we may seem to be simultaneously experiencing two different realities, only one of which can be actual. Sometimes, those elbows are simply going to have to rest on two surfaces at once.

Mill: Reading as Reception

> Society . . . practices a social tyranny more formidable than many kinds of political oppression . . . penetrating much more deeply into the details of life and enslaving the soul itself . . . and compel[ling]

all characters to fashion themselves upon the model of its own [character].[11]

"Dream Children" suggests a Schillerian notion of thought haunting a limited, knowable "reality." It emphasizes the ways in which the coexistence of the two become the basis not only for aesthetic experience but also for reveries that reveal how much even the ordinary world is shot through with problems of the imperceptible presence of ideas that persist even in the absence of any material substrate—or that precisely propagate because they lack actuality. The persistence of that way of thinking about the work of modern poetry up through the 1820s is an important indicator that Mill is not simply heir to a Kantian approach to aesthetics that emphasizes the potential of imagination to provide a distinctive framework for understanding our thought as defined both by reception and the capacity to reflect on that reception. Schiller and Lamb alike mark intervening romantic developments that prove crucial in shaping Mill's slippery, elusive, nearly paradoxical account of how the thoughts of others can become present to an individual.

Mill struggled throughout his career to find a meaningful space for individual autonomy and self-determination within a universe—and a human community—operating by indisputable rational laws.[12] Mill's perennial worry that "society" threatens to "compel all characters to fashion themselves upon the model of its own [character]" can make his work seem deeply suspicious of *all* social structures, be they enabling or constricting.[13] Yet his systematic approach to the "moral sciences" reveals that at the root of his fear of social coercion is a comprehensive and nuanced sense of how strongly all human action is shaped by well-nigh inescapable norms that cultures inevitably generate and from which no individual can ever be entirely free.

Mill grew up devoted to a Benthamite strain of Enlightenment reason, but a turn toward romanticism in early adulthood led him both to a more historical conception of Enlightenment universals and also to a distinctive conception of the role that individuated experience had to play in assembling a coherent society,[14] arguably engendering a duality that hovers over Anglo-American liberalism still.[15] Mill's unsettled attitude toward the various forms through which the individual receives a society's impress is striking. Far from having forged a perfect union between the demands of social cohesion and those of free action, Mill's work reveals a constant search for new or reconfigured structures that might be able to shape— without rigidly fixing—individual character.[16] The fraught space that reading creates—somehow at once presence and absence, much like thought in Schiller's account of sentimental poetry—proves crucial to Mill's effort to

reconcile individual liberty with the necessity, or even the onus, of inter-personal contact.

Erving Goffman, a century later, understood the individual's proper role within an omnipresent and inescapable social network as defined by *facework*—that is, by the inescapable duty of preparing one's face to fit one's world: "Face is an image of self delineated in terms of approved social attributes."[17] In Goffman's account, society is not formed out of autonomous agents but rather out of an incessant flow of social transactions: "Not, then, men and their moments. Rather, moments and their men."[18] Mill by contrast is in search of a formal alternative to such facework—a search that takes him through a variety of genres (among them lyric poetry, personal correspondence, the publicly circulating essay, and the dedication) in an attempt to locate the sorts of writing, and of reading, that best achieve print-borne intimacy.

In the 1850s and 1860s, Mill moves away from the sharp distinction in "What Is Poetry?" between poetic solitude and public ratiocination. He instead begins to construct a political philosophy that aims to preserve, concurrently, the best features of social cohesion and individualism. *On Liberty*, rather than choosing public reason over poetic reverie or demonstrating a split within Mill's notions of sociability and solitude, finds for the first time a way to align his commitment to the power of impersonal reason with the importance of "interpersonal relationships" that Mary Lyndon Shanley has identified as Mill's "important contribution to the liberal understanding of individual autonomy."[19] That alignment, however, can come about only through the mediating intervention of the written word. Mill's new ideas about semi-detachment relate to the post-Kantian thinking about presence and absence briefly explored above by way of his views on the role that reading can—and should—play in crafting character. Mill's view of reading elucidates his debt to the Schillerian conception of thought defined by absence—and beyond that, his debt to the Kantian notion of imagination triggered only by what is absent.

No Nightingale

Mill's liberalism stands or falls on its capacity to navigate a tension between autonomy and solidarity. It is this tension that makes Mill acutely aware of the threat of "compulsion and control" over an individual posed not simply by the state monopoly on "physical force in the form of legal penalties," but also—more ominously because less openly—by "the moral coercion of public opinion."[20] Kwame Anthony Appiah has described

Mill as arguing for "the *unsociability of individualism*"; Mill suggests, by Appiah's account, "that political institutions, which develop and reflect the value of sociability, are always sources of constraint on our individuality."[21] I propose a different formulation: Mill is interested in grounding his defense of individualism in semi-detached sociability. Mill wants to explore works that make others crucially present on paper in place of face-to-face contact; something like excusing oneself from a dinner with Bentham to go upstairs and read some Bentham. The role Mill envisions for reading is not a substitute for sociability but a new form of social interaction.

Mill's passionate condemnation of the tyrannical qualities of the everyday social realm certainly does not put him in a Victorian majority—but neither does it make him a complete outlier. We might compare him to another vehement opponent of social facework: Florence Nightingale. Nightingale's 1860 "Cassandra" (Mill acknowledges a debt to it in his 1869 *The Subjection of Women*) memorably describes the suffocating effect of the empty social rituals women must perform when they could instead be pursuing their real work elsewhere. The gap between Mill and Nightingale around the question of what reading offers and what it threatens helps clarify the power of written words to constitute a social network—a kind of absent presence or presence-in-absence—that direct contact fails to produce.

With a few notable exceptions, "Cassandra" depicts reading as mere escapism. The chief fare for benumbed ladies is novels, which offer romantic fantasies of escape, while, in actuality, playing a key role in the gothic confinement that ladies suffer at the hands of their immediate families and society as a whole. Cultivated women trapped in the drawing room, she says, are "exhausted like those who live on opium or on novels, all their lives—exhausted with feelings which lead to no action."[22] More than that, Nightingale loathes the vicarious escape into shared feeling that novels offer: being read to, she opines "is like lying on one's back, with one's hands tied, and having liquid poured down one's throat."[23]

Mill does not give up on a wide range of avenues to aesthetic experience—among them the reading of poetry and of novels—because he is searching for a way to retain all the benefits of solidarity and of community interaction in forms that will not impinge on individual freedom. "Cassandra" is permeated with disgust, horrified by the social world; it desperately seeks ways to forsake the world of facework. Moreover, Mill's late political works envision alternatives to social conformity that do not involve, as Nightingale's ideal vision does, a simple plunge into hard work in the public world. Instead, in the 1850s and 1860s, Mill returns to what in the 1830s had only

seemed to him a feature of poetic texts and discovers aspects of that same "feeling thought" in a range of speculative writing.

The distinction Mill implicitly erects between face-to-face interactions and those mediated by reading shapes his memorable discussion in *On Liberty* of the different ways an opinion may circulate:

> An opinion that corn-dealers are starvers of the poor, or that private property is robbery, ought to be unmolested when simply circulated through the press, but may justly incur punishment when delivered orally to an excited mob assembled before the house of a corn-dealer, or when handed about among the same mob in the form of a placard.[24]

Mill posits a form of latent resistance built into printed opinions, a way that the medium encourages reasoned judgment by discouraging the possibility of immediate (shared) emotional response. Mill's liberalism is predicated in part, then, on establishing a distinction between a "crowd" and a "public": between inherently excitable forms of social aggregation, as in a mob, and a reading public's inherent resistance to such affective intensification.[25]

However, Mill's concerns with the capacity of the printed word run deeper. Appiah's notion of unsociable individualism implies that Mill's political thinking is always predicated on establishing a secluded space in which the cool light of reason shines without the heat of passion. Appiah disregards Mill's emphasis throughout on the times when retreat to such a cool, detached realm in fact engenders the most poignant sorts of feeling. The famous case for reading lyric that Mill makes in "What Is Poetry?" is predicated on the intense emotions that can only arise in acts of solitary reading: poetry is the "overheard" utterance that sparks in the reader the same feeling (or "feeling thought"[26]) that had inspired the utterance in the author. Mill's account of poetry may have little enduring interest as an account of the creative process or as an account of the form of the lyric itself, but it has a great deal to tell us about the forms of receptive reading that Mill, in his political writings, came to see as deeply formative of the liberal subject.

"What Is Poetry?" records the surprising discovery of an emotional upwelling within a reader—implicitly, within Mill himself, as the memorable passages on Mill's own poetry reading in his *Autobiography* attest. In Mill's account, strong emotion is not triggered by direct appeal, but rather elicited indirectly. The reader's emotions are made available when the poet reveals to the reader her own inward nature, giving utterance (via the printed page) to her own deepest feelings. The reader's response to a

poem is like neither the newspaper reader nor the mob member digesting an opinion about corn-dealers. Rather, the reader of a lyric utterance seems to possess qualities both of the mob member and of the newspaper reader. What circulates through magazines and books, then, need not be dispassionate. Instead, some written words can function as the irreplaceable record of another's emotions, recollected not in tranquility but via a complete recall that unites the original speaker and the reader in a feeling that is deeply personal and yet not at all private.

This view of reading has immense implications for Mill's account of the ideal form of á liberal subject: a subject formed by exposure to the social realm, yet capable of choosing how to express the character autonomously. In spending so much time with the potential emotional charge of poetry, Mill may be after something like an extension of the Kantian notion of "representative thinking," in which others are made present inside one's own internal version of the public realm, conjured up mimetically so that they can be properly understood and answered. What his essay pointedly avoids contemplating is visceral emotional response to an appeal made directly, person-to-person. Thought hinges on absence as presence in Schiller; in Mill, socialization becomes a similarly semi-detached phenomenon.

Feeling, Heartiness, and Spectral Bipeds: Carlyle vs. Mill

Given the wide latitude that Mill's 1833 "What Is Poetry?" grants to feelings expressed through the medium of verse, Thomas Carlyle's attempt in the very same year to wring from Mill a more direct expression of sympathy makes for fascinating reading. Raised under the aegis of Benthamite radicalism, Mill was, in the early 1830s, initially overwhelmed by Carlyle's appeals for his friendship. But the correspondence reveals that, as seriously as Mill took Carlyle's vision of a sort of empathic connection different from any friendship he had known, he also took seriously his own involuntary recoil from the most direct and explicit appeals that Carlyle made for that friendship.[27]

Responding to a letter in which Carlyle pleads for sympathy and evidence of love, Mill effusively praises his ability to feel passionately and to demand fellow-feeling from friends like Mill himself. However, he declares himself incapable of returning the kind of emotions in the way Carlyle might want: "You wonder at 'the boundless capacity Man has of loving. . . .' Boundless indeed it is in some natures, immeasurable and inexhaustible; but I also wonder, judging from myself, at the limitedness and even narrowness of that capacity in others."[28] Carlyle had asked that

Mill speak to him with a "Man's" true feelings, rather than "Cackle" like a "mere spectral biped."[29] In response, Mill declares that he must lack the feeling heart such declarations require:

> Truly I do not wonder that you should desiderate more "heartiness" in my letters, and should complain of being told my thoughts only, not my feelings; especially when, as is evident from your last letter, you stand more than usually in need of the consolation and encouragement of sympathy. But alas! when I give my thoughts, I give the best I have.[30]

The very fertility of thoughts that Mill delights in elsewhere has here become a deficit. If Mill had learned nothing else from his early education, he had learned to trust the dispassionate turn toward cool calculation, which is just the turn Carlyle seeks to deny him.

Mill's attraction to Carlyle, and to the strain of nationalist romanticism that he cautiously praises in "Coleridge" (1840), has deep roots. It stems from his conviction that Benthamite radicalism lacked a route to happiness and spiritual perfection—a conviction strengthened by his own misery and bouts of depression.[31] The burgeoning friendship with Carlyle in the early 1830s seemed to offer Mill a way to restore strong feeling to the ordinary current of life.[32] However, instead of meeting Carlyle's demands head-on, Mill makes clear how far he is from being able to respond to the claim directly. Carlyle's plaint forces Mill to consider whether he is nothing but an emotionless, calculating machine.[33] Mill's response, though, involved conjecturing that the best form of character building and the most reliable form of profound social interaction lay in *mediated involvement*—that is, a form of absorption in the emotional content of poetry that depends on the reader's knowing that the emotions of others are accessible only through the print public sphere.

Far from finding a way to overcome the sense of emotive deficit that Carlyle uncovers in that 1833 exchange, Mill conjures up out of its ashes an innovative aesthetics. Rather than being an impediment to emotional connection, the realm of print (lyric poetry, but in later writings, other genres as well) becomes a way to experience others' necessarily private experience. The reader's distance—in space, in time, in possibility of reciprocation—from the lyric speaker whose feelings he understands so intimately is thus not a pitfall but, paradoxically, an asset. Schiller envisions modern poetry as defined by absence, abstraction, and the incompleteness of thought. Mill instead takes up the question of what pleasures mediation can afford.

In his letters to Carlyle, Mill seemingly disavows the capacity to sympathize directly. Yet he treasures poetry because it can produce, by way

of an operation that is part thought and part feeling, effusions that are at once private—one's own inescapably inward feelings—and public—exchangeable tokens in the common language of the world. Poetry, as the "overheard" art, opens up the possibility of indirect, nonreciprocal communication with others—by foreswearing any such direct appeals as Carlyle was making to Mill. In "What Is Poetry?" Mill represents poetry as an oasis, a place to eavesdrop on other's words and feel their feelings—as Montaigne put it, the chance to gather other men's flowers—secure in the knowledge that an enlightening return to one's own private thoughts and feelings would follow. True companionship can arise if the poet

> can succeed in excluding from his work every vestige of such lookings-forth into the outward and every-day world, and can express his emotions exactly as he has felt them in solitude, or as he is conscious that he should feel them, though they were to remain for ever unuttered, or (at the lowest) as he knows that others feel them in similar circumstances of solitude.[34]

This is the involvement Mill craves—that the utmost in inward contemplation might also turn around and become a form of external address. The unuttered emotions of oneself or others thus become precious currency, precious because they are not originally intended for utterance in the public realm at all.

Mill is looking here for a way of understanding social interaction as something that may proceed most satisfactorily when the parties involved are not mutually present: when they do not share the same physical space, when they are not in dialogue with one another. (Hannah Arendt liked Cato's apothegm for this situation: "Never am I less alone than when by myself."[35])

> Poetry is feeling confessing itself to itself in moments of solitude, and embodying itself in symbols which are the nearest possible representations of the feeling in the exact shape in which it exists in the poet's mind.[36]

By airing a feeling that is known as another's and yet recognized and felt as one's own, poetry manages to be at once subjective and objective, intimate and universal. Thus Carlyle's feelings, phrased as direct demand to Mill, can spark no response; but Wordsworth's lyrical effusions, dangling there as an objectless appeal, can readily seem at home in Mill's mind. Only by gaining poetic access to a feeling that is clearly not one's own can one understand what feelings mean and where virtue lies.

Mill establishes neither the serene realm of disinterested thought that Benthamite radicalism seems to prescribe, nor a Carlylean self, comprised

of feelings lodged in unplumbable interiors. Instead, he offers an innovative and implicitly recursive account of the role that recognizing the feelings of others plays in generating a self that only *seems* to have existed prior to the reading of the poem itself. Poetry calls into being the feeling self, a self that only seems, retrospectively, to precede the moment poetry brought it into being. It is through poetry that "feeling confessing itself to itself" takes on a material form. Poetry makes visible, to itself, a self that would otherwise have no reliable grounds of existence.

Only when poetry has opened up the reader's own feelings as belonging, antecedently, to another person can that reader begin to delineate his or her own discrete self. Only in his mediated encounter with the highly wrought feelings of others can Mill discern his own. Poetry teaches Mill how to forge his character on the model of another, but only because that other is unaware of, and unchanged by, the effect he has had upon Mill. Personal correspondence, by contrast, is a genre that partakes of two sorts of intimacy at once: the potentially universal emotive appeal of lyric poetry and a much more tangible, direct, and accordingly unsettling, even disgusting, appeal that operates much more like face-to-face social interaction. Critics generally isolate the claims that Mill makes about poetry, distinguishing them sharply from his later accounts of the basis for interaction with others in the social realm. Mill's later articulation of a new basis for liberal subjecthood actually begins here, in his description of how a reader can gain access to another's feelings—and his own—via the printed page.

Correspondence can elicit honest answers from Mill about the state of Carlyle's feelings or his own—but Mill pointedly denies that it can provide the sort of immediate succor for which he feels Carlyle is calling. This is a generic distinction, certainly, between two forms of writing. Yet for Mill, it is also something more, a difference between the admirable, immediate, and transformative effect of lyric poetry's *indirect* appeal, and the unsettling but ultimately unmoving attempt via Carlyle's direct address. For further evidence that Mill continued to endow the readerly relationship with forms of mediated involvement unavailable elsewhere, we might begin by looking at Mill's autobiographical descriptions of his relationship to reading.

MILL AMONG THE DISCIPLES

If all the dead were living they could talk to us only in the same way that the living do. And a conversation with Plato would still be a conversation, that is to say, an exercise infinitely more superficial than reading, the value of things heard or read being of less

importance than the spiritual state they create in us and which can be profound only in solitude or in that peopled solitude that reading is.

<div align="right">Marcel Proust, "On Reading Ruskin"</div>

Half a century after Mill's death, the notion that reading might be *more* intimate than face-to-face communication was, if not quite an artistic commonplace, certainly a viable hypothesis. In Proust's description of the virtues of reading, talking with Plato is far inferior to reading him. Reading, circa 1900, can look like a happy substitute for the perils of ordinary sociability.

Proust's textophilia is certainly a far cry from Mill's fascination with moments in which textual mediation seems to bring with it inescapable immediacy, a text-borne solidarity that is unmatchable in textless sociability. Mill remained fervently engaged in political and cultural battles of his own day (even entering Parliament as a Liberal in the late 1860s), battles he could and would not have fought without a passionate investment and a firm belief in the inextricability of humans from their cultural surroundings.[37] Nor did Mill's liberalism grow out of a notion of autonomy that favored reading over speech, and solitude over interaction. In fact, it is precisely the interplay of solitude and necessary interaction that marks Mill's chief innovations as a theorist of liberalism.[38]

Yet both early and late in his career, Mill is curiously fascinated by the possibility that a reading-based involvement might prove the best way for the feelings of others to make their way into an individual's thoughts. Mill argues that in parsing written work readers may come to make sense of emotional demands that are touching precisely because they are *not* directly addressed to the reader ("all poetry is of the nature of a soliloquy").[39] Nancy Yousef reads Mill's *Autobiography* as representing Mill wrapped so profoundly in solitude that he finds himself bereft even of the words with which to express loneliness.[40] But the ceaseless production of text about texts that defines the boyhood recollections in the *Autobiography* also suggests ways in which Mill's loneliness comes to be transfigured, transvalued even, by a mental solidarity that he arrives at only in his encounters with books.

In Mill's *Autobiography*—written and rewritten from the early 1850s onward—both the quantity and the quality of his encounters with books vastly overshadow the space and energy allotted to detailing face-to-face encounters. This begins with Mill's predictable recourse to books for tutorials in concepts—for example, reading a history of the French Revolution

allows Mill to gain a feeling for what liberty is and why it ought to be valued. In every meeting that Mill records, moreover, the textual trace precedes and conditions mere social contact.[41] We might even call the form that his social life took a semi-detached one: mediated involvement strikes him most forcefully and directly, while face-to-face encounters seem curiously irrelevant.[42]

When Mill speaks of friends—Ricardo, Bentham, or the radical MP Joseph Hume—his descriptions are so buttressed by commentary on their publications that their "dearness" is inextricable from his responses to their written oeuvres.[43] After having known Bentham his whole life, and having repeatedly discussed his ideas with him, Mill has nothing to say about the man, but reports his near-ecstasy when, on his first serious perusal of Bentham's writing at age eighteen, the greatest happiness principle "burst upon me with all the force of novelty."[44] It is unsurprising, then, that Mill registers nothing of his actual travels through Europe in early life—no Simplon Pass episodes, no Humboldt-like pleasure in the natural. Instead, he details mental "eminences." When reading Bentham on "Painful and Pleasurable Consequences," for example, Mill recalls feeling "taken up to an eminence from which I could survey a vast mental domain, and see stretching out into the distance intellectual results beyond all computation."[45]

Mill's descriptions of his relationship with his father have long struck readers as the ne plus ultra of emotional chilliness. Mill's curious descriptions of the nascent utilitarians who hung around James Mill and Bentham strike me as equally revealing. Mill goes out of his way at one juncture to proclaim a disjunction between those young men and his father. His initial motive is to refute the idea that a "school" of philosophical radicalism was brought together and drilled under Bentham and James Mill.

> This supposed school, then had no other existence than what was constituted by the fact, that my father's writings and conversation drew round him a certain number of young men who had already imbibed, or who imbibed from him, a greater or smaller portion of his very decided political and philosophical opinions. The notion that Bentham was surrounded by a band of disciples who received opinion from his lips, is a fable to which my father did justice in his "Fragment on Mackintosh" and which, to all who knew Mr. Bentham's habits of life and manner of conversation, is simply ridiculous. The influence which Bentham produced was by his writings. Through them he has produced, and is producing, effects on the

condition of mankind, wider and deeper, no doubt, than any which can be attributed to my father.[46]

Looking back at his youth, Mill again strikes the note that he struck in the 1830s: trust in the intimacy and passionate connection available only via the printed page. Ask for something more direct (as Carlyle had), and risk mere nullity—or the kind of irrecoverable intimacy that never achieves the poetic effect of lending itself to being overheard.

In place of such directness, Mill continually seeks a site of laudably semi-detached interchange, where thought and feeling can merge, so that what is felt as most personal can potentially be shared with any other person. Mill's attachment to the give-and-take of political magazines, for example, seems bound up with his interest in a medium that records *indirect* interactions even with one's intimates. His correspondence often records him writing to friends as if their latest articles had been personally addressed to him. At times he even tells correspondents that he does not see the need to say to them in a personal letter what he had already published in an article he presumes they have read. That suggests it would be a mistake to sequester Mill's thinking about poetic interchange and the pleasures offered by books, and a mistake to treat such claims as distinct from his thoughts on what forms of social interaction can best sustain a liberal polity. In his mature works of political philosophy, Mill remains dedicated to mapping text-based forms of solidarity or communion, forms that can allow valuable kinds of intimacy while avoiding the dangers that "society's . . . moral coercion" poses.

ON LIBERTY

By 1859, the year *On Liberty* appears, Mill is ready to find in a remarkably wide range of readerly experiences the same kinds of associative intimacy that in 1833 he had cautiously discerned within poetry alone. The final few passages examined in the following sections all shed some light on the complicated ways that Mill works to explore forms of a sustained and productive exchange of views with others from whom one may differ greatly not just in opinion, but in beliefs and forms of feeling. If we ask what paradigms Mill offers for how rival opinions and views can work on us to change our minds, then Mill's notion of mediated involvement and his reliance upon print-borne sociability begins to make more sense.

He stresses, for example, the importance of the widest and most pervasive form of exposure to divergent views. What he seems to prescribe is exposure to the human beings who can attest to those views in the broadest range of ways—a diversity of living human disagreement:

> To do justice to the arguments or bring them into real contact with his own mind [the liberal subject] must be able to hear them from persons who actually believe them. . . . He must feel the full force of the difficulty which the true view of the subject has to encounter and dispose of, else he will never really possess himself of the portion of the truth which meets and removes that difficulty. . . . [Beware of people who] have never thrown themselves into the mental position of those who think differently from them.[47]

Mill goes on to argue, however, that the actual existence of those who think and believe differently from you is not at the crux of the exercise. The crux is the capacity to think representatively, to make the ideas of others present to you in unexpected ways.

> So essential is this discipline to a real understanding of moral and human subjects that, if opponents of all-important truths do not exist, it is indispensable to imagine them and supply them with the strongest arguments which the most skillful devil's advocate can conjure up.[48]

When Mill goes on to assert that "there are many truths of which the full meaning *cannot* be realized until personal experience has brought it home,"[49] the experience to which he refers hinges simply on the capacity to "feel the full force" of skillful arguments from another perspective, conjured up out of the brain's ceaseless capacity to make other people and their views present to itself. As I argued when parsing the differences Mill sees between lyric poetry and his personal correspondence with Carlyle, we ought to think about what forms of mediated involvement various genres of writing can offer. Additionally, in order to locate the sorts of distinctions that Mill offers between the various genres' reading experiences, it is worth turning to an unobtrusive element of *On Liberty*: its dedication.

Mill opens *On Liberty* with a striking suggestion about where to find an exemplary kind of "personal experience": in the composition of *On Liberty* itself. Harriet Taylor Mill's death in 1858 may not have been the only precipitating factor in the 1859 publication of *On Liberty*, but it is quite clear from the dedication that she was on his mind in more ways than one.[50] The dedication portrays her as beloved spouse but also as the interlocutor of choice in his writing projects—and something more:

To the beloved and deplored memory of her who was the inspirer, and in part the author, of all that is best in my writings—the friend and wife whose exalted sense of truth and right was my strongest incitement, and whose approbation was my chief reward—I dedicate this volume. Like all that I have written for many years, it belongs as much to her as to me; but the work as it stands has had, in a very insufficient degree, the inestimable advantage of her revision; some of the most important portions having been reserved for a more careful re-examination, which they are now destined never to receive. Were I but capable of interpreting to the world one half the great thoughts and noble feelings which are buried in her grave, I should be the medium of a greater benefit to it, than is ever likely to arise from anything that I can write, unprompted and unassisted by her all but unrivalled wisdom.[51]

Neither entirely muse nor ghostwriter, nor actual author of Mill's works, Harriet is assigned a floating role—or rather, she moves between several roles.[52] First, she is "inspirer and incitement"—yet in that first phrase she has also become "in part the author."

This may seem a conventional courtesy to the Muse. Mill still places his own name on the title page, after all, and reserves the right to dedicate the volume to her—coauthors are never dedicatees. The claim that "it belongs as much to her as to me" could similarly fit a simple model of grateful gift-giving: I give you this volume, in exchange for love or other pervasive inspiration. The second sentence though, locates another role for her: she is the reviser of his work, and it seems usually the re-reviser, as well. Muse and editor, then, are oddly conjoined: she inspires Mill to write, it seems, and then also edits what he does write. In the final sentence, though, she becomes the fount from which both thoughts and feelings flow.

How can the person who edits his words also be the source from which they are derived? Mill thinks that two friends who are caught up in reading and writing together achieve involvement with one another through the realm of ideas—and with the realm of ideas through one another. Rather than the "audible thinking" Charlotte Brontë idealizes as the acme of conversation at the end of *Jane Eyre*, Mill has in mind a permanently mediated interplay between two reader/writers and the text that arises between them. The mutual interpretation that Harriet and John supply one another models a way in which thoughts and feelings can move within a realm larger than the individual mind, without tyrannizing that mind as society's "opinion" threatens to do.

In his reflections on the process of composition in the *Autobiography*, Mill continues the thought and sustains the ambiguity about where any particular thought or expression can be located:

> With regard to the thoughts, it is difficult to identify any particular element as being more hers than all the rest. The whole mode of thinking of which the book was the expression, was emphatically hers. But I also was so thoroughly imbued with it that the same thoughts naturally occurred to us both. That I was thus penetrated with it, however, I owe in a great degree to her.[53]

Rather than Mill deducing from Harriet Taylor Mill's influence a general duty to be open to a variety of intellectual influences, he immediately stresses that he was so "penetrated" by the thoughts that he shared with Harriet precisely because he had *not* been penetrated by stray thoughts from elsewhere. He credits her explicitly with making him a "thorough radical and democrat" because she dissuaded certain kinds of suggestibility and openness to new ideas coming from other quarters:

> My great readiness and eagerness to learn from everybody, and to make room in my opinions for every new acquisition by adjusting the old and the new to one another, might, but for her steadying influence, have seduced me into modifying my early opinions too much.[54]

Mill's praise for Harriet, both as opener and gatekeeper of his mind, seems to continue his defense of a practice of shared reading and writing with Harriet—a practice he imagined as potentially belonging as well to any reader who took seriously the possibility of thought shared through a process that may look like little more than cowriting and copyediting. Just as Schiller felt the naïve poet moved only "through sensuous truth, through living presence," while the sentimental poet moved through ideas, so too Mill finds in direct contact between persons (living presence) a simple, irrefutable, and unappealing sort of contact. By contrast, mediated involvement offers a durably shareable intimacy.

WILLFUL AND WILL-LESS

Lorraine Daston and Peter Galison have argued that Kant's influence makes will come to seem, by the middle of the nineteenth century, the basis for subjectivity. In a world defined by "a scientific self[,] grounded in

a will to willlessness at one pole, and an artistic self that circulated around a will to willfulness at the other," objectivity is defined as the site where subjectivity is suppressed—but suppressed willfully.[55] Scientific rigor is willed will-lessness.

Perhaps Mill's apology to Carlyle, then—"When I give my thoughts, I give the best I have"—is the confession of a dispassionate scientist bemoaning his unsuitability for the role of artist. Perhaps because he is part of the first generation to attempt to translate Bentham's speculations into a living political credo, or simply by good timing as part of the first generation of scientists to value objectivity (or, more narrowly, to be one of the rare avowed social scientists among that generation), Mill finds it feasible to will will-lessness. Yet Mill also evidently worries about his failure to be willful when called upon. Drawn as Mill is to mediated involvement, it would be possible for him still to see himself as a depleted subject: one of those anemic statisticians who, in Carlyle's terms, is nothing more than a pale, empyrean being, suffering from a superabundance of thought and a lack of substance—"a mere Thinking machine" who turns out not "real Facts" but a "matrix of surds."[56]

If this feeling did afflict Mill, though, he certainly does not attempt to overcome it by willing himself back into a direct emotional address to Carlyle, or indeed to any other friend. Instead, in "What Is Poetry?" he describes a readerly capacity to discover one's own emotions as an echo of another's, which has the odd effect of making the feelings triggered by poetry seem at once willful—because rooted in another's subjectivity— and unwilled—because it is the product of one's imaginative capacity to be overcome by the thoughts and feelings of another. Mill's 1833 recoil from Carlyle by letter thus casts a revealing light on his passionate advocacy, in an essay that appeared in the same month, for the thought-shaping "feelings" that are concretized in poetry.

It is not until the major writing of the 1850s—as evidenced by that anguished dedication to *On Liberty*—that Mill comes to terms with the full implications of the aesthetics nascently outlined in 1833. Not only in his fervent denunciations of the power of "moral coercion" exerted by society but also in his equally passionate avowal of that debt to Harriet, Mill offers new ways to imagine reading as the reconciling term between societal pressure and individual liberty. Schematically, it may appear that in *On Liberty*, Mill is praising the idea of emotional contact, but not with a living person: wanting sociability, but without actual society. Yet that schematic formulation risks undervaluing the subtlety with which Mill approaches the problem of how "moral coercion" pours down on individuals from

"society," while individual character simultaneously comes to be constituted out of that same individual's exposures to the rational norms that are only available through an ongoing, open-ended conversation with like and unlike minds.

Accordingly, the liberal aesthetics that Mill struggles toward as early as "What Is Poetry?" and partially constructs in *On Liberty* have a great deal to tell us about Mill's perennial problem of reconciling the impetus toward individual autonomy with the impetus toward solidarity. Rather than positing a public realm of action and thought marred by a private realm of feeling, Mill's late writing seems to suggest both that thought flows readily through our private lives (how else can we explain the poignancy of the dedication to Harriet?) and that feelings can come more thoroughly to life in the realm of letters than inside individual minds. If this is the case, then Mill's liberalism takes a romantic notion of acute self-examination and inverts it: literature is never more moving to Mill than when it allows for the inspection of interior depths that belong to others even before they belong to oneself.

If this makes liberalism into a political belief system with a crucial place for feeling (and for willing), it also ensures that such feelings can register their claim only indirectly. Sartre describes literature as an appeal to the reader. We might say that, for Mill, such an appeal can strike a chord only when the reader is certain of *not* being the text's addressee. A great deal of Mill's relationship with Harriet Taylor occurs in the realm of the face-to-face, and a great deal more in their correspondence. Yet Mill proposes at the beginning of *On Liberty* that the reader need not imagine the face-to-face realm as meaningfully distinct from the textual intercourse that constituted much of the labor of her (and what he imagined to be his) final years. Mill believed he was most passionately involved with Harriet, and she with him, when they were together imagining, writing, and revising a text, ushering it into public circulation.

Conclusion: A Novel Mill

The mediated involvement that Mill experiments with in the 1830s through the 1850s suggests a new way to think about the relationship between political liberalism and the formal work of the European novel (especially in its English and French incarnations) from 1850 into the modernist era. One reason for that link is implicit in the tension Wendy Donner identifies in Mill between social connection and autonomy. If Mill's thinking posits that

maximum freedom from constraint is a crucial desideratum, what is left for the realm of culture broadly (and literature narrowly) to do?

Certainly there have been a range of attempts to redeem liberal autonomy and cultural cohesion both: notably Matthew Arnold's, which makes Mill seem a spokesman for the notion of character development that flows readily into the moral role attributed to the modern university. But mediated involvement in Mill—a way of making other minds present to oneself, "realizing them" in ways that go beyond cordial bodily encounters in some sanctioned public space—has attracted writers suspicious of the direct moral claims levied by society.

Might there, however, be an elective affinity between mid-Victorian liberal subjects and the notion of semi-detached sociability and mediated involvement in others' lives, involvement that takes place through a new kind of reading? On the one hand, the Victorian subjects Mill addresses can take little comfort from organic community, nor an intuitive shared knowledge of a noumenal world.[57] On the other end of the epistemological spectrum, even the acolytes of James Mill and Bentham lacked faith in social science's capacity to alleviate social woe by way of pure, depersonalized, rational enlightenment. Caught between an unsatisfying romantic particularism and Enlightenment universalism that can offer no cohesive account of actual lived experience, Mill proposes that thinking of poetry as "overheard speech" is a viable way both to preserve and to share knowledge about inner states in a form that was at once personal and potentially applicable to all mankind. Taking seriously Mill's durable ambivalence about the promise and the pitfalls of coming to know the world through texts offers some intriguing new ways to think about the consolations and new kinds of understanding that literature may have had to offer to a liberal society—if that literature came to seem a viable avenue for mediated involvement between those otherwise cut off from one another.

This chapter ends, therefore with the unlikely proposal that we take Mill seriously as a literary critic. Ian Duncan has argued that one effect of the Scottish Enlightenment was to make the notion of "fiction" central to conceptions of the social, and the political, realm.

> Fiction is the discursive category that separates novels from history, from periodicals and other kinds of writing, in its designation of a strategic difference from reality—a distance or obliquity in the relation between narrative and world, a figural disguise or darkening of the real.[58]

Duncan's account helps explain a flickering quality in a wide range of romantic-era fiction, which often works by moving the reader, like the novel's characters themselves, rapidly between "absorption" and "reflection." In Mary Shelley's *Frankenstein* (1818) and James Hogg's *Confessions of a Justified Sinner* (1823), readers are repeatedly jolted between giving credence to a story and distancing themselves critically from it. Rather than being an obstacle to a novel's seeming "real," this awareness of fictiveness within the novel ironically becomes the very imprimatur not simply of realism but even of reality at large. A kind of suspended credence in the reasonableness of others' actions becomes as crucial for making sense of daily social transactions as it is for successful novel reading. Because "Humean skepticism posits this continuous, habitual world of ordinary relations as a fiction," inhabitants of the everyday social realm find themselves oscillating—like readers of a novel—between states of "absorption" and "reflection."[59]

The flickering fiction Duncan describes, with its oscillating mixture of poetry-like absorption and eloquence-like reflection, does not figure in Mill's early essay, "What Is Poetry?" Instead Mill reduces fiction to mere adventure, the actions of "men" rather than the deep musings of "man." In 1833, Mill seems a friend to poetry precisely by being an enemy to fiction. It is poetry that, by his account, offers the most salient model for making sense of that ordinary imbrication of daydreaming and empirical attentiveness that defined the composite totality of life in a world that has both inward experience and external shared actuality. Poetry, because it allows the articulation of feelings as one might confess them to oneself, is overheard, while eloquence, designed with an audience in mind, is simply heard. Mill posits a public realm that might be imagined as made up of fully engaged, thinking, arguing beings whose every word is a critical reflection, uttered with some specific audience in mind. As a counterweight to such intrusive actuality, poetry provides a resonant cavity, a site where one's own feelings can become visible to oneself precisely by comparing them to the private, inmost feelings of others, which are at once hidden away and made accessible by being overheard.

In the decades that followed, though, Mill reconsidered the relationship between the heard and the overheard. He eventually found a way to construe writing not only as a form of persuasion in a fully public realm but also as a form of intimate interaction that, in the correct form, might allow for both presence and the sort of absence upon which Kantian imagination depends. Public writing, even persuasive writing with certain features, came to seem to Mill a site where autonomous individuals, endowed

with deep feelings, could find a selfhood molded by the thoughts of others yet not conclusively defined by the "tyranny of the prevailing opinion and feeling."[60] Immersing oneself in the written emotions and thoughts of others comes to seem to Mill the best way for individuals to participate in a community without becoming rigidly committed to oppressive, every-day social roles. Mill is seeking a new form for the sharing of thoughts — and equally important, of feelings. "What Is Poetry?" begins a journey that ends in *On Liberty* (1859), with Mill's idea that the insidious and inva-sive powers of the social realm may be circumvented by taking refuge and pleasure in text-based intimacy. That model of intimacy — predicated on an imaginative capacity that allows the presence of the other to permeate one's thoughts precisely when that other person is absent — understands the essence of other people (their thoughts and feelings) to be present principally, not secondarily, as representations.

Mill's innovation comes in his coupling of seemingly contradictory convictions: first, that "the tyranny" of social conventions necessitates some form that allows withdrawal from excessive social palaver; second, that without some forum for coming into contact with both the thoughts and feelings of others, a sterile monadism might result. What in 1833 had seemed a stark choice between public eloquence and overheard passion returns as an intrinsically double medium, which offers both an occa-sion for immersion in the thoughts and feelings of others and a space to draw away and reflect upon that very immersion. The notion of mediated involvement allows us to make sense not only of Mill's impulse toward semi-detached sociability but also of the possibilities that literature opens up for him.

A key component of Mill's liberalism, commonly overlooked, is pre-cisely the weight that it places on the possibility of mediated involvement between individuals in a society. The power of political theory, like the power of poetry, is purely fictional. The irony, though, is that Mill's con-ception of what it might mean for texts to be their most intimate when they express the most universalizable notions has everything to do with the forms of vicarious intimacy on which nineteenth-century fiction de-pends. Mill arrives at his own account of emotional absorption mixed with critical reflection by initially disparaging fiction in comparison to poetry and later implicitly transferring all the most desirable features of poetry into the realm of public text exchange at large.

If fiction in the generations after Mill comes to look like an oasis for acts of antisocial solidarity, that may have more to do with the genre's sur-prising flexibility in incorporating, as part of its own formal articulations,

something that Mill assumes must be sought in a text's readers rather than in its words. Mill imagines that acts of intimate attention, of implicit emotional involvement, can underwrite texts that showcase pure critical reflection. The fiction that follows him, though, discovers ways of documenting the acts of attention that Mill assumes must serve as implicitly antecedent to the opus itself.

There is an intriguing connection, then, between Mill's conception of mediated involvement and George Eliot's withdrawn fascination with the lives of her neighbors—her belief that she could create typical "nobodies" who would become bearers of intense emotions without actually existing.[61] By the same token, something links Eliot to Henry James's experiments with building novels that, like machines, could operate to deliver the idea of other people to readers without those other people having to exist. We might say that all are experiments in semi-detached sociability, making use of the suspended disbelief that novels paradigmatically demand, but that other kinds of reading also presume. Such sociability, a sort of willful will-lessness, potentially offers a form of shared experience to liberal subjects, a shared experience that operates not as a supplement but as an *alternative* to the propulsively acculturating Arnoldian character formation by way of "the best which has been thought and said."

Such later fiction—in a way that Mill's limited experiments in collaborative textual editing with Harriet only faintly foreshadow—suggests social intimacy itself (highly attuned sensitivity to the thoughts, feelings, and will of another) not only depends upon a kind of textual close reading but may ultimately *be* nothing more than such reading. If that is so, then realist fiction takes on a new life as the acme of all sociability—precisely to the extent that it allows printed words on the page to substitute for what used to count as "real" social life. Mill's notion of fiction as nothing more than a series of surface events may have been the necessary foil that allowed him to conceive a liberalism predicated on poetic intimacy between properly autonomous souls. Victorian realist fiction proves such a potent successor to Mill's liberalism because of its unwillingness to admit that there existed a bright line between the story of "men" and of "man." Yet telling the story of that connection clearly involves looking at problems of semi-detachment and of fictionality, of narration, and of "truth to life" in another art altogether.

3

Double Visions: Pre-Raphaelite Objectivity and Its Pitfalls

Music proceeds from sensations to determinate ideas; the visual arts from determinate ideas to sensations. . . . [Painting] can penetrate much further into the region of ideas, and in conformity with them can also expand the realm of intuition more than the other visual arts can do.

<div align="right">

Immanuel Kant, *Critique of Judgment*

</div>

<div align="center">

But poets should
Exert a double vision; should have eyes
To see near things as comprehensively
As if afar they took their point of sight,
And distant things as intimately deep
As if they touched them.

</div>

<div align="right">

Elizabeth Barrett Browning, *Aurora Leigh*

</div>

DOUBLE DISTANCE

The previous chapter laid out a possible Kantian basis for semi-detachment and examined ways in which Mill—in his correspondence with Carlyle, in his writing on poetry, and in later texts such as *On Liberty*—reworked in a distinctively post-romantic way the categories of reflection and reception, and thus of aesthetic judgment. Nonetheless, novelists and other artists who explore the parameters of semi-detachment are not seamlessly aligned with Kantian or post-Kantian meditations on the imagination's power to register the coexistence of reflection and reception. Explicit theories of the epistemology of reverie or the absorption of aesthetic enthrallment will

never be precisely congruent with the works themselves—*vide* the gap between Henry James's theory and practice of fiction.

Realist fiction's struggle with the experience of being "of two minds" never occurred in a vacuum. Accordingly, this book's three Visual Interludes explore problems of distraction, absorption, and critical distance playing out in various media that, for all their formal distance, share with fiction certain narrative aspects and storytelling impulses. This chapter focuses on two Victorian painters whose work and critical reception provide a way of thinking about semi-detachment and partial absorption as a painterly problem: founding Pre-Raphaelite John Everett Millais and, around four decades later, Lawrence Alma-Tadema, a popular Academic painter who specialized in "classical studies." Semi-detachment proves useful in explaining why Millais's Pre-Raphaelite ethos of "truth to nature" was understood as both excessively *cold* (dry and overly objective) and also uncomfortably *hot* (too somatic, too productive of embarrassingly physical responses among its viewers). It also illuminates Alma-Tadema's fascination with very Victorian-looking classical scenes (a 1973 Metropolitan Museum exhibition of Alma-Tadema paintings from the collection of Alan Funt bore the telling title "Victorians in Togas") as well as his unexpectedly subtle approach to representing art-induced states of reverie.

There are various ways to make the crossing from textual problems such as pseudo-interpolation and (partial) suspension of disbelief into the realm of painting. Later in this chapter, I argue that one revealing moment comes with Charles Dickens's strange and strenuous early attack on Millais's realism, when his *Christ in the House of His Parents* debuted at the Royal Academy in 1850. The chapter ends by comparing Alma-Tadema's paintings about reverie and absentmindedness to Victorian fiction by way of the most mundane of details: what it means when figures in a painting or characters in a novel clasp hands. The chapter begins, though, by taking a step outside of the 1850s to consider one art historical paradigm that clarifies the ways in which a painting might be like fiction in its relationship to semi-detachment: David Summers's capaciously diachronic account of what he calls "double distance" in painting.

In *Real Spaces*, Summers proposes thinking about a painting as doing two things at once: on the one hand, it acknowledges its material existence as a planar image; on the other, it strives to "specify the observer *as a viewer* and itself as something seen in a virtual space."[1] The effect is that the viewer will respond to a painting in two ways: both by remarking on the object's beauty and by asking how her own self and social relations are implicated within the depicted world.

> Images on surfaces entail a double distance. . . . To see an image either as "in" a virtual space or "on" a planar surface is to see it also involved in one or another set of embracing relations, which may be more or less explicitly developed, and which may be endlessly varied.[2]

A painting presents itself to viewers both as a colorful surface and a depicted social world. The point is not to choose; rather, it is that coexistence, that doubleness that must be grasped—just as in Kantian terms the aesthetic judgment is what makes sense of the fact that our minds both receive empirical data and reflect on the meaning of such sensoria, striving to make meaning of it.

As I argued in the introduction, the doubleness of the painting (it occupies real space and creates virtual space) is an indispensable part of the conceptual encounter that viewers will have with the artwork. That makes such a painting a machine for thinking about the coexistence of the actual and virtual. By the account this book offers, a machine that helps its viewers to grasp what it means to be semi-detached: not only from the virtual world called into being by a painting but even from one's own ordinary social world. Summers's account works against oversimplified models either of painterly intent or of audience reception, arguing it is a mistake to presume that visual art

> presupposes an essentially *like* subjectivity as a "viewer." . . . Such response on our parts makes us, not just viewers, but observers of the definition of subjectivity, and this observance tends to deny double distance, thus to conceal the social spaces presupposed by our behavior.[3]

Summers presumes we never simply have a purely somatic "taste" reaction to artworks, but always a conceptual response, as well. Misleading presumptions about shareable subjectivity lead us to miss the crucial aspect of aesthetic experience that connects us to past (or geographically distant) viewers: that they too are viewing paintings at a "double distance."[4]

By Summers's account, painters implicitly (and at times explicitly) work through the implications of what it may mean for their work to strike viewers both as a planar artifact and also as a living, interacting part of their social world. Take, for an early modern example, Hans Memling's 1481 *Christ Blessing* (Fig. 3.1). The detail that once seen cannot be ignored is Christ's hands, resting on the bottom of the painting itself, available to touch in the way the rest of the painting is not. He seems to be

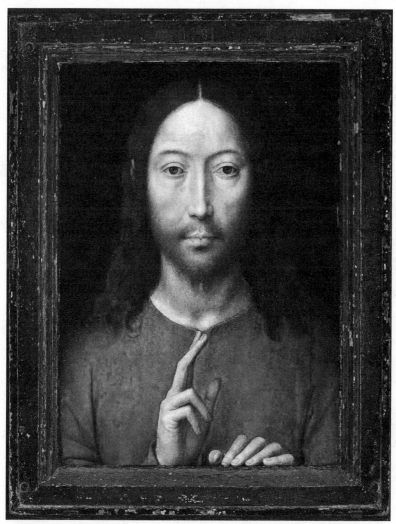

FIGURE 3.1. Hans Memling, *Christ Blessing* (1481, oil on panel, 35.1 × 25.1 cm, Museum of Fine Arts, Boston; bequest of William A. Coolidge. Photograph © 2017, Museum of Fine Arts, Boston).

acknowledging the canvas on which he is painted, yet looking out at us calmly, from what his fingers acknowledge is the other side—perhaps of a window ledge, perhaps of something more, a gateway between worlds.[5]

The concept of double distance helps make clear that in *Christ Blessing* Memling has focused on the simultaneous proximity and distance of Christ: both are established by the simple fact of his fingers, not quite

tangible but still pushing against the pictorial plane.[6] Memling's painting seems to disavow the idea that a viewer's pleasure in an artwork comes from the sensation of connection or an immediate immersion into the shared reality. What those fingers on the ledge suggest instead is that any such intimacy is founded on an original illusion: the pressure of fingers on the frame declares both that the subject is here and that the subject is in another world. The very moment that Memling's Christ marks that he is on one side of the pictorial divide and we on the other serves to heighten our sense of the intimacy between us.

Summers describes the advent in Memling's near contemporaries Jan van Eyck and Hieronymus Bosch of "pictorialization of the imagination;" in Bosch's paintings, "impossible new forms appear as if in a natural light . . . but they have a horizon of the world to themselves."[7] That observation sheds light on how certain other Memling paintings also play with the painting as planar surface and the painting as virtual world. His *Diptych of Maartin Van Nieuvenhove* (1487), for example, plays with mirrors and the logic of framed easel painting to achieve a related effect. The diptych itself physically divides the world in two: the pious praying Martin is in one painting and the object of his devotion, the Virgin, in another. However, in a mirror visible over the Virgin's right shoulder, the Virgin and Martin clearly occupy a single, shared space; the effect (two paintings, but a single shared world) is both to place the Virgin in a world apart from the man praying to her *and* to reinsert her into his own world.[8] It is not an isolated instance.

As we turn from Memling to Millais, Michael Fried's influential categories of "theatricality" and "absorption" offer a quite different way of considering what sorts of attachment between viewer and subject are feasible—or intended—in European painting of the nineteenth century.[9] Fried's influential account of the involutions of consciousness designed ultimately for public view sheds useful light on the tension between absorption into a narrative work (getting lost in a story) and staying detached from it, or located outside it, looking down upon it.

The key connection comes with Fried's observation that midcentury painters are growing skeptical of a visual effect of interiority that serves, ironically, as an improved form of theatricality. His account of the intimate access that viewers are offered by the advance of the bare backs of Caillebotte's 1875 "Floor Scrapers," and his acute analysis of the role that "optical glisten or dazzle" plays in gesturing at and yet withholding knowledge of others' interiors attest to his subtle understanding of dual challenge: to make absorption itself into a kind of theatricality. The problem that I have

been describing as semi-detachment, the experience of being invited into an aesthetic world while also being reminded of your material distance from that world, Fried approaches from a different direction in his acute focus on moments in which painters like Caillebotte think through the theatrical allure of seemingly absorbed figures who at once move forward into visibility and seem to recede, to shrink away from the viewer's gaze. The movement back into a distant pictorial world and, simultaneously, forward into an uncomfortably intimate relationship to the viewer takes a very different form in Millais, yet a suggestive underlying congruence persists.

Permanent Evanescence, Wretched Lingering

John Everett Millais may seem an unlikely candidate for studying problems associated with the idea of a painted surface that offers itself to its viewers both as a virtual world and as material object. Millais soldiered on through the second half of the Victorian era, a consummate professional and eventually president of the Royal Society, pleasing Lady Lever with works like *Cherry Ripe* and *A Child's World*, (better known under its soap commercial name, "Bubbles"). By Raymond Williams's account, he forsook Pre-Raphaelite Brotherhood (PRB) radicalism for a "new and flattering integration" that allowed not the essence of PRB radicalism but merely its "style" to "become the popular bourgeois art of the next historical period."[10]

To understand Millais's relationship with double distance, we might start with the question of temporality, although that topic might seem better suited to history painting than to Millais's paintings of the early 1850s, such as *Christ in the House of His Parents, Mariana*, and *Ophelia*. On the one hand, Millais's viewers confront the problem of the evanescent moment, the (time-consuming) capture of fleeting, ever-changing actuality; on the other, they must make sense of the frozen permanence such capture implies. In the early 1850s, Millais understood painting as capable of capturing something incredibly ephemeral, brief, and fragile (life as it is lived)— but also as bound up with the time-consuming labor of capturing such a moment, the hours of work to exempt a single instant from time's flow.[11]

Both Andrew Sanders and Isobel Armstrong have stressed the Pre-Raphaelite attachment to extremely well-known texts—to the Bible, to Shakespeare, and to Boccaccio filtered through Keats and Tennyson— and Armstrong emphasizes that it was poetry (rather than fiction) that

played the most explicitly rivalrous role for Millais (poetry by Tennyson and Keats, especially).[12] Worth stressing as well is that Millais's interest in narrative—often marked by subject matter taken from lyric poetry or from Boccaccio—was often defined by the tussle between a forward-moving narrative drive and the problem of "wretched lingering"—that is, between a storytelling impulse and the problem of treating the instant in its timelessness.[13] Many Millais paintings shed light on the era of the realist novel by engaging with what it means to be caught inside a moment, not to be able to move out of that moment toward action. The implications of Millais's paintings for the narrative logic of the day relate to the ways in which they depict frozen moments of the greatest beauty that unmistakably also exist within an ordinarily onrushing life.

This account of Millais's struggle with how the ephemeral turns into and yet remains apart from the permanent links him to Walter Pater's proposal that "to burn always with a hard gemlike flame . . . is success in life."[14] Without quite spelling out the paradox, or the tension woven into the notion of a "hard gemlike flame," Pater's essay defines a desirable state of aesthetic permanence, a kind of immortality, as being made up of pulsations, constantly flickering and mutable contingencies of matter and energy: "This at least of flamelike our life has, that it is but the concurrence, renewed from moment to moment, of forces parting sooner or later on their ways."[15] Art succeeds, then, when it turns the ephemeral and constantly mutable into a "hard gemlike flame"; a flickering eternity.

The three paintings I mentioned previously all explore the way in which an instant (a drowning, a wounding, a yawn in the middle of a featureless day) can contain an eternity—without losing its ephemeral quality. *Christ in the House of His Parents* (Fig. 3.2) is on one level a banal incident, a minor accident in a carpenter's shop; on another level it is typologically laden, pulling the viewer out of the actuality of a life to the foredoomed crucifixion of Jesus, the inescapable woe of his mother Mary. *Ophelia* (Fig. 3.3) is about the instant the doomed young woman rests right on the water's surface before plunging in. *Mariana* (Fig. 3.4) captures a woman stretching before a confining window, a micro-event that sums up all the tedium of a life lived without event (a captive's isometrics). All three unpack a single fraught moment; more than that, all three overtly explore what it means to snatch a moment out of time and to linger with it, as the permanence of canvas permits. Here, ephemerality and permanence are intimately connected to one another, and in his overt awareness of that fact, the artist implicitly takes on the role of onlooker and critic, as well.[16]

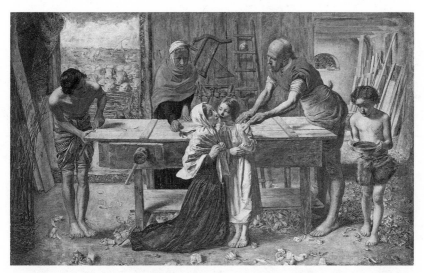

FIGURE 3.2. John Everett Millais, *Christ in the House of His Parents* (1849–50, Tate Britain). Courtesy of Bridgeman Images.

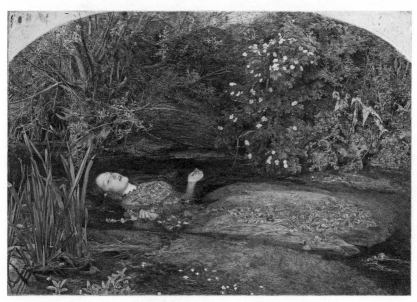

FIGURE 3.3. John Everett Millais, *Ophelia* (1851–52, Tate Britain).

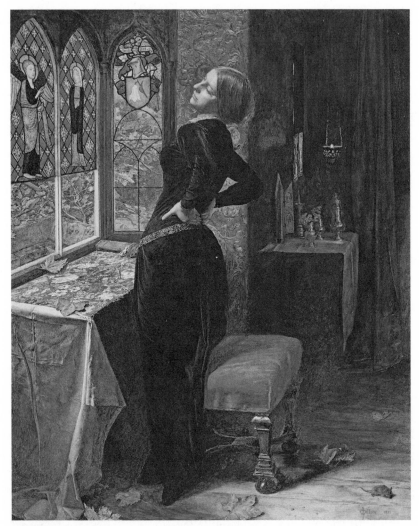

FIGURE 3.4. John Everett Millais, *Mariana* (1851, Tate Britain). Courtesy of Bridgeman Images.

Millais's encounter with the problem of durable ephemerality also pro-duced another sketch that never made it to canvas. Millais himself glossed his 1849 *Eve of the Deluge* (Fig. 3.5) as a reminder to remember that "in life we are in death," that even a wedding feast may be broken by the news of imminent demise. As far as we can tell, these (like the supernumerary figures in *Christ in the House of His Parents*) are ordinary folks, griev-ing, weeping, witnessing, despairing, panicking, and being calmed. Yet all

FIGURE 3.5. Drowned men walking: caught on paper at the moment they realize the flood is upon them, perpetually dying and about to die. John Everett Millais, *The Eve of the Deluge* (Sketch, 1849–50, The British Museum). Courtesy of Bridgeman Images.

of them are already doomed; drowned men walking (actually almost all are drowned women). These are the others, the lost folk whom we only know as those who did not take Noah's narrow path to survival. We are witnessing a death that will not take long but could nonetheless be called lingering, since we see them (horrible to depict and to consider) between the moment that they know they are doomed and the moment their doom ends in their simple extinction.[17]

Finally, though nothing by Millais actually appears in the Pre-Raphaelite house journal, *The Germ*, his son reports (in the posthumous *Life and Letters*) that he began one story, intended for its fifth issue.[18]

He also wrote a story for [*The Germ*], which would have appeared in the fifth number had the periodical survived so long. The following is a brief outline of the tale: A knight is in love with the daughter of a king who lived in a moated castle. His affections are returned but the king swears to kill him, if he attempts to see his lady-love. The lovers sigh for each other, but there is no opportunity for meeting till the winter comes and the moat is frozen over. The knight then passes over the ice and, scaling the walls of the castle, carries off the lady. As they rush across the sounds of alarm are heard within, and at that moment the surface gives way and they are seen no more in life.

The old king is inconsolable. Years pass by and the moat is drained; the skeletons of the two lovers are then found locked in each other's arms, the water-worn muslin of the lady's dress still clinging to the points of the knight's armour.[19]

Two illicit young lovers who, flying for freedom instead find themselves drowned in a frozen moat, locked forever in a first/last kiss that at once dooms them but spares them the indignity of getting old.[20] Keats ends *The Eve of St. Agnes* with the lovers successfully fleeing, but in this story, Millais's lovers find that the freeze is not deep enough. The result is that final, haunting, horrible image; that the king after many years of not knowing the fate of his daughter, discovers her frozen in that instant of transient bliss (or horror) from the only active night of her life. It is telling to place this story of eternally intertwined corpses, frozen out of sequence and succession, into a snapshot of eternal devotion, alongside Millais's paintings of drowned Ophelia, stalled Mariana, and the prefigured crucifixion of the boy Jesus. What comes through most of all is a sense of Millais's struggle with the challenge of keeping fidelity toward both the present moment and permanence.

Feeling the Burn

Grasping the significance of these Millais paintings—and, later in the chapter, the depictions of reverie and aesthetic absorption that run through Alma-Tadema—requires a sense of the larger cultural context into which Pre-Raphaelitism emerged in 1850. Anne Helmreich reports being "repeatedly struck by ways in which the aims of early photography and Pre-Raphaelitism were described in analogous terms that pointed to a shared intellectual project . . . in particular . . . a concern with truth to nature."[21] That is an argument for attending not just to the movement's specific relationship to photography but more generally the rise of the new "epistemic virtue" of "objectivity" in the mid-nineteenth century.[22] One valuable piece of evidence for the novelty of that approach is the outrage sparked by Pre-Raphaelite paintings that seemed (to contemporary viewers) to embody new and objectionable ways of attaining the Ruskinian beau ideal of "truth to nature."[23] That outrage—as evidenced by the virulent reviews that greeted Millais's *Christ in the House of His Parents*—frequently seems to arise from the novelty of the aspiration toward a sort of accuracy that is caricatured as anatomical, mercantile, or soulless: painters are accused,

rather than credited, with deploying a kind of "mechanical" or "surgical" precision understood as incompatible with genuine emotional experience.

I referred previously to *Ophelia*'s accomplishment as lying in the painting's capacity to gaze at the instant of death, at the last minute that Ophelia herself participates in the world both as object of contemplation and as contemplative subject. The immense time that Millais spent painting both foliage and female form (months of modeling that almost killed Lizzie Siddal when the bath she floated in was too cold) becomes, somehow, part and parcel of the instantaneous quality of the painting.[24] To look at it from a modern perspective (in a world that has had photography for almost two hundred years) is to feel oneself drawn into the moment of suffering but also to linger with the overall acuity with which the natural world is made present: a viewer's semi-detachment made of equal parts pathos and scrupulous objectivity. Yet this is also one of the Millais paintings that a *Times* critic in 1860 damned for its "too equally distributed elaboration."[25] That criticism of what we might call Millais's "all-over" ambition—the paramount importance of analytical objectivity, every inch of the canvas rendered suitable for up-close scrutiny—is intimately aligned with the praise given to *Ophelia* because "a certain Professor of Botany, being unable to take his class into the country and lecture from the objects before him, took them to the Guildhall, where [Ophelia] was being exhibited, and discoursed to them upon the flowers and plants before them, which were, he said, as instructive as Nature herself."[26]

In fact, the mixed reception accorded to the botanical accuracy of *Ophelia*—"too equally distributed elaboration" or "as instructive as Nature"—helps connect this painting to Jennifer Roberts's recent argument that Pre-Raphaelite realism could be perturbing to its contemporary audience because it struck audiences as, on the one hand, scientifically cool and yet, on the other hand, committed to evoking "an immediate physical response to the painting" or even "producing exaggerated sensory responses in the viewer."[27] Studying critical responses to Ford Madox Brown's *Pretty Baa-Lambs* (1852), Roberts focuses on the nurse's sunburned cheeks, arguing that when *The British Quarterly Review*'s critic fumes about this "sunburnt slut" he is marking the success of a Pre-Raphaelite aim to "relay the powerful truth-effects of sunlight from the landscape into the gallery, where it might register on the bodies of viewers [so that they] feel the burn."[28]

Recent scholarship helps illuminate ways in which Millais too may have generated discomfort by this kind of somatic invitation to *feel* the world of the painting. In praising "problematic and ambiguous . . . physical and psychological interaction" in *Christ in the House of His Parents*, Barlow

draws our attention to the way that the figures seem drawn together and yet also remain apart: where it would seem natural for mother and child to touch one another, Mary holds her own shawl, and Jesus puts a warding hand across his own body.[29] The "awkwardly alienated proximity" (Barlow's acute phrase) between the members of the holy family (Mary touching not her son but herself, Jesus with his hand up not in affection but as a barrier to entry) has something to do with the painting's efforts to convey both the fragile ever-shifting subtlety of the momentary position of a body in the grip of strong emotion—and also something deeper, the inner feelings that accompany a moment of high tension.[30]

In the contemporaneous criticism of Millais paintings generally—but of *Christ in the House of His Parents*, especially—a similar and similarly revealing discrepancy arises between the clinical, dispassionately accurate, anatomical details and the depth of supersensible feeling that a religious subject is meant to evoke. *Christ in the House of His Parents* offers a striking version of the linkage problem of ephemeral and eternal—of the holy world and of our own world explicitly conjoined by the typology of the crucifixion. Many critics objected to the minutely rendered particularity of the holy family's bodies in situ, a particularity they judged incompatible with a properly spiritualized presentation of Christ. The notice in *Punch* describes the holy family as "specimens which we may vainly endeavor to keep in spirits" and jokes that "it will be a pity if this gentleman does not turn his abilities—which, in the mechanical way, are great—to the illustration of Cooper's Surgical Dictionary; and leave the Testament alone."[31]

No detail escaped criticism: reviewers even carped that "he exerted his talent in a wrong pictorial economy, wasting it on the representation of wood-shavings."[32] It is worth noting, though, some variation in how Millais's capacity to capture minute details of the world is received. For example, a review in *The Builder* denounces "this painful display of anatomical knowledge, and studious vulgarity of portraying the youthful Saviour as a red-headed Jew boy, and the sublime personage of the virgin a sore-heeled, ugly, every-day sempstress." Yet it goes on to praise "the extraordinary depiction of shavings. If the artist will adhere to this manner, there are other subjects more fitted to his love of, and great power in, imitation, requiring less refinement and appreciation of the lovable."[33] Those shavings, the vivid index of the ongoing carpentry, are in a sense like the painting itself, proof of the care that the young worker (Jesus, or Millais) lavishes on the material surface (planks in a shop, or the painting itself) that lies before the viewer.[34]

The challenge posed by the painting, then, is how to reconcile an immediate physical response to the pointedly, painstakingly realistic details

with the reverence that a religious subject ought to require. In the main, the criticism judged the experiment a failure. *Blackwood's* announces that "[s]uch a collection of splay feet, puffed joints, and misshapen limbs was assuredly never before made within so small a compass."[35] *The Times* similarly emphasizes the incongruous yoking together of carnal suffering and high spirituality, declaring that "the attempt to associate the holy family with the meanest details of a carpenter's shop, with no conceivable omission of misery, of dirt, of even disease, all finished with the same loathsome minuteness, is disgusting." The same *Times* review also makes a different point: not only is the physicality of the holy family disgusting, the paintings is also "dry" and "conceited" and thus merely imitative rather than lifelike: "With a surprising power of imitation, this picture serves to show how far mere imitation may fall short, by dryness and conceit, of all dignity and truth."[36] Not only has Millais been excessively lifelike, he has also failed to infuse the purely carnal details with the sentiment required to achieve truth. Moreover, it is the leading realist writer of the age who brings the case against Millais to a magisterial climax.

Horrible Ugliness: Dickens contra Millais

This chapter began by considering the conceptual possibilities raised by Millais's various ways of depicting lingering ephemerality—especially the challenge of depicting a banal moment in the boyhood of Jesus that typologically foreshadows the crucifixion, gesturing upward to eternity. Roberts's insight about audiences "feel[ing] the burn" on a subject's face, Julie Codell's account of implicit physiological experimentation about body posture, and Barlow's notion of "awkwardly alienated proximity" all uncover aspects of the odd mixture of visceral engagement and distance that Millais's paintings not only produce but also explore and comment on. The most memorable early attack on the Pre-Raphaelites, though— Charles Dickens's response to *Christ in the House of His Parents*—changes the rules of the game.

William Michael Rossetti called Charles Dickens's July 1850 *Household Words* diatribe "most virulent and audacious"; he might have added "disgusted."[37] Dickens fulminates:

You will have the goodness to discharge from your minds all Post-Raphael ideas, all religious aspirations, all elevating thoughts, all tender, awful, sorrowful, ennobling, sacred, graceful, or beautiful associations, and to prepare yourselves, as befits such a subject

Pre-Raphaelly considered for the lowest depths of what is mean, odious, repulsive, and revolting. . . . [Jesus] is a hideous, wry-necked, blubbering, red-headed boy, in a bed-gown, who appears to have received a poke in the hand, from the stick of another boy with whom he has been playing in an adjacent gutter, and to be holding it up for the contemplation of a kneeling woman, a kneeling woman, so horrible in her ugliness, that, that (supposing it were possible for any human creature to exist for a moment with that dislocated throat) she would stand out from the rest of the company as a Monster, in the vilest cabaret in France, or the lowest ginshop in England. . . . Such men as the carpenters might be undressed in any hospital where dirty drunkards, in a high state of varicose veins, are received. Their very toes have walked out of Saint Giles's.[38]

A certain amount of the vehemence here accords with a general chorus of critical disapproval.[39] By Bullen's account, Dickens "caricatures" *Christ* as "a low-life realist genre piece"[40] largely because he sees Pre-Raphaelite nostalgia for archaic values as linked to the religious retrogression Dickens fears is threatening English Protestantism.[41] And certainly in understanding what irked Dickens about "wry-necked" Jesus and Mary's "dislocated throat," we might recall Codell's point about the PRB interest, circa 1850, in "emphatic rendering of bodily motion" by way of a careful physiological study.[42]

However, this contextualization risks understating the essay's visceral force.[43] There is certainly no comparison, in terms of intensity, between what Dickens writes here and the (amused) contempt he displays for the English genre painters (William Mulready and Charles Robert Leslie among them) he sees exhibited in Paris in 1855. By comparison to French and Belgian painters, he writes,

> It is no use disguising the fact that what we know to be wanting in the men is wanting in their works—character, fire, purpose. . . . There is a horrid respectability about most of the best of them—a little, finite, systematic routine in them. . . . Mere form and conventionalities usurp, in English art . . . the place of living force and truth.[44]

The criticism developed here, in fact, makes it surprising Dickens goes after Millais's painting with such ferocity. There is certainly in Millais no trace of the systematic flatness and predictability that Dickens is denouncing in Mulready. Instead, he faults Millais for being too sensual, which is to say too attached to capturing the surface of life, the minute details of a

particular model. Yet he is also denouncing Millais for failing to penetrate to the depicted subject's true emotional core: "All religious aspirations, all elevating thoughts, all tender, awful, sorrowful, ennobling, sacred, graceful, or beautiful associations" are missing. This painting is at once too much (particular details) and not enough (inward emotional reality).

We might even say that there is something downright Dickensian about this very impulse in Millais. Dickens is committed by this juncture in his career to a realism that works by making a composite picture that says something unsettling to viewers who want their types simple. Dickens attacks Mulready on account of his "little, finite, systematic routine . . . mere form and conventionalities." By contrast to Mulready's patly systematic routine, Dickens's fiction is filled with moments that break with finite mimesis. Such breaks (in chapter 5, I discuss one telltale moment of narratorial oscillation between representing an inward prayer and an outward burst of physical activity in *Our Mutual Friend*) suggest that there are more layers of reality than can ever be expressed by simple storytelling.

Dickens, then, might well have responded positively to some of the very things in Millais's painting that he instead denounced: the toes, the awkward pose of the body, the wounded, Phil Squod-like commonness in the figures. Instead, his attack lines up not just with contemporaneous critical comments about Millais's penchant for "specimens" and his "surgical" predilections but also with Buchanan's famous 1871 attack, on Pre-Raphaelitism as the "fleshly school of poetry." Buchanan argues that Rossetti's paintings resemble poetry in their

> thinness and transparence of design, the same combination of the simple and the grotesque, the same morbid deviation from healthy forms of life, the same sense of weary, wasting, yet exquisite sensuality; nothing virile, nothing tender, nothing completely sane; a superfluity of extreme sensibility, of delight in beautiful forms, hues, and tints, and a deep-seated indifference to all agitating forces and agencies, all tumultuous griefs and sorrows, all the thunderous stress of life, and all the straining storm of speculation.[45]

That is, Rossetti stands accused of sensory excess coupled with an absence of the "healthy forms of life" that permit a spiritual rather than a somatic bridge to the "agitating forces and agencies" that others experience. We might expect Dickens to applaud the capacity of Millais's realism to instantiate its subjects as suffering, bodied creatures; instead, he is disgusted (by toes, by throat, by blood) and eager for a space apart.

In Kantian terms, we might understand Dickens as seeking a way to reflect on Millais's painting, rather than merely reacting to it. His disgust may be triggered by his conviction that there is no space between himself and the subjects of the painting: their awkwardness and discomfort become his own. That disgust may be a covert impulse on Dickens's part to keep the "exactness" that fiction attains distinct from the kind of spiritual reliability that painting ought to supply. Or it may be a revealing form of misrecognition, whereby the novelist fails to see ways in which realist tactics in his own form might translate to another art. In either event, this vehemence about the excessive somatic demands made by Millais (his anguished plea to be allowed to detach himself from its visceral appeal) suggests that in the 1850s Pre-Raphaelite painting posed some of the same problems that realist fiction did. Both art forms in their very efficacy threatened to overstep the bounds of art and work directly upon its audiences in ways that made it unethical or monstrous.

In making sense of the conceptual space that fiction and Pre-Raphaelite painting might have shared or tussled over, circa 1850, it helps to know that at least some of the criticism of *Christ in the House of His Parents* had to do with the fact that "heads and bodies of the figures would have seemed inconsistent to contemporary viewers: neither recognizably sensitive intellectuals nor robust country people."[46] This occurred at least in part because Millais sought out individuals who "looked distinctive or even idiosyncratic enough to convince viewers that they existed in reality" and juxtaposed working-class bodies with bourgeois head and hand models.[47] Rossetti's Mary, modeled on his sister, read as unmistakably genteel; Millais's figures, working class in body and middle class in heads and hands, were not so readily legible.

Prettejohn makes the point that such an "artfully crafted amalgam of . . . the working-class body of the real carpenter and the head of a middle-class man" arose from the conviction that heads ought to be modeled by bourgeois subjects (in the case of Joseph, Millais's own father), since "individualism was the preserve of the middle class."[48] Millais's amalgamation is a tricky one. It aims to achieve composite realism by conjoining artisanal corporeal authenticity with signs of inner life and the traces of mental anguish. Yet its impulse toward amalgamation proceeded from the same sort of practical division that led him to combine plein air and indoor modeling in the painting of *Ophelia*. Out of various mimetic frameworks, a single "truth to nature" emerges—but with its seams very much in view. Similar seams between one way of construing reality and another can be found elsewhere in Millais's work of this period. Think for example of *Ferdinand*

Lured by Ariel, in which Ferdinand blindly attends to Ariel and his fellow fairies, who are invisible to him but plain for viewers to see. A similar argument might be made about the halos in Ford Madox Brown's paintings, painted so as to be visible to the painting's audience, yet not necessarily perceptible by figures *within* the painting.[49]

The complex relationship between pictorial space and viewer's involvement here perhaps relates to Giebelhausen's description of the "timelessness" in Millais's painting that stems from "a notion of period that depended on fragmentation rather than synthesis."[50] What seems to be a paradox—how can timelessness depend on fragmentation?—comports well with the notion that Millais aims both to embed his viewers within and detach them from the painting. The temporal fragmentation (like the "all-over" indexicality of the natural world in *Ophelia*) leaves the viewer unsure how to take these figures, whether to sympathize warmly or gaze critically.[51] If the viewer's embroiled relationship to the boy Jesus produces vociferous responses (Dickens is the most striking), those responses speak to the painting's capacity to make viewers at once enter into the scene and recognize their actual distance from it.

Nor is Millais the only painter of his era for whom that question of *partial* entry and "awkwardly alienated proximity" has resonance. The range of ways to conceive of that problem of an aesthetic experience that operates at a "double distance" takes on a series of distinctively midcentury forms not only in fiction (as chapters 4 and 5 explore in detail) but also in the visual arts that flourish after the apogee of Pre-Raphaelite experimentation in the 1850s. This Visual Interlude concludes, therefore, with a jump forward into the 1880s to consider Alma-Tadema's quite different approach to the problem of partial absorption into a virtual world: by way of the problem of inaudible music—and the allure of holding hands.

SAPPHO, HOMER, HOLDING HANDS

Anne Leonard has recently remarked on the number of European paintings of the 1880s that depict music as embodying the "emotional force and . . . capacity to command sustained attention" that painting (by virtue of its incapacity to depict interiority or mark the passage of time) lacked.[52] By her account, the turn toward representing music among the painters of the 1880s represents a straightforward attempt to "appropriate for painting qualities peculiar to music."[53] Similarly, Elizabeth Helsinger maps what listening looks and sounds like in Dante Gabriel Rossetti's poetry

and painting both: "Music rendered ideas of sense and sensation intensely perceptible through the body, heard and felt in the vibrations of breath from throat, the touch of the hand or body moving to music, the peculiar penetrating power of music-borne language."[54] Both accounts suggest the vital role that the representation of a different art may play in delineating the exact ambit of one's own art.

The value of such sideways glances at the potentially inaccessible reaches of another form of art is a persistent concern of the paintings of Lawrence Alma-Tadema. Dutch-born in 1836 but practicing in England from 1870 on, Alma-Tadema is neither a French "Academic" painter (though the linkage to the French Academician Jean-Leon Gérôme is clear) nor exactly a Pre-Raphaelite, nor does he make it into Elizabeth Prettejohn's recent book on Victorian aestheticism.[55] Caught between pillar and post, Alma-Tadema was accused of sterile classicism by Ruskin and an even more sterile presentism by the curators of a recent retrospective: to call his antique figures "Victorians in togas" is no compliment.[56] But Prettejohn is right to describe certain Alma-Tadema paintings as having a "peculiar doubleness" displaying "comforting signs of survival and disconcerting traces of loss"; and to suggest that such paintings work because they create a "pleasurable friction between the ephemeral and the lasting."[57] The man who called himself an "archaeological genre painter" turns out to be surprisingly attuned to the challenge of representing absence—showing experiences available to the depicted figures, but withheld from the painting's audience.

Rather than attempting to "bridge or overcome those fundamental differences" between a painting's capacities and those of music (or poetry), Alma-Tadema's actually underscores a painting's distinct representational capacity—a capacity that inheres precisely in pulling up short. Alma-Tadema paintings, such as *A Reading from Homer* (1885), *Sappho and Alcaeus* (1881), and *A Favourite Poet* (1888), struggle to convey not so much the presence of music (or lyric poetry) as a sense of its recessive quality. The subtleties are different in each case: in *A Favourite Poet* the figures actually recline against the lines of Horace's poetry (inscribed on a wall) that they are presumably also reading aloud, a kind of tactile encounter that underscores poetry's quasi-tangibility. In *A Reading from Homer* (Fig. 3.6), the performer (the title is ambiguous, perhaps deliberately, about whether this is meant to be Homer himself) leans forward toward the reverent, vibrating intensity of his listeners. In this case, what makes the music *almost* audible is the intertwined hands of those listening—and the fact that one of the hand-holders is also touching a lyre, as if waiting to go next.[58]

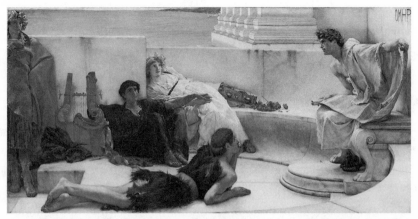

FIGURE 3.6. Lawrence Alma-Tadema, *A Reading from Homer* (1885, Philadelphia Museum of Art). Courtesy of Bridgeman Images.

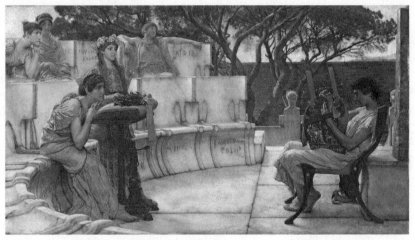

FIGURE 3.7. Lawrence Alma-Tadema, *Sappho and Alcaeus* (1881, Walters Museum, Baltimore). Courtesy of Bridgeman Images.

Sappho and Alcaeus (Fig. 3.7) may be Alma-Tadema's most striking work of virtual ekphrasis. The painting's two halves are divided by its calm white center and the receding blue sea: one side is filled up with "Sappho's girls" (as one contemporary review put it) and with the scratched names of various lovers whom Sappho commemorated in her poems. The other primarily holds the fiery, somewhat petulant Alcaeus, who gazes passionately *past* Sappho. We might reckon with the absorption of a poet (and

her presumptive pupils) into another poet's craft—an absorption whose intensity is measured by the fact that none of those intense, highly focused gazes truly meet, nor do any two characters appear to be looking at the same thing.

Most interesting of all, finally, is the light touch of the beloved on Sappho's back, a touch that neither she nor Sappho overtly acknowledges. The duality of the painting turns on Sappho as absorbed subject and also as tangible surface upon which the hand of her beloved rests. Painting can represent the physical emplacement of all its subjects and, in a very different way, it can convey what Sappho is hearing, or what she sees as she hears it. The touch that connects Sappho and her beloved (yet which also acknowledges the experiential divide between them) marks another version of Barlow's "alienated proximity." Applied to Millais, that phrase describes the way in which a social setting forces two figures together (Mary and Jesus) yet also renders them (for some difficult-to-discern reason) unable to touch. Here the proximity initially appears total, in that the figures are touching. Yet they are gazing off into different distances, responding to the same music in ways that may well not converge.

How are Alma-Tadema's figurations of absent music connected to the alienated proximity bodied forth in that moment of oblivious touch between Sappho and her beloved? In "The Metaphysics of Tragedy," Lukacs describes the moment of pure form as transcendent silence; the formal logic of these paintings, however, relies on impurity, on the mixing together of physical and metaphysical contexts, of visible and invisible stimuli. The failure of the various characters in *Sappho and Alcaeus* to meet one another's eyes, or even to share the same object in their gazes suggests one way of reading their absorption: they are lost in perennially inaccessible thoughts, in particular experiences. The touch that unites them, though, (the same could be said of the listeners in *A Reading from Homer*) suggests another interpretation—that they are socially, metonymically linked, sharing a crowd experience. The painting's accomplishment lies not in purifying either formal claim at the expense of the other but holding the two in a feasible relationship.

In a sense, these Alma-Tadema paintings aspire to failure: they succeed not by appropriating the power of music, but by definitively failing to convey the sensation of listening to lyric poetry. You might think of this as a kind of *moiré* effect that marks the interference patterns between visual and acoustical arts. The subject's absorbed listening is the negative space that the painting simply corrals by failing to reproduce it. Another pair of

phrases applies to these deliberately imperfect ekphrastic moves. One is *mediated immediacy*; as if Alma-Tadema depicted the painting's struggle to capture the perfect purity of the relationship to the poet's recital. The other is *unmediated mediation*, as if the medium had been made tangible and palpable by an interference pattern between what painting can capture and what poetry can express.

Alongside the unseen music, tangential touch like that hand on Sappho's back looms large in Alma-Tadema's work generally. *Unconscious Rivals* (1897; Fig. 3.8) is rife with the "peculiar doubleness" of temporality Prettejohn describes: determinedly classical and archaic, and yet also so evidently of its own day. True, there is the barrel vaulting modeled on the ceiling of Nero's golden house and the half-leg of an enormous statue of a seated gladiator.[59] Yet this space is like late Victorian railway stations, as well. So, are these rivals waiting for a Roman gladiator or someone about to arrive on a 5:03 commuter train from Birmingham?[60] At once ancient and modern, these two women leaning out over that (PRB-inflected) frieze of a wall into deep space are palpably listening for something that at once unites them and divides them. The marker of that double state, of joint attendance and separation? A handclasp.

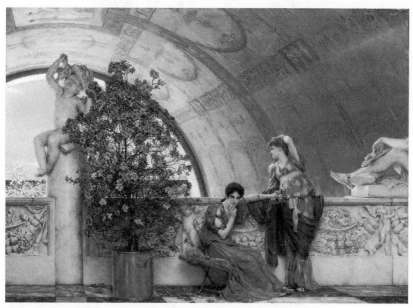

FIGURE 3.8. Lawrence Alma-Tadema, *Unconscious Rivals* (1893, Bristol City Museum and Art Gallery). Courtesy of Bridgeman Images.

The not-quite-acknowledged touch between the two women (and the garland of flowers, serving not only to aestheticize but also to blur the meaning of that contact, as if to allow each woman a sort of plausible deniability) is related to the way that the two subjects, leaning out from flatness into depth, are both thinking, though neither knows it, of the same absent figure. The interplay of knowledge and ignorance that defines this tableau (they both know their own intention in waiting, neither knows the other's) is underscored by an external fact: the painting's title—as unknowable to the figures within the painting and the title of a novel to its characters—makes viewers privy to an intersubjective fact that's not known to the rivals themselves.[61]

This chapter has made the case (via the concept of "double distance") that Millais struggles with a cognate problem about the audience's relationship to the depicted world—am I part of their world, or is their world nothing more than a piece of art hanging in my world? Four decades further on, Alma-Tadema's invisible music and his handling of the problem of tangential touch is still signaling his interest in the doubled state, not just of his figures but of his audience: at once detached from their everyday social lives and present in them, at once absorbed in an alternative world and conscious of the ordinary social constraints that define their footing in the world beyond that which they see in the artwork.

In both artists, links to problems of fiction and of narrative are discernible. Millais's approach to the material reality of the carpenter's shop where Jesus grew up implies a realism just akin enough to Dickens's own to infuriate the novelist. In the case of Alma-Tadema, one link that bears mentioning grows out of that significant yet underplayed handclasp at the center of *Unconscious Rivals*, which has more than a little to do with the memorable handclasp between Rosamond and Dorothea very late in George Eliot's *Middlemarch*—a hard-to-read moment of carnal and perhaps psychic connection, in which Dorothea's diffusive influence both does and does not flow into the waiting Rosamond's soul. I say the contact is hard to read: despite the readerly impulse to parse this moment as one of great intimacy and sympathetic connection, Eliot goes to great lengths to point out gaps in this moment of seeming fusion. When Dorothea reflects on the pleasures of taking poor Rosamond by the hand, the narrator drily observes that "she felt a great outgoing of her heart towards Rosamond for the generous effort which had redeemed her from suffering, not counting that the effort was a reflex of her own energy."[62]

Moreover, the scene is one of hand-*un*clasping as much as it is of handclasps. Dorothea actually ends up taking Rosamond's hand three times because it keeps being withdrawn from her grasp:

[Dorothea] was beginning to fear that she should not be able to sup-
press herself enough to the end of this meeting, and while her hand
was still resting on Rosamond's lap, though the hand underneath
it was withdrawn, she was struggling against her own rising sobs.[63]

Eliot is not exactly blaming Dorothea for failing to notice when Rosa-
mond's hand is withdrawn and withdrawn again. Yet she is certainly re-
minding the reader that the act of noticing, upon which all these edifices of
sympathy are built, is always partial and not directly controllable even by
the parties involved. Readers, unlike the characters themselves, are aware
that the two women are seeing images (of Will, mainly, but also of Lydgate
and of themselves in hypothetical social encounters) that differ quite radi-
cally from one another. Eliot wants the reader to be acutely aware of the
forms of detachment, even of withholding, that are woven into moments
of seemingly comprehensive clasp and conjunction.[64] Many of the same
ideas structure *Unconscious Rivals*.

CONCLUSION: BROWNING AND THE PROBLEM OF SEQUENCE

There is not a simple, unified story to be told about the relationship be-
tween the forms of realism, or truth to nature, that shaped Millais's Pre-
Raphaelite painting and the ones that gave structure to the fiction of Dick-
ens, Eliot, and their contemporaries. Following the logic of Julie Codell's
argument about the Pre-Raphaelite interest in using physiognomy and
anatomy as a way of capturing subjective states, we might even want to
find in Millais's later widely praised illustrations of Trollope's Barchester
novels (Fig. 3.9) traces of his eventual attunement of his own art to the
formal requirements of the Victorian novel.

 Such an account might emphasize that the novels of Trollope, Dickens,
and others succeeded not only by sequencing episodes one after another
but also by choosing moments to dive deep down into the experience of
particular characters, isolating their strong feeling in a kind of fictive *tab-
leau vivant* that aligns well with Millais's own mode of representing the
anguished body. The problem of semi-detachment in Millais and Alma-
Tadema is that of the coexistence of ephemeral instants and longer arcs,
the relationship between the instant or episode and the "whole story."
Millais's turn toward novels and novelists later in his career (not just those
remunerative commissions from Trollope but also a cordial reconciliation
with Dickens) also serves as a reminder that accounts of the era's painting
illuminate the other arts, as well. John Stuart Mill articulates something

Lady Mason after her Confession

FIGURE 3.9. Dejection visible: the almost occulted profile performs absorption, allowing the viewer to fabricate the character's inward life out of absence. John Everett Millais, "Lady Mason after Her Confession," illustration for Anthony Trollope, *Orley Farm* (London, Chapman, and Hall, 1862. Houghton Library, Harvard University).

very important about nineteenth-century conceptions of lyric poetry when he declares that we call someone "a poet, not because he has ideas of any particular kind, but because the succession of his ideas is subordinate to the course of his emotions."[65] It is a verbal art form, yet by Mill's account it refuses sequence and instead abides inside the precious moment. One way for this project to turn back from the visual to the verbal arts, then, is by considering poets who can shed light on this problem of perennial semi-detachment from a past that both shapes us and recedes from us.

Browning's 1855 "Memorabilia" offers one fascinating way of thinking about the relationship between the momentary and the ongoing.

> Ah, did you once see Shelley plain,
> And did he stop and speak to you?
> And did you speak to him again?
> How strange it seems, and new!
>
> But you were living before that,
> And you are living after,
> And the memory I started at—
> My starting moves your laughter!
>
> I crossed a moor, with a name of its own
> And a certain use in the world no doubt,
> Yet a hand's-breadth of it shines alone
> 'Mid the blank miles round about—
>
> For there I picked up on the heather
> And there I put inside my breast
> A moulted feather, an eagle-feather—
> Well, I forget the rest.[66]

Dickens's distaste for the ungainly limbs and pathological toes of Millais is not going to be resolved by looking at how poetry grapples with the tension between instant and eternity. Nonetheless, the core moment of this poem—the rejoinder to the speaker's awe—"but you were living before that / And you are living after" and the laughter that accompanies it—illuminates the hold that fiction's command of sequence-as-mimesis had on the audiences of the 1850s. Browning's first two stanzas grapple with the relationship that any single moment has to its surroundings: the speaker registers the fallacy associated with summing a life up in any given moment and, in effect, accepts a rebuke for his excessive excitement about one event, overlooking its milieu—both what led up to the event and what

followed from it.[67] In effect, the speaker and poem both stand accused of not following fiction's recipe for reality: one thing after another.

Browning has a remaining trick up his sleeve: the latter two stanzas of the poem essentially recoup the event from the first two stanzas, with the feather taking the place of the meeting with Shelley. This is a second pass through the problem and yet Browning's conclusion is neither sequential nor additive; "I forget the rest" registers (perhaps ruefully, perhaps not) the tendency not to establish a sequence, a legible and orderly milieu, even when the same sort of event recurs. At this moment, the problem of making sense of events as sequential, one leading to the other and shaping the meaning of the other, becomes redoubled: the speaker now proves incapable of making the first pair of stanzas stand in a productive relationship to the second pair.

Browning is playing with a persistent problem for lyric poetry: How to render, concurrently, the experiential intensity of a moment and the passage of time. In a sense, lyric poetry here aligns with both painting and with prose. Novelists and painters and poets alike are grappling at this moment with the artwork's capacity to be present in two ways at once: as the instantiation of an ephemeral instant and as durable artifact—like that Paterian paradox, a "hard gemlike flame." The implications of such balancing acts between sequence and instant, between coherent order and momentary sensation, run deep for Browning. In "The Dead," Joyce has Gabriel Conroy call Robert Browning's poetry "thought-tormented music": that odd duality captures Browning's commitment both to the palpable "thinginess" of a work of art (its musicality) and to its detachability from that "mere" materiality (hence its thought-tormented quality).

Browning is not, as early critics charged, aiming for a directness of experience that eludes him. With all of poetry's formal props and aids put on display rather than hidden away for elegance's sake, the poem in *Men and Women* that most perfectly works through the implications of thought-tormented music is "A Toccata of Galuppi's," which takes the form of a paean that effectively mimics or mirrors the piece (by a long-dead composer) it purportedly describes.[68] On the one hand, the reader of the poem is meant to feel the thrum of the music just as the speaker does: "In you come with your cold music till I creep thro' every nerve" (l.33). The overlap between imagined musicality and the verbal fabric of the poem itself is made explicit: the musical rhythm described in the poem is also meant to take (imperfect) hold of the reader in the very words that describe that rhythm.

What? Those lesser thirds so plaintive, sixths diminished, sigh on sigh,
Told them something? Those suspensions, those solutions—Must
 we die?
These commiserating sevenths—'Life might last! We can but try!'[69]

On the other hand, even at such moments of aural harmony, the semantics of the sentence generate uneasiness. The ventriloquized resolution, "We can but try!" is assigned to some particular imagined speaker, the unmarked, unspecified *we* of "Must we die?" Browning aims at producing an indeterminate sort of solidarity between reader, speaker, and the imagined originator of the musical idea. Suspensions and solutions both are tentative and partial at best, which is precisely what allows them to reach out to implicate the reader, as well. In the poem's quasi-intangibility, its materiality lies.

The poem can neither satisfactorily impersonate an object, nor can its words be granted sufficient musicality to make the question of tangibility seem temporarily irrelevant. Poetry's virtuality works by suggesting that all such intangible experiences bring readers to inconceivable heights only by forfeiting their durability across time.[70] Browning presumes that audiences respond both to his poetry's music and to its thought; this produces a persistent tension between considering the words of others (as thoughts open to critical reflection) and feeling those words enter one's body uninvited and impossible to be expelled. Those centuries-old notes still impossibly hanging on the air have some of the same paradoxical attributes that Millais's paintings do. A moment frozen into art cannot be at once durable and evanescent. Yet not all lingering is wretched: in the half-light of aesthetic experience, the moment both goes and stays.

4

Virtual Provinces, Actually

THE PROVINCIAL NOVEL

The account of aesthetic experience laid out in *Semi-Detached* aligns with Catherine Gallagher's description of voluntary frameworks of disbelief and of realist fiction's reliance on "believable stories that do not solicit belief."[1] It also proposes that throughout the nineteenth century there is a heightened awareness of, and focus upon, occasions when the voluntary nature of that disbelief is held up to the light. The advent of a self-referential literary discussion of semi-detachment—of what it means to be caught up in a moment but also capable of pulling oneself away from that moment to reflect upon it—becomes an avenue for writers and other artists to reflect upon what kind of hold upon its readers a mimetic artwork has. When the text reflects on the detached status of the reader him or herself, partially drawn into the cognitive world of the artwork, partially stepping back and contemplating it from a distance, such moments become the occasion for the author to reflect upon what such partial immersion means for the relationship between an actual social milieu and fictional ones.[2]

The doubled consciousness explored in the introduction, which crops up even in mundane moments of reverie like Jane Eyre's pensive abrogation of ordinary activity when after an overly eventful day she barricades herself into her room ("Now I simply thought"), points to a pervasive nineteenth-century realist interest in the paradoxical ways in which local attachments can abet rather than thwart moments of detachment. This chapter, however, turns to a set of novels that share with short fiction a generically anomalous status. Whether we construe the provincial novel as a subgenre within Victorian realism or as *ur*-realism, the center from which all Victorian novels truly emerge, what becomes clear is that at the heart of the provincial novel lies not so much a triumph of the local over the cosmopolitan (Little-Englandism), but a fascinating version of *magnum in parvo*, whereby provincial life is desirable for its capacity to locate its inhabitants at once in a trivial (but chartable) Nowheresville and in a universal (but strangely ephemeral) everywhere. In fact, we might even go

farther: entering the provincial spaces carved out by such novels requires an imaginative conception of oneself as existing at once within and without a tiny beehive of a world: *magnum ex parvo*, great arising from little.

When I asked a colleague to name some important Victorian provincial novels, she looked at me as if I were insane: "All of them," she explained gently, as to a drooling child. What is it, though, that nineteenth-century writers thought made a novel not simply extra urban but downright provincial? In 1824, Mary Russell Mitford offered up a long-lived answer; she praised Jane Austen's novels for successfully delineating a knowable and loveable world. In fact, a world lovable because knowable:

> Even in books I like a confined locality . . . Nothing is so delightful as to sit down in a country village in one of Miss Austen's delicious novels quite sure before we leave it to become intimate with every spot and every person it contains.[3]

Readers' interest in any known place, that is, depends on intimacy predicated on the possibility of reciprocity and connection. Austen's success is that her readers forget they have a book in hand and instead imagine they are within a geographically and psychologically compassable world. This sense of readerly security might theoretically arise in a novel not so firmly rooted as Austen's, but Mitford is skeptical that the form is capable of inducing a sense of placid stability if its subject matter is peripatetic: "Nothing is so tiresome as to be wheeled over half Europe at the chariot wheels of some hero."[4]

In praising both the knowability and the secure totality of Austen's represented worlds, Mitford does more than affirm the famous reading of Austen as a miniaturist, toiling on "the little bit (two inches wide) of ivory on which I work with so fine a brush, as produces little effect after much labour."[5] She initiates the tradition of praising the provincial novel for what is left out (troubling aspects of modern life) as much as for what is put in (evocations of a placid, rural, backward-looking England). Interestingly, Mitford's account of a comforting literature based on compassability also indirectly acknowledges the distancing effect of what James Buzard has described as the nineteenth-century novel's autoethnographic impulses.[6] We are happy in the world of the novel, Mitford explains, because we can contemplate, closely and yet with a consciousness of our own distinction from them, characters who coexist like "ants in an ant-hill [or] bees in a hive."[7]

The very features Mitford singles out for praise in the provincial novel are those that Mikhail Bakhtin influentially defines as epitomizing

the residual and irrelevant features of both provincial life and provincial novels. Bakhtin emphasizes the importance of the *bildung* tradition, specifically in contradistinction to the comparative unimportance (and rural placidity) of the "petty-bourgeois provincial town," with its "commonplace, philistine, cyclical . . . viscous and sticky . . . ancillary time."

> In the provincial novel we witness directly the progress of a family-labor, agricultural or craft-work idyll moving into the major form of the novel. The basic significance of provinciality in literature—the uninterrupted age-old link between the life of generations and a strictly delimited locale—replicates the purely idyllic relationship of time to space, the idyllic unity of the place as locus of the entire life process. . . . The provincial novel has the same heroes as does the idyll—peasants, craftsmen, rural clergy, rural schoolteacher.[8]

Bakhtin's critical template has proved surprisingly durable. According to Ian Duncan's persuasive account, the British provincial novel presents a world that is "compact" (usually traversable on foot or horseback) and "familiar," yet also "distinctive."[9] Duncan also notes the provincial setting's "comparative historical backwardness," which helps account for the "nostalgic mode" through which it is generally viewed.[10] To Duncan's five criteria could be added Franco Moretti's description of the provincial as defined primarily negatively, through the sorts of possibilities and plots that provinciality rules out.[11] Virtually everything that delineates the provincial novel is included in those cogent criteria: compactness, familiarity, distinctiveness (usually from the metropole), nostalgia-inducing comparative backwardness, and negative definition.[12]

Consider the opening paragraph of perhaps the most instantly recognizable set of British provincial novels of all, Trollope's Barchester series:

> The Rev. Septimus Harding was, a few years since, a beneficed clergyman residing in the cathedral town of—; let us call it Barchester. Were we to name Wells or Salisbury, Exeter, Hereford, or Gloucester, it might be presumed that something personal was intended; and as this tale will refer mainly to the cathedral dignitaries of the town in question, we are anxious that no personality may be suspected. Let us presume . . . that the west end of Barchester is the cathedral close.[13]

The disavowal of temporal and geographic specificity, and of personality, is provincialism incarnate: all six of the Duncan/Moretti criteria are in view by the bottom of the first page.[14]

Crucial among those criteria, perhaps, is a special kind of provincial compactness, a curiously portable kind of geographic fixity. John Locke points out that when a chessboard is picked up and moved without disturbing the pieces on it, "we say [the pieces] are all in the same place, or unmoved."[15] Provincial novels similarly are interested not in absolute location, but in the way that its pieces (its dramatis personae) are situated in relation to one another. Small wonder that many begin with the arrival of a naïve stranger (better still, a returning native) who must be briefed on everyone's comparative standing—and address. Moretti argues that "one cannot map provincial novels—you cannot map what is not there," but he also proposes a very helpful distinction between *mapping* (of the real, geographically knowable world), and *diagramming*, which simply establishes a differential relationship between locations (three houses down from the corner; next town after Middlemarch, etc.).[16] Provincial novels are unmappable, but they must be diagrammable: the one drawing Eliot made of the world of *Middlemarch* (Fig. 4.1) was a relational chart of distances between villages.[17]

PROVINCIAL SEMI-DETACHMENT

The importance of this diagram logic to the provincial novel should also help draw our attention to another aspect of the genre, equally important, but distinctly unamenable to diagramming. Bakhtin emphasizes the sticky and idyllic qualities of provincial life, but in doing so he overlooks the ways that even the most seemingly sedentary provincial worlds always contain linkages to a greater world beyond, a world that crucially discloses itself within the provincial location, even if only by way of the characters' awareness of their imbrication in that larger realm: Jane Eyre touching Roman history in Miss Temple's Roman books, Miss Marjoribanks laying Napoleonic plans to conquer Carlingford—but also Maggie Tulliver materializing (in chapter 1 of *The Mill on the Floss* [1860]) in the narrator's cold study.

Victorian readers possessed a vast arsenal of terms to describe what it felt like to get lost in a novel. Readers are engaged or enthralled; the novelist is a magician or a time traveler. The annihilation of present space and time often seems a blissful consummation.[18] The highest praise a reviewer can give *Dracula* (1897) is to admit that "at ten we could not even pause to light our pipe," and by midnight "we listened anxiously for the sound of bats' wings against the window."[19] Robert Louis Stevenson envies Fyodor

Hospital cont?

Dr. B. in 1869 refused to give a testimonial for K
C. Hospital on the ground that such a state of things
ought not to exist."

Middlemarch

Directors

Mr. Plymdale, Dyer Votes for Tyke
Mr. Powderell, Retired ironmonger " "
Mr. Hawley [Hoyden], Lawyer & townclerk .. Farebrother
Mr. Hackbutt, Tanner . Farebrother
Mr. Larcher, Carrier Tyke
Rev. S. Thesiger, Rector of St Peter's Tyke
Arthur Brooke Eq. of Tipton Grange Tyke
Nicholas Bulstrode, Eq. Banker Tyke

Lowick
3 miles
o Middlemarch
3 miles — o Tipton
Freshitt

FIGURE 4.1. Eliot's only visual aid: a diagram showing distances between important sites for the novel. *Quarry for Middlemarch* (n.d., MS Lowell 13, Houghton Library, Harvard University).

Dostoyevsky beyond all writers because "it is not reading a book, it is having a brain fever to read [*Crime and Punishment*]."[20] For many readers, then, a novel succeeded, if it could engender absorption so complete that actions the work merely represented could trigger "the 'creepy' effect, as of pounded ice dropped down the back."[21]

What of those novels, though, that present themselves neither as brain fevers nor as pounded ice? A wide range of Victorian novels implicitly or explicitly propose self-limiting claims about the sorts of power that an aesthetic experience has—or ought to have—over its readers. In such works, the reader is imagined as getting lost in a book, but remaining simultaneously aware of the real world from which she or he has begun to separate. For example, consider what might be called "phase-shift" moments, in which the narrator discovers that what had seemed to be a sensation within an artwork's imagined world is actually a sensation that can be tied to the here-and-now, as well. As we saw in the introduction, the musing narrator whose voice opens *The Mill on the Floss* finds himself located at once in the world of the Tullivers (staring at Maggie by the mill) and in his own readerly space:

> It is time, too, for me to leave off resting my arms on the cold stone of this bridge. . . .
> Ah! my arms are really benumbed.

The reader, like the narrator, is suspended between the world of the mill and the study—Eliot's peculiar ellipsis marks the moment (of waking, of dizziness?) where that confusion arises.[22]

What is it that makes Eliot commence a novel that ends up located entirely inside the world of Dorlcote Mill with this antechamber, half-bridge and half-study armchair, located so oddly between worlds? If a novel sought mainly to immerse its readers in a sensually complete shadow world, a moment like this would be a glaring anomaly, a signal of failed aesthetic effect. Enough similar instances exist, though, to paint a picture of semi-detachment not as an inadvertent way station but as a state deliberately sought out. We might, for example, trace through Victorian realist novels moments when a movement toward pure abstraction gets unavoidably anchored in the physical location from which that flight to abstraction began. The introduction discussed self-annihilating Jane Eyre reading herself into arctic bird life (in a window seat screened from and yet connected to a cold world beyond the glass) who is also cousin Jane, aware that at any moment the red curtain will be thrown back and her book will be turned into another weapon in that most common Victorian struggle,

cousin against cousin. Moreover, the experience of semi-detachment that comprises a fully realized provincial life—far away from the seemingly inescapable centrality of the metropolis, yet still connected to it—is in important ways analogous to the relationship that the reader is meant to have to the text itself. This is true both in sophisticated novels that thematically reflect on the problem of partial absorption (*Middlemarch*) and in novels that resist such attempts at reflexivity (*The Chronicles of Barchester*).

One marker of the logic of semi-detachment that powers the provincial novel is a recurrent tendency toward generic parody and half-appropriation of other genres in British provincial novels. Not just the relatively awkward parodies of Dickens and Carlyle in Trollope's *The Warden* but also Gaskell's gesture toward the fairy tale as "usual rigmarole of childhood" in one novel's opening line—and in another, toward the realm of Greek myth: "In the first place, Cranford is in the possession of the Amazons."[23] Such parody is on display in Emily Eden's *Semi-Detached House*, for example, in which the suburban languors of Dulwich are animated by a "turn for quotation" (a turn to ballads and Shakespeare, principally).[24] In quoting, characters make their lives meaningful by analogizing them to the lives they devour in distinctly nonprovincial (and nonprosaic) artworks. A fascinating palette of generic parodies is also at the core of the (unjustly) neglected provincial novels of Margaret Oliphant: especially *Miss Marjoribanks*. For Oliphant (much like Gaskell in her half heroic, half mock-heroic *Cranford*), the provincial novel holds its power precisely by simultaneously borrowing and renouncing the seemingly more grandiloquent plots and formal devices of various other genres.

If for Bakhtin the provincial novel is defined by the sense that any meaningful event has to happen elsewhere, one of the striking elements of the British provincial novel is how this disjunction is routinely turned on its head. Going up to London, which looks like productive activity, frequently turns out instead to be a misguided, even fatal loss of focus. Raymond Williams has made the case that in Hardy's novels the disjunction between past and present is not between country and city, but runs through the rural idyll itself.[25] That claim also has interesting relevance to the worlds of Cranford and Carlingford. Whether through genre parody or fiscal perturbation, in such provincial novels the macrocosmic and "world-historical" proves to be just as present in the idyll space as it is anywhere else.

In the novels of Trollope, Gaskell, and Oliphant, core and periphery frequently get reversed, so that what matters to the nation's center happens on its edges: in Gaskell, the business town of Drumble waits on backwater Cranford's decisions, and in Trollope, Barchester's family dramas

run back upstream to shape metropolitan politicking. We know how little can be expected from the new Bishop in *Barchester Towers*, for instance, when we read:

> Dr. Proudie was, therefore, quite prepared to take a conspicuous part in all theological affairs appertaining to these realms, and having such views, by no means intended to bury himself at Barchester as his predecessor had done. No! London should still be his ground: a comfortable mansion in a provincial city might be well enough for the dead months of the year. . . . The resolution was no doubt a salutary one as regarded the world at large but was not likely to make him popular either with the clergy or the people of Barchester.[26]

For London to "still be his ground," it is necessary for the Bishop to give up hope of a meaningfully active role in Barchester or in the novel that takes Barchester as its *locus amoenus*. The Bishop is instantly judged irrelevant, structurally consigned to the very same category as the various London-based writing forms that Trollope satirizes in *The Warden* (the blowhard journalist, the Carlylean prophetic ranter, and the lachrymose Dickensian social-problem novelist). In 1882, R. F. Hutton summed up Trollope's ability to *center* the world on his provincial microcosm nicely: Barchester is "the center of all sorts of crowding interests, of ecclesiastical conflicts, of attacks of the press, of temptations from the great London world."[27] It is not a retreat, but the moving center of a moving world.

Comparative Provincialism

A sly remark of Hardy's rings true: even the sprawling European plot of *The Dynasts* is provincial—when viewed from the heavens. The British tendency to center fiscal, romantic, and vocational plotting in the hinterlands stands in striking contrast to the role that bucolic interludes play even in provincially inclined Continental novels. In Leo Tolstoy's *Anna Karenina*, for instance, Levin's remarkable night spent sleeping among his peasant laborers provides a crucial benchmark. During that blissful night, Levin resolves to give up everything related to his social position and immerse himself in both rural labor and the contemplation of natural beauty.

At the very instant Levin casts his psychic lot with the peasantry, though, he hears a coach flying toward him, and in it he sees "a young girl, apparently just awakened. . . . Bright and thoughtful, all filled with graceful and complex inner life to which Levin was a stranger, she looked through

him at the glowing sunrise."[28] It is Kitty, his eventual wife, who by pure chance Levin has happened to see speeding by. With her arrival, his purely bucolic interlude ends abruptly—as it generically must. *Anna Karenina*, no matter how lovable a sidelight Levin's rural improvement schemes may be, is born from *bildung*: expect nothing less from a novel that begins with a love affair born on a train and ends with a railway suicide.

As Bakhtin's account of the provincial novel suggests, Levin's temporary retreat from his classed role offers a compact, familiar, distinctive, historically backward domain that serves as the negative space against which the metropolitan world can unfold in all its active, emergent plottedness. With a very few exceptions, in the rest of Europe the appeal of the provincial remained, like the idyll or the eclogue, a possibility glimpsed on the margins, briefly entertained and then discarded—as in this suggestive moment where Levin half succumbs to the allure of a timeless life he can never fully envision. Or worse: when Flaubert casts a cold eye on the "moeurs de province" in *Madame Bovary* (1856), the dread provincial mundanity Emma Bovary has married into is embodied in "Charles's conversation . . . flat as a sidewalk . . . everyone's ideas walked along it in their ordinary clothes."[29] Emma's only refuge from that flat, anti-cosmopolitan ordinariness is a Walter Scott-fueled Quixotism ("And you were there too, you sultans with long pipes, swooning under arbors in the arms of dancing girls, you Giaours, Turkish sabers, fezzes, and you especially, wan landscapes of dithyrambic countries") which makes Emma wish (perfect motto of the stranded provincial dreamer) "both to die and to live in Paris."[30]

The Victorian provincial novel, by contrast, is willfully centered on out-of-the-way eddies and the flotsam and jetsam that wash up in them. Life may seem to be elsewhere in Trollope's novels, but the novel takes place in the very elsewhere where life is. Think of Ang Lee's film *The Ice Storm* (1997), set in 1970s suburban Connecticut. The young, would-be protagonist of the film (who thinks he's in a *bildungsroman*) leaves his provincial town for New York in pursuit of a girl and some adventures; twelve hours later, he returns home from a series of disappointments—no girl, no stories. Meanwhile back in his hometown, where he is convinced nothing ever happens, everything—intoxication, sex, love, and death—has.

Provincial Cosmopolitanism

Victorian provincial novels do not simply proclaim that great plots happen in small places. They aim to represent what it feels like for characters (and implicitly readers) to be confined to a restricted locale—and yet

also, simultaneously, aware of an indirect connection to the currents of a greater world beyond. One way to read the provincial novel's evident anti-Londonism is to emphasize that England, unlike France and Russia, has multiple geographical centers of power.[31] However, there is also something more at play here. Matthew Arnold warns that the English are in danger of succumbing to provincialism because "we all of us like to go our own way and not to be forced out of the atmosphere of common-place habitual to most of us."[32] Yet the Victorian provincial novel point-edly inverts Arnold's logic: the most far-flung, least appealing, and most seemingly cloistered reaches of the country are its key loci, not despite but because of their "commonplace" quality.[33] You might think of the char-acters in provincial novels responding to Arnold's condemnation of their provinciality not by moving to London, but by hunkering down at home and ordering more books and journals so as to read about how cut-off and backward they are.

The relationship between provinces and larger realms (the nation, the world) is unmistakably shaped in certain ways by the neat inversion that Benedict Anderson proposes in understanding how novels make up "imagined communities": that in their depiction of a plurality of multiple locales, novels can create a nation united across vast swathes of space and time. If Mitford sees the provinces as beautifully self-contained worlds, Anderson's reading turns them potentially metonymic: the part that can also stand in for the whole, as a church stands for churches, a house for the houses of the nation as a whole. Anderson's account, though, misses a cru-cial doubled sensation that keeps recurring in these novels: the awareness that one is living at once inside a tiny world, a trivial world, caught in the middle of nowhere, and yet one is also located within the larger currents of the day, potentially locatable anywhere.

The provincial novel is built around the significantly insignificant life, a life worth remarking on *because* it is invisible, and its channels are, like Dorothea Brooke's, diffusive. In part, this simply underscores Philip Lar-kin's maxim: "Nothing, like something, happens anywhere."[34] It is remark-able how well such instances of cloistered worldliness succeed—at least inside the dream world of the Victorian provincial novel. The number of Gaskell characters who manage cosmopolitan acts of introspection and abstract cogitation—minutely inspecting leaves (Roger Hamley in *Wives and Daughters*) or beetles (Job Legh in *Mary Barton*[35])—is an important reminder that in the Victorian provincial novel every place, no matter how common, is defined in part by its uncharted edges—edges understood as trailing undiagrammably off into Belgium and Canada (Charlotte Brontë's *Shirley*) or even into the sky (Thomas Hardy's *Two on a Tower*). Those

who travel abroad clutch their copies of Gilbert White's *Natural History of Selbourne* (a late eighteenth-century work that reached a wider readership only in the mid-nineteenth century, when it became a common companion for *émigrés*[36]) in order to materialize their "home thoughts from abroad." Those who stay home, meanwhile, gaze ruminatively into terraria and Ward's boxes.

Insect contemplation, in fact, is a surprisingly useful figure with which to grasp how Victorian provincial novelists reflexively understand their own project. I made the case earlier that the era's new ways of understanding *magnum in parvo* were crucial for understanding the ways that Victorian provincial novels both acknowledged and worked beyond the way that their characters resembled, as Mitford had put it, "ants in an ant-hill." Accordingly, when a microcosm appears in these novels, it is worth considering not just what such a metonym means to readers but also what it seems to mean to the characters themselves. Thus in *Middlemarch*, just before her climactic scene with Rosamond, we find Dorothea "dilating with Mr. Farebrother on the possible histories of creatures that converse compendiously with their antennae."[37] The two conversations— Dorothea's talk with Farebrother while her mind is truly occupied with her coming talk with Rosamond, and the conversation going on between the insects whose little world looms mysteriously below—resonate curiously with one another. Readers are privy to Dorothea's effort to divert herself from private miseries by envisioning another world that lies somewhere just beneath the limits of her myopia.

If the epigraphs in *Middlemarch* are hooks that lift characters up out of their narrow neighborhood, allowing readers to reimagine the novel's social world as if it were a Renaissance play, the compendious conversations of the insects suggest that looking down is another way to shift scales. Both raise the possibility of a life that is coterminous with one's own and yet phase-shifted so as to be only semi-present. A melodramatic tableau looms for Dorothea: both she and her readers can predict (incorrectly, it turns out) just the sort of well-worn plot that awaits her. Instead, what she calls the "social spirit" leads her to talk insects with Farebrother and soil conditions with "old Master Bunney."[38] Like lifting our eyes up to the epigraph, these downward glances to earth and insects propose that the affairs of our local world can be reassessed by approaching them from a different sort of perspective altogether. Is it time, then, to reclassify Edwin Abbot's *Flatland* (discussed further in chapter 7), with its satirical account of characters incapable of grasping the truth about the three-dimensional solid moving through their planar world, as the ultimate Victorian provincial novel?

Such glimpses of a different set of axes or a new vantage point on distant worlds—glimpses that nonetheless permit characters to continue their old provincial life—form a near-omnipresent element of Victorian provincial novel. Even at the grimmest moments, these shifts in vision recur: when Tess Durbeyfield teaches her brother to see the stars as worlds, "most of them splendid and sound—a few blighted," he has to look up and survey the sky in order to grasp that he and his sister live "on a blighted one."[39] This pattern of looking downward so as not to look in the mirror of one's own life, or looking upward to abstract ideals in the sky for the same reason, is one that Hardy perfectly captures and anatomizes in that coldest of climaxes to the Victorian provincial novel, *Jude the Obscure*. That novel anatomizes Jude and Sue's semi-detachment: apart or together, the two appear "gliding steadily onward through a dusky landscape of some years later leafage," always moving on, never arriving.[40] Like Father Time himself, who glides wearily over the earth as if no part of it were any different from any other, Jude is afflicted with the modern vice of restlessness.

However, the form that it takes in *Jude the Obscure* is peculiarly abstract: Jude himself strives to see every problem as a case, as the enunciation or embodiment of a general rule. Faced with the arrival of his son, Jude enunciates a principle rather than acknowledging a blood-claim: "All the little ones of our time are collectively the children of us adults of the time and entitled to our general care."[41] For Jude to reclassify the boy that way (and for the novel itself to accept the relabeling, referring to him as Father Time from this moment onward) is somehow to make his son available as subject matter for ongoing conversations with Sue.

These conversations poignantly aim toward some abstract realm of ethereal cogitation even when Jude and Sue's lives (they bake biscuit replicas of the colleges Jude once longed to enter) are defined by the direst material circumstances. Hardy is charting what it means for his characters to take local actuality (thwarted education, bad marriage, "too menny" children) and reimagine each privation as an instance of unapproachably distant universal truths. Accomplishing this—especially within a novel that had initially seemed firmly anchored in the "Wessex" that supplied the frame through which Hardy's work was nearly inevitably interpreted—requires Hardy to explore what it means to treat one's own griefs as the property of the universe. That is the crux of Jude's making (or at least striving to make) his and his family's life into a sounding board of abstract concerns, rather than a painfully contingent and personal set of experiences.

It is not that such novels simply permit the reader to establish a semi-detached relationship to this world. Rather, they *insist* upon that

semi-detachment by modeling it with the forms of attention and of quasi-removal that open up for the novels' own characters. Mitford and Bakhtin both presume that the readers of provincial novels have a voyeuristic and a detached interest in woes and gladness not their own. In *Middlemarch*, though, the implicit readerly response is modeled in the characters' own evident awareness of what it means to observe half-removed worlds: Farebrother not only immerses himself in the parliament of bugs, he also urges Lydgate to immerse himself in the microscopic world of his own work. If we never see a character looking up to the head of a chapter to observe and reflect on the epigraph under which the forthcoming actions have been gathered (though there are moments in *Middlemarch* when characters seem to quote from a chapter's epigraph, an unsettling trick), we do find characters looking downward at yet smaller worlds (e.g., Henrietta's involuntary "beaver-like notes" as she hunts for her gift from Ladislaw, a "tortoise shell lozenge-box").[42]

Eliot and Hardy are not writing in the mode of science fiction that in subsequent decades allows H. G. Wells (subject of chapter 7) to conjure up characters who "[move] out of our space into what is called the Fourth Dimension"; the mode that also allows Abbot to introduce into his *Flatland* a three-dimensional sphere who takes a brief sojourn in a world of only two dimensions.[43] Yet details like Farebrother's insect world (and Jude's biscuit colleges) signal authorial awareness that transient attachment to such microcosms entails semi-detachment from one's own milieu. Mitford's image of the world of the novel as "ants in an ant-hill [or] bees in a hive" is at once invoked and complicated (sublimated almost) in Eliot by virtue of the reflexivity that Eliot weaves into encounters with worlds that are imagined as overhead or underfoot in her novels. Characters who gaze down at microcosms in Eliot novels (think of Lydgate's scientific ambition to trace "subtle actions inaccessible by any sort of lens, but tracked in that outer darkness through long pathways of necessary sequence by the inward light which is the last refinement of Energy, capable of bathing even the ethereal atoms in its ideally illuminated space"; not to mention Eliot's arresting image of Mrs. Cadwallader as a microbe waving "certain tiniest hairlets"[44]) are themselves reflecting on what it means to be a reader gazing down on the self-contained, yet also infinitely potentiated, world of a novel.

THE IRRITANT IN OLIPHANT

The problems associated with life in a microcosm are not unique to Eliot and Hardy. My colleague's point (all Victorian novels are provincial, you

dope!) suggests that we could range far afield from Eliot and still discover not just those Moretti/Duncan criteria in place but also the turn toward semi-detachment. Creating too wide an *omnium gatherum* of Victorian provinciality might run the risk of losing sight of the particular kinds of narrative opportunity this turn opens up for Victorian writers who hew close to the core provincial problem: how is this miniature world related to the actual Victorian social realm that it at once represents and escapes from? Accordingly, this chapter concludes by focusing on another novelist of the day, one who seems considerably less conscious than Eliot and Hardy of the most self-referential aspects of novels about provincial microcosms.

The fiction of Margaret Oliphant (1828–97)—Scottish-born author of around ninety novels, as well as hecatombs of criticism and short fiction, and an astonishing autobiography—is variegated on the surface, but consistent at its core.[45] Throughout a long, complex career Oliphant persistently grappled with what she understood as the key ethical and epistemological problem of modern life: how is one to find pleasure and satisfaction in a life that is persistently defined by small demands, petty encumbrances, and the inescapable claims that one's friends, family, and neighbors lay upon one? On the one hand the social demands that her protagonists face are baffling and onerous. On the other, to step back from such duties—which generally means neglecting one's own family—is to be ethically derelict. One's choices are twofold: either find a way, usually a fiscal way, to be freed up for abstract thought and higher, nobler action; or resign oneself to doing one's unpleasant local duties to family and neighbors (Nettie in *The Rector's Family*, for example) as they arise.[46] There is no third way.

Both Oliphant's fiction and her autobiography make plain how bitterly she resents the grind, the relentless grind that social (and financial) obligations force on the would-be autonomous individual. There is an important wrinkle, however, which brings us back to the fore of the logic of semi-detachment and its potential advantages for the novelist. On the one hand, Oliphant bemoans the kind of vexing, mundane impingements of one's daily duties on characters who (like Oliphant herself, as she sketches the scene in her *Autobiography*) want only to be left alone to get some of their own (higher, worthier) work done.[47] Oliphant is the muse of irritation, the patron saint of that prickly feeling you get during minor setbacks that temporarily divert you from higher goals. On the other hand, heaven help those who actually manage to disentangle themselves from mundane demands enough to pursue that higher calling.[48] Perhaps the key not just to her *Autobiography* but to Oliphant's work generally lies her in acid depiction of George Eliot swaddled up by Lewes, free to play Lady Bountiful without the bother of walking among her people ("Should I have done

better . . . if I had been kept, like [George Eliot] in a mental greenhouse and taken care of?").[49]

Resentful as she may be of those interruptions that prevent her getting down to a higher sort of work, Oliphant resents even more those who (like Eliot) think they can simply pull clear of those roles and walk away.[50] Her attack on Hawthorne's *Blithedale Romance* puts her position beautifully: "After all we are not ethereal people. We are neither fairies nor angels. Even to make our conversation—and still more to make our life—we want more than thoughts and fancies—we want *things*."[51] Oliphant is not, though, simply embracing pure materialism in her attack on Hawthorne. She understands her characters as continuing to strive for a "life elsewhere" even as they are surrounded by those things, those blocky objects, that make life real.[52] Oliphant does not watch her characters as if they were ants on an ant-hill: she wants her readers to recognize them as human beings like themselves, both sustained and trapped by their milieu. Oliphant protagonists never have the luxury of gazing through a window at a neighbor's funeral "with the interest of a monk on his holiday tour," like Eliot's Dorothea Brooke.

In Oliphant novels, it often emerges that the ethically proper path is seemingly available for characters, but actually unattainable, because the exigencies of the present moment oblige, or seem to oblige, characters to do something that's different from the ethical fundamentally decent course they have charted out. In *The Perpetual Curate* (1864), for example, young Wentworth (the novel's eponymous, and penurious, curate) finds himself so dogged by his daily duties and by his needy relatives that he can barely hear himself think. Perpetual social incursion on his barely present private realm ensures that he will be unprepared when moments of real opportunity crop up.

Such a moment does arrive, early on. Wentworth's only hope of marrying his beloved and pursuing his vocation honorably seems to be to please his aunts, before whom he must deliver an Easter sermon. Unfortunately, his religious beliefs differ from theirs, and the sermon he prepared (not knowing they would hear it) emphasizes his High Church beliefs in ways that are sure to alienate them.[53] This is classic Oliphant irritation: the problem of proximity, the way that his aunts appear unexpectedly and press him just where he would have loved a little bit of (Eliotic) space apart. Absent such space, what is Wentworth to do?

With a sigh, he begins the sermon he knows will doom him with his aunts, since it reveals the gap between his beliefs and theirs. Yet something curious happens inside him as he speaks:

He spoke, in very choice little sentences, of the beneficence of the Church in appointing such a feast, and of all the beautiful arrangements she had made for the keeping of it. But even in the speaking, in the excited state of mind he was in, it occurred to the young man to see, by a sudden flash of illumination, how much higher, how much more catholic, after all, his teaching would have been, could he but have once ignored the Church, and gone direct, as Nature bade, to that empty grave in which all the hopes of humanity had been entombed. He saw it by gleams of that perverse light which seemed more Satanic than heavenly in the moments it chose for shining, while he was preaching his little sermon about the Church and her beautiful institution of Easter, just as he had seen the non-importance of his lily-wreath and surplices as he was about to suffer martyrdom for them. All these circumstances were hard upon the young man. Looking down straight into the severe iron-grey eyes of his aunt Leonora, he could not of course so much as modify a single sentence of the discourse he was uttering, no more than he could permit himself to slur over a single monotone of the service; but that sudden bewildering perception that he could have done so much better—that the loftiest High-Churchism of all might have been consistent enough with Skelmersdale, had he but gone into the heart of the matter—gave a bitterness to the deeper, unseen current of the Curate's thoughts.

Besides, it was terrible to feel that he could not abstract himself from personal concerns even in the most sacred duties.[54]

Discomfort with one's own actions is a perennial problem for Oliphant characters: in *The Doctor's Family* (1863), for example, both the hero and heroine are guilty of innumerable petty actions against their own moral convictions, simply because they are forced to put up with irksome family members at close quarters and at inopportune times. With Wentworth's sermon, however, the problem is more complex. We see the character realizing an inconsistency within his own actions, but one that he cannot immediately remedy—even though it would be prudent and clever for him to do so. After all, could he find the right words, he might demonstrate his beliefs were "consistent enough with Skelmersdale" that his aunts could have him appointed to the living that would give him the wherewithal to marry his beloved.

The effect of the gap between what he realizes and what he is able to say in the crucial moment is not just to make the reader aware of discrepancies

between the character's inner world of thoughts and the actuality beyond, it is to make us reflect on the ways in which unwelcome social pressure (preaching before his aunts) can be both an irritant and also the spur that he needs to push his thinking along to a higher level. This too is a problem of semi-detachment: not physical, but mental. Wentworth realizes that he could please his aunts without betraying his core beliefs. Though those thoughts run through his brain, they do not alter his words. This is not for ethical but for practical, psychological reasons. He is committed, by rote almost, to saying one set of words while thinking quite another. George Levine has described Oliphant's attention to the gap between moral order and one's "felt life."[55] Here, we could say Wentworth is aware that he could choose not to sermonize—but aware only with the part of his mind not already busy doing that very sermonizing.

Anne Banfield's *Unspeakable Sentences* follows the logic of free indirect discourse to an unexpected conclusion: that fiction charts the gap between a sentence that seems to provide an impersonal magisterial account of the world *as it is*, and those sentences that clearly provide an account only of the experience of a particular character.[56] Wentworth's split consciousness not only highlights the gap between the world as experienced and the world as it actually is, it also details what it means for a character to become uncomfortably aware that such a space is opening up.

Such scenes, in all their fraught complexity, are what led Henry James to praise Oliphant as "a talent that could care to handle a thing to the tune of so many pages." However, the way Wentworth's quandary is immediately dropped (never recurring as a site for ethical or psychological duress) speaks to James's addendum: that having raised such an issue, Oliphant will "yet not care more to 'do' it."[57] While admitting the fiscal exigencies that shaped her writing, James judges Oliphant harshly because she raises such complex ethical and psychological moments and then brings her novels to "storybook" conclusions as if those moments had never occurred. After waxing eloquent in her praise, James ultimately judges Oliphant not by the issues she raises but by her willingness to drop them: "There is a fascination in the mere spectacle of so serene an instinct for the middle way, so visible a conviction that to reflect is to be lost."[58] What James misses in Oliphant is the attention she pays to the question of just when moments of near-escape like Wentworth's can arise: not in seclusion and quiet, but precisely in the midst of the usual havoc and confusion that surround them.

James steps back and serenely judges Oliphant for yielding to exigencies. Certainly Oliphant herself judged herself for such yielding—judged

herself but also was cogent and careful about how material circumstances formed (or deformed) her writing: "All the things I seem to want are material things. I want money. I want work, work that will pay, enough to keep this house going which there is no one to provide for but me. I don't know how to stop to change, to make another way of living."[59] Oliphant's is not a world of cultured oases, but of impinging demands. Paradoxically, however, these demands turn out to be just what characters require in order to come fully to their senses.[60]

Oliphant's instinct to resolve even the knottiest complications happily, so that plot complication and psychological uncertainty vanish in a welter of good feeling, could be taken then as an indication (but not necessarily a deleterious indication) of how she understood her work, not simply as circumscribed but as actively defined by the various economic and cultural forces that James depicts as unwelcome intruders within it.[61] If she sometimes mused bitterly that her work taken as a whole is nothing more than "an infinitude of pains and labour, and all to disappear like the stubble and the hay,"[62] she also describes herself writing with "that curious kind of self-compassion which one cannot get clear of."[63] We ought to think of Oliphant's novels as sustained rather than undermined by that "self-compassion." Not only are her novels structured by the way she yields to provincial pressures, they are themselves about the lives of those who are constantly forced to yield to just such pressure.[64]

The next chapter explores in detail James's own distinctive approach to what it might mean for a character to exist in two worlds simultaneously, whether those worlds be the mind and the social realm, the realm of ghosts and of living beings, or even in his final novel, the world of the present and the past. James has the patience (as well as the affluence-induced leisure) to abide with endlessly iterated and nuanced complexities around occasions of moral choice that may look like virtually nothing in terms of palpable public action. It is not surprising, then, that he would not be kind to Oliphant's unwillingness to abide with such moments. What he overlooks is how perfectly and brilliantly representative of actual cognition is the movement of Oliphant's prose away from such moments—back into mundane social exigencies that besiege characters like Wentworth, and exigencies that Oliphant was herself besieged by and that she thought besieged her readers, as well.

Oliphant's embedded and embodied characters (remember her brief against Hawthorne: "We are neither fairies nor angels") struggle to gain small spaces from which to look down on their own lives, spaces that become visible in little moments like Wentworth's mental half-reverie during

his sermon. But those moments remain linked to and indeed directly dependent upon the social actuality that might seem to require overcoming for contemplation to take place: contemplation in Oliphant is occasioned by irritation, rather than occurring when such irritation is overcome. Taking pride (as well as self-compassion) in never herself having been granted a sanctioned space apart, Oliphant turns the rough impositions of mundane activity into the pressure that pushes her work upward.

Conclusion: Post-Victorian Provincialism

Twentieth-century British provincial novels have an utterly different range of possibilities from those this chapter has explored by way of Eliot, Oliphant, and their contemporaries. Some of Eliot's sense for the paradoxical centrality of provincial experience may still be preserved in the few opening chapters of D. H. Lawrence's *Sons and Lovers* (1913), but the absurdity of imagining there could be any true intellectual engagement in a bungalowed provincial life becomes the central comic device of E. F. Benson's *Mapp and Lucia* series (1920–39). To quote Nietzsche in the confines of Riseholme is simply to reveal risible pretentiousness, a laughable effort to align oneself with a "life of the mind" incompatible with life in the sticks. A similar refusal to admit the compatibility of the cosmopolitan and the parochial shapes the *Bovarysme* of William Cooper's *Scenes from Provincial Life* (1950; "*que je m'ennuie*" exclaims its hero to an audience of schoolboys[65]), the parodic exuberance of Kingsley Amis's *Lucky Jim* (1954; the novel's senile old villain has no higher ambition than making it onto a radio program devoted to "provincial culture"[66]), and the genteel resignation of Penelope Fitzgerald's *The Bookshop* (1978). That refusal shapes as well the 1963 film *Billy Liar*, the 1968 concept album *The Kinks Are the Village Green Preservation Society*, Kazuo Ishiguro's *Remains of the Day* (1989; provincialism deconstructed), and a thousand subsequent British high-, middle-, and low-brow restagings of what precisely is wrong with the provinces.

The starkness of the differences between such later provincial novels and their Victorian antecedents clarifies the importance of the historical developments in ideas about semi-detachment that this book aims to chart.[67] Dorothea Brooke and her Middlemarch cohort, like Oliphant's irritated, mundanely burdened curates, businesswomen, and struggling pensioners are semi-detached provincials. In both Eliot and Oliphant—despite many immense differences in their lives, working conditions, and

the novels they produced—what emerges as a perennial provincial preoc-
cupation is the same. Both explore in detail and across a wide range of
characters, wrapped up in distinctive subjective experiences, what it means
to be half-engulfed in daily cares, and half-aware of the forces at work
elsewhere in the great world, which might offer one a different kind of
outlet if things were only slightly different.

Eliot's account of provincial life and thought runs in a somewhat hap-
pier vein, but operates according to the same ground rules. If *Middle-
march* ends with Dorothea's commitment to the invisible diffusive cur-
rents that link her to her neighbors, its other axis—the epigraphs that lift
us away from Lowick to an imagined Renaissance scene, the spiritual half-
parallels that make Dorothea simultaneously like and unlike St. Theresa,
and the insect kingdoms that open beneath her feet—works to remind us
that the provinces are in fact like the distant world to which their inhabit-
ants aspire: they are like that world, that is, precisely in being unlike any
other place. In their dislocation, their location; in their provinciality, their
cosmopolitanism.

5

Experiments in Semi-Detachment

Sensible Distributions

The previous chapter explored the rise of self-referential literary representations of the experience of semi-detachment—of what it means to be caught up in a moment but also capable of pulling oneself away from that moment to reflect upon it. Framing the problem of fictionality's appeal in that way enabled authors of provincial novels to explore the immanent provinciality of their readers—the way in which every reader might understand him or herself as at once at the center of their own world and also right out at the world's edge. Working forward from the mid-nineteenth century to the early twentieth century, from Dickens through Eliot to James, this chapter moves from simple formal problems turning on the representation of inner and outer lives to subtler challenges that relate to the self-awareness of writers, of readers, and finally even of characters about what it means for attention to be temporarily suspended within the world of a novel.

If semi-detachment comes to look like an answer in Victorian fiction, it is crucial to know what the question is. What problem might be resolved by thinking of the experience of life inside the mimetic word of the novel (or life in one's own social actuality for that matter) as a semi-detached one? One way to begin getting at the tangled question of the novel-world's believability, or the ways in which readers suspend disbelief to make sense of and enter into that world, is to link this investigation to the vexed question of whether we should think of aesthetic experiences as the product of an artist's creation or an audience's apprehension. It may seem tempting to approach that as a chicken and egg question (neither without the other), but Jacques Ranciere's recent interest in the "distribution of the sensible" offers one avenue of approach. Ranciere proposes revisiting some of the core conundrums of European aesthetic theory in light of who is implicitly or deliberately included as the potential addressee of the art. He denounces all accounts of aesthetics that presume the existence of a *sensis communis* defined by shared exposure to thought or feeling-provoking stimuli.[1]

In some ways, Ranciere aims to extend Dickens's account in *Hard Times* of Mr. Sleary's circus as a site simultaneously of entertainment for those who pay and of work for those who, being paid, are deprived the aesthetic experience of the artwork they themselves produce ("People mutht be amuthed, Thquire, thomehow. . . . I've got my living out of the horthe-riding all my life").[2] My Friday night is, inescapably, someone else's Monday morning.[3]

There is however another intriguing wrinkle to Ranciere's account, an attack on what he parses as the ossified nineteenth-century distinction between the space of labor and that of truly free aesthetic contemplation. He proposes finding a way to conceive of the aesthetic realm that will restore workers as well as idle consumers to *doubleness*.

> The democratic distribution of the sensible makes the worker into a double being. It removes the artisan from "his" place, the domestic space of work, and gives him "time" to occupy the space of public discussions and take on the identity of a deliberative citizen. The mimetic act of splitting in two, which is at work in theatrical space, consecrates this duality and makes it visible. . . . The aesthetic regime of the arts disrupts . . . apportionment of space. . . . It brings to light, once again, the distribution of occupations that upholds the apportionment of domains of activity. . . . Schiller's aesthetic space, by suspending the opposition between active understanding and passive sensibility, aims at breaking down—with an idea of art—an idea of society based on the opposition between those who think and decide and those who are doomed to material tasks.[4]

Ranciere touches here upon audience members' capacity to be semi-detached from their own laboring bodies. This way of thinking about what aesthetic experiences have to offer differs both from liberal complacency about the universality of aesthetic experiences as a withdrawal from the demands of work and from Lukacsian accounts of a proletarian experience shaped entirely by work.[5]

One way of making sense of that doubleness is to notice that within Victorian realist novels themselves this problem of double engagement with the world is already explicitly under discussion. This chapter concludes with a look at Henry James's complex coils of self-referentiality around the question of where the reader's attention is understood to be located while reading a novel. It is however possible to approach the question of "distribution of sensibility" even in the more putatively straightforward, representational realm of the midcentury realist novel.

Half a century before James's experimental gyrations, Charles Dickens's *Our Mutual Friend* makes visible a problem that the Victorian realist novel returned to repeatedly: how to tell the story of moments when thinking and acting occur simultaneously, but have to be represented sequentially.

There are myriad ways this dichotomy can be staged so as to generate a vision of utter separation between the crass material world and the higher realm into which mental reverie places one. Many modernist novels certainly stage an explicit tradeoff between aesthetic reverie and worldly engagement. Joseph Conrad's *Lord Jim* sets the pattern in place from the start: what Jim loses by sneaking belowdecks to read about nautical adventures turns out to be precisely the chance to have a nautical adventure. "In the babel of two hundred voices he would forget himself, and beforehand live in his mind the sea-life of light literature. He saw himself saving people from sinking ships." But when the call comes from above, and Jim stumbles blinking into the light of day with the chance to perform a rescue rather than read about one, he "stood still—as if confounded."[6] Precisely because he is immersed in fantasies, he can do nothing to realize them. Here the tradeoff between fantasy and action is made entirely bald: Jim cannot rescue because he is dreaming of rescue.

The contrast could hardly be greater between *Lord Jim* and the moment in *Our Mutual Friend* in which Lizzie Hexam (the beautiful boatman's daughter) has to spring into action to rescue a drowning man. Dickens splits a single moment into two: first, a long paragraph recording the prayer that she utters, and second, the description of the actions she has been taking to save a man while she mentally prays.

> Following the current with her eyes, she saw a bloody face turned up towards the moon, and drifting away.
>
> Now, merciful Heaven be thanked for that old time, and grant, O Blessed Lord, that through thy wonderful workings it may turn to good at last! To whomsoever the drifting face belongs, be it man's or woman's, help my humble hands, Lord God, to raise it from death and restore it to some one to whom it must be dear!
>
> It was thought, fervently thought, but not for a moment did the prayer check her. She was away before it welled up in her mind, away, swift and true, yet steady above all—for without steadiness it could never be done—to the landing-place under the willow-tree, where she also had seen the boat lying moored among the stakes.[7]

The reader sees what she sees, then enters her thoughts, then learns what she does. On the one hand, Lizzie's body gets instantly to work because "her old bold life and habit instantly inspired her," but on the other hand, in a free indirect discourse that is pointedly *not* put into quotation marks, she is overheard delivering a paragraph-long prayer. Readers cannot handle the rush to the oars and the prayer to the Lord simultaneously. Lizzie, though, has what might be called parallel processing capacity. She can be in two states at once; a fact readers know only because the narrator takes the trouble to spell out the overlapping temporality of two paragraphs readers have experienced serially.

As in those examples from *Jane Eyre* and *The Mill on the Floss* discussed in the previous chapter, there arises here a split within the novel's own strategy for what might have been called verisimilitude, or truth to life, or even realism; a palpable disjuncture that required readers to think in two radically dissimilar ways about the representation that was laid out before them; or even, you might want to say, to locate themselves in two places at once in relation to that world. What might seem like a formal *problem* with fiction, a lapse in its mimetic ability, is actually flipped around into a strength of the novel. The marked seriality with which the reader experiences Lizzie's simultaneity suggests that Lizzie's training and moral sense combined allow her to handle at once what the reader is required to handle consecutively.

A recent article on revision in *David Copperfield* analyzes the insertion of metaleptic moments of retrospection, for example, the famous addition of an early passage asking whether "it would have been better for Little Em'ly to have had the waters close above her head that morning in my sight."[8] That account emphasizes the ways in which the reader can gain access simultaneously to an experiential present and the as-yet-undisclosed future. My account of the split between an account of Lizzie's actions and her thoughts emphasizes the attention Dickens pays to *immanent* disruptions in temporality—that is, the impossibility of sustaining a sense of thought and bodily action simultaneously.

Ranciere has in mind aesthetic experiences that serve to fracture the location of the worker, turning work into both a site of activity and of potential contemplation that undoes or indeed redefines the act of working itself. However, his idea of aesthetics as "disrupt[ing] the apportionment of space" illuminates the ways in which Lizzie is at once inside and outside of her mundane work environment. The work of novels like Dickens's, then, can be understood both as *distracting* the reader and (as in the passages previously cited) as making sense of that very same distraction.

FREEING INDIRECT DISCOURSE

Bender and Marrinan have recently argued for the emerging early nineteenth-century importance of

> those novelistic instances of free indirect discourse where subjective and private internal states are represented impersonally as if present to external perception. Impersonal, third-person grammar produces an effect of mental presence without narrative, analogous to the raw data of physical phenomena produced by recording instruments.[9]

This impersonal subjectivity produces a "now in the past" moment within fictional discourse that Bender and Marrinan see as comparable to the sort of conjectural interpolation of a readerly presence that is evident in the scientific diagrams of Diderot's *Encyclopedie* (1751–72). Brewer and Marrinan want to locate nineteenth-century novels as part of a project—as much epistemological as aesthetic—to make sense of a world where "limits of human perception" can come to be modeled by way of a series of experiments that measure what can be captured and conveyed on white pages intermittently blackened by print. The novel is placed, in their reading, alongside a range of scientific publications, as a particular kind of "working object" in a larger culture of observation and experimentation.

There is much to be learned by asking what new vantage points are gained when free indirect discourse becomes part of the standard novelistic armamentarium. The relationship between implicit mental states of characters and the implicit stance of the reader can vary enormously, with the result of a highly differentiated range of possible standpoints from which a reader can appraise the scenes as they actually occur and as they are experienced by various participants. Consider, for example, how Jane Austen conveys Harriet Smith's excitement at meeting Emma Woodhouse:

> Miss Woodhouse was so great a personage in Highbury, that the prospect of the introduction had given as much panic as pleasure; but the humble, grateful little girl went off with highly gratified feelings, delighted with the affability with which Miss Woodhouse had treated her all the evening, and actually shaken hands with her at last![10]

Attending to what free indirect discourse adds to the novel's range here means stressing the reiterative structure of "grateful" and "gratified feelings," which hints at the gap between the impersonal narrator summing up Emma's reputation at the beginning of the sentence and the flood of feelings (culminating in the jubilant exclamation point) that occupies the sentence's end. Yet such a reading would also have to find a way to

accommodate the persistent line the text draws between reportage and "raw data" even at the moments when subjectivity seems most on display. The exclamation point at once marks Harriet's joy and encourages the reader to assume a sardonic distance.[11]

This kind of back-and-forth offers a way of registering the relationship between individual consciousness and the overall social habitus that critics have not always given its due. For the realist novel, Lukacs argues, "man is a social animal" whose "individual existence . . . cannot be separated from the social and historical environment." Within the realist novel,

> solitariness . . . is always merely a fragment, a phase, a climax or an-
> ticlimax, in the life of the community as a whole. . . . Solitariness is a
> specific social fate, not a universal *condition humaine*.[12]

By contrast, man, for modernist writers, "is by nature solitary, asocial, unable to enter into relationship with other human beings. Man may establish relationships . . . only in a superficial, accidental manner."[13] Once this modernist (post-realist) writing loses its capacity to align social context with the experiential shape of individual experience, any reliable connective logic vanishes.

Here, I make the case that Eliot's fictional experiments, building on the rise of free indirect discourse but exploring the recursive implications a step further than her predecessors, suggest the need to revisit Lukacs's account of the gulf he perceives between socially anchored realism and its subjectivist successors. The role of free indirect discourse in Eliot's novels (*Middlemarch* especially) and the principles of characterization that shape her final book, the generically odd *Impressions of Theophrastus Such* (1879), show Eliot experimenting with, refining, and altering the sorts of fiction-induced semi-detachment that earlier chapters of this book have traced. The result is a novelistic form that fits neither Lukacs's notion of a realism, which depicts individuals located in their "knowable communities" (to borrow a phrase from Raymond Williams),[14] nor his notion of a modernism that dissevers a character's temporal, spatial, and concrete links in favor of what he labels "abstract potentiality."

VIEWPOINTS

Raymond Williams argues that Eliot's "critical realism" is ultimately characterized by "withdrawal from any full response to an existing society."[15] Eliot, though, is grappling with a new set of concerns that shape the mid-Victorian novel as they had shaped predecessors like Scott and Austen.

Henry James's notion of Eliot as an expert in creating characters who are "solid and vivid in their varying degrees" suggests one way to understand the investigations her novels make possible.[16] James's formulation points to what we might think of as the Eliotic interest in *variable solidity*—characters who are present in all their knotty particularity in one moment and seem nothing more than a metonym for a general class in the next. One of Eliot's distinctive achievements as a novelist is her capacity to "scale" her characters in this way, to present them as they appear at a given moment to a particular observer. Thus Celia can one day seem to Dorothea nearly an extension of herself. Yet on the next day, informing Dorothea that Sir James is in love with her, she can appear to Dorothea as the repellent personification of the small-minded world: "How can one ever do anything nobly Christian, living among people with such petty thoughts!"[17]

Eliot takes evident pleasure in playing out the various ways in which a character can switch roles in the eyes of other characters—or of the reader. What seems worth stressing about all the ways that Eliot varies the viewpoint, however, is that they depend upon the novel's capacity suddenly to shift not just direction of gaze but even axis and orientation. The novel's art may be to conceal its artifice, but (as Eliot herself suggests in her 1868 "Notes on Form in Art") elaborate infrastructures of tacit knowledge nonetheless underlie what looks like an effortless move in the narratorial standpoint. Eliot approaches the problem of how such shifts can and should occur with a subtlety that noticeably increases throughout her career.

For evidence of how much changes between *Mill on the Floss* and Eliot's later fiction, consider an early scene from *Middlemarch* in which Will comes to visit Dorothea, a scene that positions the reader in several highly unexpected and original ways in relationship to each character's viewpoint. As the scene begins, Will has successfully plotted a way to see Dorothea alone:

> "Sit down." She seated herself on a dark ottoman with the brown books behind her, looking in her plain dress of some thin woolen-white material, without a single ornament on her besides her wedding-ring, as if she were under a vow to be different from all other women; and Will sat down opposite her at two yard's distance, the light falling on his bright curls and delicate but rather petulant profile, with its defiant curves of lip and chin.[18]

The first half of this sentence is presumably from Will's viewpoint: not only because it locates the brown books behind her, thus establishing an angle from which Dorothea is seen, but also because Will (like the

narrator, perhaps, but presumably unlike Dorothea herself) is unable to specify what that woolen-white material might be. The second half is just as clearly from Dorothea's viewpoint, delineating Will's profile and conveying to the reader not just Will's good looks but also Dorothea's attention to them.

The result of that highly personalized account of looking is not immersion in one viewpoint, but an extremely odd pivoting of the viewpoint into something like a common consciousness.

> Each looked at the other as if they had been two flowers which had opened then and there. Dorothea for the moment forgot her husband's mysterious irritation against Will: it seemed fresh water at her thirsty lips to speak without fear to the person whom she had found receptive; for in looking backward through sadness she exaggerated a past solace.[19]

Each looking at the other as a flower is straightforward, but "two flowers" is something else: the plural form poses a serious discursive problem. After all, neither Will nor Dorothea can be thinking of two flowers; each has only one flower (one profile, one woolen-white dress) in mind and sight. Only the narrator can bring us each appearing to the other as a flower.

That mutuality is rendered fragile partly by the fact that each must be a flower in the other's eyes, and yet also remain a person seeing the other as a flower. As soon as the effect is defined as shared, moreover, the axis of perception shifts; the floral perception also becomes individuated, and in a way that drives a wedge not only between the two characters but also between the characters and their own past experiences as they recollect them. Dorothea gazes as she does at Will because he has been "receptive," but the narrator reminds us immediately that in fact she has misremembered because of her sorrow since; she has "exaggerated a past solace." The exclamation point in Austen functions as a nuanced signal that the narrator has a viewpoint distinct from Harriet Smith's juvenile glee; Eliot, though, is willing to spell out explicitly not only the feeling that Dorothea has but also its mistaken roots. Eliot is concerned with establishing what it means to see things *from somewhere* but also to underscore the history behind the particular viewpoint from which sense-claims are made.

Middlemarch took on its final form (the merging of two pieces of fiction that Eliot had been working on separately) when characters antipathetic to one another were forced into contiguity and coexistence. As Welsh points out, the "first chapter [of *Middlemarch*] drafted with something like the final design in mind" is the election scene where Lydgate

casts a vote against Farebrother. The resulting "network of circumstances, opinion and individual motives over time" results in "an intertwining of alien modern beings" such as Bulstrode and Lydgate.[20] One way to think about that suturing together of distinct plots would be to analogize it to the pseudo-interpolated tales that (I argued in chapter 1) are crucial to how Victorian realism operates. In each case, seemingly distinct stories are revealed as part of one big baggy world after all—while nonetheless remaining marked as distinct from one another.

Alongside that forced contiguity of unrelated plots in the same space and time, we also ought to note in Eliot a different kind of pressure: the discrepancy that arises even between characters' current and past feelings. One result of that discrepancy not only between persons but even within one person's consciousness is that memories, even at such moments of intimacy, are inherently unreliable—as when readers are reminded by the narrator that Dorothea "exaggerated a past solace."

The net effect of that intersubjective and intrasubjective shimmer is that every event, no matter how slight, comes to the reader with epistemological uncertainty attached to it.

> "I have often thought that I should like to talk to you again," she said immediately. "It seems strange to me how many things I said to you."
>
> "I remember them all," said Will, with the unspeakable content in his soul of feeling that he was in the presence of a creature worthy to be perfectly loved. I think his own feelings at that moment were perfect, for we mortals have our divine moments, when love is satisfied in the completeness of the beloved object.[21]

The "two flowers" that Dorothea and Will see in one another are the perfect exemplification of the challenge the novel always takes on—not to provide definitive "raw data" on the subjectivity constituted by an event, but to struggle to make sense of what different things a single event may mean, and then continue to mean, to people who briefly share a space but who also then have to move onward with their lives.

Such passages signal something highly distinctive and ultimately influential about Eliot's ways of representing her characters' thoughts, a shift in available levels and vantage points, so that the narratorial movement out of the consciousness of Will and Dorothea leads readers to reflect as well on the nature of the consciousness that focalizes their experiences. Not just as a tricky narrator (who rests his arms on a bridge and an armchair simultaneously) but as the placeholder for some kind of detached viewpoint

on one's own life: the "I" who thinks that Will's feelings were perfect is perhaps something like the "I" who tries to look at one's own life from a partial remove.

MAGIC PANORAMAS, FOCAL SHIFTS

In what we have seen so far, perspective has changed, but the temporal axis has remained untroubled: Dorothea's memory of her past is wrong, but the narrator is there to set it right. However, Eliot's characters are constantly trying to make sense of their place with regard to their past and future selves as well as their present one. Like people in the real world, characters find themselves with only limited access in either direction: the past is a fixed quantity (albeit with edges that shift as pieces of it become visible to oneself or to others), while various possible futures necessarily branch out from the present.[22] Yet the contingency of such plausible future outcomes does not prevent characters from looking toward their futures in many of the same ways as they look into one another's lives. The subtlety with which Eliot reckons with such forecasting of contingencies signals an innovation: her novels concern themselves not simply with possible outcomes but also with what difference it makes to people to live their lives precisely by concerning themselves with possible outcomes. When "destiny stands by sarcastic" it is not just *"dramatis personae"* but also future actions that remain "folded in her hand."[23]

For example, after the melodramatic "discovery" scene in which Dorothea finds Will with Rosamond, he is moved fatalistically to contemplate his future fate. Lydgate and Will both at this moment seem to be slipping into a miserable future caused by provincial exigencies, social tyranny, and the particular brand of *bovarysme* that Rosamond has inflicted on them. Still uncertain of the eventual result of all this, the reader, like Will, fears the worst. At this dark moment, Eliot depicts Will providing a narrative template within which all that has happened can be fitted into that plausible worst-case outcome.

> It seemed to him as if he were beholding in a magic panorama a future where he himself was sliding into that pleasureless yielding to the small solicitations of circumstance, which is a commoner history of perdition than any single momentous bargain.[24]

Understanding what it means for Will to forecast his future based on the glimpses he has from the present involves grasping both Will's capacity

to forecast and the danger that can arise from taking a forecast as something more than the illumination of one possible pathway. The narrator casts Will's mistake in moral terms: "We are on a perilous margin when we begin to look passively at our future selves."[25] (Mr. Ladislaw, we might say, is acting as if he lacked Will.) The road leading from this "magic panorama" does not actually lead Will to perdition: in fact, if anyone in the novel treads that path, it turns out to be Lydgate.

This scene's capacity to help Will forecast his future based on present circumstances also raises the possibility that there is an implicit antidote to such magic-panorama thinking. After all, *Middlemarch*, too, offers us some glimpses of what it must be like to be ourselves, or to be people close to us, at crucial moments in our life. Viewing the state of these characters, we view ourselves at a partial remove; just as Will steps back here, puts together the pieces, and tries to figure out in what direction his narrative tends, conjecturing a life of Lydgate-like failure. By charting the various ways in which characters look toward things that may yet come to pass (and to do so in essence by gazing inward), the novel, unlike the magic panorama, allows readers to catch sight of a series of hypothetical, or virtual, worlds.[26]

Chapter 6—a Visual Interlude centered on the use William Morris made of the magic lantern in designing Kelmscott Press books—explores in detail what exactly novelists might have had to fear or envy in new technologies of visual projection and illumination. Here, it is enough to note that Eliot invokes the counterexample of the magic panorama—like the "images which succeed each other like the magic-lantern pictures of a doze" during Dorothea's moment of sublime disorientation in Rome—in order to clarify a capacity of the novel by contrast to a conceptual deficit in what visual technologies have to offer.[27] She sees the capacity to hypothesize about future outcomes—to see in one's mind a set of pictures that may or may not apply to oneself—as a mechanism that in fact returns the solitary dreamer to a social world. Even if that dreaming never itself finds a social outlet, the very fact of hypothesizing about how one's path may or may not resemble paths traveled by one's contemporaries is an attempt to make sense of oneself through their fates and of their fates through one's own possible futures.

Lukacs suggests that the modernist novels err by grounding their accounts of the human experience in solitude and neglecting the inevitable sociability of human interaction. Eliot, however, is already grappling with a subjectivity that, though formed out of a social self, struggles intermittently or continually to retreat from that social world. Sociability

hinges on particular personages who have to be acknowledged in all their distinctiveness—which also means that the work of the novel is to find ways to approach them in their prickly idiosyncrasy, their inherently unsympathetic distinctiveness. Like the narrator in *The Mill on the Floss*, such characters belong both in the social world of the novel and also back inside some hermetically sealed space. Like the Oliphant characters discussed in chapter 4, they are at once irritated by the necessity of leaving solitude for social life and brought to life by just that obligatory semi-detachment.

> One morning, some weeks after her arrival at Lowick, Dorothea— but why always Dorothea? Was her point of view the only possible one with regard to this marriage? I protest against all our interest, all our effort at understanding being given to the young skins that look blooming in spite of trouble; for these too will get faded, and will know the older and more eating griefs which we are helping to neglect.[28]

This memorable rupture renders visible the tacking required in order to form a sense of the world that will be not only consistent (a single character's viewpoint could be consistent) but also complete and persuasive. Even the notion of the imagination-engendered mirror introduced in Adam Smith's *Theory of Moral Sentiments* (that we know other's feelings by imagining ourselves inside their bodies) might seem a sufficient mechanism to force readers to put themselves in faded as much as in blooming skins. In that sense, this paragraph may initially seem structurally comparable to chapter 41 in *Emma*, which leaves Emma Wodehouse to focalize through Knightley entirely. However, a reading that saw this passage only via its links to past ways of managing viewpoint in the realist novel would fail to account for the force of the interjection itself. The surprise, the rupture that it adduces, marks the narrator's surprise, even perhaps a slight sense of shame, at her own way of narrating. Without that first, suspenseful half-sentence that found Dorothea about to do something (what she is in the middle of doing is never revealed to the reader) this turn toward Casaubon would be entirely different.

The gaps Eliot labors to describe are discernible in various directions, even in these brief passages: between characters who only guess at what they see in one another; between the narrator and characters who still conceal even from that narrator some vital aspects of their selves and thoughts; between characters and their own pasts; and the culmination of all such gaps, between what can be known inside the world of the novel and what readers can know of these characters from outside. It is not that

any one of these categories is the definitive index of how the Eliotic narrative handles the problem of other minds; rather, they comprise the whole array of problems Eliot presents as the logical outcome of an admirable but ultimately circumscribed effort to use fiction to form definitive judgments about characters, or about people in the world.

SEMI-DETACHED FICTIONALITY IN *THEOPHRASTUS SUCH*

The challenges posed by sudden shifts from one viewpoint to another also play a crucial role in *Impressions of Theophrastus Such*. That work is Eliot's final set of experiments with the ways in which understanding—of self, of others, and of fictional characters available only through a textual world—can fail. Especially in "Looking Inward" and "So Young!" Eliot tests the limits of knowledge about others by exploring sites at which a social environment begins to shape what looks like the closed inner world of character formation. The book's opening sentence contains its crucial question:

> It is my habit to give an account to myself of the characters I meet with: can I give any true account of my own?[29]

Here the "habit" of giving an account "to myself" of the characters I meet suggests that the question of whether I can give an account of my own (also to myself?) reveals how inward-looking the practice of narrative description has become. Equally habitual, too, has become the necessary self-revelatory disclaimers that are required to ground the sketches that will follow.

> I am a bachelor, without domestic distractions of any sort, and have all my life been an attentive companion to myself, flattering my nature agreeably on plausible occasions, reviling it rather bitterly when it mortified me, and in general remembering its doings and sufferings with a tenacity which is too apt to raise surprise if not disgust at the careless inaccuracy of my acquaintances, who impute to me opinions I never held, express their desire to convert me to my favorite ideas, forget whether I have been to the East, are capable of being three several times astonished at my never having told them before of my accident in the Alps, causing me the nervous shock which has ever since notably diminished my digestive powers.[30]

This second sentence, with all its odd trailings-off and unexpected turns ("surprise" and "disgust" seems at first to refer to his friends' view of Theophrastus, only to be revealed as the reverse), charts the ways in which

characters are constituted not just from the inward out nor solely by their public appearance in the world, but by the internalization of the outward into the inner, so that what others think of us becomes a significant portion of our inner lives.

This is also the problem at the center of a short later chapter, "So Young!" That piece turns on the way that an *enfant terrible* "Ganymede" has lost touch with what his public actually thinks of him—lost touch because he remains wedded to a conception of himself as a talent known mainly for his remarkable youth. The central point of "So Young!" is about the quality that Eliot in other contexts refers to as the "inwrought"; that is, the set of exterior sensations that over a time are drawn into one and, for good or ill, come to shape one's experience. As a young man, writes Theophrastus, Ganymede was "only undergoing one form of a common moral disease: being strongly mirrored for himself in the remarks of others, he was getting to see his real characteristics as a dramatic part, a type to which his doings were always in correspondence."[31]

The result is that "Ganymede's inwrought sense of his surprising youthfulness had been stronger than the superficial reckoning of his years and the merely optical phenomena of the looking-glass," even when his age and body type have changed so much that "a stranger would now have been apt to remark that Ganymede was unusually plump for a distinguished writer, rather than unusually young."[32] The writer who continues to be "so young" in his own mind after he has become objectively old and principally plump in the eye of the beholder is an instance of the person for whom what is "wrought back to the directness of sense" is of no benefit in making sense of those around him. Self-awareness is here understood as a problem that hinges upon one's capacity to feel oneself present as it were on both sides of the glass at once: looking out at the world through this face, and looking in on oneself by way of it. To imagine the face as youthful (or as plump) is to conceive it from two sides at once.

The introduction discussed the implicit doubleness of Ford's image of the brightly lit glass: it both reflects what is behind one and also allows one to peer through it into the world beyond. Eliot's version of the half-silvered, or half-reflective, glass is the question of one's *person* and one's *persona*. How does the youthfulness or the plumpness of Ganymede matter? As it really is? As I apply either label to myself? As those around me apply it to me? Indeed, even the name Ganymede itself is a fictional sobriquet, one of these real-life fictions out of which actual lives are constituted: is Ganymede a moniker attached to him by the narrator, or does it exist in his own social world?

There is no end to such recursion once it has begun; this is the insight *Theophrastus Such* pursues. Its spirals—those complex turns and twists that deny *Theophrastus Such* the designation of novel though it is clearly fiction—shed light on the ways that Eliot's earlier fiction, too, resolves around such comparison between one's inward vision of oneself and one's public character. The argument in the remaining third of this chapter credits James—especially on account of his masterful use of free indirect discourse—with a peculiarly subtle awareness of the way gaps open up between what I perceive myself to be (first-person perspective) and what others make of me (third-person perspective). James's subtlety notwithstanding, free indirect discourse is just one weapon novels have in approaching a problem of keeping one's experiential interiority and one's social actuality congruently related to one another, despite one's awareness of the enormous gap between experience and actuality. We should not forget, however, that the problem of squaring the external conceptions of oneself with the inward ones—and recognizing the discrepancies that such attempted squaring produces—is an important one to Eliot long before she turns to the not-youthful, perhaps-plump Ganymede. In *Theophrastus Such*, Eliot is not so much uncovering new ground for fiction as exploring the implications of the ground that her novels had already mapped out.

When Robert Merton decided in 1960 that science's best hope for anatomizing subjective experience lay in an "introspectometer," which could measure not the facts but the *experience* of a modern life, he traced that machine's lineage not to the electron-detecting cloud chamber nor the seismograph nor even the stethoscope, but the modernist novel. Merton was convinced that only James Joyce had come up with a mechanism for recounting the ordinary experience of someone whose subjective experiences would in ordinary life remain a profound mystery to everyone not dwelling inside their skull. Merton's conception of such a novelistically underwritten introspectometer helpfully lays bare a certain modernist aspiration: to make inward thoughts, understood as existentially individual in nature, externally shareable.[33]

What might such sharing look like? In his introduction to John Ruskin's *Sesames and Lilies*, Marcel Proust proposes that mere physical meetings are in crucial ways inferior to encounters mediated through reading alone.

Reading, contrary to conversation, consist[s] for each of us in receiving the communication of another's thought, but while we remain all alone, that is to say, while continuing to enjoy the intellectual power we have in solitude, and which conversation disperses immediately.[34]

Reading calls into being an alternative universe, doomed to disappear or shrink to a few square inches when the book ends.[35] In Proust and Woolf as much as in James, the subjectivity effect within a text never leads to pure temporal flux. The falls into flashback or jumbled *hysteron proteron* begin somewhere in the reader's actual world. In Virginia Woolf, too, two warring tendencies tug at the novel. They often appear as a war between the present (at least partially shareable, as the intermittently legible skywriting and the universally audible booms of Big Ben suggest) and the recollected past, which interjects an inescapable subjectivity into any moment's sensations. Mrs. Dalloway's exasperation with her own memorializing tendency epitomizes the tension perfectly:

> She remembered once throwing a shilling into the Serpentine. But every one remembered; what she loved was this, here, now, in front of her; the fat lady in the cab.[36]

Mrs. Dalloway's dismay when forced to choose between past and present is in some ways as distinctively modernist as is the capacity of Marcel in Proust's novels to flicker from place to place and time to time like a magic-lantern show, with recollections and a sense of time dependent on an always internally preserved, paratactic logic. However, there is a far greater debt owed by such experiments than is often acknowledged to the palpably experimental semi-detachment Eliot is perpetually refining in her writing. The similarity between Woolf here and George Eliot's depiction of characters' uneasy meditations on their partial or imperfect view of the world they share with others suggests that Lukacs underestimates the *rapprochement* between mid-Victorian and early modernist aesthetic ways of conceiving of the force that the external world manifests in a modernist novel.

The problems of mutual regard in *Middlemarch* and the problems of deformed or temporally disjointed self-regard in *Theophrastus Such* show that Eliot understands characters in her novels as a series of limited vantage points onto a world that the reader comes to know through a mixture of third-person axioms and first-person observations. Novels that seem to offer the possibility of an impartial and complete third-person vantage point always contain hints of the arms cramped by watching; the flower into which beloved faces are transformed always contains a hint of the peering eyes, the fading skin, beneath. From the numb forearms of *The Mill on the Floss* to Theophrastus's admittedly incomplete attempts to understand his own character through an investigation of others, Eliot's aesthetic enterprise is predicated on the implications of living in a world

where everyone is making imperfect inferences, not just about the lost past and the imperfectly foreseen future but also about how the present world appears from others' vantages. Flowers everywhere.

HENRY JAMES'S RAT-TAT-TAT-AH

Henry James discerns in Eliot a way to preserve from the realist novel a commitment to a shared public world coupled with an attunement to the way that the characters who share that world often, like Bulstrode, are haunted by images that rise before their eyes, temporarily blocking out an otherwise common reality. James's understanding of the novel's capacities precisely arises from his effort to account for that ongoing sensation of partial detachment from and ultimate return to a current reality.

In James's account, especially late in his career, there are almost infinite variations on the play of analogies by which a reader reconciles the experiences depicted within a book and those that a reader actually has when reading that book. Unlike other genres, James asserts in the New York edition preface to *The Ambassadors*, novels at their most "elastic" and "prodigious" are a mixture of the "dramatic" and the "representational" and their representational successes are made up of "disguised and repaired losses" and "insidious recoveries."[37] James's aesthetic credo helps clarify the significance of his praise, many decades earlier, for the "varying degrees of solidity" in Eliot's characters. James's late novels create characters neither entirely removed from nor entirely immersed in their social and physical surroundings. James's distinctive use of free indirect discourse and the shifting focalization that accompanies it produces a fascinating uncertainty about where and when a particular sentence is produced: uttered, thought, or written down. That uncertainty is tellingly signposted not just in *The Ambassadors* and its preface but also in the dictated notes that accompany James's 1915 revisions to his never-completed final novel, *The Sense of the Past*.

In the James passages that follow, three sorts of semi-detachment, each with an attendant set of possibilities, are discernible. One is the mental dislocation that allows reverie and social interaction to coexist. Another is the play of reported and inferred speech that underscores the semi-dislocation that is involved when characters are shown inferring other's thoughts and intentions. A third explores James's use of warped onomatopoeia to highlight the reader's relationship to the "happy semblance" that words in a realist novel are committed to produce. Taken together, these three

instances allow us to reconstruct James's intention of making the reader attend to the partial dislocation and deceptive reorientation that the reading experience itself can produce.

(HALF) BEING THERE

James's interest in the way in which a character's thoughts can be divided between present social realities and some kind of interior space with quite different properties can be grasped by returning to the passage from *The Ambassadors* (1903) I discussed in the introduction. To set the scene: almost on the book's final page, Maria proposes marriage to Strether. The sentences that follow that proposal, however, drift subtly away from the social scene itself, tracing Strether's train of thought, filling in what he thinks she means—until the moment in which his wandering internal supposition is interrupted:

> "Shall you make anything so good—?" But, as if remembering what Mrs. Newsome had done, it was as far as she [Gostrey] went.
>
> He [Strether] had sufficiently understood. "So good as this place at this moment? So good as what you make of everything you touch?" He took a moment to say, for, really and truly, what stood about him there in her offer—which was as the offer of exquisite service, of lightened care, for the rest of his days—might well have tempted. It built him softly round, it roofed him warmly over, it rested, all so firm, on selection. And what ruled selection was beauty and knowledge. It was awkward, it was almost stupid, not to seem to prize such things; yet, none the less, so far as they made his opportunity they made it only for a moment. She'd moreover understand— she always understood.
>
> That indeed might be, but meanwhile she was going on. "There's nothing, you know, I would n't do for you."[38]

In Strether's mind, Gostrey's proposal has been received, considered, rejected, and his refusal accepted. As Strether thinks "she'd moreover understand," the reader can sense him already readying a new topic of conversation, the proposal itself already having become a thing of the past.

The next sentence therefore comes as a rude shock: "That indeed might be, but meanwhile she was going on." Strether has not simply been caught daydreaming while the proposal unfolds around him. If it were that simple, Strether would be like Lord Jim: too late to rescue drowning men at sea

because he was fantasizing about rescuing drowning men at sea. Strether's case, though is subtler. Conrad's Jim may not be aware that he has chosen to stay on deck while he's still dreaming, but once he's made the choice, its implications become clear. Strether, by contrast, confronts a permanently muddied terrain: what she has said and what he thought she said are not unpacked as two clear alternatives. Instead, the reader must confront a text that provides only intermittent glimpses of Maria's actual speech—only the words he's been able to attend to have broken through the wall of words produced by Strether's own thoughts. Thinking that he's listening to Maria Gostrey, Strether has nonetheless gotten the subtext—and perhaps even the text—of her proposal wrong. Because Strether's thoughts have clearly drifted away from Gostrey, both he and the reader may have missed one or more sentences (just as in James Joyce's "The Dead," Gabriel, brooding on Greta's behavior, misses key details in the story that Mrs. Malins is telling about "the beautiful big big fish": his missing them means that the reader is never told what those details might be[39]).

Strether is not allowed to remain in the dark, however, about the divergence between his thoughts and Maria's actual words. The phrase "that indeed might be" jolts him out of his mistake. It does so in a revealing way, by creating a *quasi*-impersonal interlocutor. It is not enough here to say, following Dorrit Cohn's crisp anatomy of free indirect discourse's various distinctive possibilities ("psychic narration," "quoted monologue," and "narrated monologue"), that the passage sequentially lays out various viewpoints.[40] Cohn's account would allow us to posit that at one moment the reader is located inside Strether's head ("she'd moreover understand"), but at the next ("that indeed might be") entirely outside it. The slide between impersonal and personated speech is subtler than Cohn's model allows. "That indeed might be" is Strether's own sense of an impersonal narrative voice, an interjection that reminds him of the gaffe he's made, allowing Maria Gostrey to continue proposing while he assures himself she will—no, actually does—understand his rejection. The phrase is a glimpse of the character's subjective understanding of the world, rebuked by his own (perhaps equally subjective) sense of what the objective correcting world would say to mark his lapse in concentration.

Strether's embarrassment about his temporal misfire arises from James's notion that the novel creates a virtual world, a site where readers can come to understand the interplay between the elements of their thought that are social (dependent on direct interaction) and those (like losing oneself in a book or in a daydream) that are divorced from social intercourse. One of the clearest ways James has to demarcate the difference between reality

found inside characters' minds and the reality made up of their shared social universe is to show the divergence between characters' thoughts (what Strether thinks Gostrey is saying) and real-world events (what she actually does say).

The result of those interplays—something like a *moiré* pattern, in which two sets of waves meet and produce their own distinctive new pattern— is that characters will sometimes be brought up short by a sentence like "that indeed might be, but meanwhile she was going on" uttered by a speaker who is and is not the narrator himself. From such a lapse, a sly unobserved recovery is possible in the real world; indeed, nothing is more common. The novel, however—so expert at capturing those losses and recoveries and suspending them in the viscous, infinitely dilatable time of prose narration—allows the character's losses and recoveries to float inescapably, even cruelly, before the reader.

UNREAL PERSONS, UNSPEAKABLE SENTENCES

Sharon Cameron has made the case that Henry James "dissociates con- sciousness from psychology" and elucidated ways in which James is fas- cinated with thoughts and words that travel from one person's mind to another, or that show up in the novel in ways that make their source ambiguous.[41] Who exactly, then, is doing the experiencing? In James, as in George Eliot before him, what's most fascinating about the novel is *not* that it presents the reader with an accurate account of other people who share our objective world while differing from us in their subjective stances. Instead, the novel presents the sort of accounts of the world that can only ever be offered from a particular and partial viewpoint—even though no actual human being exists to inhabit that viewpoint. To press the logic of Catherine Gallagher's resonant phrase, "nobody's story," we might say that novels work by revealing ways in which subjectivity is present even without any *actual* person being there: feeling without feelers.

This chapter concludes by offering a somewhat new way of thinking about the question of impersonality. Henry James is acutely interested, especially in his final few works, in detailing what it may mean to think of oneself in such a situation: to be aware, that is, that one's life is as much virtual as it is actual.[42] And that realization—of one's own partial remove from the actual world—is one that James ultimately means to apply to his readers every bit as much as it applies to his characters.

James also approaches the conundrum of comparing the life of characters to the lives of actual people in his account of what exactly makes him jealous of a rival novelist's character: John Halifax, Gentleman—eponymous hero of a bestselling 1856 novel by the pious moralist Dinah Craik. "He is infinite, he outlasts time; he is enshrined in a million innocent breasts; and before his awful perfection and his eternal durability we respectfully lower our lance."[43] By James's account, the character thrives neither in Craik's mind nor on the physical pages of her novel, but because readers have taken him in, they have yielded to him. John Halifax is a novel-borne meme, a set of subjective sensations that can take up their dwelling in any breast. James's later critical writing makes clear that such an afterlife for characters depends on the novelist granting to characters sufficient autonomy that their reactions to the events of the novel will be plausibly separable from the novelist's own thoughts.

There is a revealing link between James's criticism of the *outré* formal experiments of George Eliot's late works and his own "late style" three decades later. On the one hand, James resembles Eliot in his wish to push away from a narrowly delimited conception of mimetic prose. On the other hand, Eliot's is an experiment with expression: how to find a place for authorial ideas to take shape within the confines of the novel. At a similar juncture in his career, James, by contrast, is thinking in readerly terms. He is not as interested in the expression of a thought as he is the kind of thinking that will be produced in a reader given access to two different sorts of information: on the one hand actions, on the other, the experiences that such actions produce in characters.

Accordingly, as James explains in his 1908 preface to *The Ambassadors*, the novels he set out to write should be thought of as double. Unlike other genres, a novel can be both "dramatic"—it can stage scenes plausibly—and "representative"—it can enter into how particular people feel and experience the world.[44] In fact, its capacity to keep the scenic and the mental both afloat within the text is the novel's unique strength (drama only supplies scenes; perhaps we can also infer that in contradistinction poetry supplies only mental states). A scene in which the reader gains a sense of what a minor character is thinking but not saying, writes James, is

> an example of the representational virtue that insists here and there on being, for the charm of opposition and renewal, other than the scenic. It wouldn't take much to make me further argue that from an equal play of such oppositions, the book gathers an intensity that fairly adds to the dramatic—though the latter is supposed to be the

sum of all intensities; or that has at any rate nothing to fear from juxtaposition with it. I consciously fail to shrink in fact from that extravagance—I risk it, rather, for the sake of the moral involved; which is not that the particular production before us exhausts the interesting questions it raises, but that the Novel remains still, under the right persuasion, the most independent, most elastic, most prodigious of literary forms.[45]

By James's account, intensity is to be found not in the dramatic or scenic (the mere surface of things), but in the juxtaposition of such scenic/dramatic events to the representational. The coexistence of the "dramatic" and the "representational" within a single apparently continuous text is a mark of the novel's generic strength: accordingly, the preface should be understood as making explicit the ways in which occurrences have been transformed into *experiences*.[46]

Furthermore, James stresses in the same paragraph the novel's enviable capacity to reveal the gaps that open up between an occurrence and a character's subjective experience of that occurrence—as they do, for example, in the case of Strether's mangled reception of Maria Gostrey's marriage proposal. "The book," writes James

> is touchingly full of these disguised and repaired losses, these insidious recoveries, these intensely redemptive consistencies.[47]

We might say that the novel works by revealing disguised losses and making sure the reader notices the insidious recoveries of the sort Strether pulls off in front of Gostrey. James's novels are not, then, the acme of baroque self-referentiality, but acute registers of a rarely remarked aspect of everyday life: that our attention is far less uniformly focused than we like to pretend upon the physical and social facts right in front of us. The attention of his characters does not wander because they are peculiarly Jamesian subjects of an experiment in pure linguistic mediation.[48] Rather, it wanders because they, like their readers, only partially attend to their immediate surroundings.[49]

This is akin to moments in Eliot where characters see their own deeds, or their own lives, taking place as if they were outside themselves: a semi-detachment predicated on historical remove. Here, James turns up the magnification on the moment of removal itself: to be busy at work with one's own inward thought process is also to have experienced a measurable gap, a moment of blank tape in one's social being. Viewed one way, this kind of tuning-out and then tuning-in again looks like a unique formal

property of the novel, depending as it does upon the felt discrepancy between what James calls its "dramatic" and "representative" aspects. Viewed another way, though, such intermittent disattending is representative of the way that a reader's own consciousness might find itself in a state of semi-detachment even at the moments when full and complete attention might seem inevitable.

Disarrayed Dictation and Onomatopoeia

Jamesian narration provides not so much a refuge from the world as a way to recognize some part of our experience that is invisible to us in ordinary experience: those insidious recoveries. If that is so, then the work of the novel is to establish its own strangeness just enough to arrest the reader's attention, while still retaining an underlying mimetic resemblance to the everyday experience of partial removal from one's actual world. Strether's wandering consciousness during Maria's speech is *un*like the actual world in providing a form of insight into insidious loss and disguised recovery that is unavailable in reality. Yet it is also like the actual world in resembling the reader's own mental vagaries. The effect is to generate a first-person account of (nonexistent) third persons who turn out to have a form of consciousness that we know ourselves to have—but can only infer in others.

Related issues around fictive semi-detachment works also arise in a pair of related moments—one turning on free indirect discourse, the other on onomatopoeia—in James's *The Sense of the Past*, an unfinished novel begun in 1900, put away, then picked up and worked on in a sustained way in 1915, just before his death. A close look at his 1915 essay "Within the Rim" and contemporaneous correspondence suggests James returned to the manuscript just before his death because wartime had sharpened his sense of the key issues involved in the leap backward in time that lies at the story's heart.

The novel's most memorable scene is the first that James wrote in 1915, with World War I front and center in his consciousness. The protagonist, Ralph, in the novel's present moment of 1900 is about to enter a doorway that he knows will take him back to 1820. Having climbed the steps, Ralph looks back over the abyss he is leaving behind, including the person who came to register his departure, the American Ambassador:

> Our young man was after that aware of a position of such eminence
> on the upper doorstep as made him, his fine rat-tat-tat-ah of the
> knocker achieved, see the whole world, the waiting, wondering, the

shrunkenly staring representative of his country included, far, far, in fact at last quite abysmally below him. Whether these had been rapid or rather retarded stages he was really never to make out. Everything had come to him through an increasingly thick other medium; the medium to which the opening door of the house gave at once an extension that was like an extraordinarily strong odour inhaled—an inward and inward warm reach that his bewildered judge would literally have seen swallow him up; though perhaps with the supreme pause of the determined diver about to plunge just marked in him before the closing of the door again placed him on the right side and the whole world as he had known it in the wrong.[50]

Anne Banfield's account of "unspeakable sentences" and James's own notion of the novel's capacity to contain both the "representational" and the "scenic" virtue are both illuminating here. In the sentence in which Ralph sees the Ambassador seeing him vanish, James wants to map three distinct things: the state of actual affairs unfolding in the world, the way they seem to a viewer whose full consciousness is not registered, and the way they seem to the focalizing subject. The key sentences for this movement from one world to another (Ralph is literally plunging or diving into the past as he crosses the threshold) make it plain that "his bewildered judge" has a perspective that Ralph only reconstructs hypothetically: and in fact, James's working note for this moment asserts that "the very law of my procedure here is to show what is passing in his excellency's mind only through Ralph's detection and interpretation, Ralph's expression of it." The transition from Ralph's "interpretation" to "expression" of the Ambassador's thought that James notes down here is especially striking.[51]

Still, can even the most elaborate combination of interpretation and expression explain the unspeakable phrase "an inward and inward warm reach that his bewildered judge would literally have seen swallow him up"? It is the "reach" that swallows Ralph up, but the reader is as bewildered by that fact as is the Ambassador—bewildered because the syntax turns away, midsentence, from the feel of what pulls Ralph into the question of what that pull looks like to the befuddled onlooking Ambassador.[52]

The bewilderment is further qualified by the subsequent clause, because the temporal uncertainty Ralph has been experiencing (am I moving fast or slow? he wonders) also leaves him uncertain how he appears to the Ambassador: "Though perhaps with the supreme pause of the determined diver about to plunge just marked in him before the closing of the door again placed him on the right side and the whole world as he had known it in the wrong." Three positions are at stake here: the scenic fact that

he paused (which he is uncertain about); the (representational) Ambassador's perspective, from which his pause may have looked like evidence of determination; and finally a representation of Ralph's own perspective from which, though he is unsure if he is moving quickly or slowly, he can be sure that if the judge has seen him pause, he will be speculating as to whether that marks the determination of a diver pausing before the plunge, a third-order representation since it is Ralph speculating on the Ambassador's speculating on his own mental state, as evidenced by the perhaps nonexistent pause.

There is also a revealing textual codicil. In dictating an earlier part of this particular scene (Fig. 5.1), James segued without notice from dictating the novel itself to dictating a "working note" to Theodora Bosanquet, his typist and interlocutor.[53]

> "It's wonderful for me," the Ambassador soon replied, "by which I mean it's quite out of my common routine, to have the share to which you invite me in such adventures—mixed, as I understand you I may regard myself, in your friend's down there as well as in yours.
>
> What I want here is to accelerate the pace for what remains of this to the end of the chapter.[54]

In a scene in which the Ambassador discusses how he feels to be invited to witness young Ralph's slip from one world into another, it is striking that James would slip imperceptibly from dictation into schematics—as if he feels his own role shifting here. I say *imperceptibly* because although Bosanquet knew James and his dictation style extremely well she did not—as evidenced by that sheet—perceive the shift from fiction to planning immediately. It seems worth pondering the difficulty that Bosanquet had in drawing the line between a character speaking about another character's adventures and the novelist's musing on the pace at which his plot advances.[55] Bosanquet may not have doubted the identity of the man speaking to her, but the persona who spoke through him remained in doubt. Bosanquet certainly perceived a gap between the James who dictated the words of his novel's narrator and the James who remained just behind the fictional mask, ready to pop out at any moment and replace the words *of* the novel with words *about* the novel. Yet that shift between diegesis and metadiegesis proved difficult to spot even for such an old and seasoned acquaintance as Bosanquet—all the more difficult because in a Henry James novel the words *of* the novel are so often themselves words *about* the novel.

The final puzzle this passage poses is in its most anomalous word of all: "rat-tat-tat-ah." James's interview with Preston Lockwood of the *New*

adventure may come in for."

"It's wonderful for me, " the Ambassador soon replied, "by

which I mean it's quite out of my common routine, to have the share

to which you invite me in such adventures — mixed, as I understand

you I may regard myself, in your friend's down there as well as in

yours..

What I want here is to accelerate the pace for what remains of

this to the end of the chapter; which will take perfectly clear doing.

In three words the Ambassador goes down stairs with him, they find

the cab at the door, but with nobody in it, to the A's recognition,

and they have again there then, out on the pavement and at the

door of the cab, another passage; which ends in the Ambassador's

getting in with him, to see him home, and so seeing him home, and

finally ..parting with him at the door in Bedford Square. Ralph

taking leave of him there as for the beginning, the entering into

what awaits him on his now going finally into the house. But the

effect and sense of all this must have been prepared by what effect-
ively

FIGURE 5.1. Dictating, but dictating what? Bosanquet, as she typed, was not sure what was fiction and what was conversation. Henry James, discarded sheet from *The Sense of the Past* (1915; MS Am 1237.8, Houghton Library, Harvard University).

York Times in March 1915 provides a useful perspective. James (who begins the interview by "asking that his punctuation as well as his words should be noted") worries that

the war has used up words; they have weakened, they have deteriorated like motor car tires; they have, like millions of other things,

been more overstrained and knocked about and voided of the happy semblance during the last six months than in all the long ages before.[56]

Deformed as they have become by wartime shocks, words are no longer capable of functioning as transparent signs. It is also worth noting at this point that only a month earlier James had written "Within the Rim," an essay that begins by explicitly comparing the advent of World War I to his youthful memories of the Civil War:

> The first sense of it all to me after the first shock and horror was that of a sudden leap back into the life of the violence with which the American Civil War broke upon us, at the North, fifty-four years ago, when I had a consciousness of youth which perhaps equaled in vivacity my present consciousness of age. The illusion was complete, in its immediate rush; everything quite exactly matched in the two cases.[57]

With that leap in mind and with the sense that words have been voided of their signifying capacity ("Happy semblance") in the same way a tire is voided of the air that allows it to function as a tire, we are better poised to understand what it means that James picks up *The Sense of the Past* where he had been forced to break off fifteen years earlier; forced to break off because in 1900 he could find no way to write the scene by which its central character falls (or plunges or leaps) "back into" a bygone nineteenth century that—like the "American Civil War" that suddenly leapt on him with the onset of war four months earlier—is both fantastically detached from actual life and somehow inescapably real.

In his working notes for the scene of the plunge or leap, James congratulates himself on grasping "what I remember originally groping for, having groped for, when I broke this off just here so many years ago."[58] His description of why he broke off, though, gives some insight of what may have changed in the interim. James recalls that when he last worked on the story fifteen years earlier, "I gave up taking time to excogitate my missing link, my jump or transition from this last appearance of my young man's in the modern world, so to speak, and his coming up again, where we next find him, after the dive, in the 'old.'"[59] In peacetime, under no particular pressure, the process of "excogitation" had not shown James the "missing link."[60]

It would be oversimplifying to think of "rat-tat-tat-ah" as a supreme instance of James marking the failure of language any longer to have "the happy semblance" to reality. Still, it is worth noting that the word is a

one-off, never used in any language before or since James dictated it to Bosanquet in March 1915.[61] What does the addition of "ah" in James's variant do to the limits of rat-tat-tat's onomatopoeia?[62] It may, like James's palpable anguish in lamenting the failure of language during wartime, relate to the corrosive effect of machine gun fire itself, as if the rat-tat-tat of the guns were beating its way even into James's dictation. Or it may be that James is tinkering with the word to represent more accurately what the "fine" knock sounded like, so that the added "ah" suggests additional confidence, or assertiveness? Would we even want to hear a more musical cadence to the sound?[63] These multiple valences, divergent pathways toward some kind of cloudy meaning, may well be the point of this word, coined, though never assimilated, at a moment when James fears that words have lost their "happy semblance." Given that James himself described his late novels as aspiring toward the "concentrated notation of experience," it may make sense to read "rat-tat-tat-ah" as the marker of another sort of dialogue, the one that continually takes place between a writer's exterior world and the mimetic universe within which he or she suspends her characters.

Roman Jakobson's "What Is Poetry?" proposes that a famous poet's private scribbles might be as meaningfully poetic as his published works.[64] It may make sense to think of the dictated notes from James's final years as a different sort of test case of the line between "artistic" and ordinary utterance. These dictated notes comprise both the "typescript" (that is, the original compositional record of novels that never had traditional manuscripts) of James's late novels and also a record of what James happened to say to his "typewriter," Theodora Bosanquet, while he was in dictating mode. This is an odd and in some ways poignant instance of the novelist as chronicler of the everyday, since what we have is Bosanquet's accidental record of Jamesian conversation (or even musing) recorded as if it were destined for publication as a novel. What are we to make of the grounding of words that (like Strether's mistaken interior monologue about Maria Gostrey's proposal) exist within a speaker's mind as an instance of his subjective misapprehension of an objective state of affairs? Words that—as with the "inward warm reach"—call into being two different subjective positions nearly simultaneously and perhaps interchangeably? And finally, what of rat-tat-tat-ah, balanced between Ralph's 1900 and 1820, as well as on the cusp between exquisitely modulated knocking and deformed gunfire?

Rat-tat-tat-ah foregrounds the semi-detachment of the reading experience not simply because a later scholar can do the detective work to recreate

the moment of composition, but because at the instant of the plunge, the "missing link" serves to make the reader acutely aware of what sort of medium it is through which her own interpretive process also moves. That James produces that awareness without dispelling the illusion—that his dictated fiction generates detachment as well as absorption—may be the best evidence we have of his interest in creating a virtual world that is built up not of alternating states of detachment and absorption, a movement into and out of the fictional realm. Rather, what we see everywhere from Strether's absentminded reception of a marriage proposal to James's half fictional, half metafictional notes to Bosanquet is evidence of the utterly inescapable and ordinary business of moving through a world in which the "objective knowledge of subjectivity" and the knowledge of objectivity itself can prove breathtakingly hard to disentangle.

Conclusion: Literary Subjectivity

How should we interpret Eliot's recursive, self-conscious consideration in *Theophrastus Such* of what it means to be a character in and of the world? Or James's self-conscious exploration of how the dramatic and representative capacities of the novel (including time travel plots, free indirect discourse, perhaps even onomatopoeia) can model the distinctive admixture of inward and outward life that shapes experience in the everyday social realm? Simon During has recently proposed a category that may shed light on Eliot's notion of what interiority may look like, for both literary characters and actual persons. "Literary subjectivity," writes During,

> involves a certain styling of a life around reading (and often writing too). . . . It involves recognition of oneself as a distinct type who takes literature seriously. At a more general level though, literary subjectivity is a disposition to engage intensely with particular modes in two larger formations which help drive modern culture: the production of fictions and simulacra, and the provision of spaces and occasions for individuals to be communicated to or to fantasize alone and without a belief in supernatural agency.[65]

Literary works can prove crucial in constructing that sort of "secular mimesis," During argues, either in a traditional sense—literary greatness allows one to regain inherited values even without transcendental authority—or in a self-reflexive way—literature is that which allows individuals to undertake the modes of reflective analysis, finding answers

by looking within themselves, with no assurance that such answers are generalizable. If literary subjectivity arises from the latter route, During suggests that problems of legitimation and autonomy remain to be adjudicated: how can we be sure such subjectivity derives from or is secured by objectivity or some other form of universal truth?

The experiments in semi-detachment that James pulled through such baroque divagations at the onset of World War I may seem centuries rather than decades removed from the split-mindedness of Lizzie Hexam in *Our Mutual Friend*. Yet the distance traveled begins to make more sense if *Middlemarch* and *Impressions of Theophrastus Such* are understood as intermediate stops. In such works, Eliot focuses her attention (much like Ford's image of the half-reflective glass) on the puzzling and incomplete nature of a story's "pertinence" to the world in which it is told—and upon the incomplete gaps that open up between fictionality and actuality, between story-world and "real world."

This chapter has traveled from Lizzie Hexam's double-mindedness through Eliot's explorations of the split inner life of Bulstrode, down through James's spiraling syntax as he attempts to make sense of the gap between what is seen from outside, what is felt from inside, and what constitutes the sum total of the represented world. It is tempting to conclude that what each case demonstrates is the authorial intervention, the absence of actuality in this artifice of a fictional world. Instead, semi-detachment may be helpful in reminding us how crucial a role "literary subjectivity," as During describes it, must play in the actual social world that each of these novelists imagines. Without a conception of individuals as already living semi-detached from their own experiences, aware of the discrepancy between what they do and what they think, as well as the space that opens up between how I think about my actions and how others think about them, the formal gyrations of each of these novelists would be incomprehensible. "Where every one feels a difference, a difference there must be," writes Mill in his first attempt at literary criticism; it is an observation that applies well to all three novelists examined in this chapter.[66] Aware of the problem of fictionality, each of them unpacks formal conundrums about what it means to be moving rapidly between possible positions with regard to one's own experience of the world.

Semi-detachment in Dickens's fictional worlds as in Eliot's and James's opens up the concept of "literary subjectivity" in its broadest sense. It is not simply that readers may be drawn to model their own lives after the immanent forms that fiction makes available. Rather, the effect of such

partial pulling away, like the pseudo-interpolation of stories into novels, is to offer readers ways of seeing themselves operating within the world's own busy fictional machinery. Although few of us can name ourselves like Pip, all of us must imagine that like Ganymede we bear a name and a character not of our own choosing, with stories about us circulating elsewhere that we can either own up to, or fitfully disavow.[67]

6

"This New-Old Industry":
William Morris's Kelmscott Press

Isabel Hofmeyr has described Gandhi's work on a collectively owned printing press during his South African years as the indispensable ground for his later political work. In navigating some of the pitfalls around print production at the Phoenix commune from 1907 onward, she argues, Gandhi put himself on the path toward his most radical political forays. William Morris may look like almost the opposite case. After a decade with a wide range of artistic activities explicitly tied to his socialist ideals, in the late 1880s he began designing medievally inflected books at Kelmscott Press: seemingly a retreat from politics altogether. To some contemporaries, Morris in those final years was reverting to a childhood spent charging around the New Forest in a suit of armor, a Scott novel tucked under his arm. Reports find him playing checkers with his wife Jane on a medieval board, cloaked in a medieval robe, or boasting to friends not that he *bought* but rather that he "*cheapened* an old chest."[1]

Does that make Gandhi a progressive success story and Morris a self-made refugee from the world of politics, who forsook dry, unpromising political landscape for what Hannah Arendt disparagingly called the "oasis of art"? No; the bases for Morris's medieval passions were more artisanal than antiquarian, and they signal a different sort of radicalism. The detached Morris, the "idle singer" born "out of his due time" was still crisscrossing the country on lecture tours, lugging his own architectural magic-lantern slides with him and consulting a matchbox filled with tiny photographs of the latest typeface for the Kelmscott Press.[2]

Moving temporarily away from the experiments with fictionality that accompany the semi-detachment of writers like George Eliot and Henry James, this chapter makes the case that for William Morris a form of aesthetic semi-detachment was a necessary step away from his present world that allowed him to return to that world from a different direction: a shift in vantage rather than an exit strategy. We know that in part because of the virtues that he praised in his artistic and political forebears, seeing the same kind of half-removal from their present-day experiences in them that he himself sought. We can also gain a sense of what might be called Morris's strategic anachronism by exploring the uses that he and his collaborators made of magic lanterns and other modern technology in the founding of Kelmscott Press. It may seem an irony, but it is ultimately no paradox that Morris's finest work in a medieval vein is shaped by his experiments with state-of-the-art technology. To boot, Morris's prose romances of the 1880s and 1890s (intended as departures from the realist novel of his own day, even though they are never explicitly marked as time travels in the way that *News from Nowhere* is) were shaped by an aesthetic he understood as both "epical" and "ornamental"—that is, by its warring impulses within the book toward narrative sequence and toward decorative stasis. Those late experiments are crucial in understanding Morris's idea of making art that could draw its audience into a mimetic reverie yet simultaneously make that audience aware of the artwork as a material object, in all its thingliness.

Morris's artistic and political evolution in the last decade of his life (he died in 1896) depends on his looking backward to medieval and early modern workers for inspiration—but looking backward in a new way.[3] His admiration for those medieval precursors to Kelmscott arises because he discerns, and seeks to make sense of, an immediate affinity between their and his own struggles with their respective media: his daughter May was right to call Morris's venture a "new-old industry." By Morris's account, those medieval bookmakers had been haunted but also nourished by their own past; like him they had sought to make something new out of their encounter with that past's demands. Accordingly, the complicated, politically germinative doubleness of Morris's final few years comes into sharpest focus if we understand the crucial role newfangled photographic technology and the magic lantern—now shorn of the adjective magic and put to work as a key late-Victorian tool for technologies of enlargement and projection—played in the inception of Kelmscott.

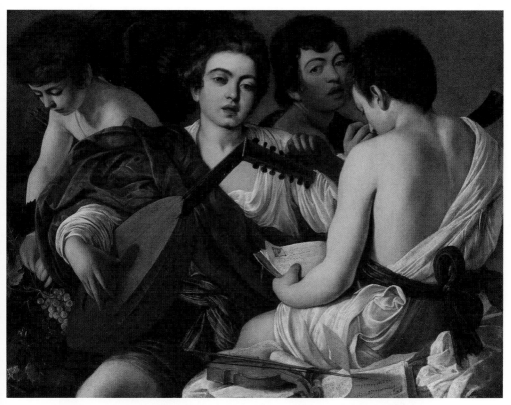

PLATE 1. Caravaggio, *The Musicians*. The viewer is invited to meet the sightless gaze of a musician listening to his own inaudible playing (c. 1595, Metropolitan Museum of Art, New York City). Courtesy of Bridgeman Images.

PLATE 2. Hans Memling, *Christ Blessing*. At a double distance: Christ's fingers, resting on the picture's frame, both acknowledge and push up against the divide between viewer and painting (1481, oil on panel, 35.1 x 25.1 cm, Museum of Fine Arts, Boston; bequest of William A. Coolidge. Photograph © 2017, Museum of Fine Arts, Boston).

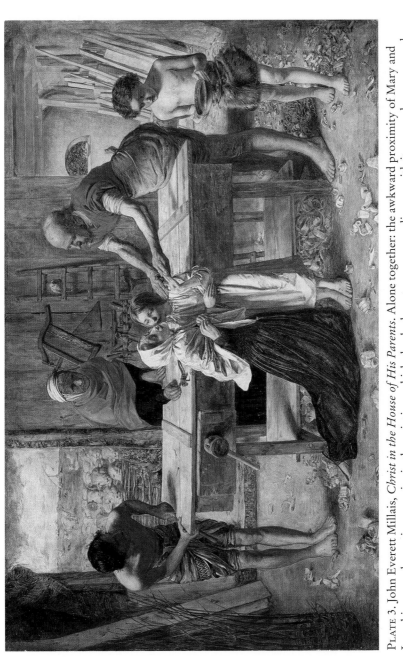

PLATE 3. John Everett Millais, *Christ in the House of His Parents*. Alone together: the awkward proximity of Mary and Jesus hints at a deeper incongruity in the painting, which shocked contemporary audiences with its scrupulous corporeal accuracy about a scene rife with supersensible feeling. Anatomy met theology, and Dickens was only the most vociferous of those left aghast (1849–50, Tate Britain). Courtesy of Bridgeman Images.

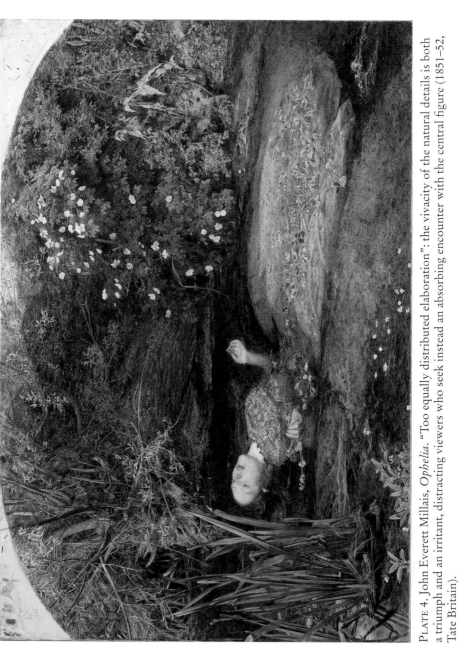

Plate 4. John Everett Millais, *Ophelia*. "Too equally distributed elaboration": the vivacity of the natural details is both a triumph and an irritant, distracting viewers who seek instead an absorbing encounter with the central figure (1851–52, Tate Britain).

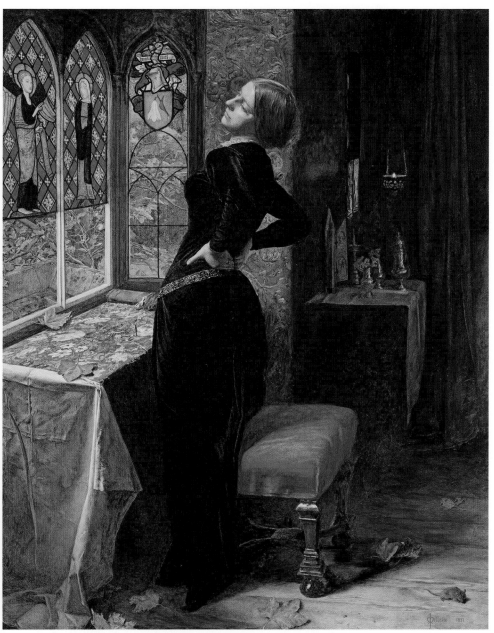

PLATE 5. John Everett Millais, *Mariana*. The captive's isometrics: capturing the tedium of eventless life, with all its inaction condensed into a depictable instant (1851, Tate Britain). Courtesy of Bridgeman Images.

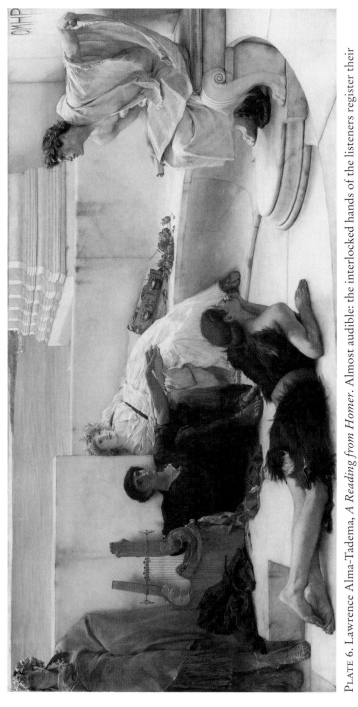

PLATE 6. Lawrence Alma-Tadema, *A Reading from Homer*. Almost audible: the interlocked hands of the listeners register their reverent intensity as part of the ongoing event (1885, Philadelphia Museum of Art). Courtesy of Bridgeman Images.

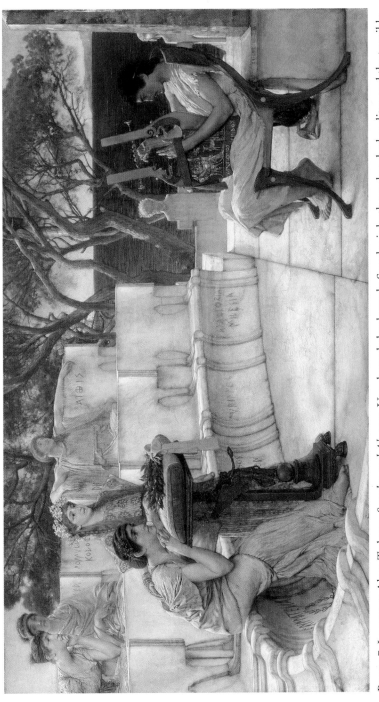

PLATE 7. Lawrence Alma-Tadema, *Sappho and Alcaeus*. Unacknowledged touch: Sappho is both an absorbed auditor and the tangible surface on which her beloved's hand rests. (1881, Walters Museum, Baltimore). Courtesy of Bridgeman Images.

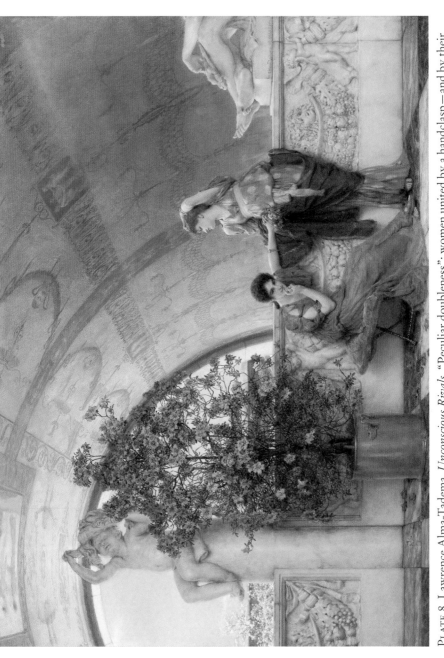

PLATE 8. Lawrence Alma-Tadema, *Unconscious Rivals*. "Peculiar doubleness": women united by a handclasp — and by their unwitting rivalry for whomever it is they are craning to see or to hear (1893, Bristol City Museum and Art Gallery). Courtesy of Bridgeman Images.

Materiality in Theory: Art's Objecthood Reconsidered

The uses to which Morris put the magic lantern for his Kelmscott venture—antiquarian and hypermodern both—give a hint of the direction his experiments in the 1890s took. The aesthetic innovations developed by gazing into a mirror of past practice led him to refract contemporary politics through the lens of art. This is a complex historical puzzle: are the key pressures that motivate Morris contemporary, and the turn to the past merely an outlet for his topical cogitation? Or is Morris primarily engaged in recovery work, cloaked at least intermittently in modern shape simply so as to be acceptable to contemporary audiences? In disciplines such as book history and media studies, questions of materiality have always been foregrounded in ways both empirical and theoretical. The past decade has seen the development of some valuable new approaches to the materiality in the aesthetic realm, as well, moving toward a new field that might be paradoxically labeled "materiality theory."[4] Recent work (by Isobel Armstrong, Jennifer Roberts, Leah Price and others) can help make sense of Morris neither as entirely dreamy nor entirely engaged: an artist whose artisanal retreat into a new kind of book production explores and reflects on a new way of living at once in and out of his everyday world. William Morris conceives of his Kelmscott Press books as both the medium upon which representation occurs (the text's material substrate, the signifying *object*) and also as the set of signs that reflect upon their own status as works of art (the *signifying* object).[5]

Accordingly, this chapter's approach to Kelmscott Press and the role new technologies played in its inception begins by considering what can be gained from Isobel Armstrong's 2008 *Victorian Glassworlds*, a compelling example of a new kind of materiality studies, one that investigates boundaries or crux points where new ideas about the limits of materiality are coming into being. Armstrong reveals the oft-overlooked developments that made that triumph of sheet glass profoundly transformative, demonstrating how lenses, mirrors, and omnipresent windows could reshape both lived environment and scientific practice. Victorians, by Armstrong's account, saw glass as simultaneously medium and barrier, an industrial product that "makes evident its materiality as a brittle film" between viewer and world, which also allowed that world to come through or bounce off it in a dizzying range of magnifications, refractions, and reflections that forced viewers to contemplate objects both in their original and in their glassed manifestations.[6] At the core of Armstrong's approach

is the idea that we ought to look carefully at what particular material, artisanal, and technological practices imply about how representation operates, and what the relationship is between objects and the people who make or use them.

This crucial idea—that we find ideas not so much in things as in a thick description of the practices and cogitation that brought those things into being, and placed them where they are—also shapes Jennifer Roberts's *Transporting Visions*. Roberts explores the way nineteenth-century American visual artists grappled with the tactile resistance that arises when mobility increases, crediting artists with having developed an account of what it means for their paintings simultaneously to represent and materially inhabit the actual world:

> Pictures in early America (a social and spatial world notable above all for its great distances) were marked by their passage through space— not only by the crushed corners, craquelure, and other indexical injuries that they may have sustained along the way, but also by their formal preprocessing of the distances they were designed to span. The friction of distance, in other words, made itself felt not only on the outsides but also on the insides of pictures: in their emblematic and allegorical configurations, their calibrations of scale and dimension, their management of the sensory matrix of delayed beholding.[7]

The recent resurgence in media studies has also increased the overlap between straightforward book history and more hermeneutic sorts of textual analysis: for example, important recent work (by Blair, Kafka, and Soll) studies the ways in which practices like note taking, recordkeeping, and book publishing have shaped and been shaped by evolving intellectual norms for defining textuality, fictionality, and aesthetic value. Similarly, Leah Price's work on the shifting ways in which the mixed material and ideational nature of books was understood in the Victorian era attempts not only to document and explain the historical shifts that occur during the nineteenth century but also to bring its analysis forward to explain why what we see of the past in the early twenty-first century may differ so greatly from what scholars perceived only a decade or so prior.[8] Price's point is that we still need to find a "history of books *and* reading" that acknowledges the difficulties involved in coming up with any one intellectual approach that could rest comfortably and continuously at the juncture point where books and reading converge.

All three approaches (Armstrong, Roberts, Price) are attuned to objects in their material form and in their status as representational, and all suggest

that only such a bimodal approach will discern what is perhaps the most crucial element of all: the ways in which the object itself bears marks of the thought that its creator put into that very doubleness. Armstrong suggests the advantages scholars can gain from attending carefully to the ambient intellectual work that surrounds, for example, lens making, or the advent of new massive panes of glass. Roberts, operating with the same close attention to how material practices encode subtle semiotic assumptions of their makers and users, also directs our attention to direct representational claims made by the very art objects she is parsing. And Price's account of the particular sorts of duality encoded into books as art objects turns our attention outward again to the divergent scholarly approaches that can produce different accounts of what looks to be the "core" meaning of an object. Kelmscott Press as an artistic venture owes something to medieval bookmaking and something to late Victorian technologies that might re-animate those past practices. They owed more, though, to the practical-minded idealism of William Morris, conjuring up a "new-old industry" as semi-detached from its time and milieu as the man himself. Consider what he made of Emery Walker's lantern slides.

LANTERNS, MAGIC AND OTHERWISE

It is no secret that Morris's decision to found the Kelmscott Press owes something to the role magic lanterns and "lantern lectures" played in the public intellectual life of the 1880s. Until recently, though, not much scholarly attention has been focused on magic lanterns themselves. Even today, to the extent literary scholars consider magic lanterns in the nineteenth century at all, their image is as quaint precinematic "attractions." It's hard to blame us: if you go by what the fiction of the day has to say, lantern shows were spectacles defined chiefly by the experience of *succession without sequence*. That is, these were idle entertainment that followed one image after another, but were disorienting (sublimely or ridiculously) because they lacked any underlying logical order. A remark by Rochester to Jane in *Jane Eyre* provides a telling template for the Victorian novel's take on lanterns:

> I wonder what thoughts are busy in your heart during all the hours you sit in yonder room with the fine people flitting before you like shapes in a magic-lantern: just as little sympathetic communion passing between you and them as if they were really mere shadows of human forms, and not the actual substance.[9]

Brontë turns to the magic lantern to evoke Jane's social detachment from the scene before her: pictures in a magic lantern are shadows and hence demand no "sympathetic communion." That detachment depends upon the untethered "flitting" that goes along with images that whip successively by without ever resolving into a single comprehensible whole. In short, the sensation of visual disconnection—the images are here in the room and yet they can't see me, we are in truth nothing to each other—ultimately justifies Jane's social and moral neglect of the "fine people."

It is in the same spirit that Eliot deploys the magic lantern in *Middlemarch* when describing Dorothea's state of sublime overthrow in the face of the wonderful but horrible art of Rome.

> Our moods are apt to bring with them images which succeed each other like the magic-lantern pictures of a doze; and in certain states of dull forlornness Dorothea all her life continued to see the vastness of St. Peter's, the huge bronze canopy, the excited intention in the attitudes and garments of the prophets and evangelists in the mosaics above, and the red drapery which was being hung for Christmas spreading itself everywhere like a disease of the retina.[10]

These "magic-lantern pictures of a doze" are consecutive but without coherence. Moreover—like Marcel's childhood show of Genevieve de Brabant a half century later in *Remembrance of Things Past*—they overlay Dorothea's reality without actually impinging on it. For Jane Eyre, a magic lantern's passing show figures forth a social burden—her duty is to interact instead of treat those passing people as an evanescent show. Here the effect at issue is aesthetic, with a magic lantern standing in for sleep's illogical sequelae.

Such novelistic accounts, though, leave out a key aspect of Victorian lantern culture. Public lantern shows in the late nineteenth century were frequently (perhaps even usually) not phantasmagoric and spectacular but factual, expositional, and didactic. Lightman, Fyfe, and other historians of science have pointed to the importance of lantern-wielding scientists, as well as spectacular visual displays of information ranging from the celebrated Reverend John Wood to the little-known lecturers who might be found displaying Krakatau to Fairfield one night, New Haven the next. "Lantern lectures" (the word "magic" starts to drop out of newspaper accounts of the events in the 1880s) mustered facts and presented evidence about places unknown more often than they dazzled and deluded.

It is entirely in the spirit of the age that when Jacob Riis first proposed the book that eventually became *How the Other Half Lives* (1889), he

announced his intention to shoot "a series of view[s] for magic lantern slides, showing, as no mere description could, the misery and vice that he had noticed in his ten years of experience."[11] In that claim, the word "showing" could not be replaced there by the word "recording"; the testimonial power inherent in the display of photographs as lantern slides is crucial. We might say that such lantern lecturers are early adapters of the latest technologically advanced wave of what Robert Nelson (writing about the birth of the art history slide lecture in the 1890s) calls *forensic* and *epideictic* expostulation.[12] That is, such prosaic lanterneers are developing new presentation styles that depend both on viewers' appreciation of the slide's present immediate and immanent qualities (the epideictic accordingly registers the slide's aesthetic force) and on their mining it for the information encoded in it, while the forensic approach aims above all for fidelity to the original meaning of the image that is represented in the room, aspiring to "truth to life."[13]

Three aspects of the booming didactic and scientific lantern lectures of the 1880s and 1890s—call it the era of the "Prosaic Lantern Show"—are worth noting. Firstly, rhetoric that pointedly distanced the lantern from its magic antecedents was on the rise. Starting in the late nineteenth century, earlier incarnations of the magic lantern (invented in Northern Europe at the height of the Renaissance) were often depicted as Oriental, so as to underscore the lantern's movement away from illusion toward rational and "Western" displays of visual information. Secondly, in the late nineteenth century, photographic lantern slides arrived. As Trevor Fawcett has shown, the technology to make photo projection reliable did not get solidly underway until the late 1860s, and the projective technology to make photographic projections really brilliantly legible on a large scale not until the late 1880s, but the impact was tremendous when that illuminated magnification did arrive.

Finally, magic lanterns operated as scientific experiments in action: if it is no surprise to learn that Marie Curie lectured with the lantern, it is striking that we can go back to the so-called "Grand Oxyhydrogen Microscope" in which "in lantern" experiments—including the disintegration of water into the very oxygen and hydrogen used to light the lamp—were shown in places like the Adelaide Gallery and the Royal Polytechnic Institution as early as 1842. Mannoni also reports that a popular showman in the 1870s experimented with projecting "slides" that were essentially two laboratory slides pressed together, between which he would insert various liquids that would, before the light of the lantern, dry and form various striking crystals.

These are effectively experiments not only conducted under the lights of the magic lantern but actually upon that light. In fact, such experiments in scalability and projection are worth comparing to T. S. Eliot's eerie fantasy that what is inexpressible in ordinary speech might be expressed if we could lay our interiors on view by way of a magic lantern: "It is impossible to say just what I mean! / But as if a magic lantern threw the nerves in patterns on a screen." Eliot, writing in 1915, imagines the lantern providing an index (an x-ray) of the true contents of the nervous system. It is a vision that resonates with these lantern-aided experiments—and is profoundly distinct from the idea in *Jane Eyre* and *Middlemarch* that magic lantern slides are dizzying ephemera, generating succession without sequence.

Emery Walker's Slides

Morris's book production at Kelmscott Press takes advantage of emergent technology to gaze backward through time. This sort of doubleness makes more sense if we understand Morris's turns toward lantern technology in the late 1880s and early 1890s as deriving in part from his appreciation of the lantern's capacity for photographic magnification and illumination.[14] The effect of new visual technologies on the Arts and Crafts circle generally, and Morris especially, was immense.[15] Crucial to the story of Morris's relationship to late Victorian visual technology is the 1888 lantern lecture by Emery Walker (self-taught printer and bookmaker) that inspired Morris to found the Kelmscott Press (though publication only began in 1891).[16] The particulars of this lantern lecture reveal a Morris far less skeptical of the latest technology than has often been inferred from his Ruskin-inflected medievalism.[17]

Emery Walker was a printer whose coachbuilder father had gone blind when Emery was only thirteen. Intensely shy, he did master one public lecture. He delivered it perhaps twenty times in his life: its first airing, after considerable urging and handholding by Morris, came on November 15, 1888, in the New Gallery, Regent Street. Walker hung a sheet from the ceiling at the front of the large hall and positioned a magic lantern at the back. With the lantern illuminated, Walker shed his shyness. According to the adulatory account of a reporter on the scene (Oscar Wilde), a series of "books were also exhibited on the screen, the size of course being very much enlarged."[18] Reconstructing the conversations she had with her father after the event, May Morris captures their shared excitement:

[The audience was] much struck by the beauty of the "incunables" [examples of early printing] shown, and by the way they bore the searching test of enlargement on the screen. One after another the old printers passed before us, one after another their splendid pages shone out in the dark room.[19]

The next day, Morris visited Walker to propose the founding of the Kelmscott Press. Though it would take three years before the first books were made, this lecture seems to have been Kelmscott's conceptual birthday.

Why? The actual images were ones Morris had seen before, repeatedly; indeed, many of the slides came from Morris's own books, loaned to Walker so he could prepare the slides.[20] The difference lay in the image and not the object—or perhaps better to say in Morris's experience of the image. We can assume that Walker was using one of the new, much brighter professional lanterns that Trevor Fawcett describes as having revolutionized the projection culture of the late 1880s: for medieval printed letters to stand the "searching test of enlargement on the screen" depended on the capacity of the projector to offer a new sort of steady magnification and illumination. Additionally, Walker's stress on how crucial heavy solid black letters are for forming beautiful patterns on a page seems to have altered Morris's sense of what role text should play on a page; Morris's later drawings and plans for his own fount of type (Fig. 6.1) give a sense of the intense attention he and Walker brought to bear, as May Morris puts it, "on the proportions and angles of say a lower case i."[21]

Walker began his lecture with an assertion that must have perfectly resonated with Morris's own sense of the intimate relationship between art and artisanal craft: printing could only be defined "by the mechanical conditions under which it was exercised. Only when strictly with reference to these limitations was it entitled to be considered as an art at all."[22] Handwriting and beautiful typefaces consorted: an age with beautiful types, he asserted, must have had beautiful handwriting, and when handwriting declined, the types did, too. Walker also stressed repeatedly the importance of the "mechanical" relationship between graphic and type elements on the page, from which all further aesthetic success had to flow: "artistic relation was the outcome of mechanical relation; without the latter, the former was impossible."[23]

Finally, Walker showed at least one comparative slide (Fig. 6.2), apparently crafted so that two images (one from a Bamberg printed missal in 1481, the other from a manuscript missal from Wurzberg of the same era) could be viewed together.[24]

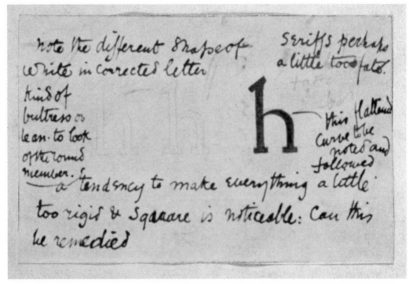

FIGURE 6.1. William Morris, notes on the letter "h": May Morris describes his meticulous attention, during the design process, to "the proportions and angles of say a lower case i" (The Morgan Library and Museum. PML 76897; gift of John M. Crawford Jr., 1975).

This splitting of the slide for heuristic purposes appears to be a significant milestone, preceding by at least a decade and perhaps more Heinrich Wolflin's introduction of the two-lantern lecture—which in its latter-day incarnation via the slide projector (and later digital descendants, Powerpoint and Keynote among them) undergirds virtually all twentieth- and twenty-first-century art history instruction.[25] This slide-splitting is a form of what Nelson calls "visual argumentation" that builds upon but also qualitatively transforms earlier experiments, among them Ruskin's watercolor marks over paintings, Cockerell's "comparative juxtapositions" by way of painted sheets, and Wood's luminous pastel sketches.[26]

If Walker's is indeed a significant new use of the medium of the lantern lecture, that originality would be consistent with what Walker did for Morris in the months immediately following, as the Kelmscott font design got under way. As May Morris describes it,

Mr. Walker got his people to photograph upon an enlarged scale some pages from Aretino's "Histroia Fiorietnina" printed in Venice by Jacques le Rouge in 1476 and pages of all the more important

FIGURE 6.2. An illustrative split-slide: prepared by the typographer and publisher Emery Walker for an 1888 magic-lantern lecture on bookmaking and typography. One image is from a Bamberg printed missal in 1481, the other from a manuscript missal from Wurzberg of the same era. Split-slide reconstructed by John Dreyfus in Matrix 11, 1991; reprinted here with the kind permission of Matrix and the estate of John Dreyfus. HRef-104no. 11, Houghton Library, Harvard University.

fifteenth century Roman types. These enlargements enabled Father to study the proportions and peculiarities of the letters. Having thoroughly absorbed these, so to speak, he started designing his own type on this big scale. When done, each letter was photographed down to the size the type was to be. Then he and Walker criticized them and brooded over them; then he worked on them again on the large scale until he got everything right. The point about all this—though it may be scarcely necessary to dwell on a rather obvious thing—that while he worked on the letters on this large scale, he did not then, as is often done with drawings for mechanical reproduction, have the design reduced and think no more about it; it was considered on its own scale as well, and indeed, when the design had passed into the expert and sympathetic hands of Mr. Prince and was cut the impression—a smoked proof—was again considered and the letter sometimes recut. My father used to go about with matchboxes containing these "smokes" of the type in his pockets, and sometimes as he sat and talked with us, he would draw one out, and thoughtfully eye the small scraps of paper inside.[27]

In creating magnified images of fonts and then reducing their corrected descendants (Fig. 6.3), then repeating the cycle as needed, Walker did with photographic miniatures and enlargements what seems very natural to May but had apparently never been done before.[28]

Two striking innovations underlie the font design at the core of Morris's Kelmscott. His medievalist press stems from a burst of modernist ingenuity.[29] Walker's split slide and magnified/minimized photos for font design fit the spirit of the 1880s. The larger cultural context for Walker's glowing slides and photographic enlargements is (as Chris Otter argues in *The Victorian Eye*) a burgeoning late Victorian interest in "technologies of visual detail." The advent of new ways of thinking about microscopic detail, he argues, depends on tools—x-rays and astronomical photographs, for example, but also detailed blueprints of intricate machinery—being made available to study microscopic features of a particular object with greater assurance.[30] Thinking about Morris's lantern slides and his use of "smokes" in the context of Otter's emphasis on these technologies of visual detail (and in relationship to Rebecca Lemov's recent work on earlier nineteenth-century development of ideas about the storage and retrieval of visually encoded information[31]) offers a useful way to revisit Lindsay Smith's argument that Morris has an "unsettled account of vision, with [an] odd blend of empiricism and transcendentalism."[32]

FIGURE 6.3. Handwritten notes on a photographic enlargement of Kelmscott letters in the design process. "When done, each letter was photographed down to the size the type was to be. Then he and Walker criticized them and brooded over them; then he worked on them again on the large scale until he got everything right" (The Morgan Library and Museum. PML 76897; gift of John M. Crawford Jr., 1975).

While I agree with Smith that Morris's notion of vision is "unsettled" by the sorts of records that photography can make, Smith's argument underestimates the dailiness of photography for Morris and the part that it plays in making "visual detail" more readily accessible to the artist's analytical eye. Indeed, the case for Morris and the forensic utility of the magic lantern may also apply to a wider range of nineteenth-century thinkers whose experience with the pervasive facticity of technologies of visual detail in the late nineteenth century can be easily overlooked: Oscar Wilde's admiration for the accuracy as well as the beauty of Walker's slides is, in the context of *Picture of Dorian Gray*, a revealing detail. Even the very wonder that Morris evidences in response to lantern slides and photographs (May's account of Morris's scrupulous attention to his matchbox full of "smokes" [Fig. 6.4] during boring table conversation is a revealing tidbit) derives not from *un*certainty about what is seen, but from delight with what is to be found in the suddenly palpable image.

FIGURE 6.4. One of the original "smokes": photographic reductions of Kelmscott letters Morris had originally designed in a larger size (The Morgan Library and Museum. PML 76897; gift of John M. Crawford Jr., 1975).

The excited markings that Morris made on the enlarged photos of fonts as he worked toward the "golden" font, and the notes Walker and Morris exchanged as they squabbled over the virtues of woodcuts and electrostatic processes for reproduction, testify to Morris's notion of letter-shapes as actively inviting photographic representation. This excitement sheds some light on what aspects of medieval book production (and reading practice) Morris valued—and also which aspects he ignored. Morris showed no interest in the medieval tradition of later interlineation of a book (that is, he failed to conceive of a book as something that might be modified by later generations of readers adding in their own commentaries). He did, however, have a very strong sense of successive waves of modification and experimentation, whereby an artist produced for publication what might be called, so many iterations had it gone through, a laminated artwork.

Problems of *malleability*, *scaleability*, and *projectability* of images play a key role in Morris's thinking about Kelmscott books. Generally speaking, he comes across as skeptical about many aspects of shifts in scale as they apply to the making of books; for instance, he opposed making a small-format book out of a large one without considerable thought to the formal challenges posed by transposing text onto new pages. Yet there seems to be a conundrum here. How can Morris be attached principally to the art object as material item, yet simultaneously be a practitioner of the whole rhythm of magnification, illumination, and contraction which is indispensable for the key technological innovations that underlay Kelmscott Press?

The tension (or paradox) is a revealing one. Morris's aesthetic is predicated on fixed sizes achieved out of fluidity, and stillness wrought out of infinite motion. This doubleness manifests itself in the interplay between the solid medieval (or Kelmscott) book and the infinitely changeable projection of letters through a magic lantern. Moreover, that doubleness finds an intriguing echo in the way that Morris sees the relationship between the art of the past and its present descendants. In both cases, Morris wants to make use of a fixed and available past in order to create, and play around with, a flexible and protean present, but his conception of the present design work always strives to retain within it a sense both of the real nature of the dimly discernible past and of the innovations and originality that are required to make a new manifestation that effectively recreates some aspect of the older work.

EMERGENT RESIDUALISM; EPICAL AND ORNAMENTAL

Morris's overall account of what he valued in the woodcut books on which the Kelmscott aesthetic was based (an account most fully aired in his lantern lecture on the topic, composed in 1890 as he drew up the founding principles of Kelmscott itself) stresses two principles that underwrite his admiration. The first is temporal—not only is Morris himself undertaking a "new-old" art, but so too were the late medieval bookmakers he studies:

> Though [this book-art] was produced by the dying Middle Ages, they [i.e., the Middle Ages] were not yet dead when it was current, so that it yet retains much of the qualities of the more hopeful period; and in addition, the necessity of adapting the current design to a new material and method gave it a special life, which is full of interest and instruction for artists of all times who are able to keep their eyes open.[33]

This temporal integration of two separate moments—the new printing press era and the old pictorial imagination of the Middle Ages that those books draw upon for their innovations—links these books to Kelmscott itself, which aims to keep something old alive and yet to do so by actively embracing the coming age and all its technological advances. Morris turns to the magic lantern because he wants to be shaped by the new and old at once—and he imagines that the fifteenth-century bookmakers he admires were similarly shaped by their present and their own backward glances. We might call this (modifying Raymond William's distinction between

"emergent" and "residual" world views) an ideology of *emergent residualism*. Morris makes use of the latest technologies (lantern-slide illumination and photographic enlargement) in order to recapture medieval aesthetic triumphs, so as to create them anew in the present.

Even in Morris's own lantern lecture of 1890, we can discern the aesthetic drive toward totality that he explicitly adopts as the credo for his own Kelmscott books. It is however, a totality that runs along two parallel tracks. The two-track approach requires that Morris coerce graphic material into narrative service, as well as requires of typefaces that they serve graphic needs.[34] The internal dynamic that Morris sees between "epical" and "ornamental" is revealed, for example, in his "Note by William Morris on his Aims in Founding the Kelmscott Press." That piece emphasizes "the force of the mere typography" in fifteenth-century books and insists that in designing the Kelmscott books he has to "consider chiefly the following things: the paper, the form of the type, the relative spacing of the letters, the words and the lines, and the position of the printed matter on the page."[35] All of this, along with Morris's belief in the importance of the horizontal rectangle—"The unit of a book is not one page but a pair of pages"—suggests a tension between the storytelling and the visual components of a book.

Morris never saw Kelmscott books simply as pairs of pages, horizontal rectangle after horizontal rectangle bound together. Alongside a conception of artwork as material object is Morris's evident allegiance to a compelling "tale"—his devotion to Scott and Dickens was lifelong and passionate. That is, Morris sees the crucial binary between taking pleasure in the look—of text and image alike—and taking pleasure in what the words have to say. Morris praised medieval books as organic precisely because they at once adorned and narrated:

> All organic art, all art that is genuinely growing, opposed to rhetorical, retrospective, or academical art, art which has no real growth in it, has two qualities in common: the epical and the ornamental; its two functions are *the telling of a story* and the *adornment of a space or tangible object.*[36]

Telling and adornment are locked in an inescapably slippery double relationship: the one seeks to delay the viewer, to encoil her in arabesques, while the other rushes her on through permutations and personalities to arrive at the completed action. Morris approaches the problem of the reader's movement through a book (from one spread of pages to the next) by conceptualizing the artwork as itself in motion. By his account, the

"artistic" quality of his books depends upon a planned blending of the still decorative quality of the printed page and the movement of the narrative arc of the "tale," the sequential imperative that keeps the reader turning pages.[37] Morris does not give up on the inertia and the impetus implied by the word *epical* (Fig. 6.5). The words, or the story they unfold, have a temporal dimension—alongside the book's existence as a durable thing of paper and ink and spacing. Not so much vibrating between the two as caught in an apprehension of both, Morris's ideal book audience is aware of a life lived doubly, in and out of time.

The emergent residualism of those backward–looking medieval book-makers aligns, then, with Morris's almost paradoxical vision of the books themselves at once epical and ornamental, defined by their rapidity of motion and their stasis both. Morris's new understanding of the press's capacities derives from Emery Walker's "smokes" and his magic lanterns, fueled by photographs and testifying to the malleability of relics from the immutable past.

Conclusion: Slow Bookmaking

This chapter has to this point emphasized Morris playing the role that Nelson calls the "epideictic lecturer"; that is, making the audience aware of being in the room with beauty. Indeed, those readers who find Kelm-scott Press books difficult to read report feeling overwhelmed by them, brought to a standstill that makes absorption in the text qua text impossi-ble. Yet Nelson's notion of the "forensic gaze" also seems apt for the man who crisscrossed the country lugging his own architectural lantern slides with him. Walker's split slides and disquisitions on type and handwriting are a crucial part of the Kelmscott collaboration, as well. Alongside that dreamer "out of his due time" is always Morris, the consummate crafts-man, whose seeming detachment from the present is better understood as a tinkerer's attachment to the past as mundane country. He remains the man who snapped at his daughter "in a moment of exasperation, a poor drawing of some medieval armor being in question: 'No one can draw armour properly unless he can draw a knight with his feet on the hob, toasting a herring on the point of a sword.'"

Where does this discussion of the interwoven epical and ornamental, the emergent residualism of Kelmscott, leave our understanding of the magic lantern and of Kelmscott—both with regard to Morris as artist and, given the crux nature of late 1888, as committed socialist? In her late

FIGURE 6.5. "The telling of a story and the adornment of a space or tangible object": William Morris's book design for Kelmscott Press explores the persistent tension between the "epical" and the "ornamental." *The Recuyell of the Historyes of Troye* (Kelmscott Press, 1892; courtesy of the Robert D. Farber University Archives & Special Collections Department, Brandeis University).

writings on Kant's aesthetics, Hannah Arendt proclaims that a work of art cannot be a character—by which she means that an artist is guilty of "reifying" actions that belong to the realm where person meets person and turning those actions into mere pieces of work, inanimate and potentially deadly to genuine human interaction. For Arendt, the virtues of "mental visiting" hinge on the absence of any materialization of the forms by which such visiting takes place: in specifying the mental encounters that make up "representative thinking," Arendt never mentions a page from which the departure occurs, never names an article that initiates the encounter.

Morris discerns the same tension, but with the valence inverted. Morris says decisively in an 1893 interview that "a building and a book" are the "best work[s] of all" and that (contrary to J. S. Mill's notion) "a character cannot be a work of art."[38] The two statements appear antithetical: Arendt faults artworks for trying to pass themselves off as human; Morris faults merely social aspects of a life for fraudulently impersonating actual artworks. Both positions draw a bright line between what occurs in the realm of art and in the realm of human interaction, and both discern dangers in crossing the line. What does that bright line mean for Morris's socialism, whether sublimated into or annihilated by his turn toward the Kelmscott project in the early 1890s? The line from Shelley that Morris used to explain the Kelmscott project—"we must look before and after"—suggests he understands artworks to be durable in ways that an unmediated human character is not. If something of a person lives after them—if something of them contains within it a sense of what the unfolding future might be—that something is housed within the artworks they produce, which live on beyond them as (*pace* Mill) a character or a reputation do not.

It has proven difficult for later scholars to decide what this tangled relationship—the superiority of artwork to character, coupled with the necessity for human equality—implies for Morris's politics and aesthetics. One possible solution would be to discern in Morris a belief in a utopic, art-mediated solution to present-day political travails. Jeffrey Skoblow's *Paradise Dislocated* stresses Morris's tendency to seek "the current," arguing that Morris's "aesthetic of habitation is a gesture towards the immediate, a politics of the antitranscendental."[39] The ways in which Morris uses magic lanterns to make medieval books, though—and the ways in which his works of the 1890s cobble together an inherently uneasy mixture of the conception of the epical and the ornamental—suggest that Skoblow may be underestimating the bifurcated nature of Morris's project. In order best

to embody that "current," Morris sees no choice but to make artworks that stand partially outside of it.

One theoretical frame for this chapter's account of Morris's experiments at Kelmscott has been the "materiality theory" implicitly offered by Armstrong, Roberts, and Price. It would be a mistake, though, to neglect Morris's relationship to the wider world of Victorian print publication in all of its rapidity and profusion. Elizabeth Miller's *Slow Print* (2013) explores various ways the late Victorian radical left sought political and aesthetic alternatives to the free flow of (commercialized) information and entertainment that by the end of the century defined the print-mediated liberal public sphere. Miller is interested in the bitter knowledge, beginning among mid-nineteenth-century radicals and socialists, that the "free press and free print" maxims of the earlier radical age had little relevance in a society where not the state but the commercial organs of publication exercised dominance over the circulation of ideas and of art.[40] Socialists, anarchists, communists, and other opponents of class-divided liberal polity faced a promiscuous market-driven publication model that did not silence political dissent, but simply drowned it out in a raucous commercially motivated chorus.[41]

Faced with that exclusion by profusion, what were radicals to do? Morris's poignant description of the "desolate freedom" that *Commonweal* had found outside the realm of widely circulating periodicals suggests the set of left-wing innovations that Miller sets out to explore: forms that avoided "selling out" partly by avoiding successful selling altogether. Miller's account of Morris as aspiring to slowness may not be a complete explanation for the movement between new and old that I have been trying to map, nor the inward tension Morris discerns between the "epical" and "ornamental" aspects of a book. Like the notion of emergent residualism and May Morris's notion of the "new-old industry," however, Miller's account of the appeal of "slow print" for Morris and his cadre sheds light on Morris's use of a medieval craft legacy to fabricate books for a new century. Noticing the appeal of slow print in a rapid age also allows us to consider, as Roberts puts it, how the "friction" of the conditions of production can be registered "not only on the outsides but also on the insides" of artworks: not only in what they materially are but also how they depict the conditions of their work of representation. Parsing that inside aspect of Morris's work requires noticing his sense that every artwork has to be understood as *partially* escaping from its own day—and also partially lodged within the material world from which it arose.

In fact, long before Morris himself had made use of magic lanterns for design purposes, he had already explored their use as a metaphor for grasping the artwork's semi-detached relationship to its own day and place. The Prologue of his early epic poem *The Earthly Paradise* (1868–70) makes the metaphor explicit:

Folk say, a wizard to a northern king
At Christmas-tide such wondrous things did show,
That through one window men beheld the spring,
And through another saw the summer glow,
And through a third the fruited vines a-row,
While still, unheard, but in its wonted way,
Piped the drear wind of that December day.

So with this Earthly Paradise it is,
If ye will read aright, and pardon me,
Who strive to build a shadowy isle of bliss
Midmost the beating of the steely sea.[42]

The wintry blast that shakes the outside of the king's hall (and, implicitly, shakes the outside of Morris's own poem) stands in a fascinating relationship to the visions of the other three seasons that the wizard has "show[n]" against the hall's windows. Kirchoff reads Morris as proposing that "an awareness of the limits of art is necessary if we are to understand its strength."[43] We might also note that this shadowy isle of bliss, projected on three windows but incapable of silencing the ambient sounds of winter, is very like a description of a magic-lantern show, which allows audiences the glories offered through the eye, a glimpse into another world, without allowing them to tune out the sound or the chill of the actual world behind.[44]

Two decades later, conjuring up visions of medieval books out of the slides that Emery Walker projected, Morris was again thinking about the relationship between a shadowy isle of bliss and the steely sea of a world filled with injustice and oppression. The world as it actually was to Morris in 1888 seemed a far cry from the idylls up on the screen. Turning those glowing images to ink-and-paper actuality, then, restores the sensation of partial remove that first arose when the wintry blast of everyday, rundown Victorian England roared behind the screens on which those images sunnily glowed.

Morris is a linchpin for a project that aims to grasp what impact ostensibly external factors like changing conceptions of visual technology

and changing modes of publication had upon prose fiction's crooked path through the nineteenth century. His musings on the lantern-slide quality of all fabulation are as crucial as his theory of the relationship between "epical" and "ornamental" in the book arts. Together, they suggest how consistently Morris strove to reconcile his image of aesthetics as a realm apart with his concrete practical knowledge of how any product of his hands was destined for a present-day audience in search of the partial retreat that the "epical" and the "ornamental" might supply.

To think of Morris as a writer of romances or of fantasy is not only to mark the ways in which his late works deviated from the fictional norms of the day, it is also to hint at a link between his socialist vision for artistic emancipation and the aspirations of a young writer whose rise to fame came just as Morris died. The "scientific romances" of H. G. Wells belong in the same kind of netherworld that Morris's Kelmscott Press had triumphantly constructed. Raymond Williams influentially concluded that the main accomplishment of Wells is to loose on British letters a "confusion of forms." If so, it is a confusion that may owe a great deal to the conglomerated work of the various "lesser arts" that William Morris drew together to build a "shadowy isle of bliss" in his Kelmscott books.

7

H. G. Wells, Realist of the Fantastic

H. G. Wells's 1896 "The Plattner Story" begins with some unlikely ana-
tomical givens. Plattner's heart beats on the right side of his body, and "all
the other unsymmetrical parts of his body are similarly misplaced."[1] Then
there are the behavioral quirks — "he cannot throw with his right hand, he
is perplexed at meal times between knife and fork, and his ideas of the rule
of the road — he is a cyclist — are still a dangerous confusion."[2] Is Plattner
a gauche American? Not quite: he is a schoolteacher who has been rotated
into some mysterious realm by one laboratory explosion, then returned
to our ordinary three-dimensional world by another — but inverted, in
seemingly impossible ways, by his extra-dimensional sojourn. "There is
no way of taking a man and moving him about *in space*, as ordinary people
understand space, that will result in our changing his sides."[3]

If Herbert George Wells were no more than a lineal heir to the weird-
ness of James Hogg or the gothic nerve-play of a descendant like Sheridan
Le Fanu, he would have stood pat with that bit of somatic uncanniness.
Putting before the reader someone shown to be outwardly unchanged yet
inwardly inverted and transmogrified would be work enough for writers
who accepted Poe's two overriding dicta about short fiction: make a story
single in its focus and singular in its shocking effect on the reader. However,
Wells's objectives stretch further. At the story's core is a vividly detailed
rendering of what Plattner experiences while *half*-separated from his own
world. It is not just that Plattner reports "a vast number of ball-shaped ob-
jects . . . watchers of the Living . . . like an eddy of dead leaves in the spring":
it is also crucial to the story's logic that "*our* world" strikes the partially
detached Plattner as a "spectral vision" while he lives among those "Watch-
ers." Crucial as well is that Plattner's students find themselves having "vi-
sions" or "dreams" of Plattner when he spectrally plows through them.[4]
Like many of Wells's protagonists, Plattner has departed from his ordinary
world without quite managing to leave it behind; all that is uncanny about
his experience follows from his partial adhesion to the everyday realm.

Plattner is not the only figure in Wells's early "scientific romances" (to use the period's own label, one Wells embraced) who is simultaneously at anchor in the actual and drifting away. Even in Wells's 1895 *The Time Machine*, the chronic argonaut is described as somehow spookily remaining present in the space of the narrator, although separated from him along the time axis: it is significant that his bicycle/time machine never moves in space, only in time. Darko Suvin has made the case that "all subsequent significant science fiction can be said to have sprung from Wells" because his stories are "ingenious balancings on the razor edge between shock and cognitive development."[5] I would put it slightly differently: Wells is fascinated by fiction's capacity to represent experience that belongs simultaneously inside and outside of the known, everyday world.

Although this chapter has space to discuss only a few in detail, there is quite a catalogue of Wells characters trapped in various states of partial presence. In "The Remarkable Case of Davidson's Eyes" (1895), for instance, Professor Davidson's eyes see the Pacific though his body remains trapped in a London lab; and who could forget Mr. Bessel, who is able to "to hypnotise himself and then to project himself as a 'phantom of the living' across the intervening space of nearly two miles into Mr. Vincey's apartment"?[6] There are also a wider set of tropes in Wells that hinge on partially present characters or related kinds of odd doubling: two doomed experimental aeronauts whose last thoughts are chronicled before their airplane crashes; a sighted man who reports that being able to see only distorted his judgment and made him a moral monster when in "the country of the blind"; an explorer who ventures into a deep-sea abyss, quickly reports his experience to the narrator, then vanishes again into the deep. There is also the "Invisible Man" (1897), who "looked more like a divin' helmet than a human man" and the "crystal egg" in the 1897 story of that name, which allows tired and receptive viewers (but not wide-awake ones) to see "a definite impression of reality . . . a moving picture" of the surface of Mars.[7]

All of these stories hinge on a kind of attenuated or partial displacement, so that characters remain anchored in the here and now, while in another sense they have already quit this earth. Wells's scientific romances consistently struggle with the problem of experience *in extremis* (including, in his remarkable "A Slip under the Microscope" [1896, in *The Yellow Book*], the extremity of an event that generates no sense of experience at all) in ways that are logical developments from nineteenth-century fictional realism.[8] Wells is part of a vigorous petri dish of experimental departures from realism, a fin de siècle dense-pack that it can be easy to overlook. Scholars note but tend to minimize the decade during which Wells associated and

sparred with Conrad, Shaw, Ford Madox Ford, Henry James (with occasional cameos by William Morris, Rudyard Kipling, and Stephen Crane) down by the Kent coast. Because of the violent aesthetic and political disagreement that by World War I had shattered the peace between most of those writers and Wells two decades later, there has been a tendency to underestimate how interested they all were during the 1890s in capturing mysterious shadings or hints of experience occurring up the Congo or on another planet.[9] Looking at Wells in the context of such "up-market" peers reminds us how much he mattered in his day to writers searching for a way forward when confronted with the apparent exhaustion of realist fiction. Asking why Wells seeks out extreme experiences as the ground for his quasi-realist fiction suggests some new thoughts about the various "moderate modernisms" that flourished between the World Wars—and that directly or indirectly benefited from Wells's earlier forays.[10]

Baroque Realism: Wells's Victorian Debts

Wells's varied and complexly reiterated experiments with Plattner-like go-betweens suggest it is a mistake to view Wells simply as a godfather of modern speculative fiction.[11] It is equally misleading to class him (as Woolf memorably does in her 1924 "Mr. Bennett and Mrs. Brown") as a ham-fisted, Bellamy-ist utopian, indifferent to (her own sort of) fiction's capacity to capture real experiences.[12] It is worth noting that Wells's various depictions of partial absorption peak between 1895 and 1906—a time that Wells himself describes in retrospect as defined by "essentially immutable institutions . . . an illusory feeling of the stability of established things."[13] Wells in 1911 looked back to that early creative rush:

> I found that, taking almost anything as a starting-point and letting my thoughts play about it, there would presently come out of the darkness, in a manner quite inexplicable, some absurd or vivid little incident more or less relevant to that initial nucleus. Little men in canoes upon sunlit oceans would come floating out of the nothingness. . . . Violent conflicts would break out amidst the flower-beds of suburban gardens; I would discover I was peering into remote and mysterious worlds ruled by an order logical indeed but other than our common sanity."[14]

He is interested, then, in what changes about everyday conceptions of experience when fiction reaches out to encompass things unseen and impossible.

I appreciate Matthew Beaumont's effort to link the rise of speculative, scientific, and utopic fictions to the way that at the fin de siècle time itself seems to be "off course, beside itself."[15] Yet in explaining why certain kinds of disrupted, experientially off-kilter fictions might have arisen in the 1890s, hypotheses that closely link the rise of Wells, Stevenson, and Stoker to "sustained economic crisis" and culture-wide loss of confidence in "the mid-Victorian narrative of ceaseless progressive development" may be reductive.[16] Similar concerns apply to a recent scholarly tendency, laid out most explicitly in Michael Saler's *As If*, to attribute the midcentury rise of fantasy to a longer tradition of "subcreation" or "secondary worldmaking." Instead, this chapter argues that genealogically, Plattner's ghostly semi-detachment links early twentieth-century speculative fiction to the experimental realism of late George Eliot and Henry James (chapter 5), as well as the magic-lantern cogitations of William Morris (chapter 6).[17] Wells's half-departures from the actual suggest a new way of understanding modernism's debt to that fin de siècle moment, when speculative fiction of various kinds flourished not in distinction from realism but alongside it, borrowing its form and its tropes.[18]

Both Wells's own early literary criticism and Conrad's notion that Wells succeeds by aligning the "flesh and blood" and the "impossible" suggest that Wells initiates a new epoch in science fiction and in fantasy principally by exploring some of the new formal capacities in late Victorian realist fiction, as discussed in chapter 5: new capacities arising from the idea that the readers of fiction are in two places at once.[19] Ian Watt proposes that realist fiction rose in the eighteenth century and flourished in the nineteenth century because it "produc[ed] what purports to be an authentic account of the actual experiences of individuals."[20] Wells takes that actual experience to a series of unforeseen edges—while adhering to the formal conventions of the realism that preceded him.

Conrad is acute in praising Wells for the way that "you contrive to give over humanity into the clutches of the Impossible and yet manage to keep it down (or up) to its flesh, blood, sorrow, folly."[21] The title Conrad proposed in an early letter remains perhaps the best description of Wells: "O! Realist of the Fantastic."[22] Conrad was the first to realize that the innovation in Wells's first decade of scientific romances is their capacity to rotate readers into another world or another dimension without ever leaving the bare ordinary earth behind—their ability to force readers to dwell on the threshold. Wells's dual commitment to the norms of realist fiction and to the rotation of his characters through some added dimension explains

more than just his successful conquest of the genre called "scientific romance" during the short-fiction explosion of the 1890s.

Oscar Wilde labeled Wells a "scientific Jules Verne" early on, and there is no denying his link to didactically technophilic fiction of the 1860s through early 1890s (cf. Flammarion's 1893 *Omega: The Last Days of the World*) nor the subsequent impact his thought experiments—from tanks to atom bombs to rocket design—had on inventors, theoreticians, and scientists. Yet at the time of Wells's death in 1945, Borges declared that "we all feel" that Wells and Verne are "incompatible."[23] Why? Verne dwelt on events, while Wells took readerly experience into account. As Wells himself put it in 1934, Jules Verne "dealt almost always with actual possibilities of invention and discovery . . . but these stories of mine do not pretend to deal with possible things; they are exercises of the imagination in a quite different field. . . . They have to hold the reader to the end by art and illusion, and not by proof and argument."[24] Verne in 1903 was more succinct: "I make use of physics. He invents!"[25]

Describing Wells as master of semi-detachment is in some senses a variant of the oldest critical observation about Wells: that his scientific romances succeed by being simultaneously wildly speculative and thoroughly down-to-earth. His readers, like Conrad, grasped this almost immediately: an 1898 piece in *The Academy* reported that Wells's fiction yokes together "two distinct gifts—of scientific imagination and of mundane observation."[26] In 1897, Basil Williams, reviewing *The Plattner Story and Others* marvels that Wells can write "stories of a most seizing interest" when "one feels that it is almost impossible for anything out of the way to have happened" to his vulgar and commonplace characters.[27] Filon calls him "the great realist of a non-existent world"; an 1898 piece in *The Critic* calls his writing "an Associated Press dispatch, describing a universal nightmare."[28] These critics are responding to the way Wells's stories move readers briefly beyond everyday existence—but do so by using the norms, tropes, methods, and forms that realist fiction had developed over the previous two centuries to capture the subtlest nuances of everyday, *un*exceptional experience. There are also hints of the way that Wells thinks about the relation between prosaic and fantastical in an 1895 letter that explains why he set some of his stranger stories in his own neighborhood. He did so, he reports, so as to "completely wreck and destroy Woking— killing my neighbors in painful and eccentric ways."[29] Wells wants to persuade his readers that deadly spacecraft may linger anywhere: if in Woking where Wells lives, then also in the town where you, dear reader, are reading this.[30]

Crucial throughout the stories of Wells's first decade or so is the question of how reliable a gauge to the actuality of the world any one character's *experience* of that world may be. Wells's interest in Plattner's extra-dimensional flip may owe a debt to an 1884 book by Charles Howard Hinton, coiner of the word *tesseract*, "What Is the Fourth Dimension?"[31] It likely owes more, though, to Edwin Abbott's 1884 *Flatland*—a satire about class and gender relations among triangles and squares who imagine they are living in a planar universe until a sphere one day cuts across their cosmos.[32] *Flatland* explicitly challenges its readers to understand themselves as incapable of grasping all the dimensions that exist around them. Its satirical point is that to hypothetical extra-dimensional visitors, they too may be flatlanders, incapable of grasping the actual nature of their own world.

Abbot's *Flatland* includes a revealing, and very Wellsian, account of how individual experience relates to actual reality. "It is true," the Square tells a three-dimensional interlocutor, that

> we really have in Flatland a Third unrecognized Dimension called "height," just as it is true that you really have in Spaceland a Fourth unrecognized Dimension, called by no name at present, but which I will call "extra-height." But we can no more take cognizance of our "height" than you can of your "extra-height."[33]

What Abbot calls "extra-height" is imperceptibly all around us. Grasping that "extra-height," however, requires a different sort of cognition: and that cognition in Wells comes into view when Plattner enters n+1 space, or the time traveler moves out along the T-axis. *Flatland* is pointing to experiential gaps in the world—gaps fiction is well suited to uncover.

Ironically, Wells learned this commitment to experiential strangeness—the gap between what we perceive and what is actually out there—from his realist novel forebears. Wells grappled with the norms of realist fiction under situations of extreme pressure, seeking out the everyday in the exceptional: in "The Plattner Story," the man who lived in n+1 dimensional space stands out because he never remembers which side of the plate his fork should be on. Moreover in Wells (as with Abbot's *Flatland*), realist fiction's implicit "vale of ignorance" (that suffering underdog might, after all, be you) is turned into an overt political message: you think of yourself as superior, you who read this, but you may turn out to be the inferior after all. This sort of estrangement and recognition of one's own provinciality is a crucial final twist in *The*

War of the Worlds (1897), where Wells suggests the only way to grasp the Martian's relationship to Earth is to think of the effect that invading Britons have had on conquered Tasmanians over the previous few decades.[34]

In short, Wells's way into scientific romance was surprisingly paved by the range of questions posed by the writers of the mid-Victorian era—about the relationship between fictional mimesis and the sort of imagining, wondering, representing, and mental picturing that constitutes everyday imaginative life inside a complex social universe (cf. my earlier discussions of Dorothea yearning toward materiality and the satirical implications of Abbot's *Flatland*). Moreover, the idea that realism had grown overtly self-referential—exploring what it felt like to be a character within a novel and asking in what ways characters and human beings differed—is not simply retrospective projection, a proleptic postmodernist account of Victorian fiction. The arabesques of difficulty for difficulty's sake shape Meredith novels such as *The Egoist* (1879).[35] The possibility that such baroque elaborations foretell serious problems of realist fictions, even the potential elaboration of the novel into obsolescence is also the central worry of Henry James's revealing 1876 "Daniel Deronda: A Conversation."

In that piece, James worries that Eliot's fiction is "cold" because her "intentions are extremely complex. The mass is for each detail and each detail is for the mass."[36] James identifies this "coldness" in Eliot's crafting of characters as intrinsic to the task undertaken: to make readers notice characters' parts within a vast social machinery of the novel, which is analogous to the place that readers themselves occupy within the vast network of their own society. His point is that as the intellectual work of charting the world's machinery waxes, making those individual pieces seem "warm" will be increasingly difficult. As the novel gets better at depicting the complex world we actually occupy, that is, it must grow cool. The more characters manifest their awareness of their existence within that complex whole, the less space there will be for readers to empathize with individual characters. One way to grasp James's point about Eliot is to recall an earlier criticism made of one of Eliot's characters: that he lacks "good red blood in his body. . . . Somebody put a drop under a magnifying-glass and it was all semicolons and parentheses."[37] That critic is also an Eliot character: *Middlemarch*'s Mrs. Cadwallader, pronouncing on Casaubon. Eliot herself had the "coolness" problem under her microscope.

An Uneasy Servant of Fact

Such observations about baroque fictionality in Eliot or James may seem of limited relevance to Wells and his time-traveling, dimension-jumping characters. There is a clear through-line from Eliot forward to later Pater-influenced writers (Conrad and Wilde among them) preoccupied with the gap between the world's actuality and one's own experience of it.[38] But do similar concerns motivate the struggling H. G. Wells in 1895, not far out of a straitened lower-middle-class childhood and scraping out income (as McLean and others have shown) by way of periodical publication under names like Septimus Browne, Sosthenes Smith, and Walter Glockenhammer?[39] Wells, who by the time World War I came was busy with books like *The War and Socialism* and *The Outline of History*, famously mocked Henry James novels as empty churches where instead of holy relics one finds "on the altar, very reverently placed there . . . a dead kitten, a bit of string"; and described James as a "leviathan retrieving pebbles . . . a magnificent but painful hippopotamus resolved at any cost, even at the cost of its dignity, upon picking up a pea which has got into a corner of its den."[40] Wells's fiction—formally bald even when conceptually rich—may seem unlikely to descend from George Eliot's late, involuted realism.[41]

The crucial bridge is semi-detachment's perennial presence in the first decade of Wells's fiction. Wells, like James and Conrad, sees fiction as a record of both events and experiences: the outward life of facts and the inward one of thoughts or sensations. True, the formal simplicity of Wells's writing can obscure this duality: that is what critics get at when they point to the "just the facts" mundanity of his experiments in time travel or extraterrestrial invasion. Posing the question epistemologically rather than formally: in Wells's stories, what relationship is there between what characters know of the world and the reader's beliefs about how the world actually is? Popular and readily accessible, his short stories are nonetheless grappling with puzzles about perception and its limits, between unreliable experience and ungraspable actuality.

In "The New Accelerator" (1901), for instance, Wells posits a drug that allows people to speed up and zoom through their surroundings while those around them seem almost frozen.[42] Wells plays the slowed-down world for laughs (rather than Proustian meditation *a la* Nicholson Baker's *The Fermata*): one concern is whether the high-speed transit through time will cause the grass or the accelerated traveler's clothes to burst into flame. Like "The Plattner Story" (or indeed *The Time Machine*; we might think of drug-induced acceleration as another sort of time travel), this is a

"fantastic voyage" through a familiar landscape, made unfamiliar only by one's changed perceptions. In this as in many Wells stories, the ultimate interest is in the nature of the experiential discrepancy between people sharing a single world, whose time senses will differ even if their actual location remains the same. Wells spells this concern out in a satirically pedantic concluding mediation on the companion drug he hopes to market alongside the Accelerator—the Retarder.

> It is the beginning of our escape from that Time Garment of which Carlyle speaks. While this Accelerator will enable us to concentrate ourselves with tremendous impact upon any moment or occasion that demands our utmost sense and vigour, the Retarder will enable us to pass in passive tranquility through infinite hardship and tedium.[43]

Wells is interested by the gap between the event (time passing chronologically) and the experience—how subjective time unfolds for those standing by.

When we look at Wells's stories from this vantage point—what difference is there between my experience and that of the ordinary bystander?—many of Wells's stories between his 1895 *The Time Machine* and his 1906 "The Door in the Wall" turn out to be preoccupied with accessing snippets of experience in threshold sites where no other reliable evidence could be brought to bear. "Argonauts of the Air" (1895) narrates a deadly crash from the perspective of two doomed aviators, laying down the model for what became a popular mid-twentieth-century form: the juvenile "We Were There" novel. "In the Abyss" has an intrepid young diver travel down into the depths, come back to report on the mermaid kingdom he saw below the waves, and then plunge below again, leaving the narrator to wonder whether the story owes more to facts or to hypoxia.

Movement through an unknown dimension is one recurrent concern of such experiential extremity—n+1 space in "The Plattner Story" and time in *The Time Machine*—downright bifurcation of consciousness is another. Alongside "The Stolen Body" (1898) and "The Remarkable Case of Davidson's Eyes," there is "The Story of the Late Mr. Elvesham" (1896), which features a soul-stealing old man who drugs a young medical student for the purpose of exchanging minds with him. The terrifying heart of the story is the pages in which the young student finds his reality melting away and the old man's experience creeping in. For example, he feels himself both walking down Regent Street and simultaneously entering Waterloo station:

I put a knuckle in my eye and it was [again] Regent Street. How can I express it? You see a skillful actor looking quietly at you, he pulls a grimace, and lo!—another person. Is it too extravagant if I tell you that it seemed to me as if Regent Street had, for the moment, done that?[44]

A boast made by the narrator in "The Plattner Story"—"I have carefully avoided any attempt at style, effect or construction"—holds true even at the moment of (Spock-like) mind-melding. Wells builds his stories on assumptions calibrated to seem like the reader's own: ordinary subjects in extraordinary circumstances. Wells's own retrospective diagnosis of his youth (in his 1934 *Experiment in Autobiography*) rings true: he strove to be "an individual becoming the conscious Common Man of his time and culture."[45]

Experiencing Nothing

Wells's turn toward a notion of semi-detachment to make sense of extreme experiences from distinctly skewed vantage points—extra dimensions, extra sensory organs, extra attuned or attenuated sense of time passing—is complemented by a telling absence: an experience that is not one. This comes in a story seemingly so devoid of all "scientific romance" that its re-publication in Wells's 1897 *Thirty Strange Stories* appears incompatible with that book's title. "A Slip under the Microscope" (1896) focuses on a working-class protagonist, Hill, who yearns to leap into the professional realm by acing a biology exam that could guarantee success in his career. Alas, disaster strikes. During an exam in which he knows that he is not allowed to touch his assigned slide-mounted specimen (i.e., a "slip"), he discovers to his horror that he has, "out of sheer habit, shifted the slip."[46] Although his aristocratic rival has deliberately cheated and kept mum about it, Hill feels impelled to ruin his career by confessing his unconscious shifting of the slip.

The story's only strangeness—hence the only thing that justifies its inclusion in the volume—is that involuntary, inexplicable shift. (If there is a parallel to Wells's idea of the movement out of "sheer habit" it may be found in Conrad's *Lord Jim* when Jim describes abandoning ship: "'I had jumped . . .' He checked himself, averted his gaze . . . 'It seems,' he added.") Hill himself is unsure if he has cheated or not. His snobbish professor finds the case cut and dried:

"Either you cheated or you did not cheat."

"I said my motion was involuntary—"

"I am not a metaphysician, I am a servant of science—of fact."[47]

"A Slip under the Microscope" has been taken as evidence of Wells's way of thinking, in an explicitly realist mode, about his own imperfect class mobility. Certainly we shouldn't underestimate the significance of Wells's own clumsiness in the lab—he left his experimental physics class with "nothing to show but painfully burned fingers and acid-stained trousers."[48]

Putting the story back into the context of all those other anatomies of extreme experience, however, suggests another possible interpretation. The key to the story is the professor's sneering certainty that being "a servant of science—of fact" means discarding all evidence of involuntary actions. To Wells, inexplicable involuntary motions (events without experience) are as worth plumbing as the fourth dimension, the depths of the South Pacific, or the mind that feels itself to be in two places at once—and potentially just as hard to explain. Wells is certainly happy to use this-worldly evidence when it exists. But at certain points, that reliable world of evidence fails, and some kind of inferential exploration of unreliable experience has to be attempted in its place.

Moments like this inexplicable involuntary motion (shifting the slip) matter to Wells because they suggest that in regions where no microscope can penetrate, fiction may provide the only useful data: evidence of experience. In places and at times when nothing mechanical or objective is available, readers must rely on translated, narrated, transcribed accounts of somebody else's consciousness. When faced with an empirical dead-end, a focalizer's experience takes on new weight. Wells locates his stories where more empirically reliable avenues for ascertaining "truth" will fail: so the best source left standing is the story's effort to "suggest, present, convey" the experiences imperfectly relayed to the narrator.

The result that this particular story produces—no experience at all for Hill to report—may seem anticlimactic when compared to extra-dimensional travel or London eyes attuned to the depths of the Pacific. Yet if the real novum in Wells is extreme experience, this "dog that did not bark" story has something important to say about the sorts of forays writers of the 1890s are making. We might draw links, in fact, between that unavailable moment of muscular habit and a whole series of unmotivated occurrences that crop up in problem fiction of the 1890s, especially in what occasionally gets labeled "The New Fiction" in England; in America, a range of fiction sometimes labeled *realism*, other times *naturalism*. Links

might be drawn to Lily Bart's accidental/purposive overdose of chloral, or McTeague's inexplicable rage, and equally inexplicable love for his canary—or even (going a bit further into the realm of contingency) to the perennial Hardy fascination with 50/50 chances: Tess Durbeyfield's letter slipped below the carpet, or Fanny going to All Saints to get married to the dashing Sergeant Troy while he is waiting for her at All Souls. Wells's experiments with such "known unknowns" as that involuntary movement of the slip mark him (as Zola's 1880 manifesto "The Experimental Novel" marks him) as a writer consciously responding to the era's newly emergent "epistemic virtue" of scientific objectivity.[49]

Between Event and Experience

The previous examples speak to Wells's sense that writing scientific romance allows him access to uncharted spaces accessible principally by way of ordinary characters reporting extraordinary experiences—Plattner, the time traveler, or the diver into the abyss. However, no matter how triumphantly the semi-detached character returns to report on the fantastically real event, the gap between ordinary mundane experience and those cognitively estranged spaces abides. He describes himself as having taken "a cleansing course of Swift and Sterne" in 1894; even Wells's stories of this era that putatively end happily nonetheless are redolent of Swiftian melancholy.[50] Both *The War of the Worlds* and "Country of the Blind" end with what should be a triumphant return to normal equipoise that is instead figured as a state of permanent embittered alienation for the narrator; in both stories that narrator's sojourn in the uncanny means he can no longer live happily in actuality.[51]

A short story that comes at the end of this phase of Wells's writing, his 1906 "The Door in the Wall," explicitly thematizes the gap between event and experience. It makes clear Wells's sense not only of fiction's capacities but also of its inescapable and ominous ambiguity.

> One confidential evening, not three months ago, Lionel Wallace told me this story of the Door in the Wall. And at the time I thought that so far as he was concerned it was a true story.[52]

The door of the story's title is one that Lionel Wallace reports having slipped through as a child, arriving at what he recalls as a marvelous fairy landscape with magical princesses, panthers, and capuchin monkeys, among other delights. At subsequent turning points in his life, Lionel again glimpses that same door. Always he finds himself desiring both

to pass through it to a panther and princess-filled fairyland and, equally strongly, not to. Once, for example, he passes the door in a taxicab and hesitates between entering or driving on to begin a prestigious scholarship at Oxford: "I had a queer moment, a double and divergent movement of my will: I tapped the little door in the roof of the cab [i.e., to stop it] and brought my arm down to pull out my watch."[53]

Readers follow his experience so long as it remains divided between adherence to the world's regular chronological time (looking at his watch) and an impulse to flee (tapping the cab roof). This is an oblique return to the Retarder and the Accelerator: Lionel is caught between moving through the world at the same rate as everyone else and opening a door into a fantasy land where all the clocks stop. To remain torn between those two alternatives is what it means for Lionel to live in our own world; when that division ceases, the story climaxes. The night after he has told the narrator his stories about lingering at the magic door's threshold, Lionel disappears through one final door. Yet unlike the protagonists of "In the Abyss" and "The Time Machine," Lionel does not entirely vanish at this point:

> They found his body very early yesterday morning in a deep excavation near East Kensington Station. It is one of two shafts that have been made in connection with an extension of the railway southward. It is protected from the intrusion of the public by a hoarding upon the high road, in which a small doorway has been cut for the convenience of some of the workmen who live in that direction. The doorway was left unfastened through a misunderstanding between two gangers, and through it he made his way.[54]

Lionel's corpse is prosaically emplotted in our own all-too-actual world, underground railway shafts and all. However, the narrator gives inaccessible experience a final word:

> We see our world fair and common, the hoarding and the pit. By our daylight standard he walked out of security into darkness, danger and death. But did he see like that?[55]

Like the Carlylean reflection on what it would mean to escape time in "The New Accelerator," this ending explores the sense of the discrepancy between what I as an individual make of the world, and what that world actually is. The subtle fillip lies in Wells's refusal to decide in favor either of personal perception or the deadweight of a body; as in the "polydoxy" stories by Hogg discussed in chapter 1, neither actual fact nor imagined experience is given the upper hand.

THE AFTERLIFE OF WELLS'S WORLD-AND-A-HALF

Each of these threshold-crossers has something to add to the reader's own understanding of what it means to cohabitate with others in a world in which the connections between distinct persons are tangible, actual, concrete—yet also simultaneously imaginative, vicarious, disembodied. The crux of Wells's problem and also of his innovation is that all around us in the everyday world are extra dimensions, new accelerants, doorways at once ordinary and extraordinary. What he wants to draw our attention to is the imperative both to recognize the possibility of extreme experience and the necessity of returning from that extremity back to the mundane. We pause and consider the uncanny doorway, even rap on the cab door to stop; then we look at our watch and go on. Wells wants his readers haunted by the possibility that Plattner visits are right here with us, that other experiences may be unfolding behind every door.[56] The characters who have gone beyond the line or gone right up to the line and come back for long enough to report their experiences are what implicate readers, making the extraordinary pertinent to the ordinary.[57]

Those transdimensional figures in Wells shed useful light on the origins of modern speculative fiction. Most of the critical debate around Suvin's paramount definition of speculative or science fiction has focused on his account of the "cognitive estrangement" itself: including Chu's recent provocative notion that "science fiction is a representational technology powered by a combination of lyrical and narrative forces that enable science fiction to generate mimetic accounts of cognitively estranging referents."[58] However, Roger Luckhurst's recent taxonomic work points to ways that the genre's self-definitions and constituent elements have varied enormously even over the past century and helpfully highlight some of the problems entailed in Suvin's reliance on an explicitly or implicitly technological "novum" as the launching point for that estrangement.

The semi-detachment I have been charting plays a crucial role in Wells's early fiction because of his interest in pursuing experiential rather than technological novelty (that is the gist of how both he and Verne describe their differences). The point about the experiences that Wells works into stories is that they are understood as providing testimony from those edges of the observable world where other forms of evidence falter—where only what is carried back in the mind of the experiencing character can shed any light. Wells offers, in effect an "art of the gaps" rationale: turn to fiction to grasp the nature of our world only at the sites of experiential limit, those discernible through no other instrument.

This chapter aims to shed some light on the rise of British speculative fiction from the 1890s onward. It begins with and centers on Wells, however, because it is in his writing that the problem of a "doubled state" turns into an overt topic for scientific romance in ways that both differentiate him from his predecessors (Wells's writing baldly enters imaginative realms that straightforwardly realist fiction cannot) and also underscore an oft-overlooked continuity. Wells, like James and Eliot before him, sees his work as making present to his readers the curiously partial state of their own everyday existence in the seemingly ordinary world. Wells does not directly copy Eliot's ways of exploring and running the variations on states of partial absorption into the fictional realm. He is very much her successor, nonetheless. His decade of experiments with the genre of "scientific romance" signals a fin-de-siècle turn away from many of the normative assumptions of Victorian realism—by unfolding curious cases of semi-detachment that allow characters to undergo extreme experiences, while simultaneously remaining anchored enough in the actual world that their stories can somehow be recovered and transmitted.

The Wells-centric endpoint to this chapter would be to conclude by simply asking what we gain by thinking of the ways that Wells uses extreme experience as a baroque elaboration of the fictionality that was spring-loaded into the realist novel tradition Wells inherited from people like Eliot and James, who had already begun to unpack its complex implications in numerous strange ways. However, the trail need not grow cold there. Asking why Wells seeks out extreme experiences as the ground for his quasi-realist fiction suggests a new set of questions to ask about other writers in the speculative tradition—among them E. M. Forster, Rudyard Kipling, Stella Benson, and Sylvia Townsend Warner.[59] Those questions in turn lead to some new thoughts about the various other "moderate modernisms" that thrived in between the World Wars. Looking forward in that way helps us keep sight of the ground Wells covered and recall how much he mattered in his day to writers searching for a way forward when confronted with the apparent exhaustion of realist fiction.

Conclusion: Moderate Modernisms

The diachronic line I have traced not just back to Wells but also beyond him to late Eliot is worth examining in part because there is an understandable tendency among scholars appraising interwar fantasy texts to see them as minor, or watered-down or even "moderate" poor cousins of the

more overtly radical modernism of Bowen, Mansfield, or Woolf. However, Wells and his descendants on the speculative side have quite as much to tell us about what became of fantasy in the early twentieth century as Tolkien does—and more impact than is usually acknowledged on modernist fiction, generally. Sayeau has recently argued that Adorno is quick to disparage a "moderate modernism" he sees as characterized by "the contradiction between the impulse to innovation and the necessity of following the prescription of received forms."[60] Adorno goes on to say "moderate modernism is self-contradictory because it restrains aesthetic rationality. That every element in a work absolutely accomplish what it is supposed to accomplish coincides directly with the modern as desideratum: The moderate work evades this requirement because it receives its means from an available or fictitious tradition to which it attributes a power it no longer possesses."[61] That putative contradiction—the moment residualism threatens to ambush the new—is precisely the flash point where Wells's fiction gets most interesting (cf. the previous discussion of emergent residualism in Morris and the related discussion of Willa Cather that follows).

Older realist fiction's ways of grappling with everyday experience are precisely what allow Wells to tackle the cognitive disruption of the fourth dimension, or of travel through time. The "traditional or fictitious form" that this moderate modernism clings to is realist fiction predicated on the plausible representation of lived experience, while the desiderated modern finds its expression in the fantastic or other-worldly content. This aligns in some ways with Raymond Williams's argument that Wells's fiction eschews modernist formal innovation, preferring to seek out new social forms. Raymond Williams's gloss on the perturbed generic state of Wells's prewar writing makes Adorno's account of moderate modernism sound right, but his indictment unpersuasive:

> Wells is unique in his time because he saw very clearly the scale of the change that was coming, the change that had to be fought for. He couldn't bring it together in any single form: the world as it is and the scale of the change. But he exploits the distance, the imaginative distance, with a skill that's the basis of both his comedy and his prophetics. . . . Ever since Wells and still with real difficulty and urgency we have seen a confusion of forms, an overlapping of interests, a formal separation of imagination, social criticism and documentary which in practice keeps breaking down as the real interests rejoin.[62]

Williams, then, thinks of Wells as inaugurating "a confusion of forms, an overlapping of interests"—a regular bad-form parade.[63] Williams's

assessment sheds some helpful light on other instances of 1930s social critique in which inherited forms are put under peculiar, unexpected pressure.[64] However, the importance of Wells's innovations lies not only in what kind of unforeseen experiential oddities his own stories bring to light but also in the thought experiments that those who come after him unfurl in his wake. [65] Herbert Read's intriguing 1928 assertion that "H. G. Wells comes as near as any writer to a sense of pure fantasy" is perhaps reason enough to spend some time with the early twentieth-century genres that cluster around scientific romance, science fiction, and fantasy.[66] Read defines fantasy as "visionary, but . . . deliberate and rational" and proposes that Wells errs (as a fantasist) only in "imparting to his fantasies a pseudo-scientific logicality."[67]

What sort of family tree for fantasy must Read have had in mind? In recent years, Michael Sandner and Gary K. Wolfe have pointed to Addison's 1712 description of a "fairy way of writing" that proclaims its own "secular magic" quality.[68] I prefer their provocative eighteenth- and nineteenth-century genealogy, which makes fantastic literature a "dark sister" to realist fiction, to Michael Saler's recent case that we should trace the lineage of fantasy as the rise of what Tolkien in his influential essay "On Fairy-Stories" memorably called "subcreation" (i.e., complete "secondary worlds" with logic all their own). While it is possible to look back and identify forebears—underground/underwater fantasies of the 1860s such as Lewis Carrol's *Alice in Wonderland* and Charles Kingsley's *Water Babies*, George McDonald's *Phantastes* (1858) and *Lilith* (1895), and William Morris's prose romances of the early 1890s, as well as cosmogenic projects like E. R. Eddison's 1922 *The Worm Ouroboros* and H. P. Lovecraft's *Chthulu* stories, it would be a mistake to tell the whole story of nineteenth- and early twentieth-century fantasy and speculative fiction via Tolkien's notion of secondary worlds.[69]

Consider all the early twentieth-century work that unpacks the tropes of extreme experience, extra-dimensionality, and hypothetical alternative worlds that Wells unleashed during his first decade. Such an account would consider both Gabriel Tarde's 1904 *Underground Man* and E. M. Forster's 1909 "The Machine Stops" as responses, perhaps even ripostes, to *The Time Machine*.[70] "The Machine Stops" presents life underground as defined by the search for ethereal encounters with pure products of thought. In the dystopic future that Forster spins off of Wells's earlier image of underground life, all material encounters are foreclosed and pure cogitation is the (machine-abetted and ultimately doomed) order of the day. Thus the protagonist, forced to fly over the earth's surface, is bored by witnessing

sunrise over the Himalayas: "Close the window, please. These mountains give me no new ideas."[71] For Forster, Wells's image of a future gone underground offers an opportunity not to create a "secondary world" but to put realism through a wringer: to reconstrue the glories and the dangers of present-day civility as harbingers of later doom.

That genealogy of post-Wells British speculative fiction might also touch on Rudyard Kipling's enigmatic tales (collected in *Puck of Pook's Hill [1906]* and *Rewards and Fairies [1910]*) about Puck as a *genius loci* from bygone England.[72] "The Tree of Justice," the last story in the latter volume, ends with all the characters gazing down at a dreaming dormouse plucked from inside a haystack and wondering if they have killed it while it slept. The context makes clear that the dormouse (in his dormition) stands in not only for the protagonists—who themselves only meet the fairy Puck while in a dream state—but also the readers of Kipling's own story. Like the child protagonists, after all, we too enter a fantastical world as long as the story lasts, yet also remain elsewhere, ensconced in our own flesh and blood. A complete genealogy of Wells-inflected British speculative fiction would also touch on Henry James's *The Sense of the Past* (discussed at greater length in chapter 5), a novel suggesting that—because all of us are trapped in our recollections even when in one another's direct presence—we all are time travelers of a sort.

Wells's work had significant transatlantic implications. Just as Henry James served as a vital conduit between British late Victorian experimentalism and later modernist fiction (Willa Cather, subject of the following chapter, included), H. G. Wells sparked the explosion of science fiction in America: Hugo Gernsback's seminal *Amazing Stories*, launched in 1926, reprinted "The New Accelerator" in its first issue, "The Crystal Egg" in its second, "The Star" in its third, and onward nearly ad infinitum. It is also worth noting, though, Wells's influence on British writing of the day. The best-known English and Irish fantasy writers of the modernist era (a "minor canon") display a Wells-like fascination with baroque experimentation with fiction's limits.[73] Lord Dunsany's strange World War I–era fantasy tales, for instance, include "A Tale of London" (in which a Baghdadi sheik hears fairy tales about London) and "How One Came, as Was Foretold, to the City of Never" (in which a visitor to Fairyland finds that its residents, too, are haunted; on the far side of Fairyland lies a land that is as mysterious and alluring to Fairyland as Fairyland is to mortals; *Flatland* redux). David Garnett's 1922 *Lady into Fox* would also belong in such a minor-canon genealogy.[74] Hope Mirrlees's 1926 *Lud-in-the-Mist*, in which fairy fruits that float down the river into Lud are packaged, candied,

and form a lucrative part of the export industry, is also redolent of Wells's experiments in extreme experience. So, too, are Herbert Read's *The Green Child* and Joseph O'Neill's *Under England*, which share the unlikely category of 1935 British bizarre deadpan fantasies about subterranean civilizations with quasi-communistic aspirations.

In fact, implicitly Wells-influenced speculative experiments proliferate between the wars. Thinking about the novel's role as representing difficult-to-get-at inward experiences, for example, might point toward a "fantastic correlative" reading of Rebecca West's 1918 *Return of the Soldier*. In that novel, battle fatigue is in some ways represented as a form of Proustian magic, one that can suspend time for the shell-shocked Chris: "He was to be as happy as a ring cast into the sea is lost, as a man whose coffin has lain for centuries beneath the sea is dead"; before he is brought psychotherapeutically back, in the name of "dignity" "from various outlying districts of the mind to the normal" and of course straight back to the trenches, to "No-Man's-Land."[75]

This road also leads to Sylvia Townsend Warner's 1926 *Lolly Willowes*, in which Satan helpfully shows up to bail the heroine out of a boring life. The Devil's main attraction as soul mate is his willingness to leave the heroine alone.

> She could sleep where she pleased, a hind couched in the Devil's coverts, a witch made free of her Master's immunity; while he, wakeful and stealthy, was already out after new game. So he would not disturb her. A closer darkness upon her slumber, a deeper voice in the murmuring leaves overhead—that would be all she would know of his undesiring gaze, his satisfied but profoundly indifferent ownership.[76]

Satanic indifference is the blessed alternative to the obligations of a normative and stifling social subjectivity. In *Lolly Willowes*, fantasy offers a trapped female character a chance *not* to be seen by one's family, hence not forced rise to the challenge of serviceable selfhood in a corrosively conformist social role.

Stella Benson's nearly forgotten *Living Alone* (1919), though, may be the purest case of post-Wells fantasy. Benson's novel exemplifies an important impulse in the era's fantasy: rather than creating a full-fledged "secondary world," such books go to the edges of actuality while leaving many of the ordinary norms of mimetic realism intact. The novel centers on Sarah Browne, an ordinary English woman who moves to London during World War I and ends up lodging in a boarding house run by witches.

Its *world-and-a-half*-ness manifests early on in a broomstick dogfight between a German and an English witch, which takes place during an actual German aerial assault on London.

Benson takes the absolute this-worldly presence of witches for granted, a *pu sto* from which the whole fiction follows. The question Benson poses is what happened in the actual world to open up space for such fantastical givens. One hint to Benson's answer comes from a discussion between Sarah and a wizard about whether war and magic can share the same universe—a discussion that follows shortly after the witch-on-witch dogfight that ended with the gruesomely depicted death of the German witch. Has your magic caused this war, she asks accusingly?

> Good Lord, no. . . . It was made and supported by men who had forgotten magic; it is the result of the coming to an end of a spell. Haven't you noticed that a spell came to the end at the beginning of the last century? Why, does not every one see something lacking about the Victorian age?[77]

Instead, he proposes that magic and the war are related in a different way:

> As for spells—we have started a new spell. That's the curious part of the War. So gross and so impossible and so unmagic was its cause, that magic, which had been virtually dead, rose again to meet it.[78]

Like Bowen, Mansfield, and Woolf (only with added witches), Benson anatomizes the social pressures that make it hard for a woman set temporarily adrift in English society to establish a sense of self without succumbing to marriage or one of the other deadening roles that haute bourgeois life provides. That the novel's title refers to a boardinghouse of anomic spinsters may be more significant than the fact that the boardinghouse is run by a witch. When the heroine Sarah Brown leaves magic behind her and heads off to America, the final line underscores the metaphoric fluidity of the title: a guard glances at her passport at Ellis Island, waves her through, "and she stepped over the threshold of the greater House of Living Alone."[79]

It is probably a good idea to avoid over-earnestness in analyzing any writer who said that reading T. S. Eliot made her feel what "I think a marshmallow must feel like . . . in the presence of a green olive or a pickled walnut."[80] Still, there is something significant in the notion that the war resurrected magic.[81] On the one hand, Benson strives to integrate the idea of "living alone" back into an eminently real-world concern about how women are meant to make their way in this volcanically shifting new social landscape—hence the ending under the shadow of the Statue of Liberty.

On the other hand, the post-War persistence of Sarah's witch (last seen giving a "flippant and ambiguous gesture of her foot" as she stumbles off the Statue of Liberty's crown[82]) suggests that Benson is searching not so much for Eliot's "objective correlative" as for a new way of grounding the real, call it a "fantastic correlative." Benson—like Warner, Read, and a whole passel of fantasists who drew inspiration from Wells and Dunsany both—is still pursuing the Wells strategy of trying to make sense of what it is like to come up against extreme, implausible experiential intrusions into a shared ordinary world. *Living Alone* is a sort of magical Rorschach blot, designed to elicit from readers a sense of their own subjective responses to this brave new world.[83]

In many ways, the modernist overhaul of the novel left its aesthetic autonomy stronger than ever, its susceptibility to the muddling together of imagination and social criticism diminished not strengthened: a comparison of the "social criticism" present in Dickens or in Zola with that in a novel by Woolf or Joyce suggests ways in which "bad form" could be sent packing. Nonetheless, the new fictional isotopes that sprang into being in the first third of the twentieth century undoubtedly respond to that "confusion of forms" Williams pointed out. Like it or hate it, the "moderate modernism" that Adorno denounced is also an outgrowth of the late realist experiments of Eliot and James, and the fantastical turn initiated by Wells. And perhaps no novelist better embodies and reflects upon the contradictions of devising a new sort of fiction after both the stridency of naturalism and the baroque stylistic inwardness of Henry James than the hard-to-place experimentalist Willa Cather.

8

Overtones and Empty Rooms:
Willa Cather's Layers

> When I look into the Aeneid now, I can always see two pictures:
> the one on the page, and another behind that: blue and purple rocks
> and yellow-green piñons with flat tops, little clustered houses cling-
> ing together for protection, a rude tower rising in their midst, ris-
> ing strong, with calmness and courage—behind a dark grotto, in its
> depths a crystal spring.
>
> Willa Cather, *The Professor's House*

Hard Work Being a God

One bridge between Wells's scientific romances and the modernist novel
is a simple opera story. The June 17, 1899, edition of the Lincoln, Ne-
braska, *Courier* reviews a "most brilliant performance" of Wagner's 1870
Die Walkure in Pittsburgh. The author chides "Frau Lehmann's stilted
posings," praises "Herr Van Rooy" as Wotan for his "vitality," and cel-
ebrates the moment when "the sword song, glorified, flashes up from the
orchestra like the steel itself." Twice, though, the review slides away from
the actual opera.

> During the intermission between the first and second acts I left the
> theatre and was crossing the bridge between the stage entrance of the
> grand opera house and the Avenue Theatre, when I was arrested by a
> most marvelous sound, The bridge extends above the dressing rooms
> of both theatres; in the dressing room just below me the skylight was
> open, and from it there streamed up a flood of light and a perfect
> geyser of the most wonderful notes that were quite unmistakable. It
> was Mme. Brema practicing the "Hi-yo" song of the Valkyries. The
> night was murky and starless; only the red lamps of the Hotel Henry
> and the line of river lights above Mount Washington were visible; on
> every side rose the tall black buildings that shut out the sounds of the

streets. Those free, unfettered notes seemed to cut the blackness and the silence, seemed to pierce the clouds which lay over the city and reach the stars and the blue space of heaven behind.[1]

This fragment of backstage song evidently affects the *Courier*'s reviewer—a very young Willa Cather—quite differently from the opera itself. There is no critical judgment here, just a tactile, vivid account of a song reshaping her experience of an ordinary evening, smogged over by the relentless production of the Pittsburgh iron mills. Readers no doubt readily pictured the overpass, recognized the sort of night, and heard that bit of rehearsal song drifting into it—a lyrical overlay on prosaic reality.

The review's other move away from straightforward opera reporting comes after the final curtain:

That night, when the singers boarded their special streetcar to take the long run out to the Hotel Schenley, where they were stopping, I got on the same car with several local musicians who were going out to a supper party. When the car was bowling off across the hill tops, I noticed a man in the further end fast asleep. His coat collar was turned up, his linen crimpled, the make-up still discolored his eyes, his face was damp with perspiration, and he looked gray and drawn and tired. It was Herr Anton Van Rooy, late of Walhalla, tired as a labourer from the iron mills. It is hard work apparently, this being a god.[2]

Here the "other world" that music conjures up no longer points the writer up toward the stars. The singer, like any factory worker, sleeps off his efforts in our shared, everyday world.

Throughout her career, Cather returns to the question this little piece raises: what do opera and the prosaic space of pedestrian bridges and streetcars have to do with one another? Opera may be incantatory and streetcars may be humdrum. Cather's prose, though, aspires to partake of both qualities at once. The passage from *The Professor's House* (1925) at the start of this chapter points to Cather's abiding interest in moments when two disconnected experiences converge so that one seems to occupy a dual position, a locus at once within and without one's ordinary surroundings.

Cather's distinctive modernism arises from her fascination with the dichotomy between the world of aesthetic dreaming and the world of hard facts—and her surprising assertion of fiction's capacity to inhabit both simultaneously. As chapter 7 argued, Wells produced a decade's worth of stories that pushed experiential realism into the extra-dimensional or

para-terrestrial realm. From early in her career, Cather represents the not-quite-separateness of the artistic realm as an abiding this-worldly mystery, something happening around us all every day. If it is hard work being a god, it is equally hard for ordinary people to make sense of our dual habitation of an actual and an imaginative realm—living in a world defined not only by one's ability to *receive* what is happening around us but also by one's capacity to *reflect* upon what has happened before and what shapes one still. Wells imagines one "invisible man" moving among an ordinary world of unremarkably visible folks. In Cather, we all of us inhabit a world populated in part by invisible men, products of our memories or our imaginings for the future.

Semi-Detached Cather

The ways that Willa Cather exploits, plays with, and reflects upon fiction's power of semi-detachment strengthen the case I have tried to make for reframing Gallagher's "rise of fictionality" hypothesis. The innovative and unexpected ways that *translucency* (visual overlay of two realities on one another) and *overtones* (a form of aural overlay) structure both characters' and readers' experiences within Cather's novels suggest that what Gallagher describes as a general property of fiction might also be understood as a curious development that overtakes and transforms late nineteenth- and early twentieth-century novels. Accordingly, this chapter sets out to track Cather's idiosyncratic movement away from antecedents ranging from James's novels of consciousness to Norris's naturalism toward ideas about overlay and echo-filled empty rooms that resonate with the Wellsian experiments traced in the previous chapter. Already nascent in those opera reviews of the 1890s is a doubled relationship between aesthetic experience and the everyday—a doubleness that continues to evolve and profoundly shape her fiction from *O Pioneers!* (1913) to *The Professor's House* (1927), and beyond. Cather's turn toward moments of aesthetic translucency (the overlay of song on cityscape, or "blue and purple rocks and yellow-green piñons with flat tops" on top of the *Aeneid*) are not simply imagistic extravagances, or grace notes. They are her direct effort to represent the problem, as well as the promise, of a semi-detached aesthetic experience.

Making the case for Cather as a writer fascinated by moments or states of partial absorption means tracing her complex literary genealogy. Paradoxes abound: She styled herself an old-fashioned body—one

of her books has the slyly off-putting title *Not Under Forty*—yet chose to live among the rowdiest and most subversive of the Greenwich Village bohemians. She was a prairie novelist who lived in New York; a cosmopolitan globe-trotter who left home at eighteen, yet boasted that more than three-quarters of those who lived in her childhood Nebraska were foreign-born.[3]

Cather's paean to her quasi-mentor Sarah Orne Jewett notwithstanding, Cather's fiction is never neatly loco-descriptive.[4] Though rooted in the Midwest, and returning to it at will, her fiction rarely features the plaints about provincial confinement that permeate major works by other writers of the region: Edgar Lee Masters's 1915 *Spoon River Anthology* (Masters was born in 1868 in Garnett, Kansas); Sherwood Anderson's 1919 *Winesburg, Ohio* (1879, Camden, Ohio); and Sinclair Lewis's 1920 *Main Street* (1885, Sauk Centre, Minnesota); not to mention the slightly older Hamlin Garland's 1891 *Main-Travelled Roads* (1860, North Salem, Wisconsin). On the other hand, she decidedly does not belong among the posse of writers who effaced (or equivocated about) their Western roots when crafting their cosmopolitan modernist personae (Ernest Hemingway, born 1899 in Oak Park, Illinois; T.S. Eliot, 1888, St. Louis; F. Scott Fitzgerald, 1896, St. Paul).[5]

Two influences kept her work at arm's length both from full-blooded regionalism and from the high modernist cosmopolitanism: her early attachment to the fiction of Henry James, and the gravitational pull of Frank Norris's naturalism. (There is perhaps also a third influence: Cather's multifarious experience in the periodical press, starting with her 1906 move to New York for an editorial role at *McClure's*, which exposed her not only to the constraints of print publication in America but also to the literary world across the Atlantic.[6]) While Cather's 1913 *O Pioneers!* sheds many of the superficial Jamesian elements she felt had weighed down her first novel, the 1912 *Alexander's Bridge*, her later work continues to testify to the impact of James's effort to make fiction explore the peculiar challenges in simultaneously representing actuality and the world as experienced. When Edmund Wilson faulted *A Lost Lady* for "a disability like that of Henry James: it is almost impossible for her to describe emotion or action except at second-hand," he is probably picking up on Cather's capacity, inherited from James, to move between what he called the "dramatic" and "representational" modes: that is, between an account of events and an account of the experience of the characters to whom those events occur.[7]

Still, Cather was deliberately pushing away from James by 1913—and toward what shore? Ahearn has made the case that in her 1915 *The Song of*

the Lark Cather marks her debt to Norris and Crane and Dreiser's brand of "American Realism," adhering to their vision of an unrelentingly determined universe of massive inescapable natural and social laws into which every individual must ultimately be shaped and compressed and regularized.[8] Cather deeply admired Norris early in her career: "He is big and warm and sometimes brutal, and the strength of the soil comes up to him with very little loss in the transmission."[9] Even without the torque that James's influence applied, however, Cather's concerns are misaligned with certain aspects of the new fictional mode Zola had brought into being (or perhaps simply recognized and described) in his 1880 manifesto, *The Experimental Novel.*

According to Michael Winkler, although literary naturalism over the centuries has sometimes been used broadly to describe "representation of a vital reciprocity between the human being and his living natural environment," in Zola's era the word *naturalism* meant

> the programmatic systematization of a literary aesthetic that sought to reconcile the aims of art with the all-pervasive authority of the natural sciences . . . subordinating an "antimodern" insistence on creative individualism to nomological methods of construction that reflect the techniques of advanced scientific specialization.[10]

That lapidary and slightly gnomic definition clarifies both Zola's commitment to the notion of novel as experiment, and his view (shared by Norris and Dreiser) that the present social habitus is a direct crystallization of natural laws: "If the experimental method leads to the knowledge of physical life, it should also lead to the knowledge of the passionate and intellectual life."[11]

Lukacs's 1936 essay, "Narrate or Describe?" adds another crucial point: that naturalist writing is descriptive not narrative, meaning that it focuses tightly, sometimes timelessly on minute details—or that it zooms upward to levels of almost godlike abstraction (Zola: "In my work there is a hypertrophy of real detail. From the springboard of exact observation it leaps to the stars").[12] Two crucial features of naturalism, then: (1) science-emulating attempts to understand the predictable rules that govern human behavior, rather than an emphasis on moments of moral decision; (2) palpable oscillation between microscopic description and macroscopic abstraction in place of experiential narrative.[13] We can see this macroscopic scientism at work, for example, in Norris's 1903 *The Pit.* Like Cather's *Song of the Lark,* it is a Chicago-based novel with an interest in opera. The novel actually begins with its heroine waiting outside an opera house,

eager to lose herself in the grand amnesiac experience that opera alone can provide. When the music starts,

> Laura shut her eyes. Never had she felt so soothed, so cradled and lulled and languid. Ah, to love like that! To love and be loved. There was no such love as that today.[14]

However, the mood can't last, and the way it's interrupted is revealing.

> But a discordant element developed. . . . She heard, in a hoarse masculine whisper, the words:
> "The shortage is a million bushels at the very least. Two hundred carloads were to arrive from Milwaukee last night — "[15]

Laura's despair at being yanked out of her reverie misses the point, Norris suggests. Opera is only fake drama: commodity trading is the real thing. The lurid melodrama that is merely being acted out inside the opera comes to real throbbing life in Chicago's other Pit — the Commodity Exchange.

In *Song of the Lark*, by contrast, opera itself turns into a material realm, one where singers struggle to keep their voices clean for thousand-dollar performances, and where the aspiration to enter into a realm of Wagnerian sublime goes hand-in-glove with cold-blooded calculations about whether its heroine, Thea Kronborg, can spare the time to visit her dying mother. Norris poses an unavoidable choice between dream worlds and commodities: in Cather, the overlay persists, so that the artistic realm is both removed from and unavoidably interwoven with mundane materiality ("hard work apparently, this being a god"). Singers belong on the stage and in the streetcar both; singing both belongs to an evanescent realm and is the product of trained throats straining to wrest the right notes from a trembling column of air. Rather than setting up a straightforward binary between high culture and the low goals of mere commerce, Cather in *Song of the Lark* aligns Dvořák's music with the masculine vigor of the West and the appeal of the realism of Crane or Norris. That combination signals something quite distinctive about the ethos Cather propounds: in her world, reveries (e.g., the power that the *Aeneid* has to bring back visions of the mesas in this novel's epigraph from *The Professor's House*) all stem from, and return to, a shared, everyday material world.

One literary aftereffect of Cather's brusque commitment to reckoning with the materiality of even the most pink-clouded reverie comes in a perennial insistence that readers think about any possible afterlife as not a spiritual but a physical fact. For instance, the final paragraph of *O*

Pioneers! muses about what the happily reunited Alexandra and Carl can give back to their home.

> Fortunate country, that is one day to receive hearts like Alexandra's into its bosom, to give them out again, in the yellow wheat, in the rustling corn, in the shining eyes of youth![16]

That a novel with an exclamation point in its title should also end with one may be taken as marking the writer's own surprise at the incongruity of the final image: that hearts will metamorphose in the grave.[17] The persistence of spiritual yearning, or romantic love, here, returns as a material proposition: Alexandra's decomposing heart leads to future shining eyes by way of wheat and corn.

Cather is not simply crediting the writer or reader with the capacity to imagine such a metempsychosis. The novel's whole economy is predicated on Alexandra's capacity to see that such transformations are possible—that investments in new machinery will turn, eventually, into verdant wheat fields and hence into future happiness. The imaginative leap required here of the reader—corn and youthful love as one and the same thing, springing out of the land annually—is the same leap that Alexandra (unlike the two stolidly unimaginative brothers she perennially battles) is able to make as a farmer, in her various sales, investments, mortgages, and modifications of the farm. That capacity to translate current holdings into the ebb and flow of capital is, by Cather's account, another form of translucency. The capacity to overlay future potency onto the material present is the imaginative gift that unites the successful farmer with the writer.

Jude's Magic Lantern

Distinguishing Cather's aesthetic both from James and from Norris does not mean thinking of her aesthetic aims as arising de novo. In fact, Cather's interest in overlaying opera music on ordinary Pittsburgh grime, in the translucent images overlaid on hard material ("When I look into the *Aeneid* now, I can always see two pictures: the one on the page, and another behind that") is strikingly prefigured in the work of another novelist who was both drawn to and leery of the hard structuralism of Zola's naturalism (a novelist who Willa Cather singled out in 1895, with Meredith and Henry James, as one of the only three great non-French living novelists).[18] Thomas Hardy's 1895 *Jude the Obscure* anticipates many of the aesthetic positions Cather stakes out two decades later.

By the mid-1890s, Hardy thought that the time for a Dickensian accounting for individual lives at the level of traditional narrative had passed. Yet he lacked Zola-esque certainty about the kind of macroscopic, generalizable plot that one might put in its place.[19] Accordingly, he turned his attention to the gap that looms between the world's actuality and the ways that world strikes various characters. Thinking of Hardy as an investigator of the gap between experience and event helps clarify not only early moments of scientifically explicable illusion—Jude glimpsing a luminous mirage of Christminster on the horizon at sunset—but also the strange night scene when Jude first arrives in Christminster and wanders the streets, conversing with ghosts of the university's past greats, before a policeman breaks in on his half-reverie. The strange peripatetic dialogues that Hardy stages between Sue and Jude, who only intermittently touch down in the physical world as they walk and talk, are another form of such partial dislocation.

The moment Jude meets his first wife, Arabella, highlights the role that translucency plays for Hardy. Musing about his future studies, he only becomes aware of his actual surroundings when she hits him with the penis of a freshly castrated pig.

> "Meanwhile [Jude says to himself as he walks] I will read, as soon as I am settled in Christminster, the books I have not been able to get hold of here: Livy, Tacitus, Herodotus, Aeschylus, Sophocles, Aristophanes—"
>
> "Ha, ha, ha! Hoity-toity!" The sounds were expressed in light voices on the other side of the hedge, but he did not notice them. His thoughts went on: "—Euripides, Plato, Aristotle, Lucretius, Epictetus, Seneca, Antoninus." . . . In his deep concentration on these transactions of the future Jude's walk had slackened, and he was now standing quite still, looking at the ground as though the future were thrown thereon by a magic lantern. On a sudden something smacked him sharply in the ear, and he became aware that a soft cold substance had been flung at him, and had fallen at his feet.[20]

The catalogue of classic authors Jude will never get to read is worth noting here, as is the fact that what he later discovers is the "characteristic part of the barrow pig" feels only like a "soft cold substance" when it first hits him. But central to the passage's force is the way that a desirable image just beyond Jude's reach—his future as a Christminster scholar—quasi-materializes to him as a magic-lantern image (shades of Tom Outland's *Aeneid*) glimpsed on the road ahead of him.[21]

Hardy is not suggesting Jude would be better off dwelling in a realm of pure ideas—"the republic of the spirit" that Edith Wharton's 1905 *House of Mirth* satirizes as Lily's Bart's unrealizable ideal.[22] Yet Jude's projected future, unattainable as it is, has a kind of reality to it. Just as a magic-lantern image needs a medium (think of Proust's Golo, trotting across the curtains, wall, and door handle of Marcel's bedroom) so, too, does Jude's dreamed future require a substrate. Hardy is not aiming here to lay bare the true material facts of the world beneath all those trappings and illusions of the ideal. Were that the case, then Jude's future would merely read as a sham and delusion—rather than an unrealizable vision. He is interested in the way that Jude's ideals and his dreams—also incarnated in those biscuit copies of Christminster colleges he bakes later on—are spread on the roadway, lodging themselves in the same world where pig penises fly through the air. In Norris, the dream is punctured and gives way to reality. In Hardy, the dream, too, is a part of the one, indivisible reality: any story that omitted such unfulfilled longings and impossible ambitions would no longer be realist.

One way to make naturalist sense of such poignant moments in Hardy—and similar ones in Cather—involves following Jameson's recent argument that naturalism's cold scientism has been overestimated, and its melodramatic qualities undervalued. Rather than accepting as central to Zola's fictional project "elaborate genealogical charts" that establish "tainted heredity" and inescapable determinism, Jameson points to the way that Zola "melodramatically intensifies" a premonition of "destiny . . . into an extravagant sense of impending doom."[23] Jameson makes the point that rather than vanishing into austere scientific determinism, Zola's version of "inevitability" is laden with highly wrought feeling, so much so that we should see it not as "regression into some older Hugolian if not Gothic excess" but rather "a unique form taken by the temporality of destiny when it is drawn into the force field of affect."[24] For Jameson, affect is woven into the melodramatic unfolding of the destiny plot.

Jude's poignant efforts to make his dreams align with the cold reality of a world where he can only glimpse the outside walls of colleges (and only come closer to them by selling biscuit replicas) would by this reading "foretell . . . the dissolution of the compact between chronology and the present that makes realism possible and thereby signals the crisis of plot which has regularly been taken to spell the end of realism as such."[25] In Hardy's relationship to Jameson's sort of naturalist affect lies a hint about Cather's debt to a particular sort of naturalism—a naturalism that works not by eradicating subjectivity, but by forcing readers

to confront the pathos of the discrepancy between objective actuality and individual experience. Like Hardy, Cather is not interested in using heightened affect to turn characters' emotions into merely material phenomena (rendering their predictable response to stimuli into evidence of mere animality and the absence of agency). Rather, she wants to make readers feel the misfit between experience and a merely dispassionate account of the world.[26]

A Picture Writing on the Sun

In Norris's naturalism, opera is cultural superstructure, punctured or even rendered nugatory by hard commercial facts. In Cather, though, the capacity to see symbolic relationships by way of fiction runs right up and down the social spectrum, rather than occupying the ethereal zone occupied by opera—when Thea enters fully into a triumphant operatic career in *The Song of the Lark*, the novel draws to a close. Cather is in fact revealingly explicit about the way that her most highly charged symbols emerge from, and return to, the ordinary earth. The flickering objects that fill Cather's novels are both breathtaking and prosaic. Tom Outland in *The Professor's House* doesn't just see images of the cliff dweller's mesa when he is reading *The Aeneid*: it has lodged itself into his consciousness so comprehensively that "by closing my eyes I could see it against the dark, like a magic-lantern slide."[27] Mystery and banality—the sleeping Wagnerian singer on the streetcar, millennium-old cliff dwellings as spectral magic-lantern images—are comprehensively mixed in Cather. She is working to develop a vocabulary to articulate the complex relationship between what is materially present and the experiential dislocation that presence can induce.

This duality makes clear the distinctive nature of Cather's interest in symbols: she cares less about the symbols themselves than the process whereby the ordinary appurtenances of the world are turned into symbols. For example, *My Antonia*'s memorable description of a plough made huge at sunset—then just as suddenly shrinking back to cold dark nothingness.

> A plough had been left standing in the field. The sun was sinking just behind it. Magnified in the distance by the horizontal light, it stood out against the sun, was exactly contained within the circle of the disk—the handles, the tongue, the share—black against the molten red. There it was, heroic in size, a picture writing on the sun.

Even while we whispered about it, our vision disappeared; the ball dropped and dropped until the red tip went beneath the earth. The fields below us were dark, the sky was growing pale, and that forgotten plough had sunk back to its own littleness somewhere on the prairie.[28]

The plough really is "a picture writing on the sun"—but it is also just a cold piece of metal a few fields over. It snaps briefly into symbolic life then reverts back to mere materiality.[29]

This offers a new kind of literary context for Cather: if the example of Norris and Crane pushed Cather toward sinews and substance, toward depicting the determinative structures that underlie any single character's life and choices, she also retained a Jamesian sense that experience, rather than bare events, might be the basic stuff of fiction.[30] In a letter to her editor about her 1915 *The Song of the Lark*, Cather told him that the "'My country, 'tis of thee' feeling that it always gives me" proved to her "how much of the West this story has in it." "The desert" she added, "will always be here in this book for me."[31] This form of self-praise suggests Cather understood representing the substance of a place and its concomitant sensibility as her primary task. It sometimes even seems Cather understands sensibility *as* the substance of the world her novels depict. Cather's interest in her character's semi-detachment from their surroundings suggests ways in which she remained aligned with the Jamesian interest in the novel as representing the experience rather than the actuality of the world.

Yet Cather's interest comes with a distinctive (and Hardy-like) wrinkle: the world's material lineaments are overlaid with, but not obliterated by, the afterlife of strong feeling or recollected memory. The entrepreneurial genius of Alexandra Bergson is not predicated on dreaming of future profits while neglecting present realities. Rather it lies in the way that she construes, or constructs, tenuous but plausible connections between current harvest and future profit. Similarly, *The Song of the Lark* hinges on moments in which the past is overlaid upon the present, and capable of adding to that present some indescribable surplus; memory overlays a magic-lantern image on everyday surroundings. Like the *Aeneid*/piñons overlay in *The Professor's House*, such moments push characters into reveries (or projective visions of the future) that remain linked to their physical point of departure. Remember the narrator's elbows in *The Mill on the Floss*, which can feel cold pressure on the stone bridge inside the story because they *actually* feel cold pressure from the arms of a chair, back in the narrator's study.

Early on, for example, Thea goes on a picnic with the first musician she has ever known, Johnny Tellamantez. When he sings at picnic's end, every listener is struck differently:

> Johnny, stretched gracefully on the sand, passed from "Ultimo Amor" to "Fluvia de Oro" and then to "Noches de Algeria," playing languidly.
>
> Every one was busy with his own thoughts. Mrs Tellamantez was thinking of the square in the little town in which she was born. . . . Thea, stirred by tales of adventure, of the Grand Canyon and Death Valley, was recalling a great adventure of her own. Early in the summer her father had been invited to conduct a reunion of old frontiersmen, up in Wyoming, near Laramie, and he took Thea along with him to play the organ and sing patriotic songs. There they stayed at the house of an old ranchman who told them about a ridge up in the hills called Laramie Plain, where the wagon-trails of the Forty-Niners and the Mormons were still visible. . . . The top of the ridge, when they reached it, was a great flat plain, strewn with white boulders, with the wind howling over it. There was not one trail as Thea had expected; there were a score; deep furrows, cut in the earth by the heavy wagon wheels, and now grown over with dry, whitish grass. . . . As Thea ran about among the white stones, her skirts blowing this way and that, the wind brought to her eyes tears that might have come anyway. . . . For long after, when she was moved by a Fourth-of-July oration, or a band, or a circus parade, she was apt to remember that windy ridge.[32]

Thea starts thinking or dreaming about the Wyoming plains, but soon she is thinking about the people who went there before her, their wagon marks making "a score" (implicit reference to writing or to musical scoring) of furrows. Later in the novel, listening to Dvořák for the first time, she thinks of the same scene: "Strange how as the first movement went on, it brought back to her that high tableland above Laramie, the grass-grown wagon trails."[33]

Spanish Johnny's playing and Dvořák's music both topple Thea backward into memories—her own or someone else's. The crux for Cather is the pleasure of just such juxtaposition: to be moved by a band or a parade is to be moved back toward a site lodged in your memory. One that others can discern only because they too have different memories or recalled feelings of their own: "Every one was busy with his own thoughts." Fitting, then, that *My Antonia* ends with its narrator, Jim Burden, summing up what he and Antonia now mean to one another: "Whatever we had

missed, we possessed together the precious, the incommunicable past."[34] How can an incommunicable past be shared? That puzzle is crucial to the way that the semi-detachment woven into Cather's aesthetic economy operates. What she makes available for readers is something that belongs, like that incommunicable past, to an aesthetic realm accessible to each of us. Sociable solitary: The novel's paradoxical strength lies in the way it offers the reader access to what's putatively the most isolated aspect of individual experiences—not the song itself, but the poignant glimpses of an individual past such songs bring.[35]

Overtones and Double Lives

Like Hardy's earlier experiments in the same vein, Cather is tacking between naturalism and Jamesian realism—or perhaps experimenting with new variants of the affective side of naturalism. (Reading Cather as within the naturalist camp rather than on its fringes, though, would also involve accounting for her memorable attack on "prose by D. H. Lawrence," which "reminds one how vast a distance lies between emotions and mere sensory reactions."[36]) Whatever retrospective taxonomy seems best suited to sum it up, her fiction moves into in an odd limbo during the interwar years, a kind of purgatory between older realist norms and avant-garde formal experimentation. Recall (from the discussion in chapter 7) the "moderate modernism" that Adorno criticized as

> self-contradictory because it restrains aesthetic rationality. That every element in a work absolutely accomplish what it is supposed to accomplish coincides directly with the modern as desideratum: The moderate work evades this requirement because it receives its means from an available or fictitious tradition to which it attributes a power it no longer possesses.[37]

To look back to such an anterior tradition despite being immersed in the novel requirements of this modern realm would mean to create an art form that defined success in two ways: by reference to earlier formal expectations and also by way of representative fidelity to a present that seemingly has no place for such residual forms (as, for example, the Victorian social realist novel). By Adorno's account, this willingness to tolerate such an overlay between past forms and present actuality leads to failure—or perhaps to what Williams refers to, apropos of Wells, as a "confusion of forms."

What might it mean to understand Cather as occupying the space that just such formal evasion or confusion opens up? Cather herself may well have understood her accomplishments in this light. In her 1922 aesthetic manifesto, "The Novel Démeublé" (i.e., stripped of furniture), she argues that meaning inheres not in what's put on the page, but what's left out. The novel works by omission and underspecification.[38]

> Whatever is felt upon the page without being specifically named there—that, one might say, is created. It is the inexplicable presence of the thing not named, of the overtone divined by the ear but not heard by it. How wonderful it would be if we could throw all the furniture out the window; and along with it, all the meaningless reiterations concerning physical sensations, all the tiresome old patters, and leave the room as bare as the stage of a Greek theatre, or as that house into which the glory of the Pentecost descended; leave the scene bare for the play of emotions great and little.[39]

Fiction is architectural—yet its spaces are meant to be filled by voices from elsewhere.[40] The novel, for Cather, is a physical substrate on which a wide set of memories, dreams, or speculations can be hung by individual readers—in much the same way that Dvořák spurs Thea to think about the wind-blown prairies she'd visited years earlier.

Cather recurs to this idea of stable evanescence, communicable incommunicability, in a variety of ways. Her essay about Katherine Mansfield, for example, praises Mansfield's domestic stories because they capture an omnipresent human

> double life . . . group life, which is the one we can observe in our neighbor's household, and underneath, another—secret and passionate and intense—which is the real life. . . . [Reading Mansfield] one realizes that human relationships are the tragic necessity of human life; that they can never be wholly satisfactory, that every ego is half the time seeking them, and half the time pulling away from them.[41]

Mansfield lays bare a sort of doubleness woven into all human social encounters: she uncovers her characters' desire simultaneously to attend to and neglect the social realm. Cather then shifts ground to praise a different kind of doubleness. Mansfield

> communicates vastly more than she actually writes. One goes back and runs through the pages to find the text which made one know certain things about Linda or Burnell or Beryl, and the text is not

there—but something was there, all the same—is there, though no typesetter will ever set it.[42]

Now, the doubleness Cather admires is no longer simply psychological—representing human beings in their social and their private selves both—but aesthetic. Mansfield triumphs not by virtue of the words that actually make it onto the page but by "this overtone, which is too fine for the printing press and comes through without it."[43]

This idea of Cather's—that the novel is told by omission and yet aimed for fidelity to the gaps between characters, their incomprehension of one another's inner lives—puzzled and tested early reviewers. Many responded by praising her "carefully detailed" Nebraska.[44] *The Sun*, however, struggling to convey the odd strength of Cather's decision to position the book as between fiction and autobiography, assesses the results of her "special genius of Memory" with this odd distinction: "She is no feminine Zola, fortunately; without any smirch of realism she achieves the happiest reality."[45] That distinction between Zola's sin of realism and Cather's "happiest reality" may be linked to Cather's capacity to show a character's experience of an event—an experience invisibly but recoverably shaped not simply by the brute reality of the event as it occurs but also by a long anterior train of associations unique to a given character.[46]

Cather plays repeatedly with this idea of the overtone, or the overlay of an image from the past onto the actuality of the present. Each of her first three major novels—*O Pioneers!* (1913), *The Song of the Lark* (1915), *My Antonia* (1918)—struggles in its final paragraphs with the question of what can possibly be passed on from writer to reader. The heart-to-grains-to-smiles image in *O Pioneers!* and the "incommunicable past" of *My Antonia* both confront the problem of a realism predicated on the quasi-presence of memory, of imaginative experience, within the—empty and resonant—actual world. The analogy that ends *The Song of the Lark* involves neither decomposition nor paradoxical incommunicability. It is, though, no less insistent upon the crucial interplay between material processes and acts of imaginative renewal.

The Song of the Lark's epilogue focuses not on Thea herself, but on her elderly aunt, Tillie Kronborg, who drifts through the little town of Moonstone, sustained in her habitual daydreaming by a gramophone record she has received of Thea singing: "evidence in hair lines on metal disks."[47] This sketch of Aunt Tillie undergirds Cather's concluding meditation on what such mementoes (and the dream-lives they spawn) mean for those who live vicariously. Cather offers an intriguing aquatic

metaphor for news bulletins from the world of fame and fortune, like Tillie's record of Thea:

> The many naked little sandbars which lie between Venice and the mainland, in the seemingly stagnant water of the lagoons, are made habitable and wholesome only because, every night, a foot and a half of tide creeps in from the sea and winds its fresh brine up through all that network of shining waterways. So, into all the little settlements of quiet people, tidings of what their boys and girls are doing in the world bring real refreshment; bring to the old, memories, and to the young, dreams.[48]

Like *O Pioneers!*, this novel ends with the materialization of the pathways of thought; less blatantly a collapsing of material and ideal qualities but nonetheless a way of thinking about an invisible, hard to quantify experience (the advent of memories and dreams) by way of the facticity of tides in the Venetian lagoon. Tellingly, Cather concludes with a metaphor that itself relies on both cosmopolitan competence and local knowledge: only a peripatetic with a capacious worldview could recognize that "real refreshment" of Moonstone news has its objective correlative in Venetian "fresh brine."

Toward the end of her life Cather described her desire to write books that emulate "old . . . Dutch paintings . . . [in which] there was a square window, open, through which one saw the masts of ships, or a stretch of gray sea. The feeling of the sea that one got through those square windows was really remarkable."[49] Like those sea windows on a canvas, both news and brine are valedictory signatures of a true elsewhere, beyond even the artist's own handiwork, capable of sustaining far-flung provincial lives.[50] They are just what Adorno denounced: evocations of an imperfectly discernible elsewhere inside a modernist artwork that depends for its success on aesthetic totality. The "double distance" that Cather praises in those Dutch windows is just what her own novels aim for: not tone but overtone, not presence but the present sensation of absence.

CONCLUSION: THE DESIGN OF LIFE, NOT JUST THE PICTURE

This attempt to illuminate Cather's thinking about the centrality of semi-detachment to the work of fiction builds on recent work that has shed light on the complex relationship between Cather and the high modernism of the mid-1920s. As Michael North puts it, "Cather may seem to

epitomize the kind of writing that literary modernism notoriously sought
to displace . . . stylistically conventional, popular, nostalgic and regional at
a time when writers like Eliot and Pound were demanding that literature
be difficult, up-to-date and international."[51] In cataloguing the taxonomy-
troubling features at work in Cather's Pulitzer-winning *One of Ours*
(1922), North mentions one that resonates strongly with the account of
Cather's fiction I offer here. Rather than being a novel that praises France's
spirituality over Nebraska's materiality (or vice versa), North reads *One
of Ours* as about "the sheer experience of expatriation." Like the "eve-
ning primrose" (a flower that had seemed to Ed valueless in Nebraska
but glimpsed in France is suddenly resonant and beautiful), Cather's hero
"acquires a name and a distinction through imaginative transplantation."[52]

The imaginative transplantation predicated on the simultaneous ex-
istence of both sites (the primrose as both French and Nebraskan) is a
crucial component of Cather's aesthetic. A component that aligns intrigu-
ingly with her sustained interest in what can be called indirect action; that
is, in the ways that a real-world push may produce an effect far down
the road—but not an effect that any outside observer would relate to the
original impetus. It is a kind of "black box" effect: a particle dropped into
a character's consciousness in Cather will emerge eventually elsewhere,
with an unpredictable spin and velocity. Late in *A Lost Lady*, for instance,
the young protagonist Niel goes on a summer-long reading jag with a curi-
ous twist at the end:

> He read the *Heroides* over and over, and felt that they were the most
> glowing love stories ever told. . . . Those rapt evenings beside the
> lamp gave him a long perspective, influenced his conception of the
> people about him, made him know just what he wished his own rela-
> tions with these people to be. For some reason, his reading made him
> wish to become an architect.[53]

Cather's idea of empty rooms filled with overtones suggests her interest in
finding a new model for tracking the relationship between what we were,
what we are reading now, and what we will become. Neil's new orbit (I'll
design buildings) seemingly has nothing of the *Heroides* in it; it is not even
clear to Niel himself why those stories pushed him toward architecture.

The art of unexpected aftereffects, of altered orbits, is for Cather al-
ways a prosaic one. For example, Cather's account of the writing of *The
Professor's House* highlights the distance she has traveled from Norris and
Dreiser. In embedding Tom Outlaw's story within a novel about a quiet
Midwestern college town, she explains, she was aiming to

get[] the design of life, not just the picture. I could have written a
story of those two boys out on the mesa like a Zane Grey novel, but
I would have died of boredom doing it. The fascinating thing to me
is how that incident, that thrilling exciting enthusiasm reacted on a
group of rather middle-class unenthusiastic people.[54]

Cather wants the "design" not the "picture" in the same way that she
wants the novel defined by its overtones rather than what is overtly on
view. A design, a template, can serve as an overlay on a life transpiring
elsewhere, in the same way that reading the *Heroides* can trigger an archi-
tectural impulse.

"Herr Anton Van Rooy, late of Walhalla, tired as a labourer from the
iron mills" returns transmogrified as the sleep-deprived Thea Kronborg,
similarly glimpsed from afar by Spanish Johnny at the end of *Song of the
Lark*. Seen on the street or on a streetcar, Van Rooy and Thea both per-
sonify the aftereffects of great excitement slowly percolating through an
unenthusiastic world. If Norris's naturalism proposes that placing opera
in its material context makes a mockery of its power to enchant listeners,
Cather's prosaic observation of the singer with his mouth shut, or open
to snore rather than to sing, signals that enchantment and disenchant-
ment are both crucial components of her own prosaic aesthetic expe-
rience. Tom may belong in "a Zane Grey novel" (*Riders of the Purple
Sage*, presumably) while he is up on the mesa. Dropped into the St. Peter
household, however, and made the site of fantasies for "a group of rather
middle-class unenthusiastic people," his story becomes something else
altogether.

Cather's interest is in relating the vagaries of mental liberty to their
everyday contexts without reducing them to simple manifestations of
that context; explaining mental flight without explaining it away. Despite
Hardy's often extravagantly vivid poetic or prosaic renderings of the natu-
ral world's "spots in time," despite Cather's frequent recourse to the lan-
guage of musicality, or the concept of poetical revelation that can crop up
within an everyday life, we should not see Hardy and Cather simply as
late romantics, adhering to a Benjaminian notion of the messianic *Jetztzeit*
that interrupts ordinary life with incantatory revelations. Indeed, if there
is room in our account of naturalism for the sort of fiction that treats sus-
ceptibility to fiction as itself a feature of the social universe (an expansive
account of Naturalism indeed), then all of Cather's hostility to Lawrence
may not prevent our putting the two writers alongside Zola, Norris, and
Dreiser, studying congruencies along with dissimilarities.

Symbolic interludes in Cather—picture writing on the sun, music-fueled memories of the prairies, the overlay of piñons on a printed page, magic-lantern reveries—have both costs and rewards within quotidian life. It is not only we latter-day readers who profit from Gallagher's insight that fiction's success depends both upon the capacity simply to become receptive to a novelist's story-world and upon one's cognitive awareness that the story-world is not actually present. Cather's novels are themselves—and in this at least, they resemble the scientific romances of H. G. Wells—explorations of just that doubleness. Not just descriptions of semi-detached sensations, they are themselves machines for generating that feeling and subtle investigations of just what it means that fiction works on its readers in this way. Nor was Cather alone in that line of work in early twentieth-century America.

9

The Great Stone Face: Buster Keaton, Semi-Detached

At present our only true names are nicknames. I knew a boy who, from his peculiar energy, was called "Buster" by his playmates, and this rightly supplanted his Christian name.

> Henry David Thoreau, "Walking"

An audience will laugh at things happening to you, and they certainly wouldn't laugh if it happened to them.

> Buster Keaton

KEATON IN CONTEXT

The most striking 1920s forays into semi-detachment occurred not on paper but on celluloid. Alongside Cather's Greenwich Village world of writers and publishers, a new kind of storytelling had begun to flourish in Manhattan. One Monday in March 1917, Buster Keaton walked into Fatty Arbuckle's third-floor studio at 318 East 48th Street; a half hour later, he was pratfalling with a molasses bucket in *The Butcher Boy*. Within five years, Keaton, master of gags that played on his character's intermittent obliviousness to the world around him, was bringing the experience of partial absorption in virtual worlds off the page and onto the flickering screen. Keaton tackled problems that resembled those Cather had wrestled with: What would it mean to lose myself inside an artwork? Can I find some way to dwell in the actual, but simultaneously let my thoughts and sensations drift away into a vividly realized space that seems real despite being wholly made up? Within the moving pictures—not just a new technology but a wholly new form that could be mimetic in ways shaped

by both the narrative and the visual arts that preceded it—such questions began to register in unexpected and often wildly funny ways.

What sets Keaton's genius apart from his comic peers is the peculiar, remarkable way that he manages to cycle in and out of awareness of his surroundings. For example, early on in *Seven Chances* (1924) the shy, reclusive Buster is seated on a bench rehearsing a marriage proposal (Fig. 9.1a).[1] While rehearsing, he is in his element: passionate, expressive (privately extroverted we might say) because he knows he is in no danger of being heard by the woman he loves, but is too shy to speak to. Only this particular practice session turns into the real thing when the intended herself accidentally wanders into the scene, hears his proposal (rehearsal no longer), and accepts it (Fig. 9.1b).

The event is akin to the moment in Keats's *The Eve of St. Agnes* when Madeline dreams of Porphyro, only to wake and realize that he is no dream. It was only in solitude—in a dream, a rehearsal, a fantasy world—that Buster could bring himself to say what he has now accidentally said in his beloved's presence. By itself the rehearsal is hammy (deliberately so), by itself the moment of acceptance is merely sweet. The distinctive brilliance lies in the way that Buster comes back into sync with a world that has changed while he was off in the virtual space that a rehearsal or a work of art can create.[2]

While this is in some sense a form of dramatic irony, the audience is not raised above Buster by its capacity to grasp what he has missed. It is his Everyman quality that predominates: who hasn't been caught similarly semi-oblivious to actual surroundings? Northrop Frye finds comedy's generic essence in this sort of volta—bashfulness overcome without agency, the universe conspiring to do what characters themselves cannot accomplish. Yet classing Keaton's films as comedy pure and simple would mean overlooking the persistent slippage between intent and action in his world, the space that opens up between what Buster intends and what occurs, between the actual facts of his world and what he imagines is going on.

Anyone who has watched the hapless Sherlock Jr. wander out of his job as film projectionist and *into* the world of the film that he has been projecting knows how real fantasy worlds are to Keaton.[3] The scene-shifting Sherlock Jr. and Buster's absent-minded proposal in *Seven Chances* both present audiences with an alter ego whose inner life is not quite aligned with the actual world through which he unpredictably moves. This kind of here-and-gone flickering is more than an ephemeron—what we might call the trope of *disattending Buster*. In this context, Andre Gaudreault's

FIGURE 9.1 A/B. A practice proposal becomes real when overheard. Keaton 1925, *Seven Chances*.

concept of the *cultural series* proves a helpful way of tracing Buster Keaton's playful inversion and deformation of the film, theater, and vaudeville antecedents that make up his professional milieu. His films' slippery formal devices bespeak a complex and subtle awareness of what his films may have meant to his audiences: the films themselves explore the question

of what kind of experience it was to watch a Keaton film. In fact, a crucial and often overlooked aspect of Keaton's screen style is his capacity to suggest (as in that accidental proposal scene) his semi-detachment from the actual social and physical world through which he moves.

The jump here from Cather's fiction to Keaton's film follows from the introduction's hypothesis that semi-detachment is an aesthetic mode that has long implicitly shaped the making of various kinds of narrative art. In chapters 4 and 5 (provincial and experimental novel) and in chapters 7 and 8 (speculative fiction and Cather's modernism), semi-detachment looked like primarily a fictional problem. Henry James's experiments with the half-absence of the consciousness of characters, the shifting relationship between actual events ("dramatic") and inward experiences ("representational") in Cather become extended mediations on the empty house of fiction, a resonant chamber filled with overtones and echoes. Later, Wells's influential forays into half-discernible other worlds make the novel's ownership of the problem seem almost absolute.

The prior two interludes were careful to grant the importance of the space between visual and textual arts. The first (chapter 3) confronted the problem of the "double distance" encoded in paintings that explored their own status both as material objects and as representations of a virtual world beyond that mere materiality. In making sense of Pre-Raphaelite paintings, it stressed the gap that opened up between the narrative possibilities encoded in prose fiction and the immediate sensational impact of a painting—a gap that may have been minimized by painters like Ford Madox Brown in his meditations on the capacity of history painting, but was visible enough to prompt visceral and vicious responses such as Dickens's to Millais's *Christ in the House of His Parents*. Similarly, the second visual interlude (chapter 6) focused on the use that William Morris made of magic lanterns and photographs in the new design project, positing the separability of what Morris himself called the "epical" and the "ornamental": a palpable tension between thinking about Kelmscott books as temporally extended "tales" and as spatially defined ornamental objects.

Both chapters suggested ways in which the conceptual gap between visual and textual arts remained up for debate; moreover, the site where that debate went on was frequently the artworks themselves. Both Dickens's attack on Millais and George Eliot and Charlotte Brontë's suspicion of the magic lantern's tendency to offer "succession without sequence" underscore the implicit logic of rivalry. If *Middlemarch* locates a "magic

panorama" as the antithesis of what a novel's virtuous sequentiality has to offer, elsewhere in the public realm were visual artists who thought of the disjuncture between lantern shows and novels in profoundly different ways. This project generally is committed to tracing that sort of implicit tussle about how one might represent states of aesthetic semi-detachment by visual or textual means. That commitment to seeing semi-detachment as both an intellectual puzzle and a formal challenge explains my move from Wells and post-Wells speculative fiction to the more canonically modernist forays of Cather's fiction. It also explains why this final chapter examines a storytelling form that is heir to both novels and the visual arts: the movies.

REPERTOIRES, BURLESQUES, AND PORKPIE HATS

Rapid-fire inventions saw lantern shows giving way to *actualités* and nickelodeons in the 1890s, and then into a worldwide story picture industry by World War I. Once the motion-picture industry had demonstrated the commercial as well as the formal potential of rapidly flickering pictures in the dark, the rules that governed the relationship between visual and textual art forms entered a period of rapid change. Scholars have argued and will continue to argue about the nuances of cinema's arrival: from the notion of an art that arrived fully developed, bursting out of Athena's head, to those who trace its roots back to late Victorian theater, to the lantern-show tradition of the late nineteenth century, or even to such collateral kin as the realist novel, narrative poem, and Victorian historical painting.[4] Debate also rages as to when the "cinema of attractions" gave way to "story pictures" and how complete that break was.[5]

For the purposes of this chapter's turn to Buster Keaton (born Joseph Frank Keaton in 1896 into a traveling stage family and nicknamed Buster early in life for his energetic pratfalls), the crucial historical point is the immense opportunities for full-length feature films in post–World War I (or post *Birth of a Nation)* America. The timing was perfect for Keaton to turn his vaudeville training and eager experimentation with camera tricks and special effects into distinctive comic films that borrowed narrative arc and a marital finale from the romantic feature films of the day without giving up the sheer sensory appeal of his stunts and gags. Having gotten his start in comic shorts by Fatty Arbuckle, Keaton was able by age twenty-four to start making his own two-reel comedic shorts (including *The Boat, One Week, The Playhouse, Cops,* and *The Electric House*) and (thanks to

professional and personal ties with Joseph Schenck) between 1923 and 1928 at least six brilliant features: *Our Hospitality*, *The Navigator*, *Sherlock Jr.*, *Seven Chances*, *The General*, and *Steamboat Bill Jr.*[6]

Andre Gaudreault has recently argued that the best way to avoid teleological and reductively retrospective readings of narrative film is by looking back to the "cultural series" within which any given work locates itself. The cultural series that Gaudreault sees stretching backward behind any given movie, establishing its generic and formal presumptions, bears a revealing relationship to what Charles Tilly has labeled "repertoires of collective interaction": the various forms of plausible political action that are available in a given culture at a given moment.[7] Practitioners are always consciously inventing and developing their own distinctive styles, along with their variant forms, with reference to a cultural milieu that allows for and rewards certain kinds of variations. Given that interplay between setting and artwork, we can learn a lot about the parameters of style as a concept by watching the rise and fall of a particular artist, whose efforts range from rough to polished and whose reception not only alters through his career but also alters the nature of each subsequent work.

Gaudreault's proposal helps clarify what is most distinctive about Keaton's film.[8] Beginning an account of Buster Keaton's style with the ideas of "cultural series" and "repertoires of coactive interaction" makes particular sense because Keaton's own account of his early vaudeville and filmmaking days stresses one word: burlesque. Critics have picked up on Keaton's parodic impulse in short films like *The Frozen North*, his spoof Western, but by Keaton's own lights everything he did was tinged with this kind of burlesque: each stage door gag, each cross-dressing routine, right down to the moment in *Go West* when the resolutely antisentimental Keaton gamely tries to turn his deadpan into a smile (Fig. 9.2a)—via a gesture lifted from an actress from the world of melodrama, Lillian Gish (Fig. 9.2b). Keaton strove to master publicly accepted norms and mores, not in order to conform to them strictly, but in order to play on them parodically, satirically. This is not simply hilarity grounded in mockery: for every overt rip-off, like that faux-Gish facial gesture, there are a hundred minute gestures Buster has stolen from everyday life, copying the way an awkward man enters a room or fumbles for the telephone.[9] Even something as seemingly arcane as his choice of hat sheds light on how he positioned himself against what had come before.

The jauntiness of those hats is certainly part of what sanctioned Keaton's famous deadpan expression while still allowing him to signal—with plausible deniability—his own desire to be stylish. Circa 1920, "fashion films"

FIGURE 9.2 A/B. "Burlesque": the sincerest form of flattery. Lillian Gish in Griffith 1919, *Broken Blossoms*; Keaton 1925, *Go West*.

were the rage, serials filled seats by guaranteeing "a new Worth gown for every sequence" and the "it" that Clara Bow self-evidently had was constituted rather than concealed by the monotonous mutability of her look. Slightly harder to spot was a complementary norm for male stars of the days: a signature look (Arbuckle's bowler, Lloyd's boater, and Chaplin's bowler/cane).[10] As a result, beginning with the very first comic short Keaton made with Fatty Arbuckle, his porkpie was present and in cinematic play.

An early scene from *Our Hospitality* condenses some key Keaton ideas about the power of the right porkpie. The Buster character is riding south in 1830 (on a comical early train) to claim a family inheritance when chances to sit beside a beautiful young lady, whose acquaintance he has yet to make.[11] He is, initially, attired in a hat suitable to the day but it keeps getting smashed onto and over his eyes by the bouncing railway carriage (Fig 9.3a). Finally, he rescues the situation by pulling a (pre-flattened) porkpie out of an enormous carpet bag, in order to adapt and survive (Fig. 9.3b and c).

Scenes like this one lend themselves very readily to a generally accepted Keaton myth that we might label "Porkpie Buster," a role into which Keaton, with his loving wife Eleanor's collusion, was essentially trapped in the final four decades of his life.[12] However, a few things about this shot help us to think about the role that the porkpie plays in establishing Buster's relationship with his milieu. First, Keaton's comic camerawork relies on full frontal shots that skillfully avoid any overt

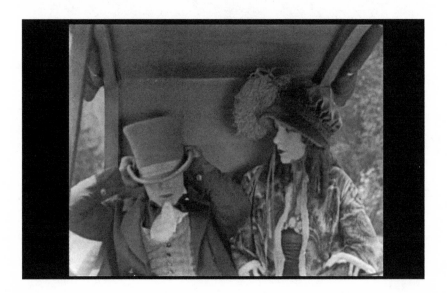

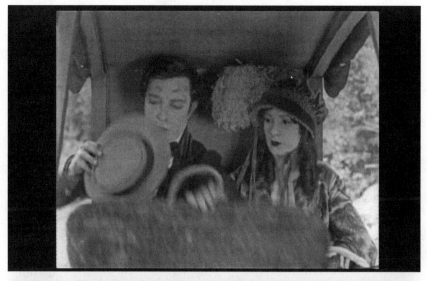

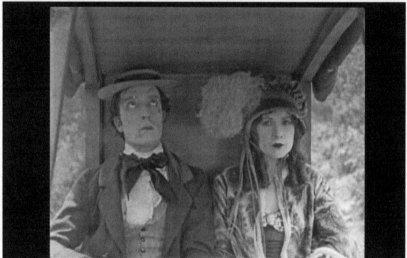

FIGURE 9.3 A/B/C. Love blooms only when Buster replaces the rigid, oversized stovepipe hat with a flexible, pre-crushed porkpie. Keaton 1923, *Our Hospitality*.

acknowledgement of the performer's reliance on his audience, but that nonetheless give that audience the pleasure of an overt gaze.[13] Second, Keaton employs self-conscious iteration. He never redoes a gag within the same scene or indeed within the same film, but he is sure to exploit the joke from every angle.[14]

Finally, and crucially, this scene underscores how persistently Keaton's comedy depends both on *incongruity* and on *adaptability*. The scene depends upon the comical height of the hats he has managed to shed—only a minute before this scene he is shown back in New York, clad in an absurdly oversized mad-hatter topper meant to signify the rigid fashions of the 1830s life that he is escaping by heading down south. His switch to a porkpie thus strikes the perennial note of style in Keaton: that it is for the younger generation to signal to one another, while the older generation counts instead on fixed reliable markers: the old have icons, we youth have flexible signaling systems.

Arbuckle, Lloyd, and Chaplin keep determinedly propagating their straightforward reactions to the exigencies and indignities of life: Arbuckle's response was to clown (until offstage accusations destroyed him), Lloyd's to flirt and flex his way through to the promise of a happily procreative ending, Chaplin (and no wonder he was Samuel Beckett's first choice as a clown for *Film*) to remain an untouched perhaps untouchable bit of grit in the machine, a little seed that will neither break nor germinate. Keaton aims higher and lower at once. He is not the life of the party, but he is also not external to the machinery of life—the hexagonal or even octagonal peg in the round hole. In Keaton, we can feel the desire to get along—coupled with the knowledge that trying may be the one bit of real freedom you have, that there's no more real play left in store if things do turn out "right" (there are more than a dozen Keaton variations on the hyper accelerated *married/babies/doomed to tedium* ending that is the norm for a 1920s story-film).[15]

Hence the emblematic greatness of the porkpie, as in this scene: by being pre-crumpled, the porkpie enables Buster *not* to be squashed. The porkpie against the train canopy is a flexuous response to a mutable environment, one that preserves an iota of individuality within that jiggling canopied train carriage. To go on wearing that same hat indefinitely, however, would indicate not flexibility but fossilization. What is novel the first time becomes, when iterated, novelty's antithesis. This problem of novelty within seriality is also emblematized and explored in an amazing *Steamboat Bill Jr.* scene, which turns on the fact that Buster is not able to identify himself to his father after a long absence by the simple semiotic expedient of wearing a white carnation to the train station (everyone at the station has a white carnation on, so the father inadvertently claims an absurd number of unsuitable candidates as his son). What audiences learn from those multiple identical carnations is that straightforward, unmistakable

denotation will always let you down, forcing you to fall back on difficult to decipher codes: the empire of connotation.

The white carnation scene is only one instance of Keaton's perennial awareness—perennial concern, really—with the moment when the stylish hardens into the iconic (when *a* Keaton hat becomes *the* Keaton hat). At such moments—the dangers of putting on a uniform are a perennial trope in Keaton films—youth's advantage over the old disappears. Youth in Keaton will not simply prevail over the calcified parents; it will prevail by way of its flexibility and mutability. If denotation by way of a rigid archaic sign like a white carnation is out, however, what takes its place as a useful signifier? Logical enough to suppose that Steamboat Bill Jr. would turn with a sigh of relief (like that which accompanies the hat switch in *Our Hospitality*) to a comfortable and stylish porkpie. That is not what happens. In fact, there is a delightfully hammy moment (Figs. 9.4a, b, and c) where we see young Buster being fitted with a porkpie—and rapidly rejecting it, with a reproving roll of the eye.

At moments like this (they crop up in every Keaton movie) the danger of hardening into one's own iconic identity is marked as every bit as dangerous as any parental fiat. This is Buster reflecting on what it means that his porkpie can flatten itself into mere denotation, can become a merely iconic white carnation. The series of carnation jokes and the rapid-fire catalogue of hats in the mirror would be impossible without Keaton's having thought about such moments of self-fashioning as turning on the discrepancy between appearance and essence; the very gap that allows his films to show audiences both the world as it is, and as it seems to Buster.

Beyond the Cabin, the Ocean

Keaton has rightly been praised for his fluid stunts and dazzling special effects. In short films and long, Buster is alert to every open window (he will plunge through it), every rope looped on the ground (his foot will snag in it). He exploits (which is to say, succumbs to) every possibility of his surroundings: seated in front of the handlebars of a speeding motorcycle (in *Sherlock Jr.*), it is inevitable he will end up steering from there; a railway tie in his hand (in *The General*) must end up serving as the unexpectedly perfect lever to knock other ties off the track in front of his speeding train.[16] Buster's incredible fluidity always translates into *vulnerability* to an onrushing modern world.

On the other hand, that same vulnerability eventually gets transformed into a serendipitous mastery of his world: in both *College* and *Steamboat Bill Jr.*, the rousing finale involves Buster returning to sites where he stumbled and turning the exact agents of ignominy into tools for a dazzling triumph. This eventual mastery of his environment is the aspect of Keaton's genius that his four most prominent recent critics have emphasized. Henry Jenkins traces this rubber-legged high jinks back to

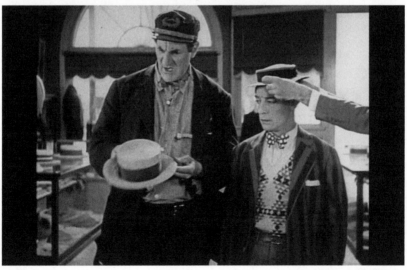

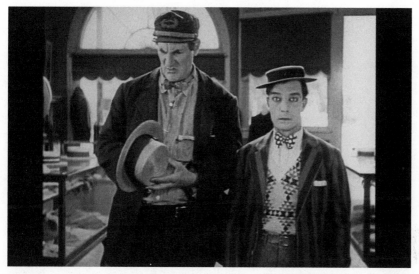

FIGURE 9.4 A/B/C. The only constant is mutability: this time, donning the pork-pie is as frightful a prospect to Buster as a Chaplin-style bowler hat. Keaton 1928, *Steamboat Bill Jr.*

vaudeville, while Gunning stresses Keaton's role as a twitching, virtually invisible animalcule inside a mechanized and hence scarily clockwork universe. Gilberto Perez traces the ways that Keaton the "bewildered equlibrist" struggles to fit into this environment (both technologically and socially) as a way of warding off loneliness, while Noel Carroll reads Keaton's decision to set several films at the beginning of the Industrial Age as a nostalgic recursion to a world in which automaticity was not the rule of the day.[17]

That account of Keaton's recipe for success, however, is not comprehensive. It is worth paying more attention than critics usually accord to Buster's intermittent absences from his ambient world: his failures, his disengagements, the moments when his wheels are spinning without his being able to move forward. To see Keaton's humor simply as the capacity to fit his body into any situation, no matter how absurd or impossible—to become the situation—would define the performance Buster gives as nothing but surface, as if he were a pure cipher put up on stage in order to do what the "Comedic system" demands of him.[18] Buster is neither the master of his universe, nor purely set adrift on its ebbs and flows, nor tracked smoothly into its whirring cogs. He is endowed with partially visible desires and thoughts, difficult but not impossible to express

in a world that he partially understands, partially finds flabbergasting. It is true that Keaton's stunting ability (along with his mastery of innovative camera tricks like the transparent garage in *Sherlock Jr.*) gives him a *Felix the Cat*-like ability to turn his body as well as his environs into comedic props.[19] However, scenes like that inadvertent (yet intended) proposal in *Seven Chances*—or many of Buster's inadvertent triumphs during the railway chase scenes in *The General*—finally rely less on sheer physical brilliance than on his audience's wondering what is going on *within* semi-detached Buster.

Thinking of Keaton as the conscious, *burlesquing* inheritor of a cultural series with roots both in vaudeville and the cinema of attractions helps to clarify his most important formal innovations. In that satiric vein, Keaton's films frequently work through versions of what in *Sherlock Jr.* becomes the "entering another world" routine: Buster finds himself both sleeping in a projection booth and running capers as a dapper detective. Even in less schematic films, the doubleness is always present—the gap between where Buster thinks he is and where the audience knows he is. Many versions of this routine feature theater prominently, including *The Playhouse* and an interlude in *Steamboat Bill Jr.* when Buster wanders into in a theater during a storm. There is also Buster in *The General* as the engineer who no sooner drops his head to stoke his engine than he steams into enemy territory without noticing it. In a 1921 two-reeler, *The Boat*, he is the earnest homemaker who only remembers to hang a picture on his wall when the wall is actually the hull of a boat (Fig. 9.5a), so that hanging the picture also involves poking a hole in the boat's side and letting in the ocean (Fig. 9.5b).[20]

This is a joke that Keaton heightens by zooming in on the painting that Buster has been hammering into the boat's side. It is an oceanscape, and Buster's first reaction when the water starts pouring through is to check the painted waves, as if it were the painting that had suddenly come to life and started leaking. Keaton's burlesque runs deep here: he is playing with the fact that the same rule applies to narrative film that Gallagher sees applying to the experience of reading fiction. Viewing a film entails a conscious decision to grant the plausibility of what you know is imaginary: in this scene, that juxtaposition of the actual and the virtual setting of the film (Buster is on a boat, and on the ocean, and looking at a picture) is a sly commentary on the fact that his audience is looking up at Buster and his antics—but also looking at the play of light on a white screen in a darkened room. When you get right down to it, where *is* that water coming from, anyway?

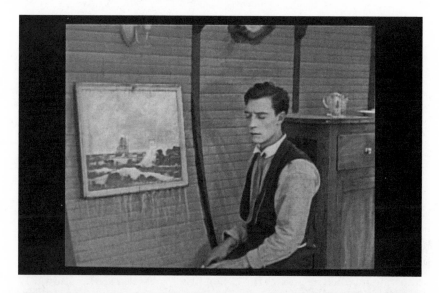

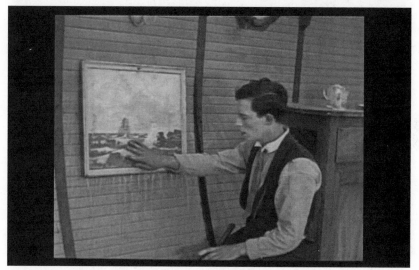

FIGURE 9.5 A/B. Might be a dream, might be painted water: Buster is not sure how to square the actual world with his sense of reality. Keaton 1921, *The Boat*.

Einstein's relativistic point about frames of reference—that there is no saying that any one frame is "at rest" in an absolute sense, only that it is at rest *relative* to another frame—may not seem a major concern for 1920s Hollywood. It is noteworthy nonetheless that Keaton made liberal use of boat and train voyages, and that he frequently unfurled

gags that depended upon the fact that a character may feel securely at rest inside such a speeding vehicle, only to discover that the external frame of reference has changed radically. Keaton responds to one frame, but we the audience are always aware of another running just behind—the ocean that lurks behind that punctured wall is not so different from the extra dimension spectrally present in H. G. Wells stories like "The Plattner Story."[21]

The ocean painting that causes the actual ocean to enter the boat in *The Boat* is a lapidary example of this problem of overlapping, conceptually incompatible worlds, but Keaton's *The General* is a dizzying collection of variants on this same basic problem of conflicting frames of reference, or doubled worlds. There is no way to grasp one's world completely—because that seemingly complete world is itself always also only a limited frame of reference in motion through a larger world. So not only do audiences see Buster going from loyal train engineer to traitor without knowing it (when he crosses the Union lines), they also see him furiously shoveling sand onto a railway track in order to free the passage of a train—but a train that had already departed while his back was turned. Or uncoupling a pesky train car that has been hitched in front of his engine, so as to speed his engine ahead and leave the car behind. But because he decouples when the train is moving downhill, the audience sees gravity move that decoupled car right back in front of Buster.

What all such moments suggest is how consciously Keaton is exploring what it means to have to conceive of oneself as occupying more than one world simultaneously; to acknowledge, that is, that the domain one inhabits may permit a sense of mastery in one way, and yet also suddenly reveal itself to be part of a larger domain (the sea, the world where one's beloved can actually overhear one's rehearsal) that one has not been attending to at all. This series of gags is reminiscent of the pamphlet in Melville's *Pierre*, which explores two incompatible but equally valid ways of measuring time while on a long ocean voyage: "chronometricals and horologicals," pick your frame, and pick the timescale that goes with it.

Critics who have remarked on the sense of doubleness in Keaton generally agree in attributing it to Keaton's being caught between two different generic/formal systems.[22] By my account, rather than being shaped by his being caught between two poles (free farce on one side, scripted tame comedy on the other), Keaton's films knowingly explore the ways that the world is always threatening to change. They themselves generate and explore the problem inside which they appear to be trapped (I thought this bench was a solitary outdoor space, but it turns out to be a

site for unplanned assignations). Keaton's art is not trapped between two modes; rather it explores the perpetually timely problem of finding oneself trapped between modes—or rather, the problem of inhabiting rival modes, the impossibility of mastering all one's frames of reference at once.

Keaton's comedy does not push audiences, however, to root for him in a heroic struggle against that oppressive outer world. Buster is less existential resistor than a vaguely stymied subaltern: he wants nothing more than to reconcile his "chronometricals and horologicals." From James Agee's famous early appreciation through Dwight Macdonald's various encomia in the 1970s up to Michael North's recent *Machine-Age Comedy*, critics have emphasized the mechanical nature of the outside world in Keaton— not just the perennial struggle against industry but also the way that even nature itself turns into a vast impersonal and antagonistic machine. That reading, however, risks underplaying how heroically Buster strives not to defeat but to get along with that mechanical onslaught.[23] Watching his incomplete adjustment, audiences grow aware of their own sometimes successful and sometimes failed efforts to slide into their allotted slots.[24]

Chaplin gins up the pathos by presenting himself as a still point in a changing world; Harold Lloyd is so well adjusted to his environment we can sometimes forget which is the environment and which is Harold Lloyd. Unlike both Chaplin and Lloyd, Keaton films rest neither on rebellion nor conformity, but on imperfect alignment: Buster would succumb in an instant, if he could just figure out *how*.[25] In fact, the most memorable pieces of Keaton humor are founded on what might be called partial obliviousness. That is, his success derives from the implicit parallel that exists between Buster—semi-detached participant in the world that whirs around him—and his audiences, who find themselves partially drawn into the world of Buster's escapades. The elaborately self-referential setup of *Sherlock Jr.* brings this question of audience implication explicitly to the fore. But the accidental proposal in *Seven Chances*, too, is just one of a thousand telling moments that underscores Buster's flickering semi-detachment from the film-world around him.

CONCLUSION: STONE-FACE STYLE
AND SEMI-DETACHABLE REPERTOIRES

Marcel Proust's "On Flaubert's Style" praises Flaubert for "rendering . . . his vision without in the meanwhile any note of humor or touch of sensibility."[26] Proust seems to be praising Flaubert for impersonality. Yet he

goes on to argue that what he calls "the subjectivism of Flaubert" comprises the quintessence of his style: a subjectivism constituted by the withholding of sensibility. Proust's praise for Flaubert is like Agee's praise for Keaton's lack of sentiment. I like to imagine Proust praising Keaton in just the same way, pointing as evidence to Keaton's 1920's moniker, "The Great Stone Face." From that face, any trace of sensibility has been expelled (hence Agee can call it "anti-sentimental"), and yet in it, as in Flaubert's prose, subjectivity appears in its purest form. A face that audiences loved *for* (not despite) its blankness, which offered them both a recognizable comic persona, complete with trademark hat, and Everyman (*that could be me*).[27] "An audience will laugh at things happening to you, and they certainly wouldn't laugh if it happened to them."[28]

Proust attributes Flaubert's greatness to the use that he makes of "blanks," by which he means gaps between scenes. Blanks within Keaton films are a worthy subject for a whole dissertation of their own: as far as a cultural series goes, he has not garnered the recognition he deserves for his obliteration of the bombastic Griffith intertitle, until only the barest few remain, virtually all functioning as gags (like an intertitle lasting for exactly ten seconds that appears for no reason in the middle of *The Boat* reading, "Ten seconds later").[29] But the real analogy when it comes to blanks is the one Keaton drops right into the middle of the screen: his own immobilized visage. Keaton's comedy depends on viewers seeing what Keaton *doesn't* see, which allows them to enjoy his reactions to his own reduced perceptual range.[30] A crucial component of the comedy, then, is the moment of adjustment: the camera lingers on his (almost) immobile stone face, letting them delight in his rediscovery of his true relationship to the world around him.[31]

This book as a whole has aimed to explore how nineteenth- and early twentieth-century artworks attempt to represent, convey, or simply to instigate within their audiences an experience. As Martin Jay argues, that word has long served as a crucial touchstone for those who argue for the relative priority of conceptual (a priori) and sensible (or a posteriori) ways of grasping the world: between those who emphasize the intellectual forms that shape whatever we encounter in the world out there, and those who emphasize or value the empirical "real." Accounts of the filmmaking of this era have emphasized the *sensible* side of film: John Dewey's 1934 phrase "that delightful perception which is aesthetic experience" might sum up the way in which critics have treated comic films by Keaton and his peers as vehicles for heightening the apperception of the world, for

reveling in physicality by way of absurd antics that heighten our aware-
ness of its tactile haecceity.[32] This chapter's reading of Keaton's hats and
his stone face as devices that mark the interface between an intrusive world
and a self struggling to get back into better alignment with its environment
rejects the idea that "delightful perception" alone can constitute aesthetic
experience. Instead, that experience depends on a mixture of perception
and conceptualization: in the Kantian terms discussed earlier in this book,
both reception and reflection.

Even the most blatant of physical pratfalls rely on the moment of
realization—shared albeit imperfectly between actor and audience—that
the world has gone subtly wrong. If dirt is matter out of place, comedy
arises from the struggle, in those everyday ineffectual ways audiences
know all too well, to put matter back into place.

This is a point underscored in Keaton's film by the attention paid to
Buster's intermittent and unreliable comprehension of what is going on
around him. Buster's way of locating himself within "worlds not realized"
or at least worlds only imperfectly realized makes an implicit comparison:
audience members too move about in a world that usually spares them
the embarrassing knowledge of the yawning differences in perception be-
tween themselves and those whose world they putatively share, but that
occasionally reveals how embarrassingly out of touch they have become.
The postmodern critical accounts that single out the leap that Sherlock
Jr. takes into filmic space underestimate the persistent complexity of the
ways that Keaton characters essentially move in and out of touch with
the world around them. It is not that Sherlock doesn't jump; it is just that
such jumps are prefigured in every Keaton film: the startled leap Buster
takes on that bench when his proposal is overheard is also a leap between
worlds, in its own way.

Take the way that Buster's stone face functions in the final shot of *Sher-
lock Jr.* Although the whole film's comic conceit is about a character who
can fall asleep and dream himself into a role in a film, the final shot in
Sherlock Jr. returns that oneiric fantasy back into a world in which the
ways that we dream ourselves into films are not fantastical but shockingly,
unexpectedly everyday. In wooing and winning the girl he adores, Buster's
character (Figs. 9.6 and 9.7) is explicitly cued by the film he gazes at, gazes
at along with us, the audience: he holds his beloved, he kisses, as he sees
the hero kissing, then finally he turns to the screen to view the result of
that kiss—*ex nihilo*, or *ex osculo*, a pair of babies appear. In that sense he
is immersed, mimicking the shared aesthetic form in order to live his life.

The shot ends with a dissolve into a happy couple with their brand new twin babies, the logical conclusion of his having won the girl. The film's final shot is a barely discernible twitch on the great stone face, as he realizes the longer-term implications of the replicable performance he has both watched and taken part in. Whether we are meant to imagine audiences, too, walking out of the theater holding hands, embracing, wedding, and giving birth is never stipulated. If they do leave with such thoughts, however, it is in part because Buster up on the screen has shown them the imperfect, partial ligatures that bind them to what they watch.

Buster's rapid oscillation between clown and leading-man attests to Keaton's keen perception of his audience's sense of their own semi-detachment, the ways in which they too are never quite sure of where they stand with regard to their own social habitus, the ways in which they know that being a fall guy or a hero is mainly a question of timing and sheer dumb luck. Chaplin is forever Chaplin; Lloyd is the guy next door; but Keaton, Keaton is *me*, half attuned and half adrift. In watching Keaton within his world, moviegoers know what it is to be dissevered from his world, caught up in a dream-space—and know also what it means to come out of that illusory separation with a jolt.

Admiring audiences probably do not, like Buster in the final scene of *Sherlock Jr.*, take kissing cues directly from the movies. Unlike Madeline in Keats's *The Eve of St. Agnes*," they do not wake to find their dream lover has stepped out of a dream and into their actuality. Like Buster, however,

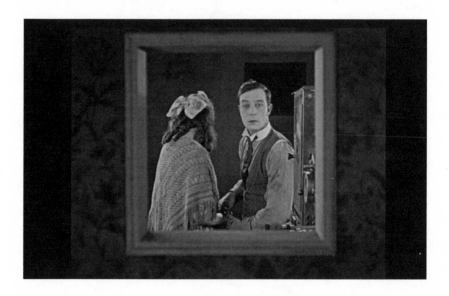

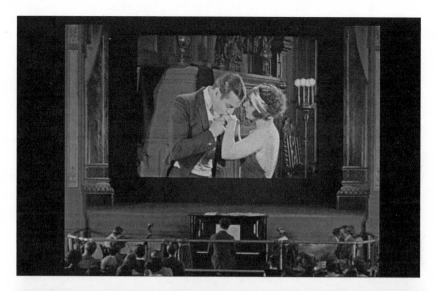

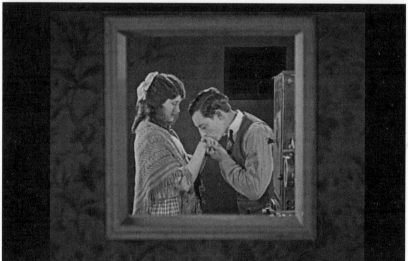

FIGURE 9.6 A/B/C. Taking cues: Gazing out through a window, Buster strives to align his actions with those he sees on screen. Keaton 1924, *Sherlock Jr.*

they struggle to align their own surroundings with the images they see up there on the screen, which both do and do not belong to their own lives. Keaton—proposing by accident, flipping through hats, or looking to the screen for cues on how to hug, kiss, and reproduce—reminds viewers that they persistently dream and recover their footing. Like him, his audiences

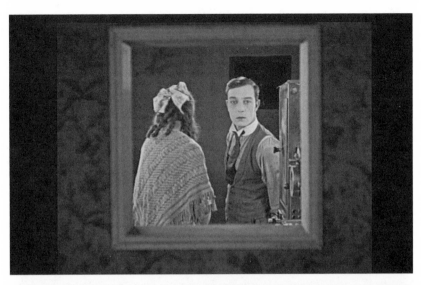

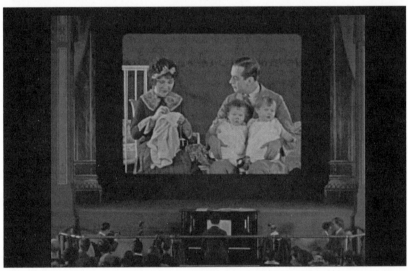

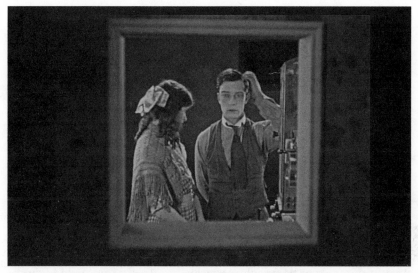

FIGURE 9.7 A/B/C. When cues go awry: The film's telegraphic logic and sequential jumps always threaten Buster's effort to align himself with what he sees. Keaton 1924, *Sherlock Jr* (final shot).

live semi-detached lives; like him, they daydream and partially lose them-selves at the movies, undergoing what Henry James refers to as "disguised and repaired losses" and "insidious recoveries." What remains to viewers is recognition of their own semi-detachment, their capacity to make sense of the world by recognizing the imperfect, partial, and mediated nature of their attachment to his world—and to their own.

Conclusion: Apparitional Criticism

> What business have I in the woods, if I am thinking of something
> out of the woods?
>
> <div style="text-align:right">Henry David Thoreau, "Walking"</div>

I meant this book to be straightforwardly historical. How could I hope to establish the aesthetics of semi-detachment without also providing a time-lapse account of the rise of certain ideas: partial absorption, translucency, and the discrepancy that James sketches between "the dramatic " and the "representational"? I had visions of neatly distinguishing between John Galt's strange authorial aside in 1831 ("But still she has been a mystery to me. For what use was knowledge and instruction given to her? I ponder when I think of it, but have no answer to the question"[1]) and Charles Dickens's wry 1837 meditations (in "Our Next-Door Neighbour") on the metonymic relationship between London door knockers and the people who dwell behind them. I'd carve so cleanly that decades (or even half-decades) would fall apart from one another as neatly as the sections of a Terry's Chocolate Orange ("tap it, then unwrap it"). I felt sure only laziness or obtuseness could prevent my charting a neat trajectory from John Stuart Mill's opaque anxieties about poetry's place between feeling and thought to Willa Cather's idea of the novel as an empty room filled with resonant overtones emanating from the reader herself.

Yet somehow I couldn't stop thinking about Caravaggio's *The Musicians* (Plate 1), about the way its central figure gazed outward—vividly present yet manifestly unseeing. Somehow, that blind gaze incarnated for me what Ford Madox Ford described as "those queer effects of real life that are like so many views seen through bright glass."[2] I was a voyeur peeping at a musician blindly going about his tuning—and I was also the painting's intended audience, seeing just what the painter had willed me to see. Like that double-imaged pane of glass that Ford imagines, the canvas

I stood before at once opened up a window into that musician's world and also mirrored back to me my own thoughts and feelings—that musician wasn't the only one gazing slack-jawed into space.

The Musicians reminded me to reckon with semi-detachment as a state that I myself experienced. I have worked hard to show how moments of distant or veiled recognition are registered, accounted for, or represented within artworks, or in artists' accounts of their work. Yet my own experience is also manifestly a key part of the aesthetic phenomenon I am describing. Recognizing that basis in particular thoughts and feelings, including my own, also meant recognizing the importance of *slippage*, of the play between authorial intent and audience uptake. That slippage, too, the impossibility of any original intent entirely defining what an artwork is or does, seemed intrinsic to my argument.

In my earlier books (one about the nineteenth-century crowd and another about Victorian conceptions of portable property), the longer I spent with my materials, the more I felt I learned about original intent and import. This time, though, what stayed with me most of all was the sense of discrepancy, of slippage. In those previous projects, I aimed to wipe all the slippery surfaces dry and present the reader with sturdy, finished objects: dry weight. Here, the more I wiped the surfaces, the slicker they got. That slickness suggested that the problem with supplying a history of ideas (their apex and their extinction) is not that such history explains nothing, but that the very fact of our grasping the ideas of the past suggests that we are closer to them than we think. To know and recognize an idea may not be to own it as one's own, but it certainly demonstrates the idea's continued life: after all, here one sits, having that idea all over again.[3]

In his introduction to *Ivanhoe*, Scott remarks that any piece of historical fiction that used *only* words that had fallen out of common usage would both alienate readers and miss a fundamental fact about the continuity between past lives and our own.[4] Like Ford's doubled glass, the artwork exists neither within one world nor another; it is a lens, propped up to give us an image that reaches backward to another time while still remaining firmly anchored in the viewer's own. That is no justification for abandoning historicism in favor of a hunt for timeless truths. Rather, it is a reason to think harder about the ways in which our own experience of recognition of a past thought conjures up commonality, as well. The present is only the way that it is because of the past's peculiar bequests, its double-edged legacies. The ways we study now depend on the affordances of intellectual tools inherited from the very past we labor to study.

A late George Eliot poem, "The Legend of Jubal" (1870) offers one intriguing way of thinking about how exactly such cultural persistence works. In it, Eliot recounts the story of Jubal the lyre player, who returns to his people after an immensely long absence—and is promptly beaten to death by two flutists. The fatal instruments are not exact replicas of his own lyre, but in Eliot's telling, they are nonetheless unmistakably its descendants.[5] Genealogy matters: present modes of assaying the past—in Eliot's analogy, our flutes, with which we strike out at the lyre of the past—are descendants (or perhaps collateral kin) of the objects we study. Such affiliations offer no guarantee that any leap into the conjectured past will land us there.[6] Still, a vital first step involves acknowledging the way in which not-totally-bygone intellectual tools still shape present-day practice. Those painted, unseeing eyes into which we stare so deeply may not be looking back at us. But they are still with us, if we think they are.

READING LIKE THE DEAD

In short, Eliot's image of lyres-turned-into-flutes gave me hope. Semi-detachment might offer a new way of hearing ancient lyres—if not hearing what they sounded like then, at least a sense of what they sound like now, across the years.[7] It was in that frame of mind that I undertook *Semi-Detached*'s strangest piece of research: an experiment in reading like a teenager from the 1890s. For as long as I can remember, I have wanted to read like the dead. Not just to read dead authors—something a little bit creepier. People have gone out of their way to educate me on the fallacies involved: I know that recapturing the actual experiences of long-ago readers is no more plausible than visiting Mars or traveling in time.

Still, when I learned about *What Middletown Read*, a database that tracks the borrowing records of the Muncie, Indiana Public Library between 1891 and 1902, I had some of the same feelings physicists probably have when new subatomic particles show up in their cloud chambers.[8] Could you see how many times a particular book had been taken out? Could you find out when? And by whom? Yes, yes, and yes. We know, for example, that on Wednesday February 3, 1892, a factory worker's son, Louis Bloom, ascended to the second floor of the Muncie City Building, turned left at the top of the stairs, entered the city library, signed the ledger kept by librarian Kate Wilson, and checked out *The Wonders of Electricity*. He came back the next day to return it and take out *Frank*

Before Vicksburg; Friday it was Horatio Alger's *Ragged Dick*; Saturday *The North Pole: And Charlie Wilson's Adventures in Search of It*. Sunday, the library was closed; Monday, February 8, 1892, (his 13th birthday) he took out James Fenimore Cooper's *The Deerslayer*. If library records are usually the night sky of cultural history, a dim backdrop to action elsewhere, Louis's borrowing history is like a supernova.

This sudden access of information, tightly clustered but shining all the brighter for it, tempted me into a thought experiment. Could I make myself into a proxy reader, simply by recreating a single borrower's history — make Louis's experience somehow my own? I could not resist the fantasy of popping back into the past for a brief bibliographic séance — a kind of hermeneutics without suspicion. I gave myself a month to read as far as I could in the 291 books Louis Bloom had checked out over a decade. I would happily gather what external facts I could about Louis, but fundamentally his booklist would be my passport back in time.

The experiment's limitations soon became apparent. As an effort to travel back in time, my Bloom month ended in failure: though it also put me in contact with Louis's own charming grandchildren and — when I reported the results in *Slate* — with many small-town librarians. Though I dutifully read in natural light when I could and was delighted when a power failure in our neighborhood meant I had to read *Elsie Dinsmore* for hours by a camping lantern, there never came a moment that felt like time travelling. As I painstakingly checked to make sure that I'd gotten the same edition Louis would have been reading, I was aware of how distant my pedantic antiquarianism was from what his own teenage first encounters must have been. I was partially there with Louis in the Muncie library — but I was also a long way away. I was always gaining on Louis, but somehow I was never fast enough to fall into stride with him, to turn sideways and find myself looking him straight in the eye.

My Bloom month experiment taught me what Walter Benjamin's dialectical historicism ought already to have made clear. The past's lyres stayed silent. There is no wading the same river twice; no account of the past that does not account for the distance across which we regard it, and the instruments we rely upon for that regard. I had gathered and crunched some data and heard some stories, but the problem with aiming for antiquarianism is that you can never be quite antiquarian enough. Despite weeks of pleasant correspondence with his grandchildren, despite time spent with photographs and archival records and letters, by my experiment's end Louis Bloom remained only a shadow, a dimly visible pair of shoulders, a motionless back of the head (with protruding ears) between

me and Horatio Alger's *Ben the Luggage Boy*, or Henry Mayhew's *The Story of the Peasant-Boy Philosopher*.

Yet that problem was also the payoff. As an experiment in semi-detachment, some of my experiment's failures ultimately struck me as successes in disguise. The gap between our own era and the past can be bridged, imperfectly, by artworks themselves to the extent that their aesthetic operations activate modern imaginations: if the notion of elbows that are frozen at once by being on the bridge at Dorlcote Mill and the arms of my armchair back home remains a redolent one, then Eliot's still in the house.

To see my phase-shifted connection with Louis only as a failed anti-quarian reconstruction of the subjective life of the mid-nineteenth century would be to disregard the very questions of regression and distance that *Semi-Detached* studies. In the books Louis checked out, he found, as readers everywhere always do, something other than a perfect mirror of his own life. Not even the most battle-hardened cultural historian will proclaim that what Middletown read equals what Middletown *was*. Like me, Louis found a way out of his actuality; caught a glimpse of his own future in the world of mechanics and of physics, far from Muncie. Thanks to those books, he too had a telescope. Like mine, it was small and imperfect, with no guarantees about the accuracy of what he glimpsed through it. To understand what Louis Bloom felt opening up a book in Muncie, I had to grasp not only the space between me and the past I thought I had found but also the gaps and glitches in his own life, the way that what Louis sought also eluded him or receded from him as he pursued it.

Ina Ferris has described the "apparitional poetics" by which Scott aims to make the past loom forward into the present in his historical narratives.[9] By Ferris's account, Scott earned the title "magician of the North" because of his ability to conjure up an apparent overflow of past into present. Not the past as it was, but as it is now, creeping up on us in our present actu-ality. Scott's fiction presents itself as apparitional, collapsing the bound-ary between dream and reality so as to create a sense of doubled present reality.[10]

Semi-Detached offers a kind of "apparitional criticism." A criticism that attends to the imperfections attendant on any kind of historical retro-spection, that registers the inevitability of one's understanding being shaped as much by the distance that is traveled as by what is glimpsed on arrival—a criticism that puts us in Louis Bloom's shoes, but only in the moment that he is trying to step out of those shoes himself, heading some-where else. Understanding oneself as partially present, partially distant,

when facing the semi-remote, semi-obtrusive artwork thus becomes not just the story of a certain kind of semi-detachment in days gone by but also a story about how we ourselves hope to bring that past close enough to catch a wavering glimpse. What divides us from the past also connects us: semi-detachment all the way down.

Notes

INTRODUCTION: THROUGH BRIGHT GLASS

1. Eliot, *Mill on The Floss*, 12. Ellipsis in original.
2. James, Preface to *The Ambassadors*, xxiii.
3. Peter Otto has argued in *Multiplying Worlds* that it is in the late eighteenth century that "the virtual first becomes understood as the space of emergence of the new, the unthought, the unrealized" (191). That artworks may preserve their relationship to reality precisely by disavowing any claim to actuality is the underlying claim of work initiated by Deleuze and cogently argued in Pierre Levy's *Becoming Virtual*. Levy's notion is that "an intellectual activity nearly always exteriorizes, objectifies, virtualizes a cognitive function . . . because it is virtual, writing desynchronizes and delocalizes" (50). The book's crucial distinction is between the possible (or potential) and the virtual. By Levy's account, the possible is digitizable, quantifiable, renderable in statistical terms: it belongs to the "taming of chance" that Ian Hacking sees accompanying the rise of the statistical sciences in the nineteenth century. The virtual, by contrast, exists as a qualitative rather than a quantitative experience, not to be expressed as a possible percentage.
4. Conrad, Preface to *The Nigger of the Narcissus*, 15–16.
5. Swinburne, "Before the Mirror," lines 47–48. The poem was written to accompany an 1864 Whistler painting of an introspective young woman, *Symphony in White, No. 2*.
6. The question of how mid-nineteenth-century Britons came to think differently about glass as refractive surface and as pass-thorough, as lens and window both, is extensively explored and unpacked in Isobel Armstrong's *Victorian Glassworlds*, discussed in more detail in chapter 6.
7. "Virtually Being There: Edmund Wilson's Suburbs" and "The Return of the Blob: Or How Sociologists Learned to Stop Worrying and Love the Crowd."
8. Cf. the discussion of "cognitive archaeology" and "material engagement theory" in Malafouris, *How Things Shape the Mind*, esp. 7–18.
9. The latter would align this book with the sort of historical taxonomy undertaken in John Bender and Michael Marrinan's *Culture of Diagram*.
10. Foucault's discussion in *The Order of Things* of the unreliability of a stable mimetic order in Velazquez's *Las Meninas* (1656) raises somewhat related questions about how a painter understands and depicts the difficulties or the

paradox that surrounds the viewer's "entry" into the space of the painting: "As soon as they place the spectator in the field of their gaze, the painter's eyes seize hold of him, force him to enter the picture, assign him a place at once privileged and inescapable, levy their luminous and visible tribute from him, and project it upon the inaccessible surface of the canvas within the picture. He sees his invisibility made visible to the painter and transposed into an image forever invisible to himself. . . . Perhaps there exists, in this painting by Velazquez, the representation as it were, of Classical representation, and the definition of the space it opens up to us" (3, 15). Foucault's account is predicated upon the painting's central aporia and its relationship to sovereignty. By contrast, my account of the semi-detached relationship that is both depicted and reflected upon in Caravaggio's painting is predicated upon a workable representational system that nonetheless contains at its heart the awareness of what cannot be made part of a system of representations: those eyes are both alert and blank; the musician sees, and the canvas is blind.

11. Gallagher, "Rise of Fictionality," 340.
12. Ibid.
13. Idem, 351–52.
14. Cf. Bolter and Grusin's *Remediation*, which also discounts the importance of fiction's doubleness, its capacity to seem at once made up and believable.
15. Saler, *As If*, 12, 17. Saler's emphasis falls less on the Holmes stories themselves than on the advent of a fan culture around the Holmes stories, which he sees as the first manifestation of a fanatically immersive, modern-day "fan-boy" culture. To hear Saler tell it, Jane McGonigle's *Reality Is Broken*, a 2011 paean to immersive video games, might have been published in 1890 with Arthur Conan Doyle's little world of 221B Baker St. in mind.
16. The account offered here of readers' semi-detached relationship to the fictional world is also related to the tension that Alex Woloch identifies in *The One vs. the Many*: between readers responding to a novel's "character system"—i.e., the overarching structure into which each character fits—and "character space"—i.e., the person-like aspect of characters, who appear to readers to be living beings moving around in a world like the reader's. Cf. also John Frow's attempt in *Character and Person* to explain (rather than explain away) the readerly impulse to treat characters as persons.
17. Cf. Gallagher's striking proposal that "character's peculiar affective force . . . is generated by the mutual implication of unreal knowability and their apparent depth" culminates with an image of George Eliot's Dorothea Brooke, yearning for the very realness that we readers possess: the result of such apparent yearning on the part of characters, Gallagher proposes, is that it "allows us to experience an uncanny yearning to be that which we already are" ("Rise of Fictionality," 361).
18. Moretti, *Way of the World*, 82. Insightful recent work on the role of the episode in narrative includes Miall, "Episode Structures," and Garrett, *Episodic Poetics*.
19. Or events can refuse to cohere toward an explicable telos, in which case one has, for example, serial TV. When Captain Kirk notices this failure of larger patterns to emerge in a recent *Star Trek* movie, he diagnoses the situation aptly: "Things are starting to feel a little . . . episodic" (Quoted in A. O. Scott,

"Review: *Star Trek Beyond* sticks to its brand" (*New York Times*, July 22, 2016, C1).

20. Cf. Derrida's notion of *play* as a way of understanding this looseness, the potential discrepancy that opens up between signifier and signified.

21. As I argue in chapter 6, recent works by Leah Price, Isobel Armstrong, Jennifer Roberts, and others have already helped make sense of such states of aesthetic semi-detachment, in part by undermining sharp divisions between hermeneutic and material ways of grasping the objecthood of an artwork.

22. Scott, *Four-Dimensional Human*, 3–4.

23. Ibid., 228.

1. PERTINENT FICTION: SHORT STORIES INTO NOVELS

1. Allen, *Short Story in English*, 3.

2. Poe, Review of *Twice-Told Tales*, 572.

3. Moretti, "Graphs, Maps and Trees," 80. For the argument that even small inflection points in the modernist era and with the postmodernism of Borges or Barthelme have left the fundamentals of the genre unchanged, see a range of scholarly work: e.g., Pratt, "Long and Short of It"; May, *New Short Story Theories*; O'Connor, *Lonely Voice*; and Eikhenbaum, "O. Henry." Even writers who claim to leave the 1840s far behind—e.g., Elizabeth Bowen in 1937, "The short story . . . as we now know it, is the child of this Century"—end up with nearly identical recipes for the short story's distinctiveness: "Poetic tautness and clarity . . . self-imposed discipline and regard for form. . . . Action . . . in the short story regains heroic simplicity" (Introduction to *The Faber Book of Modern*, 7).

4. James, Preface to *The Ambassadors*, x.

5. Quoted in Korte, *Short Story in Britain*, 10.

6. Ibid., 9.

7. Baldwin, *Art and Commerce*, 1, 3.

8. Ibid., 13. Building on both Baldwin and Korte, Winnie Chan understands the 1880s upsurge and the explosion of diversity in English short fiction as a formal response to a publishing boom. In *The Economy of the Short Story*, Chan accordingly sees an uneasy awareness among writers in the proliferating experiments of the 1890s that demonstrates how common, and hence how vulgar and merely popular, short stories may be.

9. Cf. also Korte's suggestion in *The Short Story in Britain* that English short fiction is not so much delayed as it is always already present: that is, that its genealogy can be traced smoothly back to sixteenth-century "coney-catching tales" without significant inflection points.

10. Killick, *British Short Fiction*, 1–2. To Killick's point, we might also add David Stewart's observation about "the difficulties inherent in producing writing for a mass market, rather than particular readers" which made "the Reading Public" into an inescapable preoccupation among Romantic-era writers (*Romantic Magazines*, 1–2).

11. Cf. also Ian Duncan's recent argument: new work "has begun to redirect our attention from the book-based genres favored in literary history and critical

canons, such as the novel, towards the other kinds and formats that made up the early nineteenth-century literary field" ("Altered States," 53).

12. Matthews, *Philosophy of the Short-Story*, 73.
13. Poe, Review of *Twice-Told Tales*, 299.
14. For Brander Matthews, Poe's principal acolyte, see May, *New Short Story Theories*, and Pratt, "Long and the Short of It." For similar views of the genre's key formal features and genealogy, see Eikhenbaum, "O. Henry," and Baldwin, "Tardy Evolution of the Short Story," 24.
15. Quoted in Killick, *British Short Fiction*, 14.
16. E.g., Killick's assertion that "the relatively brief, self-contained prose fiction narrative that constitutes the modern idea of the short story does exist during the [early nineteenth century] but it is tied into a complex network of miscellaneous and comic extracts, single-volume tales, narrative essays and sketches, and other ephemeral and elastic modes of writing" (Ibid., 19).
17. For the straightforward chronicle of early short fiction in English, see Korte, *Short Story in Britain*. One helpful account of recent criticism that attempts to locate a long genealogy of the short-story collection as a "programmatically cosmopolitan form" is that of Johnson, Maxwell, and Trumpener ("Arabian Nights," 247).
18. Crawford, "Bad Shepherd," 28–29.
19. Douglas Mack has pointed out that Hogg does his best to balance the necessity and absurdity of supernatural beliefs, and Killick describes his predilection for a "zone of dispute" (Mack, "Aspects of the Supernatural"; Killick, *British Short Fiction*, 149).
20. Allen, "What Is a Short Story?," 405.
21. Cecil, Introduction to *The Two Drovers*, viii.
22. Scott, "Two Drovers," 259. A useful point of formal comparison may be Franco Moretti's proposal to divide the Bildungsroman into "classification" and "transformation" novels. In the former, "events acquire meaning when they lead to one ending and one only," while in the latter, "what makes a story meaningful is its narrativity, its being an open-ended process." In such works, "the ending, the privileged narrative moment of taxonomic mentality, becomes the most meaningless one" (Moretti, *Way of the World*, 7).
23. Hogg, "Old Soldier's Tale."
24. McLane, *Balladeering*, 182. McLane sees seven often overlapping ways in which poetic authority can be generated: authority of inspiration, authority of anonymity, authority of imitative authorship, authoritative translation, editorial authority, ethnographic authority, and experiential authority. On Victorian versions of "ethnographic authority," cf. Herbert, *Culture and Anomie*, and Buzard, *Disorienting Fiction*. Buzard's work focuses on the "self-interrupting" narrator, a voice that creates a sense of movement between the reader's world and a "knowable community" made up of the ethnographically grounded but quaint beliefs of various characters (34). Buzard sees such self-interruptions working in Victorian realist novels, much as free indirect discourse may, to fortify an ultimately seamless sense of realist authority.
25. Hogg, "Mr. Adamson of Laverhope," 54.
26. Idem, "Long Pack," 134.

27. Cf. Theissen, "Simultaneity."
28. "Galt's output veers disconcertingly from surges of radical, original experimentation to an all-but-mechanical reproduction of established styles and genres" (Duncan, "Altered States," 53).
29. "Conjectural history" seems to Hewitt a more apt way to describe Galt's fiction; he also points back to Dugald Stewart's use of the phrase "theoretical or conjectural history" and to work on conjectural history by Mark Salber Phillips (Introduction to *John Galt*, 4).
30. This is sometimes ethnographic—the Scots word *eydent* for example inspires "the Seamstress," a pithy Galt sketch exemplifying a particular kind of thrifty industry that Galt claims is as lacking in England as it is in English. At other times his gift is for sui generis neologism: it was in *Annals of the Parish* that John Stuart Mill came across and was inspired by the word "utilitarian." (Although Mill evidently overlooks it, Bentham had used the word earlier, in 1795.)
31. Cf. Ian Duncan's argument that "against the form of agency encoded in the entail, a teleological nostalgia that corrupts human intention, Galt poses an alternative, objective, recalcitrant narrative modality of contingency and accident" (*Scott's Shadow*, 239). Ian Gordon argues that though Galt's "photographic realism can be a snare for the reader," a careful reading brings a strong sense of "Galt the artificer, selecting, interpreting, manipulating character and incident with . . . affection and irony, offering by implication in his picture of the small world a commentary on the impact of changing ideas in the larger world" (*John Galt*, 142).
32. Duncan, "Altered States," 54.
33. On the changes c. 1830, cf. Jarrells, "Short Fictional Forms"; Killick, *British Short Fiction*; Duncan, "Altered States," and Stewart, *Romantic Magazines*.
34. Galt, "Mem," 8.
35. Ibid., 9.
36. Cf. the final lines of Beckett's story "Dante and the Lobster": "Well, thought Belacqua, it's a quick death, God help us all. It is not." (22).
37. Gordon, Introduction to *Selected Short Stories*, viii.
38. In a recent article, Matthew Wickman notes Galt's attention in *Annals of the Parish* to "the great web of commercial reciprocities"; but also emphasizes that the narrator, Micah Balwhidder, is wise mainly in knowing his own ignorance of the totality: in his "comprehension of incomprehension" ("Of Tangled Webs," 1, 3).
39. Cf. Trumpener: "Galt . . . refashion[s] the annual form to explore the temporal unevenness of development and the otherwise invisible connections between local occurrences and long-term processes, local agency, and centralizing institutions. . . . In *The Entail* and *The Provost* (both 1822) John Galt emphasizes the nonsynchronicity of historical change and the increasing invisibility of historical agency" (*Bardic Nationalism*, 152–53).
40. Gordon, *John Galt*, 133.
41. Ferris, "Scholarly Revivals," 272.
42. Ibid., 272. "Under an emergent historicism that posited historical change as substantial rather than superficial, the reality of the past was thought to inhere in an alterity to which material remains provided access. At the same time,

the truth of the past continued to be (as it always had been) a matter of present determination, that is, a function of the judgment of the historian." These two imperatives of history—the real and the true—implied different kinds of authorship and different formal protocols.

43. A phrase that Thomas Laqueur cogently glosses in "Bodies, Details and the Humanitarian Narrative."

44. The simultaneous advent of the Hegelian notion of "concrete universals" and the revaluing of the real or the "relic" may be germane here. Certainly it is noteworthy that the (politically reactionary) period after the Napoleonic wars (1815–30) sees a wide range of new ways in which the novel's particularization (its turn toward *realia* and the documentation of unpredictably idiosyncratic moments) comes to carry a more indexical, and a more authoritative, status.

45. Hazlitt, *Spirit of the Age*, 87.

46. The account offered here raises some questions about Toril Moi's claim in *Henrik Ibsen* that it is only with the naturalism of the 1890s that aesthetic idealism is dislodged as the dominant cultural form for European fiction.

47. Killick, *British Short Fiction*, 157, 158–59.

48. Lauster, *Sketches*, 12.

49. Garcha, *From Sketch to Novel*, 3.

50. Like Deidre Lynch's work on eighteenth-century character and caricature in *The Economy of Character*, and John Bender and Michael Marrinan's *Culture of Diagram*—but with a distinctive nineteenth-century focus on a more Hegelian sense of materiality, of persons as innately bodied—Lauster's account helps readers understand what role sketches might have had in a world where urban crowding and complex economic relations impinge on the average reader's consciousness, so that readers struggle to order their experience in new ways.

51. Garcha argues that while the fiction of the 1830s may have returned after a romantic-era detour to many of the norms of eighteenth-century fiction, it returned with some crucial differences—among them the widespread importation into the novel of the kind of description that is encoded in sketches. "Between 1820 and 1840 . . . the literary sketch's fragmented forms and more-or-less synchronic temporality, created by 'incomplete' descriptive and essayistic text and a lack of plot, became more closely identified with the novel" (*From Sketch to Novel*, 8).

52. Poe, "Man of the Crowd," 389.

53. Ibid., 391.

54. Ibid., 392.

55. Dickens, "Our Next-Door Neighbour," 37.

56. Ibid., 43.

57. The utter eclipse of Hogg's reputation between his death in 1835 and Gide's successful championing of *The Private Memoirs and Confessions* in his 1947 introduction to the text is remarkable. No matter how badly Hogg's reputation was damaged by ill-advised pruning and bowdlerizing in the posthumous *The Poetical Works of the Ettrick Shepherd* (1838), it seems hard to avoid the conclusion that subsequent generations of readers wanted something very different in their short fiction than what Hogg provided.

58. Korte, *Short Story in Britain*, 9.

59. Gallagher, "Rise of Fictionality," 340.

60. Ian Duncan's work in *Scott's Shadow* on generic instability in the 1820s and 1830s, and Ina Ferris's account of the shifting romantic-era relationship between the "real" and the "true" in "Scholarly Revivals" offer compelling reasons why even the most inveterate lumper will want to be a splitter in parsing the rapid transformation of British fiction, short and long form both, c. 1830. Cf. as well Hina Nazar's recent argument that "sympathetic engagement with characters in a story, Eliot argues, encourages attentiveness to the claims of actual others" and Nazar's interest in mobilizing "Eliot's optimism about storytelling and a representative humanity in relation to the pessimism informing many strands of recent theory" ("Facing Ethics," 438).

61. Cf. Andrew Miller's *The Burdens of Perfection* and Rae Greiner's *Sympathetic Realism*, both of which see prose fiction in the nineteenth century as deeply committed to making the reader experience what she or he comes to believe characters have themselves experienced *within* the novel ("Reader, I married him.")

62. In his argument for the explosion of short stories as a separate genre post 1880, Baldwin proposes that short stories in mid-nineteenth-century Britain are dissatisfying because they aimed either to be merely descriptive sketches or "brief novels" (*Art and Commerce*, 10).

63. The relative paucity of Victorian stories that succeed when judged by the Poe yardstick does not mean that the readers of the day felt themselves bereft of short fiction. Ghost stories by Mary Elizabeth Braddon, Sheridan Le Fanu, and others sold briskly; ethically uplifting tales like Geraldine Jewsbury's 1857 "Agnes Lee" flourished; and there was a brisk market for short stories for children: Frances Browne's *Granny's Wonderful Chair* (1857) and Lewis Carroll's "Sylvie and Bruno" (1895) are only the iceberg's tip. For further examples, see the illuminating *Broadview Anthology of Victorian Short Stories*, ed. Dennis Denisoff.

64. Dickens, *Sketches by Boz*, xv.

65. Genette, *Narrative Discourse Revisited*, 85. Borges's proposal that Scheherazade herself appears in one of the nested tales from *One Thousand and One Nights*, thus making the book's structure truly Eschersque and recursive, belongs to the twentieth rather than to earlier centuries.

66. Aptly, the standard Oxford edition of *Pickwick Papers* prints a cast of "characters in the introduced stories" (*Prince Bladud* to *Maria Lobbs*), right after the dramatis personae of the novel itself (Dickens, *Posthumous Papers*, 33, 681, xxiii).

67. Ibid., 697.

68. Cf. Susan McNamara's "Mirrors of Fiction" on the formal implication of overtly nested tales in *Tom Jones*.

69. Watt, *Rise of the Novel*, 285. Even critics who deny that the interpolated tales are an interruption do so by affirming that they are a feature that distinguishes eighteenth-century fiction from its aftermath: according to J. Paul Hunter, for example, "While the tales might be an 'embarrassment' to the expectation of organic unity, such digressive or interruptive features were not

unusual in eighteenth-century narratives" (paraphrased in Williams, "Narrative Circle," 474).

70. "The tales disrupt the conventions of formal realism, signaling instead what Roland Barthes calls the literary code. That is, while one assumes that they depict a realistic scenario of characters travelling in a stagecoach or sitting in a parlor, this representation is charged rhetorically in excess of any naturalistic scene, one which postulates a preternaturally propitious time and place for narrative to occur, the act of narrative elevated in exaggerated terms, proffered to extraordinarily receptive consumers" (Ibid., 475).

71. One noteworthy exception is Wilkie Collins's 1859 *Queen of Hearts*, which, with shrewd commercial logic, transforms ten previously published short stories into a kind of novel by surrounding them with a frame-narrative and a love plot.

72. Dickens, *Oliver Twist*, 75.

73. Scott, *Redgauntlet*, 112.

74. I am grateful to David Stewart for bringing this tale to my attention. In this context, it is amusing to note that one of the fiercest critics of the use of interpolated tales in Fielding's *Joseph Andrews* (1742) was Scott himself, who reported that the reader "glides down the narrative like a boat on the surface of some broad navigable river . . . [but] one exception to this praise . . . [is that] Fielding has thrust into the midst of his narrative . . . the history of Leonora, unnecessarily and inartificially" (qtd. in Williams, "Narrative Circle," 473).

75. Dickens, *Oliver Twist*, 355.

76. Radcliffe, *Italian*, 271, 107. Leah Price pointed me to a wide range of such occasions in this text.

77. Dickens, *Great Expectations*, 177.

78. McNamara, "Mirrors of Fiction," 374.

79. Dickens, *Great Expectations*, 456.

80. Ibid., 309–10.

81. Ibid., 413.

82. Eliot, *Middlemarch*, 138.

83. Ibid., 139.

84. Ibid., 169.

85. Ibid., 821.

86. Ibid., 142.

87. Williams, "Narrative Circle," 482.

88. Cf. Nicholas Dames on the mid-nineteenth-century self-consciousness about a particular occurrence becoming a "chapter" in a life: "A group of young people spends a night at a public garden; one of them gets a little too drunk, and in the process a possible marital engagement is spoiled. It is a brief episode, 'so short that it scarce deserves to be called a chapter at all,' as W. M. Thackeray writes in 'Vanity Fair.' And yet, Thackeray continues, 'it is a chapter, and a very important one too. Are not there little chapters in everybody's life, that seem to be nothing, and yet affect all the rest of the history?' Already in the eighteen-forties, the metaphor was a common one. To 'close that chapter of my life' with regret, to excitedly 'start a new chapter': these are at once experiences of reading and experiences of living. They are ways in which our lives, in fact, take on the shape of a novel" ("Chapter," *New Yorker* online).

89. Moretti, *Bourgeois*.

90. E.g., Pratt's thesis in "The Long and Short of It" that the story is minor, the novel its major complement.

2. Mediated Involvement: John Stuart Mill's Partial Sociability

1. The original Kantian impulse necessitates both an external material universe and the application, inside the mind, of the categories given by reason. Schiller's idea of the "play drive" and the Hegelian "concrete universal" respond to the Kantian account of the imagination as that which preserves taste while nonetheless holding the original object of that taste apart from the perceiving subject.

2. Hughes, Introduction to *Altrive Tales*, 2.

3. Ibid., 5.

4. Arendt, *Lectures on Kant's Political Philosophy*, 65.

5. Cf. Hina Nazar's argument that in the early nineteenth century "by contrast with the a priori character it develops in many Enlightenment paradigms, judgment emerges under sentimentalism as a worldly and contingent process, one that is inextricably tied to feelings and sociability" (*Enlightened Sentiments*, 2). Kevin McLaughlin's *Poetic Force: Poetry After Kant* offers a different genealogy of the role that Kantian aesthetics play in shaping English poetry. That account focuses on "an a priori capacity of language to free itself from having empirical content" and makes the case that "by virtue of its very ability to communicate or produce the feeling of the faculty of reason, this force of language is also accompanied by an unforce that must be felt in Kant's writing even as it remains (perhaps aptly) unstressed" (xiv).

6. Schiller, *On the Naïve and Sentimental in Literature*, 42.

7. Ibid.

8. Lamb, "Dream Children," 103.

9. Cf. Thomas Hardy's *The Well-Beloved* (1892) in which a single soul seems to recur in three generations of women.

10. Schiller, *On the Naïve and Sentimental in Literature*, 42.

11. Mill, *On Liberty*, 18:220.

12. Cf. Carlisle, *John Stuart Mill*.

13. Appiah criticizes this aspect of Mill's thought because it "can lead us to think that the good of individuality is reined in by or traded-off against the goods of sociability so that there is an intrinsic opposition between self and society" ("Liberalism," 319).

14. Cf. Mill, "Coleridge." Some recent critics stress Mill's deep roots in Benthamite utilitarianism, while others argue that his debt to Anglo-German romanticism makes Mill value "autonomy" and the development of character as goods superior even to happiness itself. Cf. Capaldi, *John Stuart Mill*. There is also a recent interest in exploring Mill's affinities with Hegelian historicism. Cf. Skorupski, "Philosophy of John Stuart Mill." Collini provides a cogent account of Mill's posthumous reputation in Britain in "From Sectarian Radical."

15. Wendy Donner has aptly described Mill's liberalism as born out of the tension between an almost monadic conception of human autonomy and a palpable yearning toward strongly knotted social ties (*Liberal Self*). Nancy Yousef argues that the tension in Mill's liberalism between autonomy and the necessity for sociability was never resolved, and that it resulted in a split intellectual project. "The limited impact of Mill's seemingly profound valuation of sociality," she argues, is evidenced by the tension between his openness to the "light of other minds" and his craving for poetry, understood as a categorically private form of utterance (*Isolated Cases*, 172). This helps explain why even Habermas's influential critique of Mill's liberalism argues that Mill took the positive step, absent in other theorists of democracy, of arguing for the necessary rather than the contingent exclusion of the working class from suffrage.

16. Perhaps trying to have it two ways at once, Mill asserts that society "both does its duty and protects its interests" principally by *not* imposing its stamp on its individual members: "A person whose desires and impulses are his own—are the expression of his own nature, as it has been developed and modified by his own culture—is said to have a character. One whose desires and impulses are not his own has no character, no more than a steam engine has a character" (*On Liberty*, 18:264).

17. Goffman, *Interaction Ritual*, 5.

18. Ibid., 3.

19. Shanley, "Subjection of Women," 398.

20. Mill, *On Liberty*, 18:223. The word "moral" in this context (as frequently in the "moral sciences" section of *A System of Logic*) is not ethical but ethnographic; Mill uses it to refer to the "self-evident and self-justifying" rules that make "custom" a "second nature . . . continually mistaken for the first" (8:220). Far from being normative, then, the "moral" instructions that society issues are liable to mold others into society's homogeneous blueprint. By the same token, the "moral freedom" that Mill advocates for in *A System of Logic* consists of recognizing the ways in which one was trained, but knowing oneself capable of discarding that training should it prove inconsistent with reason: "a person feels morally free who feels that his habits and temptations are not his masters, but he theirs" (8:841).

21. Appiah, "Liberalism," 319, emphasis in original.

22. Nightingale, "Cassandra," 219. Although she often represents novels as enervating vessels of escapist fantasy, occasionally Nightingale will turn to the plots of novels as proof that women do in fact dream of something better than domestic confinement (cf. 226, especially).

23. Ibid., 213.

24. Mill, *On Liberty*, 18:260.

25. Cf. Gabriel Tarde's discussion of "crowd and public" in his *L'Opinion et la Foule* and Robert Park's *Mass und Publikum* in his *Crowd and the Public* more than three decades later.

26. Or "thought [waiting] upon feeling" (Mill, *Autobiography*, 1:357).

27. Amanda Anderson has discussed Mill's commitment to the sympathy and imagination he found lacking in Bentham, the necessity of "deriving light from

other minds." She describes Mill's final effort to reconcile the twin aspirations of justice and intersubjective sympathy as "a complex dialectic of detachment and engagement; ethical and epistemological process achieved through the flexible agency of sympathetic understanding" (*Powers of Distance*, 17).

28. Mill, letter to Thomas Carlyle (March 9, 1833), *Earlier Letters*, 143.

29. Carlyle, letter to Mill (February 22, 1833), *Collected Letters*, 328–39.

30. Mill, letter to Thomas Carlyle (March 9, 1833), *Earlier Letters*, 143.

31. In the "mental crisis" chapter of the *Autobiography*, Mill describes the despair he felt realizing that "to know that a feeling would make me happy if I had it, did not give me the feeling," and his discovery that "the habit of analysis has a tendency to wear away the feelings" (1:141).

32. Compare Williams: "We are concerned with means and values as they are actively lived and felt . . . specifically, affective elements of consciousness and relationships: not feelings against thought, but thought as felt and feeling as thought" (*Marxism and Literature*, 132).

33. Carlyle described Mill as such a machine in a letter to his brother John.

34. Mill, "Thoughts on Poetry and Its Varieties," 1:349.

35. Arendt, *Life of the Mind*, 216.

36. Mill, "Thoughts on Poetry and Its Varieties," 1:348.

37. I am grateful to Lauren Goodlad for a vigorous response (Notre Dame, March 2008) to an earlier version of this chapter and to Elaine Hadley for subsequent discussion. Both offered insights that aided me in exploring Mill's conflicted commitment both to the realm of reading and to the realm of direct political action.

38. Lisa Gitelman's notion of the negotiation that occurs at moments of paradigm shifts between media helps clarify how profoundly antimodernist Mill is in one key regard. He conceives of lyric utterance as a pure conduit between the author's feelings and the reader's (*Always Already New*). He sees lyric poetry not as capable of noting and responding to its own materiality, but as a genre in search of divested, immaterial intimacy. On the interplay of solitude and necessary interaction, see Donner's discussion of "the intersubjective dimension" of Mill's thought (*Liberal Self*).

39. Mill, "Thoughts on Poetry and Its Varieties," 1:348, originally published in *Monthly Review*, January 1833, as "What Is Poetry?".

40. Yousef, *Isolated Cases*, 170–97.

41. Mill, *Autobiography*, 1:45. The portions of the *Autobiography* describing Mill's early years were written between 1851 and 1853, but then extensively edited and revised by Mill and Harriet Taylor Mill together in 1854: her penciled notes are all over the manuscript (Robson and Stillinger, Introduction to *Collected Works*, 1:xix–xxv). It was also extensively revised in 1861, two years after Harriet's death, at which point many of the more personal details were edited out (1:xxv–xxvii). One effect of this is to make the published version of the *Autobiography* seem oriented a great deal more toward books, and away from personalities, than earlier versions. However, some of the revisions actually have the effect of concealing how strongly Mill had stressed his formative experiences as a reader in the 1851 version. For example, there is a notable passage in the 1851 manuscript in which Mill boastfully compares himself to

Plato, which he revised to a general statement about the Platonic method for the 1873 edition (*Autobiography*, 1:24–25).

42. When Mill fondly recalls meeting Saint-Simon, for example, he omits any personal description, instead avowing enthusiastically that "the chief fruit which I carried away from the society I saw was a strong and permanent interest in Continental Liberalism" (Ibid., 1:44). This is reminiscent in some ways of Cobbett's *Rural Rides*, in which every natural detail he glimpses reminds him of some political debate raging at the time: crows look like unscrupulous bankers, starlings remind him of pensioners who eat up the national budget, etc.

43. The correspondence with Carlyle provides another useful way to think about Mill's odd views of friendship and the role letters or printed matter could play in it. Carlyle regretted the fact that their friendship had to be carried on by letter: "We are so like two Spirits to one another, two Thinking-Machines" (*Collected Letters*, letter of September 24, 1833 [6:445]). By contrast Mill, in his correspondence with Carlyle and with other friends as well as in the *Autobiography*, sees letters and essays as the logical medium for forging a friendship; even a debate that takes place in articles published in rival journals he frequently depicts as a kind of friendly chit-chat with a kindred spirit.

44. Mill, *Autobiography*, 1:46.

45. Ibid., 1:47.

46. Ibid., 1:103, 105.

47. Idem, *On Liberty*, 18:245.

48. Ibid.

49. Ibid., 18:249, emphasis in original.

50. Mill's *On Liberty* was, like his *Autobiography* and *Utilitarianism*, begun in the early 1850s, when Mill and Harriet both thought they had little time left to live, and then completed many years later. *On Liberty* came first in 1859; *Utilitarianism* and *Considerations of Representative Government* followed in 1861, while the *Autobiography* did not appear until after his death in 1873. "The death of Harriet, on 3 November, 1858 drove Mill to consider it [*On Liberty*] almost as a memorial to her that should never be altered by revision" (Robson, Textual Introduction to *Collected Works*, 18:lxxxiii). For a reconstruction of the relationship that posits a yet stronger role for Harriet in composing the works of the 1850s, see Jacobs, *Voice of Harriet Taylor Mill*.

51. Mill, *On Liberty*, 18:216.

52. Cf. Mill's more explicit discussion of the various technical and inspirational roles that she played in the composition of the book (*On Liberty*,18: 252–60). He is particularly explicit about the composition of *On Liberty*: "The *Liberty* was more directly and literally our joint production than anything else which bears my name, for there was not a sentence of it that was not several times gone through by us together, turned over in many ways, and carefully weeded of any faults. It is in consequence of this that, although it never underwent her final revision it far surpasses, as a mere specimen of composition, anything which has preceded from me either before or since" (18:257–59).

53. Ibid., 259.

54. Ibid.

55. Daston and Galison, *Objectivity*, 38–39.

56. Carlyle, letter to Mill (September 24, 1833), *Collected Letters*, 6:445.
57. Charles Taylor's account of romanticism as a discourse of "immanent counter-Enlightenment" misreads romantic-era yearning for belief, interpreting it as a form of credulity that lacked substantial purchase in the empiricist, and even skeptical capitalist milieu characterized, from the mid-eighteenth century on, as Gallagher puts it, by "disbelief, speculation, and credit" (Gallagher, "Rise of Fictionality,", 346).
58. Duncan, *Scott's Shadow*, 120, 128–29.
59. Ibid., 120.
60. Mill, *On Liberty*, 18:220.
61. Cf. John Frow's recent attempt in *Character and Person* to reframe the relationship between persons and characters around the questions of modes of being.

3. Visual Interlude I / Double Visions

1. Summers, *Real Spaces*, 338.
2. Ibid., 339.
3. Ibid., 625.
4. For the particulars of how such double distance manifests in nineteenth-century unease about the impossibility of knowing in what sense an artwork claims "truth to nature," it is worth considering Jonathan Crary's argument in *Suspensions of Perception* that "attention becomes a specifically modern problem only because of the *historical* obliteration of the possibility of presence. . . . An immense social remaking of the observer in the nineteenth century proceeds on the general assumption that perception cannot be thought of in terms of immediacy, presence, punctuality" (4).
5. Cf. also the odd placement of hands on ledges at the picture's bottom in Memling's 1475 *Portrait of a Man Holding a Letter*, *Portrait of the Young Pietro Bembo* (1504–5), and *Portrait of a Man* (1465–70), though in all those cases there is a palpable mimetic ledge on which the fingers rest, unlike the Christ, whose fingers actually seem to rest on the painting's own frame. Memling's *Portrait of a Young Man before a Landscape* (1475–80) and *Portrait of a Young Woman* (1480) are more ambiguous; in the latter, the fingertips clearly spill over onto the fake marble that forms the interior frame of the painting. Similarly, in his *Jans Floreins Triptych* (1479), the brown robe of a supplicant spills out onto the frame without covering the text painted there and the halo of the Virgin glows like gold on top of the mundane street scene that is glimpsable in the two open windows behind her.
6. A similar logic, perhaps, to that found in his contemporary Andrea Mantegna's almost *trompe-l'oeil Mourning over the Dead Christ* in which we gaze up at the prone Christ's body from just beyond his massive, inescapably corporeal feet. As Summers puts it, "The body of Christ, acknowledgement of whose suffering was the first step in the salvation of the mediator, is shown with a kind of iconic centrality and with a kind of semi-independence, since his body does not lose dimension at the same time that his appearance is determined to

the point of misshapenness by his relation to the viewer. The dead Christ is presented with an insistent physicality, which is both in light and in defiance of the laws of optics" (*Real Spaces*, 526).

7. Ibid., 30.

8. The role played by this spectral gesture (like the spookily foreshortened gesturing hand in "Virgin of the Annunciation" in Memling's 1475 counterpart's painting, *Messina*) is illuminated by Susie Nash's argument that Memling's paintings of mirrors and "reflections are often complex and clever. . . . [He seems] less interested in making a point concerning his facture of these works and their artificiality as created image, and more interested in a clever expansion and explication of his invented space and the figures in it, using them to suggest the continuation of his images beyond the painted surface" (*Northern Renaissance Art*, 123). Nash adds that "Memling's paintings have settings that are so carefully and logically constructed that viewers can picture themselves in relationship to the images with some precision and even mentally enter the scene, imagining themselves walking around or through the buildings represented" (277).

9. Fried's "Caillebotte's Impressionism" offers one lapidary account of his overall project:

Courbet was one of two culminating figures, the other being Manet, in what I describe as an antitheatrical tradition that lay at the heart of the evolution of French painting between the middle of the eighteenth century and the advent of Manet and his generation in the 1860s. At the core of that tradition was the demand, first articulated theoretically by Denis Diderot in his writings of the 1750s and 1760s on the theater and painting, that a picture somehow establish the metaphysical illusion that the beholder does not exist, that there is no one present before the canvas. In the work of a succession of major figures from Jean-Baptiste Greuze to Jean-François Millet, this was to be done by closing the representation to the beholder, above all by depicting figures wholly engrossed or absorbed in actions or states of mind, who therefore were felt to be unaware of being beheld. By the 1840s and 1850s, however, [in France] the resort to absorption increasingly fell short of producing the desired effect; the figures in question tended more and more to be perceived not as truly given over to what they were doing, thinking, or feeling but as merely wishing to appear so, which, far from persuading the beholder that he had been forgotten, positively confirmed the suspicion of theatricality that the absorptive strategy had been mobilized to defeat. [And a generation later] . . . absorption's dependence on effects of inwardness and closure on a metaphorics of "depth" was in tension with Impressionism's emphasis on surface liveliness and what as early as 1874 was called decorative unity (4–5, 18).

10. Williams, "Bloomsbury Fraction," 231. In 1884, William Morris called him "a genius bought and sold and thrown away" (*Collected Works*, 16:xx); in 1922, Beerbohm added fuel to the fire in *Christmas Garland* with a witty, cruel cartoon imagining the shock that the young Millais would have had confronted with "Cherry Ripe" and his older self. Cf. Debra Mancoff, "John Everett

Millais," on the rise of an account of Millais as an artist whose *only* greatness lay in his early commitments to a new sort of realism in art.

11. Cf. Lisa Tickner's recent call to appreciate the ways in which Victorian art was *modern* by rejecting both "a modernist account of the avant-gardes (which puts English artists into a continental shadow)" and also "an eccentric genealogy of Englishness—Blake, Burne-Jones, Spenser, Bacon, Freud—largely regionalist and biographical" ("English Modernism," 30). It also accords with Barlow's argument that scholars should not assume that "Millais's collusion in social convention negates the worth of his art, turning it into a mere historical document" ("Millais," 52).

12. Cf. Tim Barringer's gloss of Millais's 1857 *Autumn Leaves* as "prophetic of artistic developments of the next two decades, as the Pre Raphaelites explored new forms of expression turning away literary narrative" (Barringer, Rosenfeld, and Smith, *Pre-Raphaelites*, 156).

13. This account of Millais understands him as part of the PRB impulse to, as Raymond Williams puts it, "[try] to find new and less formal ways of living among themselves . . . a corresponding rejection of the received conventions . . . [coupled with a] positive aim [of] truth to nature" ("Bloomsbury Fraction," 230). This means attending not only to their professed aim to "have genuine ideas to express" and "to study nature attentively," but also the *Athenaeum*'s pronouncement that 1856 "exactness is the tendency of the age" and to Tim Barringer's compelling account of the impact upon Ruskin, upon Millais, and indeed upon Millais's painting of Ruskin, of a "key aspect of the painter's realism . . . learned from the camera" ("Antidote to Mechanical Poison," 21). To this might be added Lindsay Smith's argument that "the invention of the camera . . . signalled an unprecedented disturbance in a range of cultural investments in the visual" with eventual repercussions including "radical interrogat[ion of] the means by which vision is made possible," "fascination with perceptual aberration," and among the Pre-Raphaelites, "a more hesitant and provisional account of vision . . . with [an] odd blend of empiricism and transcendentalism" (*Victorian Photography*, 1–4).

14. Pater, *Studies in the History of the Renaissance*.

15. Ibid.

16. Compare Prettejohn's recent argument that in Ford Madox Brown's view, "a genuinely adequate history painting must not only deal with a present-day perspective and a time-based past; it must also reckon somehow with the timeless" ("Ford Madox Brown and History Painting," 252–53).

17. Although it does not seem to have become a more widespread preoccupation in the nineteenth century, such interstices, doomed spaces in which unrecoverable events occur, are an interesting kind of narrative annex-space: there is a John Galt story from the 1830s told from the perspective of a daughter of Noah who gets left behind ("The Deluge").

18. Hence, presumably (since numbers 1 to 4 came out between January and April 1850) written in early 1850.

19. Millais, *Life*, 1:67.

20. Millais was very fond of Keats, and especially of *The Eve of St. Agnes*: he painted Keats's Madeline, both drew and etched Tennyson's "St. Agnes," and

in the first days of the PRB, assisted Hunt in finishing his "The flight of Madeline and Porphyro during the drunkenness attending the revelry (*The Eve of St. Agnes*)" (1848). It is possible to see in this not-quite-story the lineaments of that poem's plot.

21. Helmreich, *Nature's Truth*, 23.
22. On photography and the Pre-Raphaelites, see Barringer, "Antidote to Mechanical Poison," and Roberts, "Certain Dark Rays"; on the epistemic virtue of objectivity see Daston and Galison, "Objectivity."
23. Pamela Smith has recently asked, "Why did naturalism in painting arise simultaneously with the new science?" and answered by positing an "artisanal epistemology" that was "incorporat[ed] into the new science of the sixteenth and seventeenth centuries" (*Body of the Artisan*, viii). It may be worth looking at the Pre-Raphaelites as early practitioners of a new "objective epistemology."
24. Cf. Jennifer Roberts's recent analysis of how nineteenth-century American paintings register their own materiality and the challenges associated with their movement through the world: "Art history needs to look beyond the theories of illusion, representation, and iconography that underlie its formation as a modern discipline and confront the unavoidable material basis of its referential operations, the weight and heft of which its images are made. Likewise, although material culture offers inroads to the interpretation of things, it reaches a methodological impasse with representation, which by definition signifies something beyond the material specificity of the work" (*Transporting Visions*, 162–63).
25. *Times*, May 5, 1860.
26. Millais, *Life*, 145.
27. Roberts, "Certain Dark Rays," 64.
28. Ibid.
29. Barlow, *Time Present*, 18.
30. This aligns with an observation Julie Codell makes about Millais's project of conveying the inward experience of fleeting moments of intense emotion: "The Virgin's off-balance leanings and Christ's angling towards her for a comforting kiss are [an] emphatic rendering of bodily motion for which they were sharply criticized as displaying an eccentric predilection for joints" ("Empiricism," 122–23). Codell's account of Millais's struggle to depict "the fugitive nature of emotions" explicitly links the PRB with ongoing empirical investigations into the transitory nature of emotions among scientists of the day.
31. "Pathological Exhibition at the Royal Academy (Noticed by our Surgical Advisor)," *Punch* 19 (May 18, 1850): 198.
32. Giebelhausen, *Painting the Bible*, 101, summarizing contemporary critical reception.
33. "Royal Academy Exhibition," *Builder* (June 1, 1850): 255–56.
34. I am grateful to Nicholas Robbins for comments about those shavings during a presentation of this work at the Yale Art History Department, November 2015.
35. "Pictures of the Season," *Blackwood's Edinburgh Magazine* (July 1850): 82.
36. Qtd. in Marsh, *Pre Raphaelites*, 32.
37. Qtd. in Andres, *Pre-Raphaelite Art*, 9
38. Dickens, "Old Lamps for New Ones," *Household Words* 12 (June 15, 1850): 12–14.

39. Bullen's points out that Dickens's piece differs from the immediate wave of reviews in being "a meditated and carefully targeted attack," in being written about only a single painting, and in being virtually a unique foray into art criticism by a writer, as Bullen puts it, "whose knowledge of painting was self-confessedly limited" (*Pre-Raphaelite Body*, 15).

40. Ibid., 17.

41. "Physiognomic immediacy," Bullen goes on to argue, "was interpreted by Dickens and his contemporaries in entirely negative terms" (Ibid., 16, 17). Interestingly, Landow argues that Millais "turns the coarse details of genre painting into spiritual fact" (*Victorian Types*, 123); is this a possibility that Dickens overlooks, or one that outrages him because it points toward, as Bullen suggests, a taste for "grotesque physiognomy" that Dickens links to "Catholic art"? (*Pre-Raphaelite Body*, 19).

42. Giebelhausen hears Dickens responding as if to blasphemy: "The temple has been desecrated" (*Painting the Bible*, 105). Cf. Giebelhausen's idea that *Christ in the House of His Parents* "mobilized a defense strategy that relied on the key values of academic theory—nature and beauty. They provided strong moral categories when turned into their opposites: Unnatural and ugly. Both terms possessed great potential for metaphorisation through which the periodical press pathologised the Pre-Raphaelite project. In the morally charged language deployed to defend the established orthodoxy, the alternative aesthetic of the Pre-Raphaelites was conceptualised as heresy" ("Academic Orthodoxy," 176).

43. We are very far, at this moment, from George Eliot's 1873 praise of Burne Jones, "Your work makes life larger and more beautiful to me"; Thomas Hardy's 1878 journal entry, "To Grosvenor Gallery. Seemed to have left flesh behind and entered a world of the soul"; far even from Gaskell's 1859 letter to Charles Norton: "I am not going to define and shape my feelings and thoughts at seeing either Rossetti's or Hunt's pictures into words; because I did feel them deeply and after all words are coarse things" (all qtd. in Andres, *Pre-Raphaelite Art*, xvi).

44. Qtd. in Ackroyd, Dickens, 463.

45. Buchanan, *Fleshly School of Poetry*, 34.

46. Barlow, *Time Present*, 18.

47. Prettejohn, *Art of the Pre-Raphaelites*, 189–90. Pursuing this line of thought even further, Giebelhausen stresses how "ambiguous and demanding" Millais's painting is, and makes the case that "the demands this picture makes of the viewer are diametrically opposed to those traditionally associated with high art. Millais inverted Reynolds's famous dictum of painting's inferiority to poetry: "what is done by painting, must be done at one blow" (*Painting the Bible*, 114).

48. Prettejohn, *Art of the Pre-Raphaelites*, 190.

49. Cf. Prettejohn's recent argument that Brown's paintings offer an avenue toward religious experience (a supplement or a replacement) by letting you see something that exists only within your own retrospective conception of the event—the holiness marked by those halos ("Ford Madox Brown and History Painting," 244).

50. Giebelhausen intriguingly links the way that Millais "combined deliberate anachronisms with an aggressive realism that flew in the face of academic

conventions" to Anna Jameson's praise, in her 1848 *Sacred and Legendary Art*, for "so-called *anachronisms* in devotional subjects, where personages who lived at different and distant periods of time are found grouped together" (*Painting the Bible*, 114). Lindsay Errington's conclusion that *Christ in the House of His Parents* "suffers from his multiplicity of purpose" is perhaps an extension of just this contemporary unease with Pre-Raphaelite experimentation (*Social and Religious Themes*, 247).

51. Prettejohn discusses ways in which Ford Madox Brown's history paintings (e.g., *Cromwell on his Farm* [1874]) made viewers simultaneously aware of the past, the present viewing scene, and a kind of timeless space of art: "Besides the timed and the timeless, then, there is a third temporality at work: the perspective of the modern artist, or spectator, from which either the timed or the timeless aspect of the subject is necessarily viewed simultaneously" ("Ford Madox Brown and History Painting," 252). On the one hand, Brown spent a great deal of energy trying to enter into the mindset of Cromwell at this moment of retreat, on the other hand, in his essay of 1850, "On the Mechanism of a Historical Picture," Brown advises that when it comes to impersonating historical figures one should study the character by acting it out in a looking-glass. So Cromwell is a portrait of Brown himself. This is not mere vanity, but a curious kind of invitation: you, too, should imagine your own face in this position as you undergo a moment of tribulation—your seeing my face on Cromwell is in fact an invitation to you to put your face and your own feelings there, as well.

52. Leonard, "Picturing," 266.

53. Ibid.

54. Helsinger, "Listening," 409.

55. Prettejohn, *Art for Art's Sake*, 7–8; Alma-Tadema is not mentioned in the book.

56. In understanding Alma-Tadema's relationship to the commercially successful painting of his day and to movements like the Pre-Raphaelite Brotherhood, I have profited from Elizabeth Prettejohn's account of Leighton as both aesthete and academic painter. Rather than disavowing Leighton's connection to the Academy, Prettejohn argues that figuring the academic "as a theoretical category . . . can open fresh perspectives on the aesthetic debates of the nineteenth century—particularly debates involving formalism and intentionality. . . . Leighton's academic position can help us to rescue current art history from its recidivist bias toward Modernist aesthetics" ("Leighton," 34). Although I do not pursue the argument about Alma-Tadema's cultural prestige and its relationship to his academic orientation here, Prettejohn's analysis seems to me to open the door for a helpful attention to the intentions and the formal conceptions that motivate what Alma-Tadema describes as his "antique genre" paintings as well as the "flawless" or "polished" surfaces that drove Fry to excoriate him in 1913, declaring that Alma-Tadema "caters with amazing industry and ingenuity . . . for an extreme of mental and imaginative laziness" ("Case of the Late Sir Lawrence," 666.)

57. Prettejohn, "Lawrence Alma-Tadema," 125.

58. In a preparatory sketch, the three listeners, all female, recline against one another, with the third figure actually playing the lyre that rests against the wall in the finished painting. Reproduced in Barrow, *Lawrence Alma-Tadema*, 124; dated 1884–85.

59. Alma-Tadema owned a photographic reproduction of the ancient statue in question.

60. That absent third, the subject of the rivalry, may also (as Kate Flint acutely pointed out to me) be implicitly referenced by the presence of the Three Graces high up on the wall to the right.

61. On the general implications of painting names in the Victorian period, see Ruth Yeazell, *Picture Titles*.

62. Eliot, *Middlemarch*, ch. 81.

63. Ibid.

64. Cf. David Kurnick's account of *Middlemarch*'s "conflation of detachment and surrender, of inattention and over-attentiveness" ("Erotics of Detachment," 587). Kurnick's intriguing notion of critical detachment as itself a compulsion of the flesh resonates with my own account of those moments in which detachment looks like something that occurs only in situ, and only to characters who are grappling as much with physical and social anchors as with their own mental processes.

65. Mill, "Thoughts on Poetry and Its Varieties," 1:362.

66. Browning, *Men and Women*, 183.

67. Cf. Sider's recent account of Browning's relationship to a "Victorian discourse of exemplarity, in which public address and personated intimacy commingle." He sees Browning's poems as offering "a fantasy of relation . . . in which the character's way of imagining his or her transmission and reception anticipates the transmission and reception of the poem itself as a public and circulated object" ("Dramatic Monologue," 1137).

68. The poem's narrator even addresses distant Galuppi from modern England—"I was never out of England—it's as if I saw it all"—even though Browning probably wrote the poem while in Venice (Browning, "Tocatta," 39–42 in *Men and Women*, line 9).

69. Ibid., lines 19–21.

70. The poem ends by ejecting the speaker into a disenchanted world:

Dear dead women, with such hair, too—what's become of all the gold
Used to hang and brush their bosoms? I feel chilly and grown old.

(Ibid., lines 44–45)

There's no hair to hang the tale on. Like the wrenching perspective shift that leaves everything "cold" at the end of Keats's *The Eve of St. Agnes* ("And they are gone: ay, ages long ago / These lovers fled away into the storm"), Browning's ending suggests that poems impersonate the palpable presence a thing ought to provide—but ultimately, insidiously, undermine just such solidity.

4. VIRTUAL PROVINCES, ACTUALLY

1. Gallagher, "Rise of Fictionality," 340.

2. There are various ways to understand how fiction departs from and returns to the purposive, developmentally ordered world. In the spirit of Anne-Lise Francois's fascinating notion of literature's capacity to register or produce "desistance" from "heroic, goal-oriented energies" (*Open Secrets*, 33), Elisha Cohn's

recent *Still Life* approaches the question of the relationship between novel and actual world by emphasizing "a common structure of evasion—a quiet rhythm or 'visionary hollow'—in the story of development, where the burdens of self-making are held at bay" (184). Cohn sees a wide array of novelists who "propose a non-instrumental understanding of *narrative* by limiting the novel's efforts at theorizing the mind, and instead put narrative in a lyric mood" (Ibid., 6).

3. Mitford, *Works of Mary Russell Mitford*, 7.
4. Ibid.
5. Austen, *Janes Austen's Letters*, 468–69.
6. Buzard, *Disorienting Fiction*, 3–18.
7. Mitford, *Works of Mary Russell Mitford*, 7.
8. Bakhtin, "Forms of Time," 248, 229.
9. Distinct from the metropolis—that is, I have argued that in the *regional* novel, an intriguing variant of the provincial novel, the world is marked as peculiarly distinct from other provinces, as well (Plotz, *Portable Property*, 93–121).
10. Duncan, "Provincial or Regional Novel," 320–26.
11. Moretti, *Graphs, Maps, Trees*, 52.
12. Joseph Rezek has recently offered a somewhat different reading of provincial literature, stressing romantic-era instances to different effect: "A paradox arises throughout modernity: that a great work of literature is both particular and universal, that it arises from a distinct context defined by a unique worldview with its own internal values, and also that it transcends that context, that worldview, and those values. . . . The opposed concepts mutually inform each other in a profoundly circular logic: the representation of particularity provides access to a universal truth, while universality accrues meaning and importance to the particular. . . . Caught in an impossible wish that their works be accepted as both national and universal, provincial authors offered powerful claims for the unique place of literature in society. . . . The aesthetics of provinciality consists of a range of representational modes, derived from geographically inflected cultural subordination, that vacillate between national and universal conceptions of art; it takes refuge in the belief that literature enjoys an exalted role in human affairs" (*London*, 14–15). The appeal of Rezek's model of provinciality is that it allows him a way out of a narrowly nationalist conception of literary production in a period in which questions of attachment to the metropolitan center and its near monopoly of the means of literary production is paramount: thus, Rezek's claim to map Casanova's model of early twentieth-century Paris to early nineteenth-century London. One potential drawback to this model's application to the Victorian era is that it proves an imperfect predictor of the ways that literary production develops in the intervening half century. Specifically, the provinciality that so offends Arnold is also, for a writer like Eliot, a strangely empowering position. The same "Greater Britain" (cf. Duncan Bell's recent work) that generates distance effects also generates a sense of omnipresent attachment: a society of mediation in which anyone anywhere has a differentiated but also a potentially common access to the culture's finest products. The life of the provinces is shaped by being a life that is available in the metropolis, as well: this is an economy that satisfies both the provincial and the urban cosmopolite, because there is enough shared experience for the differences to be (pleasingly) visible.

13. Trollope, *Barchester Towers*, 1.
14. Recent criticism has stressed the distinctive features of Victorian serial fiction; I have argued against projecting backward onto Victorian fiction too many of the formal features of the serial forms of our own day (Plotz, "Serial Pleasures").
15. Locke, *Essay*, 100.
16. Moretti, *Graphs, Maps, Trees*, 53, 54.
17. Chapter 7 discusses the rise of the frequently map-centric genre of "secondary world" fantasy, of the Tolkien variety. For a discussion of one of the rare exceptions to that rule, see Joanna Taylor's recent article, "(Re-)Mapping the 'native vale,'" on a hand-drawn map that accompanies the ms. of Sara Coleridge's 1837 *Phantasmion*.
18. Cf. on novelistic reverie, Arata, "On Not Paying Attention."
19. Review of *Dracula*, 363–64.
20. Stevenson, *Letters*, 151.
21. Qtd. in Sweet, Introduction to *The Woman in White*, xvi.
22. "Eliot invites us into an imaginative space that is characterized not as a state of mind but as a location" argues Alison Byerly, as part of her persuasive claim that in the period a "booming market developed for realistic representations of popular locations, and new ways of representing place . . . seemed to offer themselves as substitutes for actual travel" (*Are We There Yet?*, 28).
23. Gaskell, *Wives and Daughters*, 3; idem, *Cranford*, 1.
24. Eden, *Semi-Detached House*, 223. Emily Eden also deserves ancestral credit and acknowledgment in this book for coining the word "semi-detached" in 1859 to describe houses that share a "party" wall (less successful was her suggestion that people living on the other side of your house should be called your "semi-detachment.")
25. Williams, *Country and the City*, 197–215.
26. Trollope, *Warden*, 18.
27. Reprinted in Smalley, *Trollope*, 509–10.
28. Tolstoy, *Anna Karenina*, 277.
29. Flaubert, *Madame Bovary*, 35.
30. Ibid., 33, 51.
31. Moretti, *Graphs, Maps, Trees*, 52–53.
32. Arnold, "Literary Influence," 46.
33. Cf. Rezek: "In Romantic-era Scotland, provinciality was a productive state of mind for novelists, not one to be lamented in the name of an indigenous national tradition. They played around with the idea of the London book trade as much as they played with the idea of a distinctive national culture, and the idea that literature transcends nationalized definitions of culture. . . . The same is true for American novels from the 1820s that stage the union of an English or Anglicized figure with an American one. . . . It is the explicit nature of its reckoning with English readers that assigns to provincial literature an important role in the consolidation of Romantic idealizations of the literary" (*London*, 147–48).
34. Larkin, "I Remember," 82.
35. See Coriale, "Gaskell's Naturalist."

36. Menely, "Travelling in Place."
37. Eliot, *Middlemarch*, 483.
38. Ibid.
39. Hardy, *Tess*, 37.
40. Idem, *Jude*, 87.
41. Ibid., 324.
42. Eliot, *Middlemarch*, 484.
43. Wells, "Plattner," 38–39.
44. "Even with a microscope directed on a water-drop we find ourselves making interpretations which turn out to be rather coarse; for whereas under a weak lens you may seem to see a creature exhibiting an active voracity into which other smaller creatures actively play as if they were so many animated tax-pennies, a stronger lens reveals to you certain tiniest hairlets which make vortices for these victims while the swallower waits passively at his receipt of custom. In this way, metaphorically speaking, a strong lens applied to Mrs. Cadwallader's match-making will show a play of minute causes producing what may be called thought and speech vortices to bring her the sort of food she needed" (*Middlemarch*, 58–59).
45. My account is based on a close acquaintance with only about a tenth of her published work, including *The Chronicles of Carlingford* (i.e., *Salem Chapel*, *The Rector*, *The Doctor's Family*, *The Perpetual Curate*, *Miss Marjoribanks*, and *Phoebe Junior*), *A Beleaguered City*, *Hester*, and *Kirsteen*.
46. Cf. Langbauer's description of Oliphant, along with Charlotte Yonge, as a writer of "domestic realism" for whom "the everyday seems to refuse ideal solutions. It insists that there is no utopia outside of ideology's confines" (*Novels of Everyday Life*, 58). My account of Oliphant as aware of what it means to be trapped in unwelcome circumstances, forced to act according to predetermined patterns despite one's own awareness of what a better path may be, is also indebted to Langbauer's astute analysis of the way that the cyclical and the "spiraling circuit" can seem to those readers and critics who dislike "trivial" or "domestic" and quintessentially "feminine" writing with the erosion of any "*essential* meaning or value"; a "limbo" of "spiraling circuits" (Ibid., 52).
47. Elsie Michie's recent analysis of the motivations—both noble and carnal—of Oliphant's heroines describes Phoebe as acting from "both altruistic and self-interested" motives, which strikes me as a description that applies to a much broader range of Oliphant's protagonists than one would expect of a canonized, "reputable" novelist of her day (*Vulgar Question of Money*, 168). As Michie puts it, Oliphant is interested in "the ideological crossover between the two courses that have been represented as polar opposites in the traditional marriage lot: wealth and virtue" (170).
48. Oliphant's own life as a perpetually straitened professional writer, robbed of the freedom both to reflect at leisure and to relax, living always within earshot of domestic travail, able only rarely to achieve the partial separation that let her write what she wanted, must have played a crucial role in both what is most memorable about her fiction—and in her bitter envy of Eliot.
49. Oliphant, *Autobiography*, 15. Joanne Shattock's insightful and astute account of the negotiations between Oliphant and John Blackwood during the composition

and publication of *The Perpetual Curate* makes an explicit comparison between the "criticism and even interference" that Oliphant learned to bear "with a minimum of fuss, and the delicate and it would seem more deeply sympathetic relationship that developed between George Eliot and her first publisher" ("Making of a Novelist," 121). The differences between Eliot and Oliphant were not then simply about pay-scale (Eliot earned at least three times as much per novel as Oliphant [122]) but also about the insulation of the novelist's prose and plotting from editorial intrusion—which is just the sort of irritating, meddling incursions that Oliphant so astutely anatomizes in her work.

50. This accords with Valerie Sander's notion that "Oliphant's novels are concerned with distinguishing between the theatrical gestures performed by women who make a drama out of a crisis, and the secret inner lives of those who truly feel" ("Mrs. Oliphant," 188). I don't feel confident enough in relating fiction to fact to share Sanders's judgment that "the novels suggest Oliphant saw freely displayed emotion, especially in women, as a sign of weakness" (183). Sanders's observations are a response to Oliphant's interest in characters who register the gap between what their social role demands of them and what they can safely display of their own feelings. It is also worth remarking that characters who feel and keep silent provide valuable occasions for Oliphant to explore the gap, ever fascinating to her, between subjective experience and outward action.

51. Oliphant continues: "You may sneer at the common place necessity, yet it *is* one; and it is precisely your Zenobias and Holingsworths your middle-aged people who have broken loose from family and kindred and have no events in their lives, who do all the mischiefs, and make all the sentimentalisms and false philosophies in the world. When we come to have no duties, except those that we 'owe to ourselves' or 'to society' woe to us!" ("Modern Novelists," 96.)

52. Langland rightly stresses the social protest woven through Oliphant's novels—and the price they paid in prestige and reputation for "challenging . . . so many Victorian sacred cows—romance, angels, feminine duty, innocence, passivity, and the separation of home and state" (*Nobody's Angels*, 153).

53. Elisabeth Jay captures the mixed motives that shape Frank Wentworth's actions before his aunts: "His decision to abide by his principles, even though they have been foolishly invested in non-essential symbols, has little to do with spirituality and everything to do with that dangerously nebulous, characteristically nineteenth-century concept: Conduct becoming in a gentleman" (*Mrs Oliphant*, 85).

54. Oliphant, *Perpetual Curate*, 1:60.

55. Levine, "Reading Margaret Oliphant," 236.

56. Banfield draws on a modified version of Chomsky's generative grammar to suggest that there has always existed within language a potential that is more perfectly exercised in the written word than it could ever be in speech: the potential to create an entirely constative utterance unassociated with any identifiable speaker. Banfield is rigorous about separating out the two forms of language: "It is in the language of narrative fiction that literature departs most from ordinary discourse and from those of its functions which narrative reveals as separable from language itself. . . . In narration language can be studied not as a system of signs or communication but in itself. . . . In narrative, subjectivity

or the expressive function of language emerges free of communication and con-
fronts its other *in the form of a sentence empty of all subjectivity*" (*Unspeakable
Sentences*, 10). Banfield's account of the role played by free indirect discourse
is useful in understanding this kind of moment in Oliphant because it clarifies
what it might it mean for characters *not* to be sure of their own perspective.

57. James, "London Notes," 455.

58. James acknowledges the tension here: he is praising her for moments where
she pushes beyond what her readership expected of her, and faulting her for
providing the kind of product her audience sought and paid for: "She worked
largely from obligation—to meet the necessities and charges and pleasures and
sorrows of which she had a plentiful share. She showed in it all a sort of seden-
tary dash—an acceptance of the day's task and an abstention from the plaintive
note from which I confess I could never withhold my admiration" (Ibid., 453).
James's tone throughout is complex: ambivalent admiration from a distance.
He praises Oliphant as a writer who can court difficulties like Wentworth's
sermon. Yet he also notes, with a mixture of admiration and disdain, her pru-
dent professional reasons sailing out of those complications again, seemingly
without a backward glance.

59. Oliphant, *Autobiography*, 155.

60. In that sense, I grant Oliphant more credit than Levine recently has: "While
I do not claim that her work pushes the limits of Victorian form—in the way
that, obviously, Charles Dickens and George Eliot do—Oliphant often ex-
plores consciousness with a subtlety and intricacy that the apparently easy
lucidity of her style can disguise" (*Reading Margaret Oliphant*, 233).

61. This account aligns well with D'Albertis's view of how subjectivity is depicted
in Oliphant's novels: "In eschewing depths, the romantic model of subjectivity
offered both by Charlotte Brontë's domestic fiction and George Eliot's nov-
elistic art, Oliphant rejected neither literary meaning, nor the personal, but a
particular way of creating value out of these things" ("Domestic Drone," 825).

62. Quoted in Jay, *Mrs Oliphant*, vii.

63. Oliphant, *Autobiography*, 14.

64. Oliphant's novels, then, merit the praise Corbett lavishes on her (posthumously
published) *Autobiography*, because the novels, too, make clear the struggles of
"middle-class women who worked for money, who spoke out publicly, and
who tried to represent the difficulties of doing so even as they sought a form
and idiom that would enable them to represent themselves" (*Representing
Femininity*, 106).

65. Cooper, *Scenes from Provincial Life*, 45.

66. Amis, *Lucky Jim*, 24.

67. See both the introduction and the conclusion for discussion of the advantages
and pitfalls of offering a decade-by-decade genealogy of shifting ideas about
aesthetic semi-detachment and partial absorption.

5. EXPERIMENTS IN SEMI-DETACHMENT

1. "Plato states that artisans cannot be put in charge of the shared or common
elements of the community because they *do not have the time* to devote

themselves to anything other than their work. They cannot be *somewhere else* because *work will not wait*" (Ranciere, *Politics of Aesthetics*, 7; emphasis in original).

2. Dickens, *Hard Times*, 35.

3. There is a longer genealogy to this approach, partially rooted in British cultural studies, especially in Raymond Williams's account of culture as base rather than superstructure. Williams's preoccupation with how the "common people" were integrated into, or written out of, the aesthetic realm led among its intellectual descendants to a two-pronged project (or perhaps a double-edged one) in Victorian studies over the past three decades. One strand led to the evidentiary project of finding stories not told, or not retold; and of recovering by way of textual analysis lives and experiences lost (cf. David Vincent, *Bread, Knowledge and Freedom*, Jonathan Rose, *Intellectual Life*, and Ian Haywood, *Revolution in Popular Literature*, as well as such textual history as Seth Koven's recent *Match Girl and the Heiress*). The other strand led to projects that struggled to make sense of the representation of "the people" *within* the aesthetic sphere. Bruce Robbins's 1986 *The Servant's Hand* and Alex Woloch's 2003 *The One vs. The Many* epitomize two decades of attempts to grapple with the role played within nineteenth-century fiction by depictions of "the worker" and the implications that such depictions have for the sorts of freedom and access to power that are possible for actual working-class subjects.

4. Ranciere, *Politics of Aesthetics*, 41.

5. There are inklings of this idea already in Ranciere's *Nights of Labor*, his account of Fourierist utopic thinking among French artisans, c. 1830.

6. Conrad, *Lord Jim*, 4.

7. Dickens, *Our Mutual Friend*, 299–300.

8. "Dickens's additions are often to do with two connected matters: with temporal shifts and with added meta-levels, offering a double density of story-forward and recall—backward in emphatic denial of the simple linear straightforwardness of time, of sentences, and of narrative" (Davis, "Deep Reading," 67).

9. Bender and Marrinan, *Culture of Diagram*, 81.

10. Austen, *Emma*, 24.

11. Bender and Marrinan, *Culture of Diagram*, 81.

12. Lukacs, "Ideology of Modernism," 19–20.

13. Ibid., 20.

14. Williams, *Country and the City*, 165.

15. Ibid., 180.

16. James, Review of *Middlemarch*, reprinted in *George Eliot: Critical Heritage*, 357.

17. Eliot, *Middlemarch*, 36.

18. Ibid., 354.

19. Ibid.

20. Welsh, "Later Novels," 62.

21. Eliot, *Middlemarch*, 354.

22. Cf. Andrew Miller's discussion in *The Burdens of Perfection* of the optative in Victorian fiction, esp. 198.

23. Eliot, *Middlemarch*, 93.
24. Ibid., 772.
25. Ibid.
26. Cf. Plotz, "No Future? The Novel's Pasts" for another version of this argument, via a reading of *Our Mutual Friend*.
27. Eliot, *Middlemarch*, 188.
28. Ibid., 271–72.
29. Eliot, *Impressions of Theophrastus Such*, 3.
30. Ibid.
31. Ibid., 100.
32. Ibid., 101.
33. Merton devotes a fascinating paragraph and footnote to delineating, enviously, fiction's capacity to "capture" consciousness. "To capture all the details of an individual's definition of a situation would presumably require a complete and literal recording of his responses as they occur. The technique of the interior monologue—codified if not invented by the symbolist Edouard Dujardin and brought nearer to perfection by James Joyce—is one kind of literary device designed for the purpose of describing, in cinematic style, the imagined details of ongoing human experiences. In place of literary craft, we can conceive a technological contrivance—an introspectometer, say—which would record, in accurate and intimate detail, all that the individual perceives as he takes part in social interaction or is exposed to various situations. . . . Since no such device exists at this writing, the nearest equivalent available to the interviewer is to have each subject act as his own introspectometer during the interview" (Merton, Fiske, and Kendall, *Focused Interview*, 22–23). For a further discussion of Merton's introspectometer, cf. Lemov, *Database of Dreams*, 232.
34. Proust, "Preface to *Sésame*," 112.
35. Ibid., 100.
36. Woolf, *Mrs. Dalloway*, 12.
37. James, Preface to *The Ambassadors*, xxiii.
38. James, *Ambassadors*, 325–26.
39. Joyce, "Dead," 166.
40. Cohn, *Transparent Minds*, 11–13.
41. Cameron, *Thinking in Henry James*, 1.
42. John Frow's recent acute discussion of the different "modes" of life that belong to actual human beings and to literary characters has been extremely helpful to me on the questions this section explores. Cf. inter alia, "Characters and persons are at once ontologically discontinuous and logically interdependent" (*Character and Person*, vii).
43. James, "Noble Life," 277.
44. Idem, Preface to *The Ambassadors*, xix.
45. Ibid., xxiii.
46. In his "Notes for *The Ivory Tower*," James stresses the importance of "joints" in writing fiction; that is, sites at which force traveling in one direction is transformed into a transverse force. (e.g., "What I want is to get my right firm *joints*, each working on its own hinge, and forming together the play of my machine: they *are* the machine, and when each of them is settled and determined it will

work as I want it. The first of these, definitely, is that Gray does inherit, has inherited" [223].) This is a helpful analogy with which to think of James's interest in how events are translated into experiences, and how the event of reading a novel is transformed into a reader's experience of that novel. The image of "joint" also sheds light on the relationship that James imagines in the New York edition between the prefaces and the novels themselves.

47. Preface to *The Ambassadors*, xxii.

48. This differs from the account offered by Bersani ("Jamesian Lie," 143).

49. A complementary notion—that the novel makes visible facts about other minds and even one's own mind that the linguistic exchanges of everyday life never could—is central to Ann Banfield's account, in *Unspeakable Sentences*, of the valuable light that fiction, and specifically free indirect discourse, can shed on modern notions of subjectivity. Mikhail Bakhtin's account of the novel's capacity to record sociolects (the polyglossia of the real world) hinges on the novelist's capacity to notice and record actually occurring linguistic interactions and deformations. By contrast, Banfield stresses the novel's capacity to capture nuances of subjective orientation toward any given statement, which she understands as qualitatively distinct from what happens in spoken interaction. Just because we recognize something as subjective does not mean that we automatically assign it to a particular person. In ordinary speech, this dissociation is impossible to discern, because any utterance is automatically pegged to a speaker unless disavowed. In a novel, though, utterances can become detached from their speakers in ways that ordinary speech will not (normally) sustain.

Through narrative, language is revealed to contain another sense of subjectivity than the one directly displayed by the act of saying "I." The particular expressive elements and constructions are in the sentences in which they appear as the traces of this subjectivity (*Unspeakable Sentences*, 97).

By Banfield's account,

It is narrative style which strips the social mask for the self and shows behind the speaking *I* the silent shifting point of consciousness which is the *I*'s special reference. In narrative then, language can be seen as the repository of an objective knowledge of subjectivity (Ibid.).

Banfield's argument makes sense of the ways in which James tests the limits of the novel's capacity to make present a "silent shifting point of consciousness" that makes the *voice* of his novels at once personal and impersonal—that explains the wry semi-detachment of a corrective utterance like "that indeed might be." While key "scenic" business gets accomplished, narrative prose (thanks to its introspective "representative" capacity) can move the reader inside the mind of a character who is watching crucial scenic matters unfold—or even, as in the case of Strether, *not* watching what is occurring right in front of his face.

50. James, *Sense of the Past*, 112–13.

51. Idem, "Notes for *The Sense of the Past*," 292–93.

52. In editing this passage, James added the word "warm" to the typescript, possibly in order to underscore the subjective quality of the pull Ralph is feeling (Henry James Papers for *The Sense of the Past*, MS Am 1237.8, Binder 8).

53. Ibid., Leaf 3; cf. Fig. 1. Cf. Thurschwell's illuminating account of the relationship between Bosanquet and James—as well as his relationship to her typewriter. Bosanquet herself reports James saying that "he had reached a stage where the click of the Remington acted as a positive spur" and that "it all seems to be much more effectively and unceasingly *pulled* out of me in speech than in writing" (575).

54. Ibid., Binder 8.

55. Additional evidence that this confusion between words that belong to the novelist and those that belong to James continued in those final months of James's life also appears in those poignant and ultimately uninterpretable final fragments that James dictated in his final two days, which Lubbock, Edel, and later interpreters have been unable to classify definitively. Did James think of them as letters to his actual siblings, were they bits of a new novel about the Napoleonic era, or were they dictated when James actually believed himself to be "Napoléone"? (*Henry James Letters*, 4:811; cf. Henry James Papers, 44m–456.)

56. James, "Henry James's First Interview," 138, 144.

57. James, "Within the Rim," 11.

58. James, "Notes for *The Sense of the Past*," 292.

59. Ibid., 291–92.

60. James mentions having recommenced *The Sense of the Past* in a letter that also describes his near-perpetual focus on the ongoing war as effectively annihilating his sense of self—except when writing: "Really one has too little of a self in these days to be formulated in any manner at all; one's consciousness is wholly that of the Cause . . . save that is, for two or three hours each forenoon, when I have come back to the ability to push a work of fiction of sorts uphill at the rate of about an inch a day" (*Henry James Letters*, 751).

61. Its kissing cousin, *rat-tat-tat*, has two onomatopoetic meanings. Ever since the 1770s, *rat-tat-tat* has been used both for knocks on the door and small-arms fire (first usages in 1774 and 1779, respectively). One might argue, in fact, that the overlap between the sound of a knock and of a gunshot makes these onomatopoetic homonyms themselves a test of language's carrying capacity. It is one thing for "where" and "wear" to sound the same, or for "tattoo" of a drum and "tattoo" on the skin to sound and look the same (one is Anglo-Saxon and the other Tahitian in origin); but quite another for knocks and bullets to converge on a single onomatopoetic word.

62. William is the great word-coiner in the James family, with 116 OED first-author credits, but Henry had his fair share at 38. It is, however, worth noting that none are from *The Sense of the Past*, that the only James coinage later than 1909 is "constation" and that approximately eighty percent of his coinages were translations from the French.

63. In addition, two colleagues (Laurel Bossen and Seth Lerer) reported hearing echoes of the opening chords of Beethoven's *Fifth Symphony* in the triumphantly open ending: rat-tat-tat-AH.

64. Michel Foucault's "What Is an Author?" even adds "a laundry bill" as possibly poetical, if written by a poet (118).

65. During, "Literary Subjectivity," 39, 49.

66. The passage continues: "All other appearances may be fallacious; but the appearance of a difference is a real difference. Appearances too, like other things, must have a cause; and that which can cause any thing, even an illusion, must be a reality." (Mill, "Thoughts on Poetry and Its Varieties," 1:343.)

67. One comic variation on the Ganymede problem of the misattributed character comes in Randall Jarrell's *Pictures from an Institution*. That work features a literature professor who specializes in the eighteenth-century poet Cowper, but who finds himself—because the poet's name is pronounced like that of James Fenimore *Cooper*—often invited to speak on nineteenth-century American topics. Decades later, embittered by the confusion but resigned to it, he has become a specialist in American literature—and a dean. An academic bildung, of a sort.

6. Visual Interlude II / "This New-Old Industry"

1. Morris, *Collected Letters*, 3:167; to Georgiana Burne-Jones. There is also a memorable 1869 letter from Henry James mocking Jane Morris as "this dark silent medieval woman with her medieval toothache"—and an anecdote that describes Morris discovering a fifteenth-century brass in Great Coxwell honoring "Willm Morrys . . . [and] Johane the Wyf of Willm Morrys"—and immediately putting a framed rubbing of "the dead William and Johane" in his front hall, as if to claim not only kinship but a kind of congruence with the dead (James, *Henry James Letters*, 23).

2. The end of 1888 and the beginning 1889 saw Morris liable to turn artistic queries into political ones: invited by an Arts and Crafts colleague to Glasgow, he replies, "I should not care to go merely to lecture about art . . . [instead] I think I can suit [the Comrades] with a lecture 'Society of the Future' which is not mere orthodox Socialism" (to James Mavor, January 14, 1889). Many of his 1889 letters, especially to his daughter Jenny, dwell on Blanquist triumphs, the prospect for revolution, and the coming Paris party congress. Yet his conception of his vocation is always composite in nature: Morris spends the climactic last day of that Congress taking a friend to revisit the stained-glass of Rouen, his most beloved cathedral. For further discussion of this period, see both Mackail, *Life of William Morris*, and MacCarthy, *William Morris*.

3. Cf. an 1893 interview: "If a man nowadays wants to do anything beautiful he must just choose the epoch which suits him and identify himself with that—he must be a thirteenth-century man, for instance. Though, mind you, it isn't fair to call us copyists, for . . . this work . . . is all good, new, original work, though in the style of a different time" ("Art, Craft and Life: A Chat with Mr. William Morris," *Daily Chronicle*, October 9, 1893; reprt. Pinkney, *We Met Morris*, 76).

4. Key works include Matthew Kirschenbaum, *Mechanisms*, and Lisa Gitelman, *Always Already New*.

5. Cf. on one side of the intentionalism wars Walter Benn Michaels's *The Shape of the Signifier*, on the other side Jane Bennett's *Vibrant Matter* and work by the proponent of object-oriented ontology, Graham Harman, including his 2012 article, "The Well-Wrought Broken Hammer: Object-Oriented Literary Criticism."

6. Armstrong, *Victorian Glassworlds*, 115, 362.

7. Roberts, *Transporting Visions*, 1–2. Roberts has the tension between painting as object and as representation in mind when proposing this corrective to her discipline:

 Art history needs to look beyond the theories of illusion, representation, and iconography that underlie its formation as a modern discipline and confront the unavoidable material basis of its referential operations, the weight and heft of which its images are made. Likewise, although material culture offers inroads to the interpretation of things, it reaches a methodological impasse with representation, which by definition signifies something beyond the material specificity of the work (162–63).

8. Price casts a plague both on surface-oriented book historians and on literary critics trapped in sermonizing mode. The rift she describes is one that not just "history of books and reading" but any history of "objects and interpreters" would have to contain. One virtue of her approach is her observation that the new quasi-field of "thing theory" is the heir to a deep history of divided models for interpreting the sites at which knowledge is transmitted. She is skeptical of "oxymoronic subfields like 'thing theory' . . . [in which] scholars change from the freest of associators into the most slavish of idiot savants" (*How to Do Things*, 22). "The dethronement of reading requires an assault upon metaphor" she proposes, with one result being the worst kind of aesthetic deafness that settles over a scholarly community that formerly prided itself on identifying and responding to nuances of aesthetic value, in part by capturing and reporting on aesthetic pleasure (23). Price's sardonic acuity about the extremes to which surface reading can bring book historians does not prevent her from indicting those Platonist close readers who still suppose that criticism can proceed without reference to the material object itself. On the one hand, book historians are the rightful heirs (and hence perhaps the likeliest explicators) of the realist novel: "Both are detail-oriented, business-minded and petty . . . inclined to privilege the mundane over the ideal, the local over the transcendent" (28). On the other, "Twenty-first century literary critics look more like heirs to the sermon. . . . From Protestant theology, secular explicators have learned to prize spirit over matter" (28).

9. Brontë, *Jane Eyre*,198.
10. Eliot, *Middlemarch*, ch. 20.
11. *New York Sun*, February, 12 1888.
12. Nelson, "Slide Lecture," 418 *et seq*.
13. Recent scholarship has shed light on this rise in factual lantern presentations; cf. Terry and Debbie Borton's careful study of the thrice-weekly lantern lectures (almost all studious in nature) even in the modest town of Fairfield, CT: January 8–25, 1895, for example, they report lantern lectures on "paleontology . . . English cathedrals . . . Spain . . . early oriental civilization . . . across continent . . . flower photography . . . English cathedrals" ("How Many," 107); Deborah Harlan on the lecture slides of the Ashmolean in "Archaeology"; Lester Smith on the Royal Polytechnic Institution in "Entertainment and Amusement"; and Mike Simkin in "Birmingham" on that city's magic-lantern shows. Substantial recent work in the history of science—including articles by Lightman, Fyfe, Iwan Rhys Morus, and other contributors to Fyfe and Lightman, *Victorian*

Science in the Marketplace — charts the developments in popular conceptions of science that turned such presentations into a crucial conjunction of instruction and delight by the fin de siècle.

14. Helsinger, *Poetry*, and Arscott, *William Morris*, discuss Morris's preoccupation with light and with illumination: a trip to Rheims and nearby Gothic churches in the summer of 1888 produces some of his most impassioned writing about the beauty of Gothic blue.

15. Cf. Fawcett, "Graphic," and Stansky, *William Morris*, as well as Barringer, "Antidote to Mechanical Poison," and Roberts, "Certain Dark Rays," discussed in chapter 3.

16. The lecture has been studied in depth by such Morris scholars as Bill Peterson, *Kelmscott Press*, Peter Stansky, *William Morris*; and John Dreyfus, "William Morris."

17. Ruskin himself experimented, as early as 1884 after various other experiments in public presentation, with lantern slide reproductions of artworks ("Fiction, Fair and Foul").

18. Reprinted in Peterson, *Kelmscott Press*, 329–30. The exact magnification is not recorded, but Walker made use of varying scales, and images with single letters as large as a foot in height are conceivable.

19. Morris, Introduction to *Collected Works*, xv.

20. Dreyfus, "Reconstruction," 27.

21. Morris, Introduction to *Collected Works*, xxiii.

22. Walker, "Relation of Illustrations to Type," 60.

23. Ibid., 92.

24. "To illustrate his 1888 lecture, Walker combined on one slide the two subjects show opposite, thus enabling him to make a comparison between part of a page from a missal printed at Bamberg in 1481 and a Manuscript Missal written at the same period in Wurtzburg" (Dreyfus, "Reconstruction," 33).

25. Heinrich Wölfflin, sometime after 1897 when he took over the art history chair at Basel, "is . . . credited with the practice of showing two slides at one time, the hallmark ever since, it seems, of an art historical lecture." Nelson does note that "already at midcentury the English architectural historian Cockerell was lecturing from two large drawings" ("Slide Lecture," 429). I have found no evidence prior to Walker's 1888 lecture for the use of split or side-by-side magic lantern slides used to present comparative visual evidence.

26. On Cockerell, see ibid., 424.

27. Morris, Introduction to *Collected Works*, xxii.

28. "Walker's enlargments provided [Morris] with a merciful release from working in a tiresomely small scale. . . . Morris then drew the designs for his own type in the same large scale as Walker's enlargements. Next his drawings were photographically reduced by Walker to the scale in which the Golden type was to be cut. At this stage both Morris and Walker criticized them and brooded over them" (Dreyfus, "William Morris," 77–78).

29. "The impact of Walker's lecture was considerably extended by his personal involvement with so many of the leading typographical figures of his time. . . . He also pioneered the use of photographic techniques for helping Morris and others to produce type designs" (idem, "Reconstruction," 29).

30. Cf. Benjamin Morgan's intriguing recent argument, in relation to Morris's work designing Kelmscott typefaces, that "the kind of beauty that applies to a typeface, much like the beauty of a beautiful book, falls somewhere between perception and judgment" (*Outward Mind*, 239).

31. Cf. Lemov, *Database of Dreams*, esp. 92–93, 218, and her discussion of the miniaturization experiments of John Benjamin Dancer and Eugene Power.

32. Smith, *Victorian Photography*, 3.

33. "The Woodcuts of Gothic Books," *Times* (January 25 and 28, 1892); reprinted in Peterson, *Ideal Book*.

34. When Morris writes to a typographical friend about a Kelmscott book, "I hope you admire its literature," the word *literature* means the typefaces employed (*Collected Letters*, 3:198; to Frederic Startridge Ellis, August 29, 1890). In more generalist contexts, however (e.g., in the question-and-answer session recorded in his 1892 lantern lecture on illustrated books), he goes on to distinguish between a merely "literary" appreciation of a book and a properly aesthetic appreciation—the latter requiring an appreciation not only for the printed word but also of the relationship between text and image it undertakes to create on every page.

35. Ibid., 2:493–95.

36. "The Woodcuts of Gothic Books," *Times* (January 25 and 28, 1892); reprinted in Peterson, *Ideal Book*.

37. Helsinger, "William Morris," notes this drive toward integrating graphic and narrative logics in Morris's earlier bookmaking experiments, speaking of the layering of flat planes that allow for ornamental complexity without the illusion of depth.

38. Pinkney, *We Met Morris*, 78.

39. Skoblow, *Paradise Dislocated*, 187.

40. Cf. Bevir, *Making of British Socialism*, which characterizes the 1880s rise of both socialism and a new sort of liberalism (fueled by Jevons's neoclassical theories) as intellectual and cultural responses to the collapse of classical, production-centric, economic theory in the 1870s.

41. Not only raucous but also, as Lynda Nead's *Haunted Gallery* shows, fast-moving and with a rising sense of its own velocity: speed understood, that is, not simply as an attribute but actually a *virtue* of the print public sphere.

42. Morris, Prologue to *The Earthly Paradise*.

43. Kirchoff, "William Morris's Anti-Books," 96.

44. Cf. Emily Harrington's interest in late Victorian reflections on how the site of the lyric "I" can oscillate between the represented subject of a poem and the interpolated reader, and her argument that Michael Field's poetry "asserts not only the instability—and the portability—of the lyric 'I,' but that the processes of detachment and attachment are fundamental to the lyric as a genre" ("Michael Field," 221).

7. H. G. Wells, Realist of the Fantastic

1. Wells, "Plattner," 36.

2. Ibid.

3. Ibid., 38. Emphasis in original.
4. Ibid., 50–63.
5. Suvin, *Metamorphosis*, 32.
6. Wells, "Stolen Body," 94.
7. Borges explicitly borrows this idea for his 1949 story "The Aleph"; it also seems likely (to me, anyway) that Tolkien likely lifted it for the "palantirs" or "seeing stones" of Middle Earth.
8. Le Guin has a helpful way of placing Wells between two worlds: "He invented a literature, because he was the first person to write fiction as a scientist" (Introduction to *Selected Stories*, x).
9. Delbanco in *Group Portrait* offers a vivid account of that literary world, its intellectually sustaining friendships, and the political and aesthetic forces that eventually broke many of its bonds in the decade before World War I.
10. Cf. Aaron Worth's acute account of Wells's first publishing success coming at "a time of fluid, rapidly evolving media ecologies, certainly in the industrialized West . . . [when] Britain's empire and its media were enmeshed in a symbiotic relationship, as information technologies were . . . indispensable to projects of colonial expansion and control"; also Worth's argument that for Wells "new media could provide . . . frames for conceiving modern imperialism" ("Imperial Transmissions," 67, 68).
11. A key cultural precondition to Wells's success, explored briefly in chapter 1, is the fin de siècle British short fiction explosion. Recent scholarship has explained that publishing explosion in various ways. Barbara Korte, in the latest version of the "delay hypothesis" makes a formalist argument that "the short story 'proper' emerged in Britain with considerable delay, not until the *late* nineteenth century" (*Short Story in Britain*, 9). Dean Baldwin argues that "the rise and fall of the British short story is intimately connected to the economics of writing and publishing" and that "between 1880 and 1950 the market for short fiction became sufficiently broad, deep[ly] varied and flexible to accommodate all writers of talent and many of very limited abilities" (*Art and Commerce*, 1, 3). Winnie Chan, building on both accounts, explains the upsurge and the explosion of diversity in short fiction as a formal response to the fact of that publishing boom; she sees in the proliferating experiments of the 1890s an uneasy awareness among writers of how common, and hence potentially how vulgar and merely popular, short stories may be. Chan is especially helpful on the point I want to stress: the ways that such texts themselves register the constraints of the publishing moment (*Economy of the Short Story*).
12. "I do not think that Mr. Wells, in his passion to make [ordinary Mrs. Brown] what she ought to be, would waste a thought upon her as she is" (Woolf, "Mr. Bennett," 45).
13. Wells, *Experiment in Autobiography*, 198.
14. Sherborne, *H. G. Wells*, 92. There are echoes here not just of Swift's Lilliputians but also of Darwin's teeming bank, which seems so placid and beautiful from a benighted perspective but viewed close up is a site of carnage and ceaseless action.
15. Beaumont, *Spectre of Utopia*, 11.
16. What Daston and Galison have referred to as a new "epistemic virtue" of objectivity in the latter nineteenth century might in fact be thought of as shaping

the aspirations not just of scientists but novelists (*Objectivity*, 19). Shaping those aspirations, however, in a variety of ways, some tending toward the embrace and others toward the rejection of objectivity as virtue. Both Wilde's "Critic as Artist" on the status of Darwinian evidence and Henry Adams on the "suprasensual world" of x-rays register the effect that the epistemic virtue of objectivity had on writing well outside the scientific realm. "X-rays had played no part whatever in man's consciousness, and the atom itself had figured only as a fiction of thought. In these seven years man had translated himself into a new universe which had no common scale of measurement with the old. He had entered a supersensual world, in which he could measure nothing except by chance collisions of movements imperceptible to each other, and so to some known ray at the end of the scale. Langley seemed prepared for anything, even for an indeterminable number of universes interfused—physics stark mad in metaphysics" (Adams, *Education*, 381–82).

17. *Genealogical* in the sense Foucault delineates, aiming to trace "dissension," "disparity" in "an unstable assemblage of faults, fissures, and heterogeneous layers that threaten the fragile inheritor from within or from underneath" ("Nietzsche, Genealogy," 22).

18. Todorov's account of fantasy in *The Fantastic* as permanently liminal between the fabulous and the merely uncanny or psychologically explicable is relevant here. However, Todorov is committed to a notion of perpetual hovering or undecidability as genre-constitutive: there is nothing uncertain about the mix of this and other-worldly in Wells, and yet the doubleness Conrad singles out is crucial in taxonomizing not only his work but also its legacy in British speculative fiction.

19. Conrad's praise for Wells's successful spookiness might be counterposed to his 1898 complaint about the naturalist Stephen Crane, whose work Conrad considers meticulously observant but lifeless because Crane lacks emotional variation: "The Crane thing is just—precisely just a ray flashed and showing all there is" (*Collected Letters*, 132).

20. Watt, *Rise of the Novel*, 117–18.

21. Conrad, *Collected Letters*, December 4, 1898, 106–7.

22. Ibid., 106.

23. Parrinder, *H. G. Wells*, 330.

24. Qtd. in Unwin, *Jules Verne*, 10.

25. Parrinder, *H. G. Wells*, 101.

26. Ibid., 70.

27. Ibid., 57.

28. Ibid., 69, 100.

29. Sherborne, *H. G. Wells*, 110.

30. Cf. the discussion in chapter 3 of how Ford Madox Brown conceived of his history paintings, using his own face as a model for Cromwell's so as to encourage viewers to imagine themselves, too, as personally semi-embedded in the past.

31. Cf. Kreisel, "Discreet Charm," 402 *et seq.*

32. See also Kline on the question of how late nineteenth-century mathematics, as well, was beset by new conceptual puzzles about the relationship between our actual, empirically verifiable world and by imaginable, or conceptualizable

mathematical truths, especially his discussion of the implications of Cantor's set theory (*Mathematics*, 213).

33. Abbot, *Annotated Flatland*, 22.

34. Cf. as well Wells's "The Star," which ends with Martian astronomers remarking on how little the Earth seems to have been damaged by a close call with a comet—how little that is when the damage is appraised from a few million miles off.

35. Markovits has recently explored their impact on the day's verse-novels as well in "Adulterated Form."

36. James, "Daniel Deronda."

37. Eliot, *Middlemarch*, 53.

38. In chapter 5, I examine the solution that James himself seeks in his later fiction when faced with this seemingly formal exhaustion of fiction. He offers, especially in the prefaces to the New York edition, an account of fiction as innately double: both "dramatic"—showing the world of social, known shareable events—and "representative"—penetrating through free indirect discourse into characters' idiosyncratic and concealed experiences of that world.

39. When Wells was starting out, a five-pound note from his mother was so rare and precious a gift that for greater security she divided the note in two and sent him the two halves in separate envelopes (Sherborne, *H. G. Wells*, 70, 63, *et passim*).

40. Wells, *Boon*, 110.

41. Wells himself notes the divergence between his way and that of his colleagues: even in his generally admiring criticism of 1895–96, Wells has begun to deplore James's "ground-glass style" and the way in Conrad that the "story is not so much told as seen intermittently through a haze of sentences. . . . You read fast, you run and jump, only to bring yourself to your knees in . . . mud. Then suddenly things loom up again, and in a moment become real, intense, swift" ("Outcast of the Islands," 509). For Conrad's view of Wells, cf. McCarthy, "*Heart of Darkness*."

42. Marcus sees this story and "The Door in the Wall" shaping key British meditations during the mid-twentieth century of film's new approach to "corporeal proprioception"—that is, what it feels like to see a strange new world up on the screen (*Tenth Muse*, 48–51).

43. Wells, "New Accelerator," 92.

44. Idem, "Story of the Late Mr. Elvesham," 96–97.

45. Idem, *Experiment in Autobiography*, 418.

46. Idem, "A Slip under the Microscope," 17.

47. Ibid., 20.

48. Sherborne, *H. G. Wells*, 61. The Bromley-born Wells himself (whose parents were servants and whose father moonlighted as a professional cricketer) earned a scholarship to study under Thomas Huxley at the Normal School of Science in South Kensington between 1885 and 1887.

49. "Epistemic virtue" is a category central to Daston and Galison's *Objectivity*. Gavin Dawson, Jonathan Smith, and others writing in the wake of Gillian Beer have shown how thoroughly Darwinian scientific naturalism was woven inextricably into all aspects of British intellectual life starting in the 1860s—in

ways distinct from the later and more narrowly focused impact that versions of "social Darwinism" had in France, America, and elsewhere.

50. Sherborne, *H. G. Wells*, 94.

51. Augustin Filon, writing in 1904, was astute in pointing to the "severe and somber grandeur" that connects *The War of the Worlds* to Defoe's *Journal of the Plague Year* (Parrinder, *H. G. Wells*, 54); it was Filon as well who argued in 1902 that Wells's writing avoided the two "usual English" vices of "imperialism and insularity" on account of its ties to "London and science" (101). An 1898 *Spectator* review also invokes Defoe and Swift in calling Wells more "human" and imaginative than the pedantic and mechanical Poe (63).

52. Wells, "Door in the Wall," 5. Readers may think here not only of James Thurber's later dream-hero, Walter Mitty, but also of Wells's own version of inveterate Quixote in *The History of Mr. Polly* (1909). As a child, Mr. Polly "shot bears with a revolver—a cigarette in the other hand . . . thought it would be splendid to be a diver and go down into the dark-green mysteries of the sea. . . . Engaged in these pursuits he would neglect the work immediately in hand, sitting somewhat slackly on the form and projecting himself in a manner tempting to a schoolmaster with a cane. . . . And twice he had books confiscated" (*History of Mr. Polly*, 13–14; last set of ellipses in original).

53. Wells, "Door in the Wall," 19.

54. Ibid., 23.

55. Ibid., 24.

56. These intuitions of a life elsewhere do not disappear in Wells's later work. They do, however, transmute into more of a hectoring jeremiad to coincide with his self-anointed role as despairing prophet of an age unable to grapple with the implications of its scientific progress. His 1936 *The Croquet Player* is, for instance, poised between the present-day reality of the ordinary "unusually banal" life of a croquet player (who also dabbles in bridge, archery and correspondence chess) and the grim atavistic urges that emanate from the sleepy provincial backwater of "Cainmarsh," where the murderous stone-age past of humanity comes looming close to the surface of life, making the residents drink heavily, mutilate sheep, shoot scarecrows, and eventually do away with themselves. Cainmarsh atrocities are depicted not as an anomalous Twilight Zone but omnipresent, under different names: the narrator muses about "little children killed by air-raids in the street" and men "killed in Belfast and Liverpool and Spain" (70). I am grateful to Sarah Cole for several productive exchanges on this topic, and for generously sharing her own forthcoming work on Wells.

57. A line from *Invisible Man* (the one written not by Wells but a half century later by Ralph Ellison) may sum it up best: "And it is this which frightens me: Who knows but that, on the lower frequencies, I speak for you?" (9).

58. Chu, *Do Metaphors*, 73; cf. as well Beaumont, *Spectre of Utopia*, and Parrinder, *Utopian Literature*.

59. Tempting also to include on that list a boy who in 1889 was a pupil of Wells: A. A. Milne (Sherborne, *H. G. Wells*, 89).

60. Sayeau, *Against the Event*, 40. This reading of Adorno resonates with Esty's account of "English modernism [as] a compromise formation, a semi-modernized modernism" (*Shrinking Island*, 5).

61. Qtd. in ibid., 39–40.

62. Williams, *English Novel*, 129–30.

63. John Attridge has recently argued that Ford Madox Ford was moving from ethnographic work toward subjectivist impressionistic fiction between 1905 and 1915, "*The Soul of London* (1905)—the first volume of a trilogy of social criticism and a breakthrough work for his literary career . . . [to] his novel Mr. Apollo (1908)" ("Steadily and Whole," 298) onward to the exquisite Conradian inwardness that culminates in *The Good Soldier*.

64. For example, the foreword to Brittain's *Testament of Youth* (1933) apologizes for choosing a genre that is neither novel nor diary—as a way of summing up her generation's youth. Brittain goes through the alternative genres she might have used: fiction is too detached, a diary would entail the use of fake names, etc. She undertakes neither reportage nor diary, she asserts, because a *testament* allows her to represent her own feelings only insofar as they are "typical" of someone undergoing the Great History of her generation. That is, she claims that the testament is semi-detached in a formal sense: it depends *both* upon the subjective purchase allowed by access to her own feelings (like young Pip in *Great Expectations*) and upon the distance allowed by her retrospective detached survey of a generation. Four years later, when George Orwell published his own experiment in bad form, *Road to Wigan Pier*, it is possible to imagine him going through a similar sort of choice, faced with various formal alternatives that the Wells generation had shown to be unsatisfactory.

65. Farah Mendelsohn proposes taxonomizing some related sorts of fantasy as *liminal* and *portal-quest* (*Rhetorics of Fantasy*, xix–xx, xx–xxi). Her categories however seem to me to obscure rather than clarify the formal and genealogical links between various writers of fantasy; the issue is that she deploys an ahistorical litmus test, grouping writers based on her outward reading of their tropes.

66. Read, *English Prose*, 131.

67. Ibid., 131, 132.

68. Cf. Sandner: "Fantastic literature emerges as a site for critical debate in the eighteenth century, partly as a result of increasing disbelief in but continued fascination with the supernatural, partly as a negative byproduct of arguments for the realistic novel and, perhaps most importantly, as a vital component of the emergent discourse of the sublime" (Introduction to *Fantastic Literature*, 6). Jamie Williamson's *The Evolution of Modern Fantasy* traces the roots of modern Anglophone prose fantasy (of the Morris and Tolkien family) *not* in the novel, but rather in the scholarly work of "the eighteenth century, the period when the retrieval of, and construction of modern mediated texts derived from, traditional literatures was inaugurated under the aegis of antiquarianism" (34).

69. There is, for example, a revealing paucity of maps in the century of fantasy prior to Tolkien: none in George McDonald, for instance, nor Wells; even in William Morris's late strange prose romances, the only map appears in the posthumously published *The Sundering Flood*.

70. *Underground Man*, a 1904 satire by French sociologist Gabriel Tarde (Wells himself wrote the preface to its 1905 English translation) plays around darkly with the Wells notion of what might living underground will do to future human culture.

71. Forster, "Machine Stops," 37.
72. Williamson also astutely notes the influence of the four Edith Nesbit books (*Five Children and It, The Phoenix and the Carpet, The Story of the Amulet, The Enchanted Castle*) that between 1902 and 1907 "center on the impingement of the magical on realistically drawn 'modern' children" (*Evolution of Modern Fantasy*, 130).
73. Cf. Williamson's recent helpful genealogy/taxonomy of the genre that comes to be known as *fantasy* only in the late 1960s, with the appearance of Lin Carter's Ballantine Adult Fantasy Series (Ibid.).
74. A wittily updated Ovidian metamorphosis tale, *Lady into Fox*, includes a remarkable scene describing the eponymous fox that was formerly a lady staring hungrily at a caged dove while her husband reads *Clarissa* out loud. Garnett, born in 1892, grew up in Kent in the company of Wells, James, and Conrad, all close friends and correspondents of his parents Edward and Constance Garnett. Wells in 1934 opined that his own early stories were best understood by comparing them to *The Golden Ass* and "some admirable inventions by Mr. David Garnett, *Lady into Fox* for instance" (reprinted in Haining, *Jules Verne Companion*, 62).
75. West, *Return of the Soldier*, 176, 179, 184. That trope of the wounded warrior laid out into a kind of amnesia-shrouded Elysium, the past depicted as a *visitable* foreign country, also seems a promising way to approach both the shell-shocked Tietjens in *Parade's End* and the bizarre plot of Ford's 1911/1935 *Ladies Whose Bright Eyes*, in which the seeming detour into medieval times is revealed at the novel's end to have been the product of a modern-day nurse whispering stories into the ear of the immobilized hero. See Saint-Amour's recent persuasive account of the allure and limitations of encyclopedic form in Ford and the challenge posed to such encyclopedism by wartime trauma.
76. Warner, *Lolly Willowes*, 133; final lines.
77. Benson, *Living Alone*, 190.
78. Ibid., 191.
79. Ibid., 264.
80. Mitchison, *You May Well Ask*, 130.
81. In introducing this idea that the war revivifies the realm of faery, *Living Alone* marks an intriguing reversal of direction for Benson's relationship to realism. Her first novel, *This Is the End* (1917) begins by invoking a desirable realm of fantasy "system is a fairy and a dream. . . . I should not really be surprised if the policeman across the way grew wings, or if the deep sea rose and washed out the chaos of the land" (1). But in that novel, with World War I "the secret world died and there is nothing left. . . . There are no secret stories, there is no secret world, there are no secret friends" (233). Striking then that only two years later Benson has so fully developed an account of the capacity of World War I to bring the secret system of witches and faeries back to life.
82. Benson, *Living Alone*, 264.
83. Rorschach first published his blots in 1921; on his ideas about the ways in which objective blots could elicit "deep" subjective responses, see Galison, "Image of Self."

8. Overtones and Empty Rooms: Willa Cather's Layers

1. Willa Cather, *World and the Parish*, 2:624.
2. Ibid., 2:625–26.
3. Idem, "Nebraska: The End of the First Cycle."
4. Idem, "Miss Jewett."
5. Critics who emphasize Cather's capacity for subversion and reinvention and those who instead hail her as prairie regionalist make their respective cases by excluding half the Cather story; both locality and mobility are indispensable.
6. Her editorial role, for example, meant that Cather in 1909 not only acquired work by London and Dreiser but also met H. G. Wells, along with Ford Madox Ford and Lady Gregory (O'Brien, *Willa Cather*, 289).
7. 1924, in O'Connor, *Willa Cather*, 213.
8. Ahearn, "Full-Blooded Writing," esp. 144.
9. Cather, *World and the Parish*, 2:747.
10. Winkler, "Naturalism," 919.
11. Zola, "Experimental Novel," 2.
12. The literary criticism of the latter twentieth century frequently drew an explicit link between French and American ideas of "social Darwinism" and naturalism (Bannister, *Social Darwinism*). Compare as well Bender's argument that in parsing London and his peers, "it helps to realize how much of the evolutionary puzzle in literature can be traced back to the theory of sexual selection . . . [in which] the season to live is that of battle" ("Nature in Naturalism," 56). But it may be that Peter Bowler's *Eclipse of Darwinism* has had the unfortunate effect of discouraging recent scholars from analyzing how that connection developed during the last few decades of the nineteenth century.
13. Arguably a third criterion might be added: Jennifer Fleissner has recently made the case that American naturalism persistently struggled against the narrative temporality of realist fiction by showing characters, women especially, trapped in time, compulsively repeating the same set of mechanical gestures (*Women, Compulsion, Modernity*).
14. Norris, "Plea for Romantic Fiction," 22.
15. Ibid., 23.
16. Cather, *My Antonia*, 290.
17. I am grateful to Sean McCann for reminding me that the exclamation point in the title relates to its being a quotation from Walt Whitman. Though most early reviews praised this early novel for accuracy of social observation ("the fidelity of a Kodak picture or a graphola record" [Cooper, in O'Connor, *Willa Cather*, 49]), some contemporaries perceived Cather's interest in blurring lines between figure and ground: Gardner Wood in *McClure's*, for instance, writes of "the soil dominating everything, even the human drama that takes place upon it" (in O'Connor, *Willa Cather*, 45).
18. Cather, *World and the Parish*, 1:150.
19. Hardy's relationship to naturalism is examined in more detail in Plotz, "Speculative Naturalism."
20. Hardy, *Jude*, 37–38.

21. The magic lantern's role in shaping fin-de-siècle ideas about fictionality and translucency is explored in greater detail in chapter 6.
22. "My idea of success," [Selden] said, "is personal freedom."
 "Freedom? Freedom from worries?"
 "From everything—from money, from poverty, from ease and anxiety, from all the material accidents. To keep a kind of republic of the spirit—that's what I call success" (Wharton, *House of Mirth*, 108).
23. Jameson, *Antinomies of Realism*, 46. While noting the difference between Zola and his realist antecedents and modernist successors, Jameson is reluctant to accord naturalism's distinct status as anything more than a "mass culture" autonomy, arguing that Zola's "codification of the naturalist novel as a form then serves as a standard for the practice of mass culture and the bestseller up to our own time and all over the world" (45). Yet he also affirms Zola's "unrequited claim to stand among Lukacs' 'great realists'" against "generations of critics intent on somehow separating Zola from the mainstream of nineteenth century realism" (Ibid.) and accuses those who separate him from modernism of being conservative.
24. Ibid., 46.
25. Ibid.
26. Cf. another image from Wharton's *House of Mirth*, as Lily loses her privileged insider status and begins to see her social world as an outsider: "Lily had an odd sense of being behind the social tapestry, on the side where the threads were knotted and the loose ends hung" (445).
27. Cather, *Professor's House*, 222.
28. Cather, *My Antonia*, 865–66.
29. Compare Virginia Woolf's analogous account of meaning "descending" symbolically then vanishing again in *To the Lighthouse*:

 And suddenly the meaning which, for no reason at all, as perhaps they are stepping out of the Tube or ringing a doorbell, descends on people, making them symbolical, making them representative, came upon them, and made them in the dusk standing, looking, the symbols of marriage, husband and wife. Then, after an instant, the symbolical outline which transcended the real figures sank down again, and they became, as they met them, Mr. and Mrs. Ramsay watching the children throwing catches. (114–15)

30. When the critic A. Hamilton Gibbs proclaimed, "Presumably one should expect a queer, unusual book from Willa Cather," this seems to be the sort of work he had in mind (1925, reprinted in O'Connor, *Willa Cather*, 233).
31. Cather, *Selected Letters*, 199. For further discussion, see Plotz, "'On the Spot,'" 21.
32. Cather, *Song of the Lark*, 340–41.
33. Ibid., 467–68.
34. Idem, *My Antonia*, 936.
35. Such communicable incommunicability also lies at the core of Cather's late poignant story, "Two Friends." Looking back at the gulf that opens up in her childhood when two older men, her "heroes" quarreled and stopped spending

their evenings together, she characterizes the lost "mathematical harmony which gave a third person pleasure" as made up of "the silence, — the strong, rich out-flowing silence between two friends, that was as full and satisfying as the moonlight" (688).

36. Cather charges Lawrence with "literalness" and "reduc[ing characters] to mere pulp" by making a "laboratory study of the behavior of their bodily organs under sensory stimuli" ("Novel Démeublé," 837). As Cather sees it, her work is separated from the follies of Lawrence's naturalism by use of the form to suggest an evanescent and recessive second life beyond the printed page, a life of emotions rather than mere impulses, of words unspoken rather than those that find direct utterance.

37. Adorno, *Aesthetic Theory*, 35.

38. "It was through giving up and blindness that [Cather] was able to speak in a way that often reveals to the reader something extraordinarily valuable that seems to have been in his mind always" (Van Ghent, *Willa Cather*, 44).

39. Cather, "Novel Démeublé," 837.

40. The early reviewer who praised Cather for "sparseness of detail . . . absolute-ness of phrase" [reprinted in O'Connor, *Willa Cather*, 182) was presumably responding to this emptying-out.

41. Cather, "Katherine Mansfield," 878.

42. Ibid.

43. Ibid.

44. *New York Times Book Review*, reprinted in O'Connor, *Willa Cather*, 79.

45. October 6, 1918; reprinted, ibid., 81.

46. Cf. Van Ghent: "It is as if the aridities of her girlhood, and the drudgery that followed, had left her with a haunting sense of a 'self' that had been effaced" (*Willa Cather*, 8).

47. *Song of the Lark*, 703. The epilogue is heavily pruned in Cather's 1937 revision of the novel.

48. Ibid., 706.

49. Cather, "On *The Professor's House*."

50. In Cather's "A Wagner Matinee" (1904), a young man struggles to describe the transformation he sees coming over his aunt's face when she listens to Wagner after long years trapped on the prairie:

From the trembling of her face I could well believe that before the last number she had been carried out where the myriad graves are, into the gray, nameless burying grounds of the sea; or into some world of death vaster yet, where, from the beginning of the world, hope has lain down with hope and dream with dream and, renouncing, slept. (109)

Here art is impersonal, deadly, and irresistible: it is tempting to think of these lines somehow shaping the final lines of James Joyce's "The Dead" a decade later. Hence the aunt's reluctance to return to the prairie life sketched grimly in the story's final line: "naked as a tower, the crook-backed ash seed-lings where the dishcloths hung to dry; the gaunt, molting turkeys picking up refuse about the kitchen door" (110). However, this is youthful writing; Cather's later fiction accepts, sometimes even rejoices in, the semi-detached

vantage that a provincial life offers, its way of allowing characters like Thea's Aunt Tillie to enjoy triumphs vicariously and from afar.

51. North, *Reading 1922*, 173.

52. Ibid., 180.

53. Cather, *Lost Lady*, 44.

54. Qtd. in Fanny Butcher, "Willa Cather Tells Purpose of New Novel," *Chicago Tribune*, September 12, 1925 (in O'Connor, *Willa Cather*, 238). Interestingly, H. L. Mencken made almost the same point: "*The Professor's House* is a study of the effects of a purple episode upon a dull life—perhaps more accurately, of the effects of a purple episode upon a life that is dull only superficially, with purple glows of its own deep down" (November 6, 1925, reprinted in ibid., 258).

9. VISUAL INTERLUDE III / THE GREAT STONE FACE

1. Like all of Keaton's silent features and many of his shorts from the 1920s, *Seven Chances* is in the public domain and readily available on YouTube and elsewhere. This particular shot begins 10 minutes and 15 seconds into the movie; the crucial part lasts about 30 seconds.

2. I am indebted to Lyn Tribble for the suggestion that such moments of sudden awareness—I thought I was in one world but I am actually in another—are somehow related to the unfakeable *startle* reflex; cf. her discussion of the topic in *Macbeth* (Tribble, "'When Every Noise Appalls Me,'" 81–82).

3. Keaton as filmmaker I will refer to as "Keaton," but I will refer to his on-screen persona as "Buster."

4. For example, Robinson argues—against a longstanding critical tradition that stressed the sheer novelty of film—that "the first filmmakers did not suddenly invent a new form. Rather they relied upon existing patterns and analogies" (*From Peep Show*, 69). Münsterberg, *Photoplay*, and Lindsay, *Art of the Moving Picture*, are both intriguing early contributors to this "straight from the forehead of Zeus" debate about the rapidity of film's rise.

5. Subsequent scholarship seems in agreement with Gunning's revisionist insight that prior to 1907 cinema is dominated by "a conception that sees cinema less as a way of telling stories than as a way of presenting a series of views to the audience, fascinating because of their illusory power . . . and exoticism"; and that "the cinema of attraction does not disappear with the dominance of narrative, but rather goes underground, both into certain avant-garde practices and as component of narrative films" ("Cinema of Attraction," 61). Cf. also Musser, "Moving Towards Fictional Narratives," as well as the influential 1990 collection, Elsaesser, *Early Cinema: Space, Frame, Narrative* (especially contributions by Gunning, Gaudreault, and Musser) and that volume's 2006 successor, Strauven, *Cinema of Attractions Reloaded*.

6. *The Cameraman*, the final major Keaton film, was made in an uneasy arrangement with MGM. After 1928 the MGM years and the advent of the talkies and the studio system were generally disastrous for Keaton.

7. Tilly, *Popular Contention*, 41. Tilly argues, for example, that the Chartists developed new varieties of public-square protests like—the analogy is Tilly's—jazz musicians riffing on an extant musical vocabulary.

8. Various "influence studies" (e.g., Kramer, "Battered Child," and Jenkins, "'Fellow Keaton'") stress Keaton's debt not just to Arbuckle's comic shorts of the 1910s but also the vaudeville shows that Keaton had performed in ever since he was a child. Cf. also Robinson's argument that Griffiths was "working from his love of Victorian painting" when he "showed that the screen image was not just two-dimensional but had a background and a foreground" (*From Peep Show*, 128).

9. In *Film and Attraction*, Gaudreault offers the idea of "cultural series" that looks backward from the moment a film was made in order to understand what the filmmaker would have had to hand, and in mind, when filming. Gaudreault's point is that film history ought not be merely retrospective: as he, Gunning, Burch, and others have argued, film scholars long misread the early years of Hollywood by telling a retrospective tale about the inevitable rise of narrative film, at the expense of the precinema era of attraction/spectacle films. Still, looking forward has its virtues. By Tilly's account, repertoires (he makes the analogy to improvisatory jazz as opposed to classical music) do mutate, and openness to future innovation is actually part of any given move's significance and its meaning, even at its introduction.

 Although there is not space to explore this idea further here, it is worth noticing that a surprisingly wide and wide-ranging collection of Keaton's filmic ideas—techniques, tricks, formal strategies—flourished even as his own career declined. For example, the afterlife of Keaton's famous "stone face" is visible in the films of Armenian-born Rouben Mamoulian, despite the fact that Mamoulian positioned himself as bringing the prestigious cultural power of European theater into what had before him been a merely a debased popular art form. In the final shot of Greta Garbo in his *Queen Christina* (1933), Garbo stands wind-whipped in the ship's prow, as Mamoulian had instructed her to, with a face like a "blank sheet of paper." "You do nothing," he told her. "You don't act. You don't have a thought nor a feeling, In fact, try not to blink your eyes. Just hold them open. Make your face into a mask" (Qtd. Luhrssen, *Mamoulain*, 72). There are dozens of reasons why *Queen Christina* is not part of the Keaton "cultural series," which more logically should run through from the Marx Brothers to Laurel and Hardy, to Peter Sellers's Inspector Clouseau films straight through to Jackie Chan, who has reported that his earliest, deepest inspiration was *The General*. And yet, in a Mamoulian melodrama that succeeds by tugging on emotional strings Keaton himself never cared to touch, Garbo's blankness does exactly what Keaton's stone face did—it lets the viewer move into the character's world at precisely the moment where the character herself is moving away. Just as Lillian Gish lent her para-smile to Keaton, the Great Stone Face has a worthy successor in Garbo.

10. Anne Hollander's argument in *Sex and Suits* about the stylishly unstylish nature of male garb is germane here.

11. The scene begins 17 minutes into *Our Hospitality* and lasts about a minute.

12. In the twilight to which he was relegated after 1929, when the talkies and the MGM-dominated studio system put an end to his brilliant career as an director/star in collaboration with his brother-in-law Joseph Schenk, his porkpie became more than a trademark, it actually became a kind of salvific fetish. (Benayon's book is replete with photographs of porkpie Buster.) You might

say that his porkpie persona (along with his famously impassive expression) is what enabled him to wait out the bad years and seize the roles that began, finally to reappear in the 1960s, when his sad, mad, bad drinking days were well behind him.

13. Fatty Arbuckle-style clowns in the comic shorts of 1915–25 always look at the camera to make sure the viewer gets the point of the gag. By contrast, the typical dramatic film of the 1920s is played with full absorption: actors behave as if the camera didn't exist. Keaton, though, offers you even in such a simple-seeming shot as this one, a subtle twist on that convention, one that manages to preserve what would seem to be incompatible virtues: "Fourth wall" absorption and vaudevillian knowingness.

14. Keaton rejects the easy joke of having the hat crumple into the proper shape. Instead after being symbolically beheaded, smudges still visible on his forehead, he pulls out of a carpet bag a perfect porkpie. We even get to see it serve its purpose, as Keaton reacts with a quick eye-roll upward to its *not* crumpling against the roof of the train.

15. There are many such burlesqued endings, including the decorated gravestone in *Cops* and the sudden appearance of twin babes in the arms in *Sherlock Jr.*, but my favorite Keaton burlesque of the "happily ever after" ending is a dizzying set of shots that ends *College*: wedding; grumpy old couple by the fireside; matching gravestones.

16. Keaton's success has accordingly been described as principally the product of an anomalous moment in the history of Hollywood film, when what Harris has dubbed the "operational aesthetic" of farcical performers, their vaudevillian orientation, was giving way to the oppressive narrative drive of the studio system era: Buster the performer forced to give way to Jimmy Durante the actor (and Hitchcock the auteur).

 Neil Harris coined the phrase *operational aesthetics* to explain why the displays in Barnum's Museum were so appealing to audiences: "They exposed their process of action . . . an approach to experience that equated beauty with information and technique, accepting guile because it was more complicated than candor" (*Humbug*, 57).

17. James Agee's 1949 "Comedy's Greatest Era" is an important point of departure for much of the work since; David Robinson's *Buster Keaton* (1969) insightfully explored Keaton's nostalgic cinematography. Recently, Michael T. Smith has offered a Merleau-Ponty–inflected account of Keaton's bodily self-awareness, arguing that "Keaton's motion is an impossibility that is directly reflective of the impossibility of film motion itself." ("Notes," 101).

18. Cf. Roland Barthes's rigidly structuralist account of the "Fashion System" in his 1985 book of the same title.

19. Tracing the cultural series that Gaudreault sees underlying the evolving form of narrative film can take us, via Keaton, into unexpected places. For example, in "McCay and Keaton," Crafton has recently examined possible public performances on stages where work by early cartoonist Windsor McKay was also screened between 1900 and 1915. Keaton's influence forward on modernism, surrealism, and other high-cultural forms has also been traced extensively, most recently in Barea, "Buster Keaton."

20. The scene starts 12 minutes and 30 seconds into *The Boat* and lasts about 45 seconds.

21. This doubled frame for Buster—he understands how picture and wall go together, but fails to grasp how things change when the wall is also the side of a boat—taps into a basic rule of how subjectivity gets registered in moving pictures, going back to the first Lumiere story-film "the sprinkler sprinkled": the camera informs viewers of some basic facts that a character within the depicted world does not grasp, even though that fact is completely pertinent to that oblivious character and about to become even more pertinent.

22. Parshall for instance reads Keaton's feature films as trapped between "farcical and comic space"; sometimes, he is a vaudevillian physical comic, at other times, he's uneasily entering into a more cloistered bourgeois interior where the romantic plot will tame him ("Buster Keaton," 34).

23. Peter Kramer has made the case that even in his 1920 leading-man debut (in the forgettable *The Saphead*), Keaton is already developing a persona who is oddly, almost pathologically cut off from the immediate ebb and flow of other's social ease: "Keaton's deadpan performance not only serves to characterize Bertie as an intellectually and emotionally retarded young man, but also highlights Keaton's own distance from the fiction, his irreducible and transgressive presence as a comedian in the universe of serious drama" ("Making," 284). The movie's most memorable scene, which was choreographed by Keaton himself, shows him flung around the floor of the Stock Exchange, suspended above a hostile sea of greedy traders.

24. The way that Keaton's Buster moves in and out of touch with the actuality that surrounds him bears an interesting relationship to Daniel Morgan's idea that in certain films of the 1930s the camera signals a "dual attunement"—seeming to oscillate, that is, between being linked to an individual character and being linked to that character's social milieu. Keaton's movies all struggle with (i.e., make gags out of) the way that his style depends on his doing his very best to fit into whatever world he is thrown into, but always finding himself a half-step off, syncopated into a strange and memorable rhythm when striving most desperately for simple conformity. King Vidor's *The Crowd* (1927) explores what it means for an individual to succumb to the pull of the masses, of life within a homogenous crowd. Vidor, unlike Keaton, stages it as the tragedy (or tragi-comedy) that threatens us all.

25. Keaton is no overt rebel, but his changing relationship to a uniform (and often, given the importance of soldiers and police in his films, literally uniformed) world has something in common with the punk rocker "subcultures" analyzed by Dick Hebdige in the late 1970s. Hebdige famously describes, among those subcultures, a style that turns "a smile or a sneer," or even "a safety pin, a pointed shoe, a motorcycle" into a "gesture of defiance or contempt." But equally worth remarking is his notion that such bits of social graffiti are "an expression both of impotence and a kind of power." That is, a subcultural style works by indicating *both* awareness of the constraints on any exercise of autonomy *and* willingness to test that constraint's limits in unexpected and perforce innovative ways. (Hebdige, *Subculture*, 2–3).

26. Proust, "On Flaubert's Style," 263.

27. Compare Scott McCloud's argument that heroes' faces are often drawn as nearly blank even in comic books that render the natural world vividly and with granular details (think of *Tintin*)—all the better to entice readers to insert their own face into the blank (*Understanding Comics*, esp. 36–37).
28. Qtd. in Dardis, *Keaton*, 56.
29. Another example of Keaton's indirect influence: that exact gag is resurrected by *The Lego Movie*.
30. This applies well beyond *The General*. In an early short, *The Paleface* (1922), Buster the lepidopterist comes into an Indian encampment and performs an array of butterfly-collecting maneuvers that are perfectly *mis*interpreted by his observers.
31. What Pasolini in 1965 describes as the "free indirect subjective" camera may in a sense already be present here. Pasolini means that the camera produces "constant, indiscernible movement between the objective and subjective, real and imaginary" (Gelley, *Stardom*, 106). Either way, what the film shows us is what it means *not* to realize one's relationship to the world that is flickering by.
32. Qtd in Jay, *Songs of Experience*, 164.

CONCLUSION: APPARITIONAL CRITICISM

1. Galt, "Mem," 9.
2. Ford, "On Impressionism," 267. Cf. the discussion in chapter 3 of Prettejohn's astute analysis of Ford Madox Brown paintings (e.g., *Cromwell on his Farm*) that use the trope of the blank inward gaze of the central subject as a way of formally reconciling the competing generic impulses of on the one hand history painting and on the other the PRB imperative to make "present history" palpable. Mark Phillips also describe the painting in terms that are germane to the same problem: "The blank gaze of the protagonist[] project[s] a sense of an inner state wholly disconnected from [his] surroundings" (*On Historical Distance*,138–39).
3. Cf. Ted Underwood's argument in *Why Literary Periods Mattered* (2013) that the historical period emerged as far back as the mid-nineteenth century as the crucial category in university literature curricula, an impulse toward strict periodization that he intriguingly links to Foucault's interest in the "episteme" as the logical unity of historical study. For the Victorian education reformer F. D. Maurice as for Foucault, Underwood argues, such sealed realms provide both the possibility of "total knowledge" and a formally advantageous historical separation between past and present: "Our failure to recognize the congruence between Foucauldian and New Critical attacks on 'continuity' is probably a symptom of a broader blind spot in literary history, which is, simply, a widespread amnesia about the whole history of the discipline before New Criticism" (134). Also relevant to the notion of semi-detachment is Underwood's argument that "an organizing principle of historical contrast has been central to the prestige of Anglo-American literary culture since the early nineteenth century," and that "the contribution [to ideas about historicism] that poets, novelists and eventually critics made was to render discontinuity imaginable

and meaningful . . . not by reducing different eras to some common standard but by dramatizing the vertiginous gulfs between eras, and then claiming vertigo itself as a source of meaning" (2–4).

4. "In distinguishing between what was ancient and modern [the modern author should not forget] that extensive neutral ground, the large proportion, that is, of manners and sentiments which are common to us and to our ancestors, having been handed down unaltered from them to us, or which, arising out of the principles of our common nature, must have existed alike in either state of society" (Scott, *Ivanhoe*, 18).

5. This account of "Legend of Jubal" responds to and benefits deeply from an interpretation offered by Isobel Armstrong ("Plenary"; NVSA conference, April 2013, Boston).

6. For an account of critical legacies that stresses such plausible continuities between past writers and present interlocutors, see Andrew Miller's discussion of "critical free indirect discourse" (*Burdens of Perfection*, 84–91).

7. Eliot has another useful apothegm on the time-boundedness of art. Even if Samuel Daniel's poems strikes you as thin, she cautions readers of *Middlemarch*, remember the unrecoverable feelings that accompanied them: "Would it not be rash to conclude that there was no passion behind those sonnets to Delia which strike us as the thin music of a mandolin?" (*Middlemarch*, 50).

8. Felsenstein and Connolly, the architects of the database (http://bsu.edu /libraries/wmr/index.php), recently published a monograph presenting many of their demographic conclusions in *What Middletown Read*; I published a brief article in *Slate* discussing my experiment ("This Book").

9. Deidre Lynch's recent *Loving Literature* has a fascinating account of the approachability of the real, as opposed to the apparitional (esp. 194–234).

10. Ferris, "Before Our Eyes," 73.

Bibliography

Abbot, Edwin A. *The Annotated Flatland: A Romance of Many Dimensions*. [1884]. With introduction and notes by Ian Stewart. Cambridge, MA: Perseus Publishing, 2002.

Ackroyd, Peter. *Dickens*. London: Sinclair-Stevenson, 1990.

Adams, Henry. *The Education of Henry Adams: A Centennial Version*. Edited by Edward Chalfant and Conrad Edick Wright. Boston: Massachusetts Historical Society; Charlottesville: University of Virginia Press, 2007.

Addison, Joseph. "Fairy Way of Writing." [1712] In *Fantastic Literature: A Critical Reader*, edited by David Sandner, 21–24. London: Praeger, 2004.

Adorno, Theodor. *Aesthetic Theory*. Translated and edited by Robert Hullot-Kentor. London: Continuum, 1997.

Agee, James. "Comedy's Greatest Era." *Life*. September 5, 1949.

Ahearn, Amy. "Full-Blooded Writing and Journalistic Fictions: Naturalism, the Female Artist and Willa Cather's 'The Song of the Lark.'" *American Literary Realism* 33:2 (Winter 2001): 143–56.

Allen, Walter. *The Short Story in English*. Oxford: Clarendon Press, 1981.

———. "What Is a Short Story?" *Listener* (March 28, 1974): 405–6.

Amis, Kingsley. *Lucky Jim*. London: V. Gollancz, 1953.

Anderson, Amanda. *The Powers of Distance: Cosmopolitanism and the Cultivation of Detachment*. Princeton, NJ: Princeton University Press, 2001.

Anderson, Benedict. *Imagined Communities*. London: Verso, 1983.

Andres, Sophia. *The Pre-Raphaelite Art of the Victorian Novel*. Columbus: Ohio State University Press, 2005.

Appiah, Kwame Anthony. "Liberalism, Individuality, and Identity." *Critical Inquiry* 27 (Winter 2001): 305–32.

Arata, Stephen. "On Not Paying Attention." *Victorian Studies* 46:2 (2004): 193–205.

Arendt, Hannah. *Lectures on Kant's Political Philosophy*. Edited by Ronald Beiner. Chicago: University of Chicago Press, 1982.

———. *The Life of the Mind*. Vol. 1, *Thinking*. New York: Harcourt Brace Jovanovich, 1977.

Armstrong, Isobel. *Victorian Glassworlds: Glass Culture and the Imagination, 1830–1880*. Oxford: Oxford University Press, 2008.

Arnold, Matthew. "The Literary Influence of Academies." In *Essays in Criticism*, 42–78. London: Macmillan, 1865.

Arscott, Caroline. *William Morris and Edward Burne-Jones: Interlacings*. New Haven, CT: Yale University Press, 2008.

Attridge, John. "Steadily and Whole." *Modernism/Modernity* 15:2 (2008): 297–315.

Austen, Jane. *Emma*. Edited by Richard Cronin and Dorothy McMillan. Cambridge: Cambridge University Press, 2005.

——. *Jane Austen's Letters to Her Sister Cassandra and Others*. Edited by R. W. Chapman. 2nd ed. London: Oxford University Press, 1959.

——. *Persuasion*. Edited by James Kinsley, with an introduction and notes by Deirdre Shauna Lynch. Oxford: Oxford University Press, 2008.

Bakhtin, Mikhail. "Forms of Time and of the Chronotope in the Novel: Towards a Historical Poetics." In *The Dialogic Imagination: Four Essays*, edited by Michael Holquist, translated by Caryl Emerson and Michael Holquist, 84–258. Austin: University of Texas Press, 1981.

Baldwin, Dean. *Art and Commerce in the British Short Story, 1880–1950*. London: Pickering & Chatto, 2013.

——. "The Tardy Evolution of the Short Story." *Studies in Short Fiction* 30 (1993): 23–33.

Banfield, Ann. *Unspeakable Sentences: Narration and Representation in the Language of Fiction*. Boston: Routledge & Kegan Paul, 1989.

Bannister, Robert C. *Social Darwinism: Science and Myth in Anglo-American Social Thought*. Philadelphia: Temple University Press, 1979.

Barea, Maria Del Carmen Molina. "Buster Keaton and Surrealism in the Residencia de Estudiantes: Reasons for Convergence." *Archivo español de arte* 86:341 (2013): 29–48.

Barlow, Paul. "Millais, Manet, Modernity." In *English Art 1860–1914: Modern Artists and Identity*, edited by D. P. Corbett and Lara Perry, 49–63. New Brunswick, NJ: Rutgers University Press, 2001.

——. *Time Present and Time Past: The Art of John Everett Millais*. Aldershot: Ashgate, 2005.

Barringer, Tim. "An Antidote to Mechanical Poison." In *The Pre-Raphaelite Lens: British Photography and Painting, 1848–1875*, edited by Diane Waggoner, 18–31. Washington DC: National Gallery of Art, 2010.

Barringer, Tim, Jason Rosenfeld, and Alison Smith, eds. *Pre-Raphaelites: Victorian Art and Design*. New Haven, CT: Yale University Press, 2012.

Barrow, R. J. *Lawrence Alma-Tadema*. London: Phaidon Press, 2001.

Barthes, Roland. *The Fashion System*. Translated by Matthew Ward and Richard Howard. London: Cape, 1985.

——. "Garbo's Face." In *Mythologies*, 73–75. London: Vintage, 1993.

——. *The Neutral: Lecture Course at the Collège de France (1977–1978)*. Translated by Rosalind E. Krauss and Denis Hollier. New York: Columbia University Press, 2005.

Beaumont, Matthew. *The Spectre of Utopia: Utopian and Science Fictions at the fin de siècle*. Bern: Peter Lang, 2012.

Beckett, Samuel. "Dante and the Lobster." In *More Pricks than Kicks*, 9–22. New York: Grove Press, 1972.

Beer, Gillian. *Darwin's Plots: Evolutionary Narrative in Darwin, George Eliot and Nineteenth-Century Fiction*. 3rd ed. Cambridge: Cambridge University Press, 2009.

Beerbohm, Max. *A Christmas Garland*. New York: E. P. Dutton & Co., 1912.

Bell, Duncan. *Remaking the World: Essays on Liberalism and Empire*. Princeton, NJ: Princeton University Press, 2016.

Benayon, Robert. *The Look of Buster Keaton*. Edited and translated by Randall Conrad. New York: St. Martin's Press, 1983.

Bender, Bert. "Nature in Naturalism." In *Oxford Handbook of American Literary Naturalism*, edited by Keith Newlin, 52–70. Oxford: Oxford University Press, 2011.

Bender, John, and Michael Marrinan. *Culture of Diagram*. Stanford, CA: Stanford University Press, 2010.

Bennett, Jane. *Vibrant Matter: A Political Ecology of Things*. Durham, NC: Duke University Press, 2010.

Benson, Stella. *Living Alone*. London: Macmillan, 1919.

Bersani, Leo. "The Jamesian Lie." In *A Future for Astyanax: Character and Desire in Literature*, 128–55. Boston: Little, Brown, 1976.

Bevir, Mark. *The Making of British Socialism*. Princeton, NJ: Princeton University Press, 2011.

Blair, Ann. *Too Much to Know: Managing Scholarly Information before the Modern Age*. New Haven, CT: Yale University Press, 2010.

Bolter, Jay David, and Richard Grusin. *Remediation: Understanding New Media*. Cambridge, MA: MIT Press, 1999.

Borges, Jorge Luis. "The Aleph." In *The Aleph and Other Stories*, translated with an introduction by Andrew Hurley, 118–33. London: Penguin, 1998.

Borton, Terry, and Deborah Borton. "How Many American Lantern Shows in a Year?" In Crangle, Heard, and Van Dooren, *Realms of Light*, 105–15.

Bosanquet, Theodora. "Henry James." *Bookman* 45 (1917): 571–81.

Bowen, Elizabeth. Introduction to *The Faber Book of Modern Stories*, 7–19. London: Faber and Faber, 1937.

Bowler, Peter. *The Eclipse of Darwinism: Anti-Darwinian Evolution Theories in the Decades Around 1900*. Baltimore: Johns Hopkins University Press, 1983.

Brontë, Charlotte. *Jane Eyre*. Edited by Margaret Smith. Oxford: Oxford University Press, 2008.

Browning, Elizabeth Barrett. *Aurora Leigh*. Edited by Kery McSweeney. Oxford: Oxford University Press, 2008.

Browning, Robert. *Men and Women and Other Poems*. Edited with an introduction and notes by J. W. Harper. London: J. M. Dent, 1975.

Buchanan, Robert. *The Fleshly School of Poetry and Other Phenomena of the Day*. London: Strahan, 1872.

Bullen, J. B. *The Pre-Raphaelite Body: Fear and Desire in Painting, Poetry, and Criticism*. Oxford: Clarendon Press, 1998.

Buzard, James. *Disorienting Fiction: The Auto-Ethnographic Work of Nineteenth-Century British Novels*. Princeton, NJ: Princeton University Press, 2005.

Byerly, Alison. *Are We There Yet?: Virtual Travel and Victorian Realism*. Ann Arbor: University of Michigan Press, 2012.

Cameron, Sharon, *Thinking in Henry James*. Chicago: University of Chicago Press, 1989.

Capaldi, Nicholas. *John Stuart Mill: A Biography*. Cambridge: Cambridge University Press, 2004.

Carlisle, Janice. *John Stuart Mill and the Writing of Character*. Athens: University of Georgia Press, 1991.

Carlyle, Thomas. *Collected Letters of Thomas and Jane Welsh Carlyle*. Edited by Charles Richard Sanders. Vol. 6. Durham, NC: Duke University Press, 1970.

Carrol, Noel. *Comedy Incarnate: Buster Keaton, Physical Humor, and Bodily Coping*. Malden, MA: Blackwell, 2007.

Cather, Willa. *My Antonia*. In *Early Novels and Stories*, selected by Sharon O'Brien, 707–938. New York: Library of America, 1987.

——. "Katherine Mansfield." 123–147. *Not Under Forty*. [1925, revised 1936]. Lincoln: University of Nebraska, 1988.

——. *A Lost Lady*. In *Later Novels*, selected by Sharon O'Brien, 1–98. New York: Library of America, 1990.

——. "Miss Jewett." In *Not Under Forty*, 76–95.

——. "Nebraska: The End of the First Cycle." *Nation* (September 5, 1923): 236–38.

——. "The Novel Démeublé." In *Not Under Forty*, 43–51.

——. *O Pioneers!* In *Early Novels and Stories*, 133–290.

——. "On *The Professor's House*." In *Early Novels and Stories*, 974–76.

——. *One of Ours*. In *Early Novels and Stories*, 939–1298.

——. *The Professor's House*. In *Later Novels*, 99–272.

——. *The Selected Letters of Willa Cather*. Edited by Andrew Jewell and Janis Stout. New York: Alfred A. Knopf, 2013.

——. *The Song of the Lark*. In *Early Novels and Stories*, 291–606.

——. "Two Friends." [July, 1932, *Woman's Home Companion*]. In *Stories Poems and Other Writings*, selected by Sharon O'Brien, 673–90. New York: Library of America, 1992.

——. "A Wagner Matinee." In *Early Novels and Stories*, 102–10.

——. *The World and the Parish: Willa Cather's Articles and Reviews, 1893–1902*. 2 vols. Selected and edited with a commentary by William M. Curtin. Lincoln: University of Nebraska Press, 1970.

Cecil, David. Introduction to *The Two Drovers and Other Stories*, edited by Graham Tulloch, vi–xx. Oxford: Oxford University Press, 1987.

Chan, Winnie. *The Economy of the Short Story in British Periodicals of the 1890s*. New York: Routledge, 2007.

Chu, Seo-Young. *Do Metaphors Dream of Literal Sleep?: A Science-Fictional Theory of Representation*. Cambridge, MA: Harvard University Press, 2010.

Cobbett, William. *Rural Rides*. London: Penguin, 2001.

Codell, Julie. "Empiricism, Naturalism and Science in Millais's Paintings." In *John Everett Millais: Beyond the Pre-Raphaelite Brotherhood*, edited by Debra Mancoff, 119–48. New Haven, CT: Yale University Press, 2001.

Cohn, Dorrit. *Transparent Minds: Narrative Modes for Presenting Consciousness in Fiction*. Princeton, NJ: Princeton University Press, 1978.

Cohn, Elisha. *Still Life: Suspended Development in the Victorian Novel*. Oxford: Oxford University Press, 2016.

Collini, Stefan. "From Sectarian Radical to National Possession: John Stuart Mill in English Culture, 1873–1945." In *A Cultivated Mind: Essays on J. S. Mill Presented to John M. Robson*, edited and with an introduction by Michael Laine, 242–72. Toronto: University of Toronto, 1991.

Collins, Wilkie. *Queen of Hearts*. London: Hurst & Blackett, 1859.

Conrad, Joseph. *The Collected Letters of Joseph Conrad, 1898–1902*. Edited by Frederick R. Karl and Laurence Davies. Cambridge: Cambridge University Press, 1986.

———. *Lord Jim: A Romance*. Garden City, NY: Doubleday, Page and Co., 1919.

———. Preface to *The Nigger of the Narcissus: A Tale of the Sea*, 11–16. Garden City, NY: Doubleday, Page, 1914.

Cooper, William. *Scenes from Provincial Life*. London: Jonathan Cape, 1950.

Corbett, Mary Jean. *Representing Femininity: Middle-Class Subjectivity in Victorian and Edwardian Women's Autobiographies*. New York: Oxford University Press, 1992.

Coriale, Danielle. "Gaskell's Naturalist." *Nineteenth-Century Literature* 63:3 (2008): 346–75.

Crafton, Donald. "McCay and Keaton: Colligating, Conjecturing, and Conjuring." *Film History* 2:1–2 (2013): 31–44.

Crangle, Richard, Mervyn Heard, and Ine Van Dooren, eds. *Realms of Light: Uses and Perceptions of the Magic Lantern from the 17th to the 21st Century: An Illustrated Collection of Essays by 27 Authors from Six Countries*. London: Magic Lantern Society, 2005.

Crary, Jonathan. *Suspensions of Perception: Attention, Spectacle and Modern Culture*. Cambridge, MA: MIT Press, 1999.

Crawford, Robert. "Bad Shepherd," *London Review of Books* (5 April 2010): 28–29.

D'Albertis, Deirdre. "The Domestic Drone: Margaret Oliphant and a Political History of the Novel." *Studies in English Literature, 1500–1900* 37:4 (Autumn 1997): 805–29.

Dames, Nicholas. "The Chapter: A History." *New Yorker* online. October 29, 2014.

Dardis, Tom. *Keaton: The Man Who Wouldn't Lie Down*. New York: Scribner, 1979.

Daston, Lorraine, and Peter Galison. *Objectivity*. New York: Zone Books, 2007.

Davis, Philip. "Deep Reading in the Manuscripts: Dickens and the Manuscript of *David Copperfield*." In *Reading and the Victorians*, edited by Matthew Bradley and Juliet John, 65–78. Farnham, Surrey: Ashgate, 2015.

Dawson, Gavin. *Darwin, Literature and Victorian Respectability*. Cambridge: Cambridge University Press, 2007.

Delbanco, Nicholas. *Group Portrait: Conrad, Crane, Ford, James and Wells*. New York: Morrow, 1982.

Denisoff, Dennis, ed. *Broadview Anthology of Victorian Short Stories*. Peterborough, Ontario: Broadview, 2004.

Derrida, Jacques. "Structure, Sign and Play in the Discourse of the Human Sciences." In *Writing and Difference*, translated with an introduction and additional notes by Alan Bass, 278–93. Chicago: University of Chicago, 1967.

Dewey, John. *Art as Experience*. New York: Minton, Balch, 1934.

Dickens, Charles. *Great Expectations*. Edited by Margaret Caldwell. Oxford: Oxford University Press, 1993.

———. *Hard Times*. New York: W. W. Norton & Co., 2001.

———. *Oliver Twist*. Edited by Kathleen Tillotson. Oxford: Oxford University Press, 1966.

———. "Old Lamps for New Ones." *Household Words* 12 (June 15, 1850): 12–14.

———. *Our Mutual Friend*. New York: Pollard and Moss, 1884.

——. "Our Next-Door Neighbour." In *Sketches by Boz*. London: Macmillan, 1892. Originally appeared in *The Morning Chronicle*, March 18, 1836.

——. *The Posthumous Papers of the Pickwick Club*. Oxford: Oxford University Press, 1947.

——. *Sketches by Boz*. London: Macmillan, 1892.

Donner, Wendy. *The Liberal Self*. Ithaca, NY: Cornell University Press, 1991.

Dreyfus, John. "A Reconstruction of the Lecture Given by Emery Walker on 15 November 1888." *Matrix* 11 (1991): 27–52.

——. "William Morris: Typographer." In *William Morris and the Art of the Book*, 71–96. With a preface by Charles Ryskamp. New York: Morgan Library, Oxford University Press, 1976.

Duncan, Ian. "Altered States: Galt, Serial Fiction and the Romantic Miscellany." In *John Galt: Observations and Conjectures on Literature, History, and Society*, edited by Regina Hewitt, 53–71. Lewisburg, PA: Bucknell University Press 2012.

——. "Provincial or Regional Novel." In *A Companion to the Victorian Novel*, edited by Patrick Brantlinger and William Thesing, 318–35. Malden, MA: Blackwell, 2002.

——. *Scott's Shadow: The Novel in Romantic Edinburgh*. Princeton, NJ: Princeton University Press, 2007.

Dunsany, Edward. *Tales of Wonder*. With illustrations by S. H. Sime. London: Elkin Mathews, 1916.

During, Simon. "Literary Subjectivity." *Ariel* 31 (2000): 33–50.

Eden, Emily. *The Semi-Detached House*. Boston: Ticknor and Fields, 1860.

Eikhenbaum, Boris. "O. Henry and the Theory of the Short Story." [1925]. Translated by I. R. Titunik. In *Readings in Russian Poetics*, edited by L. Matejka, 227–70. Cambridge, MA: MIT Press, 1971.

Elsaesser, Thomas, ed. *Early Cinema: Space, Frame, Narrative*. London: British Film Institute, 1990.

Eliot, George. *Impressions of Theophrastus Such*. Edited by Nancy Henry. Iowa City: University of Iowa Press, 1994.

——. *Middlemarch*. Edited by David Carroll. Oxford: Oxford University Press, 1986.

——. *The Mill on the Floss*. Edited by Gordon S. Haight. Oxford: Oxford University Press, 1980.

——. *Romola*. Edited by Dorothea Barrett. Harmondsworth, UK: Penguin, 1996.

Ellison, Ralph. *Invisible Man*. With a preface by Charles Johnson. New York: Modern Library, 1994.

Errington, Lindsay. *Social and Religious Themes in English Painting 1840–1860*. New York: Garland, 1984.

Esty, Jed. *A Shrinking Island: Modernism and National Culture in England*. Princeton, NJ: Princeton University Press, 2004.

Fawcett, Trevor. "Graphic versus Photographic in the Nineteenth-Century Reproduction." *Art History* 9:2 (June 1986): 185–212.

Felsenstein, Frank, and James J. Connolly. *What Middletown Read: Print Culture in an American Small City*. Amherst: University of Massachusetts Press, 2015.

Ferris, Ina. "'Before Our Eyes': Romantic Historical Fiction and the Apparitions of Reading." *Representations* 121:1 (Winter 2013): 60–84.

——. "Scholarly Revivals." In *Recognizing the Romantic Novel*, edited by Jillian Heydt-Stevenson and Charlotte Sussman, 267–84. Liverpool English Texts and Studies 53. Liverpool: Liverpool University Press, 2008.

Flammarion, Camille. *Omega: The Last Days of the World*. [1893]. New York: Cosmopolitan, 1894.

Flaubert, Gustave. *Madame Bovary*. Translated with an introduction and notes by Lydia Davis. New York: Viking, 2012.

Fleissner, Jennifer. *Women, Compulsion, Modernity: The Moment of American Naturalism*. Chicago: University of Chicago, 2004.

Flint, Kate. *The Victorians and Visual Imagination*. Cambridge: Cambridge University Press, 2000.

Ford, Ford Madox. *Ladies Whose Bright Eyes: A Romance*. [1911]. Garden City, NY: Doubleday, 1912.

——. *Ladies Whose Bright Eyes: A Romance*. [2nd ed., 1935]. With an afterword by C. H. Sisson. Manchester: Carcanet, 1988.

——. "On Impressionism." In *The Good Soldier*, edited by William Baker, 259–80. Peterborough, Ontario: Broadview, 2003.

Forster, E. M. "The Machine Stops." [1909]. In The Eternal Moment *and Other Stories*. 13–86. New York: Harcourt and Brace, 1928.

Foucault, Michel. "Nietzsche, Genealogy, History." In *The Foucault Reader*, 76–100. Edited by Paul Rabinow. New York: Pantheon Books, 1984.

——. *The Order of Things: An Archaeology of the Human Sciences*. With a foreword to the English ed. by the author. New York: Vintage Books, 1994.

——. "What Is an Author?" Translated by Donald F. Bouchard and Sherry Simon. In *Language, Counter-Memory, Practice*, edited by Donald F. Bouchard, 113–38. Ithaca, NY: Cornell University Press, 1977.

Francois, Anne-Lise. *Open Secrets: The Literature of Uncounted Experience*. Stanford, CA: Stanford University Press, 2008.

Fried, Michael. "Caillebotte's Impressionism." *Representations* 66 (Spring 1999): 1–51.

Frow, John. *Character and Person*. Oxford: Oxford University Press, 2014.

Fry, Roger. "The Case of the Late Sir Lawrence Alma-Tadema, O. M." *Nation* (January 18, 1913): 666–67.

Frye, Northrop. *Anatomy of Criticism*. Princeton, NJ: Princeton University Press, 1957.

Fyfe, Aileen. "Reading Natural History at the British Museum and the *Pictorial Museum*." In Fyfe and Lightman, *Science in the Marketplace*, 196–230.

Fyfe, Aileen, and Bernard Lightman, eds. *Science in the Marketplace: Nineteenth-Century Sites and Experiences*. Chicago: University of Chicago Press, 2007.

Galison, Peter. "Image of Self." In *Things That Talk: Object Lessons from Art and Science*, edited by Lorraine Daston, 257–96. New York: Zone Books (MIT Press), 2004.

Gallagher, Catherine. *Nobody's Story: The Vanishing Acts of Women Writers in the Marketplace, 1670–1820*. Berkeley: University of California Press, 1994.

——. "The Rise of Fictionality." In *The Novel*. Vol. 1, *History, Geography and Culture*, edited by Franco Moretti, 336–63. Princeton, NJ: Princeton University Press, 2006.

Galt, John. *Annals of the Parish*. Edited with an introduction by James Kinsley. London: Oxford University Press, 1967.

———. "The Mem." [*Frasers*, August 1834]. In *Selected Short Stories*, edited by Ian Gordon, 1–9. Edinburgh: Scottish Academic Press, 1978.

———. *Selected Short Stories*. Ed. Ian Gordon. Edinburgh: Scottish Academic Press, 1978.

———. *Stories of the Study*. London: Cochrane and McCrone, 1833.

Garcha, Amanpal. *From Sketch to Novel: The Development of Victorian Fiction*. Cambridge: Cambridge University Press, 2009.

Garnett, David. *Lady into Fox*. Illustrated with wood engravings by R. A. Garnett. London: Hesperus, 2008.

Garrett, Matthew. *Episodic Poetics: Politics and Literary Form after the Constitution*. New York: Oxford University Press, 2014.

Gaskell, Elizabeth. *Cranford*. Edited by Elizabeth Porges Watson. Oxford: Oxford University Press, 1980.

———. *Wives and Daughters*. Vol. 10, *The Works of Elizabeth Gaskell*. Edited by Joanne Shattock. London: Pickering & Chatto, 2005–6.

Gaudreault, Andre. *Film and Attraction: From Kinematography to Cinema*. Translated by Timothy Barnard. With a foreword by Rick Altman. Urbana: University of Illinois Press, 2011.

Gelley, Ora. *Stardom and the Aesthetics of Neorealism: Ingrid Bergman in Rossellini's Italy*. New York: Routledge, 2012.

Genette, Gerard. *Narrative Discourse Revisited*. Ithaca, NY: Cornell University Press, 1988.

Gettelman, Debra. "'Making Out' Jane Eyre." *ELH* 74:3 (2007): 557–81.

Gide, André. Introduction to *The Private Memoirs and Confessions of a Justified Sinner*, by James Hogg. London: Cresset Press, 1947.

Giebelhausen, Michaela. "Academic Orthodoxy versus Pre-Raphaelite Heresy: Debating Religious Painting at the Royal Academy, 1840–1850." In *Art and the Academy in the Nineteenth Century*, edited by Rafael Cardoso Denis and Colin Trodd, 150–63. New Brunswick, NJ: Rutgers University Press, 2000.

———. *Painting the Bible: Representation and Belief in Mid-Victorian Britain*. Burlington, VT: Ashgate, 2006.

Gitelman, Lisa. *Always Already New: Media, History and the Data of Culture*. Cambridge, MA: MIT Press, 2006.

Goffman, Erving. *Interaction Ritual: Essays on Face-to-Face Behavior*. Garden City, NY: Anchor Books, 1967.

Gordon, Ian. Introduction to *Selected Short Stories*, by John Galt, vii–ix. Ddited by Ian Gordon. Edinburgh: Scottish Academic Press, 1978.

———. *John Galt: The Life of a Writer*. Edinburgh: Oliver and Boyd, 1972.

Greiner, Rae. *Sympathetic Realism in Nineteenth-Century British Fiction*. Baltimore: Johns Hopkins University Press, 2012.

Gunning, Thomas. "The Cinema of Attraction: Early Film, Its Spectator and the Avant-Garde." In *Early Cinema: Space Frame Narrative*, edited by Thomas Elsaesser, 60–71. London: British Film Institute, 1990.

Habermas, Jürgen. *Structural Transformation of the Public Sphere: An Inquiry into a Category of Bourgeois Society*. [1962]. Translated by Thomas Burger with the assistance of Frederick Lawrence. Cambridge, MA: MIT Press, 1989.

Hadley, Elaine. *Living Liberalism*. Chicago: University of Chicago Press, 2010.

Haining, Peter, ed. *The Jules Verne Companion*. London: Souvenir Press, 1978.

Hardy, Thomas. *Jude the Obscure*. Edited with an introduction and notes by Patricia Ingham. New York: Oxford University Press, 2002.

———. *Tess of the d'Urbervilles*. Oxford: Oxford University Press, 2005.

Harlan, Deborah. "The Archaeology of Lantern Slides: The Teaching Slide Collection of the Ashmolean Museum, Oxford." In Crangle, Heard, and Van Dooren, *Realms of Light*, 203–10.

Harman, Graham. "The Well-Wrought Broken Hammer: Object-Oriented Literary Criticism." *New Literary History* 43 (2012): 183–203.

Harrington, Emily. "Michael Field and the Detachable Lyric." *Victorian Studies* 50:2 (2008): 221–32.

Harris, Neil. *Humbug: The Art of P. T. Barnum*. Boston: Little, Brown, 1973.

Haywood, Ian. *The Revolution in Popular Literature: Print, Politics, and the People, 1790–1860*. Cambridge: Cambridge University Press, 2004.

Hazlitt, William. *Spirit of the Age*. [1825]. New York: Derby and Jackson, 1857.

Hebdige, Dick. *Subculture: The Meaning of Style*. [1979]. London: Routledge, 2001.

Hegel, G. W. F. *Outlines of the Philosophy of Right*. [1820]. Translated by T. M. Knox. Revised, edited, and introduced by Stephen Houlgate. Oxford: Oxford University Press, 2008.

Helmreich, Anne. *Nature's Truth: Photography, Painting, and Science in Victorian Britain*. University Park, PA: Penn University State Press, 2016.

Helsinger, Elizabeth. "Listening: Dante Gabriel Rossetti and the Persistence of Song." *Victorian Studies* 51:3 (2009): 409–21.

———. *Poetry and the Pre-Raphaelite Arts: Dante Gabriel Rossetti and William Morris*. New Haven, CT: Yale University Press, 2008.

———. "William Morris before Kelmscott: Poetry and Design in the 1860s." In *Victorian Illustrated Book*, edited by Richard Maxwell, 209–38. Charlottesville: University of Virginia Press, 2002.

Herbert, Christopher. *Culture and Anomie: Ethnographic Imagination in the Nineteenth Century*. Chicago: University of Chicago Press, 1995.

Hewitt, Regina. Introduction to *John Galt: Observations and Conjectures on Literature, History, and Society*, edited by Regina Hewitt, 1–31. Lewisburg, PA: Bucknell University Press, 2012.

Hofmeyr, Isabel. *Gandhi's Printing Press: Experiments in Slow Reading*. Cambridge, MA: Harvard University Press, 2013.

Hogg, James. "The Long Pack." In Duncan, *Winter Evening Tales*, 130–40.

———. "Mr. Adamson of Laverhope." *Shepherd's Calendar*, edited by Douglas Mack, 38–56. Edinburgh: Edinburgh University Press, 2002.

———. "An Old Soldier's Tale." In Duncan, *Winter Evening Tales*, 98–107.

———. *The Poetical Works of the Ettrick Shepherd, Including The Queen's Wake, Pilgrims of the Sun, Mador of the Moor, Mountain bard, &c*. With a "Life of the author" by Professor Wilson and illustrative engravings from original drawings by D. O. Hill. Glasgow: Blackie & Son, 1838–40.

———. *The Private Memoirs and Confessions of a Justified Sinner*. With an introduction by André Gide. London: Cresset Press, 1947.

———. *The Spy*. Ed. Gillian Hughes. Edinburgh: Edinburgh University Press, 2000.

Hollander, Anne. *Sex and Suits*. New York: Knopf, 1994.

Hughes, Gillian. Introduction to *Altrive Tales: Collected among the Peasantry of Scotland and from Foreign Adventurers*, by James Hogg, xi–lxvii. Edited by G. Hughes. Edinburgh: Edinburgh University Press, 2005.

Huizinga, Johan. *Homo Ludens: A Study of the Play-Element in Culture*. London: Routledge & K. Paul, 1949.

Hutton, R. F. [Jane Austen and Anthony Trollope]. *Spectator* 55 (December 9, 1882): 1573–54.

Jacobs, Jo Ellen. *Voice of Harriet Taylor Mill*. Bloomington: Indiana University Press, 2002.

Jakobson, Roman. "What Is Poetry?" [1933–34]. In *Semiotics of Art*, edited by Ladislav Matejka and Irwin R. Titunik, 164–75. Cambridge, MA: MIT Press, 1976.

James, Edward, and Farah Mendlesohn, eds. *The Cambridge Companion to Fantasy Literature*. Cambridge: Cambridge University Press, 2012.

James, Henry. *The Ambassadors*. In *The Novels and Tales of Henry James*. Vols. 21–22. New York: Scribner's, 1909.

——. "Daniel Deronda: A Conversation" *Atlantic Monthly* 38 (December 1876): 684–94.

——. "Discarded Sheets." Henry James Papers for *The Sense of the Past* (MS Am 1237.8). Houghton Library, Harvard University.

——. *Henry James Letters*. Vol. 4, *1895–1916*. Edited by Leon Edel. Cambridge, MA: Harvard University Press, 1984.

——. Henry James Papers for *The Sense of the Past* (MS Am 1237.8). Houghton Library, Harvard University.

——. "Henry James's First Interview." In *Henry James on Culture: Collected Essays on Politics and the American Social Scene*, edited by Pierre A. Walker, 138–45. Lincoln: University of Nebraska Press, 1999.

——. "London Notes, August, 1897." In *Notes on Novelists: With Some Other Notes*, 446–56. New York: C. Scribner's Sons, 1914.

——. "A Noble Life." *Nation* (March 1, 1866): 276–78.

——. "Notes for *The Ivory Tower*." In *The Ivory Tower*. With an introduction by Alan Hollinghurst and an essay by Ezra Pound, 197–259. New York: New York Review Books, 2004.

——. "Notes for *The Sense of the Past*." In *The Sense of the Past: The Novels and Tales of Henry James*. Vol. 26, 291–358. New York: Scribner's, 1917.

——. Preface to *The Ambassadors*. In *The New York Edition of Henry James*. Vol. 21, v–xxiii. New York: Scribner's, 1909.

——. *The Sense of the Past: The Novels and Tales of Henry James*. Vol. 26. New York: Scribner's, 1917.

——. Unsigned review of *Middlemarch*. *Galaxy* 15 (March 1873): 424–28. Reprinted in *George Eliot: The Critical Heritage*, edited by David Carroll, 353–59. London: Routledge, 1971.

——. "Within the Rim." In *Within the Rim, and Other Essays, 1914–15*, 11–38. London: W. Collins Sons & Co. Ltd., 1918.

Jameson, Frederic. *The Antinomies of Realism*. London: Verso, 2013.

Jarrells, Anthony. "Short Fictional Forms and the Rise of the Tale." In *The Oxford History of the Novel in English*. Vol. 2, *English and British Fiction, 1750–1820*, edited by Peter Garside and Karen O'Brien, 478–94. Oxford: Oxford University Press, 2015.

Jay, Elizabeth. *Mrs Oliphant: "A Fiction to Herself"—A Literary Life*. Oxford: Clarendon Press, 1995.

Jay, Martin. *Songs of Experience*. Berkeley: University of California Press, 2005.

Jenkins, Henry. "'The Fellow Keaton Seems to be the Whole Show': Buster Keaton Interrupted Performance, and the Vaudeville Aesthetic." In *Buster Keaton's Sherlock Jr.*, edited by Andrew Horton, 29–66. Cambridge: Cambridge University Press, 1997.

Johnson, R. R. Maxwell, and K. Trumpener, "The Arabian Nights, Arab-European Literary Influence, and the Lineages of the Novel." *Modern Language Quarterly* 68:2 (2007): 243–79.

Joyce, James. "The Dead." In *Dubliners*, edited by Margot Norris. Text edited by Hans Walter Gabler with Walter Hettche, 151–94. New York: W. W. Norton, 2006.

Kafka, Ben. *The Demon of Writing: Powers and Failures of Paperwork*. Cambridge, MA: MIT Press, 2012.

Kant, Immanuel. *Critique of Judgment*. Translated by James Creed Meredith. Revised, edited, and introduced by Nicholas Walker. New York: Oxford University Press, 2007.

Killick, Tim. *British Short Fiction in the Early Nineteenth Century: The Rise of the Tale*. Aldershot: Ashgate, 2008.

Kipling, Rudyard. "The Tree of Justice." In *Puck of Pook's Hill and Rewards and Fairies*, edited by Donald Mackenzie, 387–407. Oxford: Oxford University Press, 1993.

Kirchoff, Frederick. "William Morris's Anti-Books: The Kelmscott Press and the Late Prose Romances." In *Forms of the Fantastic*, edited by Jan Hokenson and Howard Pearce, 93–100. New York: Greenwood Press, 1986.

Kirschenbaum, Matthew. *Mechanisms: New Media and the Forensic Imagination*. Cambridge, MA: MIT Press, 2008.

Kline, Morris. *Mathematics: The Loss of Certainty*. New York: Oxford University Press, 1980.

Korte, Barbara. *The Short Story in Britain: A Historical Sketch and Anthology*. Tubingen: Francker Verlag, 2003.

Koven, Seth. *The Match Girl and the Heiress*. Princeton, NJ: Princeton University Press, 2014.

Kramer, Peter. "Battered Child: Buster Keaton's Stage Performance and Vaudeville Stardom in the Early 1900s." *New Review of Film and Television Studies* 5:3 (December 2007): 253–67.

———. "The Making of a Comic Star: Buster Keaton and *The Saphead*." In *The Silent Cinema Reader*, edited by Lee Grieveson and Peter Krämer, 279–89. London: Routledge, 2004.

Kreisel, Deanna. "The Discreet Charm of Abstraction: Hyperspace Worlds and Victorian Geometry." *Victorian Studies* 56:3 (2014): 398–410.

Kurnick, David. "An Erotics of Detachment." *ELH* 74:3 (2007): 583–608.

Lamb, Charles. "Dream Children." In *Works of Charles and Mary Lamb*. Vol. 2, *Elia and the Last Essays of Elia*, edited by E. V. Lucas, 101–3. London: Methuen, 1903.

Landow, George P. *Victorian Types, Victorian Shadows: Biblical Typology in Victorian Literature, Art, and Thought*. Boston: Routledge & Kegan Paul, 1980.

Langabuer, Laurie. *Novels of Everyday Life: The Series in English Fiction, 1850–1930*. Ithaca, NY: Cornell University Press, 1999.

Langland, Elizabeth. *Nobody's Angels: Middle-Class Women and Domestic Ideology in Victorian Culture*. Ithaca, NY: Cornell University Press, 1995.

Laqueur, Thomas. "Bodies, Details, and the Humanitarian Narrative." In *The New Cultural History: Essays*, edited by Lynn Hunt, 176–204. Berkeley: University of California Press, 1989.

Larkin, Philip. "I Remember, I Remember." In *Collected Poems*, edited and with an introduction by Anthony Thwaite, 68–69. New York: Farrar, Straus and Giroux, 2004.

Lauster, Martina. *Sketches of the Nineteenth Century: European Journalism and its Physiologies, 1830–1850*. Basingstoke: Macmillan, 2007.

Le Guin, Ursula. Introduction to *Selected Stories of H. G. Wells*, edited by Ursula Le Guin, vii–xii. New York: Modern Library, 2004.

Lemov, Rebecca. *Database of Dreams: The Lost Quest to Catalog Humanity*. New Haven, CT: Yale University Press, 2015.

Leonard, Anne. "Picturing Listening in the Late Nineteenth Century." *Art Bulletin* 89:2 (June 2007): 266–86.

Levine, George. "Reading Margaret Oliphant." *Journal of Victorian Culture* 19:2 (2014): 232–46.

Levy, Pierre. *Becoming Virtual: Reality in the Digital Age*. Translated from the French by Robert Bononno. New York: Plenum Trade, 1998.

Lewis, C. S. *The Magician's Nephew*. London: Bodley Head, 1955.

Lightman, Bernard. "Lecturing in the Spatial Economy of Science." In *Science in the Marketplace: Nineteenth-Century Sites and Experiences*, edited by Aileen Fyfe and Bernard Lightman, 97–134. Chicago: University of Chicago Press, 2007.

———. *Victorian Popularizers of Science: Designing Nature for New Audiences*. Chicago: University of Chicago Press, 2007.

Lindsay, Vachel. *Art of the Moving Picture*. New York: Macmillan, 1915.

Locke, John. *An Essay Concerning Human Understanding*. London: Tegg, 1838.

Luckhurst, Roger. *Science Fiction*. Cambridge: Polity, 2005.

Luhrssen, David. *Mamoulian: Life on Stage and Screen*. Lexington: University Press of Kentucky, 2013.

Lukacs, Gyorgy. "Ideology of Modernism." In *The Meaning of Contemporary Realism*, translated by Jon and Necke Mander, 17–46. London: Merlin, 1963.

———. "Narrate or Describe?" [1936]. In *Writer and Critic*, edited and translated by Arthur Kahn, 110–48. London: Merlin Press, 1970.

Lynch, Deidre. *The Economy of Character: Novels, Market Culture, and the Business of Inner Meaning*. Chicago: University of Chicago Press, 1998.

———. *Loving Literature: A Cultural History*. Chicago: University of Chicago, 2015.

MacCarthy, Fiona. *William Morris: A Life for our Time*. London: Faber and Faber, 1994.

Macdonald, Dwight. "Vote for Keaton." *New York Review of Books* (October 9, 1980): 33–38.

Mack, Douglas. "Aspects of the Supernatural in the Shorter Fiction of James Hogg." In *Exhibited by Candlelight*, edited by Y. Valerie Tinkler-Villani and Peter Davidson, 129–35. Atlanta: Rodopi, 1995.

Mackail, J. W. *The Life of William Morris*. London: Longmans, Green and Co., 1899.

Malafouris, Lambros. *How Things Shape the Mind: A Theory of Material Engagement*. Cambridge, MA: MIT Press, 2013.

Mancoff, Debra. "John Everett Millais: Caught Between the Myths." In *John Everett Millais: Beyond the Pre-Raphaelite Brotherhood*, edited by Debra Mancoff, 3–20. New Haven, CT: Yale University Press, 2001.

Marcus, Laura. *The Tenth Muse: Writing about Cinema in the Modernist Period*. Oxford: Oxford University Press, 2007.

Markovits, Stefanie. "Adulterated Form: Violet Fane and the Victorian Verse-Novel." *ELH* 81:2 (2014): 635–61.

Marsh, Jan. *The Pre Raphaelites: Their Lives in Letters and Diaries*. London: Collins and Brown, 1996.

Matthews, Brander. *The Philosophy of the Short-Story*. New York: Longmans, Green, 1901.

May, Charles, ed. *The New Short Story Theories*. Athens: Ohio State University Press, 1984.

McCarthy, Patrick. "*Heart of Darkness* and the Early Novels of H. G. Wells: Evolution, Anarchy, Entropy." *Journal of Modern Literature* 13:1 (March 1986): 37–60.

McCloud, Scott. *Understanding Comics: The Invisible Art*. Northampton, MA: Tundra Pub., 1993.

McGonigle, Jane. *Reality Is Broken: Why Games Make Us Better and How They Can Change the World*. New York: Penguin Press, 2011.

McLane, Maureen. *Balladeering, Minstrelsy and the Making of British Romantic Poetry*. New York: Cambridge University Press, 2008.

McLaughlin, Kevin. *Poetic Force: Poetry After Kant*. Stanford, CA: Stanford University Press, 2014.

McLean, Steven. *The Early Fiction of H. G. Wells: Fantasies of Science*. Basingstoke: Palgrave Macmillan, 2009.

McNamara, Susan. "Mirrors of Fiction within Tom Jones: The Paradox of Self-Reference." *Eighteenth-Century Studies* 12 (1978–79): 372–90.

Mendlesohn, Farah. *Rhetorics of Fantasy*. Middletown, CT: Wesleyan University Press, 2008.

Menely, Tobias. "Travelling in Place: Gilbert White's Cosmopolitan Parochialism." *Eighteenth-Century Life* 28:3 (2004): 46–65.

Merton, Robert K., Marjorie Fiske, and Patricia Kendall. *The Focused Interview: A Manual of Problems and Procedures*. Glencoe, IL: Free Press, 1956.

Miall, D. S. "Episode Structures in Literary Narratives." *Journal of Literary Semantics* 33:2 (2004): 111–29.

Michaels, Walter Benn. *The Shape of the Signifier: From 1967 to the End of History*. Princeton, NJ: Princeton University Press, 2004.

Michie, Elsie. *The Vulgar Question of Money: Heiresses, Materialism, and the Novel of Manners from Jane Austen to Henry James*. Baltimore: Johns Hopkins University Press, 2012.

Mill, John Stuart. *Autobiography*. In *Collected Works of John Stuart Mill*. Vol. 1, edited by J. M. Robson, 1–290.

———. "Coleridge." In *Collected Works of John Stuart Mill*. Vol. 10, 117–63.

———. *The Earlier Letters 1812 to 1848*. In *Collected Works of John Stuart Mill*. Vol. 7, edited by J. M. Robson. Toronto: University of Toronto Press, 1963.

———. *On Liberty*. In *Collected Works of John Stuart Mill*. Vol. 18, edited by J. M. Robson, 213–310. Toronto: University of Toronto Press, 1977.

———. *A System of Logic*, bks. 4–6. In *Collected Works of John Stuart Mill*. Vol. 8, edited by J. M. Robson. Toronto: University of Toronto Press, 1974.

———. "Thoughts on Poetry and Its Varieties." In *Collected Works of John Stuart Mill*. Vol. 1, edited by J. M. Robson, 341–65. Toronto: University of Toronto Press, 1981.

Millais, John Guile. *Life and Letters of John Everett Millais, President of the Royal Academy*. New York: Frederick A. Stokes Company, 1899.

Miller, Andrew. *The Burdens of Perfection: On Ethics and Reading in Nineteenth-Century British Literature*. Ithaca, NY: Cornell University Press, 2008.

Miller, Elizabeth Carolyn. *Slow Print: Literary Radicalism and Late Victorian Print Culture*. Stanford, CA: Stanford University Press, 2013.

Mirrlees, Hope. *Lud-in-the-Mist*. New York: A. A. Knopf, 1927.

Mitchison, Naomi. *You May Well Ask*. London: Golancz, 1979.

Mitford, Mary Russell. *The Works of Mary Russell Mitford: Prose and Verse*. Philadelphia: Crissy and Markley, 1846.

Moi, Toril. *Henrik Ibsen and the Birth of Modernism: Art, Theater, Philosophy*. Oxford: Oxford University Press, 2006.

Moretti, Franco. *The Bourgeois: Between History and Literature*. Brooklyn, NY: Verso, 2013.

———. "Graphs, Maps and Trees: Abstract Models for Literary History—1." *New Left Review* 24 (November/December 2003): 67–93.

———. *Graphs, Maps, Trees: Abstract Models for a Literary History*. London: Verso, 2005.

———. *The Way of the World: The Bildungsroman in European Culture*. Translated by Albert Sbragia. 2nd ed. London: Verso, 2000.

Morgan, Benjamin. *The Outward Mind: Materialist Aesthetics in Victorian Science and Literature*. Chicago: University of Chicago Press, 2017.

Morgan, Dan. "Max Ophuls and the Limits of Virtuosity: On the Aesthetics and Ethics of Camera Movement." *Critical Inquiry* 38 (Autumn 2011): 127–63.

Morris, May. Introduction to *Collected Works of William Morris*, xi–xxxii.

Morris, William. *The Collected Letters of William Morris*. 4 vols. Edited by Norman Kelvin. Princeton, NJ: Princeton University Press, 1983–96.

———. *The Collected Works of William Morris*. 24 vols. London: Longmans, Green and Co, 1910–15.

———. *The Earthly Paradise*. Vol. 4. In *Collected Works of William Morris*.

Morus, Iwan Rhys. "'More the Aspect of Magic than Anything Natural': The Philosophy of Demonstration." In Fyfe and Lightman, *Science in the Marketplace*, 336–70.

Münsterburg, Hugo. *The Photoplay: A Psychological Study*. New York: Appleton, 1916.

Musser, Charles. "Moving Towards Fictional Narratives: Story Films Become the Dominant Product, 1903–1904." In *The Silent Cinema Reader*, edited by Lee Grieveson and Peter Krämer, 87–103. London: Routledge, 2004.

Nash, Susie. *Northern Renaissance Art*. Oxford: Oxford University Press, 2008.

Nazar, Hina. *Enlightened Sentiments: Judgment and Autonomy in the Age of Sensibility*. New York: Fordham University Press, 2012.

——. "Facing Ethics: Narrative and Recognition from George Eliot to Judith Butler." *Nineteenth-Century Contexts* 33:5 (December 2011): 437–50.

Nead, Lynda. *The Haunted Gallery: Painting, Photography, Film c. 1900*. New Haven, CT: Yale University Press, 2007.

Nelson, Robert. "The Slide Lecture, or the Work of Art 'History' in the Age of Mechanical Reproduction." *Critical Inquiry* 26:3 (Spring 2000): 414–34.

Nightingale, Florence. "Cassandra." In *Cassandra and Other Selections from Suggestions for Thought*, edited by Mary Poovey, 205–32. New York: New York University Press, 1992.

Norris, Frank. "A Plea for Romantic Fiction." [*Boston Evening Transcript*, December 18, 1901]. In *Documents of American Realism and Naturalism*, edited by Donald Pizer, 171–74. Carbondale: Southern Illinois University Press, 1998.

——. *The Pit*. New York: Doubleday, 1903.

North, Michael. *Machine-Age Comedy*. Oxford: Oxford University Press, 2009.

——. *Reading 1922: A Return to the Scene of the Modern*. New York: Oxford University Press, 1999.

O'Brien, Sharon. *Willa Cather: The Emerging Voice*. With a new preface. Cambridge, MA: Harvard University Press, 1997.

O'Connor, Frank. *The Lonely Voice: A Study of the Short Story*. New York: Harper & Row, 1985.

O'Connor, Margaret Anne, ed. *Willa Cather: The Contemporary Reviews*. Cambridge: Cambridge University Press, 2001.

Oliphant, Margaret. *The Autobiography of Margaret Oliphant: The Complete Text*. Edited and introduced by Elisabeth Jay. Oxford: Oxford University Press, 1990.

——. "Modern Novelists—Great and Small." [*Blackwood's*, 1855]. In *Selected Works of Margaret Oliphant*. Part I, edited by Joanne Shattock, 81–100. London: Pickering and Chatto, 2011.

——. *The Perpetual Curate*. 3 vols. London: Blackwood and Sons, 1864.

Otter, Chris. *The Victorian Eye: A Political History of Light and Vision in Britain, 1800–1910*. Chicago: Chicago University Press, 2008.

Otto, Peter. *Multiplying Worlds: Romanticism, Modernity, and the Emergence of Virtual Reality*. Oxford: Oxford University Press, 2011.

Park, Robert. *The Crowd and the Public and Other Essays*. Translated by Charlotte Elsner. Chicago: University of Chicago Press, 1972.

Parrinder, Patrick, ed. *H. G. Wells: The Critical Heritage*. London: Rutledge Kegan Paul, 1972.

——. *Utopian Literature and Science: From the Scientific Revolution to Brave New World and Beyond*. Basingstoke: Palgrave Macmillan, 2015.

Parshall, Peter. "Buster Keaton and the Space of Farce: *Steamboat Bill, Jr.* versus *The Cameraman*." *Journal of Film and Video* 46:3 (Fall 1994): 29–46.

Pater, Walter. *Studies in the History of the Renaissance*. Edited with an introduction and notes by Matthew Beaumont. Oxford: Oxford University Press, 2010.

"Pathological Exhibition at the Royal Academy (Noticed by our Surgical Advisor)." *Punch* 19 (May 18, 1850).

Perez, Gilberto. *The Material Ghost: Films and their Medium*. Baltimore: Johns Hopkins University Press, 1998.

Peterson, William, ed. *The Ideal Book: Essays and Lectures on the Arts of the Book by William Morris*. Berkeley: University of California Press, 1982.

——. *The Kelmscott Press: A History of William Morris's Typographical Adventure*. New York: Oxford University Press, 1991.

Phillips, Mark. *On Historical Distance*. New Haven, CT: Yale University Press, 2013.

"The Pictures of the Season." *Blackwood's Edinburgh Magazine* (July 1850): 82.

Pinkney, Tony, ed. *We Met Morris: Interviews with William Morris, 1885–96*. Reading, UK: Spire Books, 2005.

Plotz, John. "No Future? The Novel's Pasts." *Novel* 44:1 (Summer 2011): 23–26.

——. "'On the Spot': Willa Cather's Remarkable Quotation Marks." *Willa Cather Newsletter and Review* 56:2 (Spring 2013): 20–21.

——. *Portable Property*. Princeton, NJ: Princeton University Press, 2008.

——. "Serial Pleasures: The Influence of Television on the Victorian Novel." *Ravon* 63 special issue, "Television for Victorianists" (2014). Available at http://www.erudit.org/revue/ravon/2013/v/n63/1025619ar.html?lang=en.

——. "Speculative Naturalism and the Problem of Scale: Richard Jefferies's *After London*, After Darwin." *MLQ* 76:1 (2015): 31–56.

——. "This Book is 119 Years Overdue." *Slate* (November 17, 2011). Available at http://www.slate.com/articles/arts/culturebox/2011/11/the_wondrous _database_that_reveals_what_books_americans_checked_out_of_the_library _a_century_ago_.html.

Poe, Edgar Allan. "Man of the Crowd." In *Poetry and Tales*, 388–96. New York: Library of America, 1984.

——. Review of *Twice-Told Tales*. In *Essays and Reviews*, 569–77. New York: Library of America, 1984.

Pratt, Mary Louise. "The Long and Short of It." *Poetics* 10 (1981): 175–94.

Prettejohn, Elizabeth. *Art for Art's Sake: Aestheticism in Victorian Painting*. New Haven, CT: Published for the Paul Mellon Centre for Studies in British Art by Yale University Press, 2007.

——. *The Art of the Pre-Raphaelites*. Princeton, NJ: Princeton University Press, 2000.

——, ed. *The Cambridge Companion to the Pre-Raphaelites*. New York: Cambridge University Press, 2012.

——. "Ford Madox Brown and History Painting." *Visual Culture in Britain* 15:3 (2014): 239–57.

——. "Lawrence Alma-Tadema and the Modern City of Ancient Rome." *Art Bulletin* 84:1 (2002): 115–29.

——. "Leighton: The Aesthete as Academic." In *Art and the Academy in the Nineteenth Century*, edited by Rafael Cardoso Denis and Colin Trodd, 33–52. New Brunswick, NJ: Rutgers University Press, 2000.

Price, Leah. *How to Do Things with Books in Victorian Britain*. Princeton, NJ: Princeton University Press, 2012.

——. "Reader's Block: Response." *Victorian Studies* 46:2 (2004): 231–42.

Proust, Marcel. "On Flaubert's Style." In *Against Sainte-Beuve and Other Essays*. Translated with an introduction and notes by John Sturrock, 261–74. London: Penguin Books, 1988.

——. *On Reading Ruskin*. Translated and edited by Jean Autret, William Burford, and Phillip J. Wolfe. New Haven, CT: Yale University Press, 1987.

——. Preface to *Sésame et les Lys*. In *On Reading Ruskin: Prefaces to La Bible d'Amiens and Sésame et les Lys, with Selections from the Notes to the Translated Texts*. Translated and edited by Jean Autret, William Burford, and Phillip J. Wolfe with an introduction by Richard Macksey, 99–129. New Haven, CT: Yale University Press, 1987.

Putnam, Robert. *Bowling Alone: The Collapse and Revival of American Community*. New York: Simon & Schuster, 2000.

Radcliffe, Ann. *The Italian, or, The Confessional of the Black Penitents*. Edited by Frederick Garber. Oxford: Oxford University Press, 1998.

Ranciere, Jacques. *The Nights of Labor: The Workers' Dream in Nineteenth-Century France*. Translated from the French by John Drury with an introduction by Donald Reid. Philadelphia: Temple University Press, 1989.

——. *The Politics of Aesthetics: The Distribution of the Sensible*. Edited and translated by Gabriel Rockhill. London: Blomsbury, 2004.

Read, Herbert. *English Prose Style*. 2nd ed. Boston: Beacon Press, 1952.

——. *The Green Child: A Romance*. London: W. Heinemann, 1935.

Review of *Dracula*. *Daily Mail* June 1, 1897. Rpt. in Bram Stoker. *Dracula*, edited by Nina Auerbach and David Skal. New York: Norton, 1997.

Rezek, Joseph. *London and the Making of Provincial Literature: Aesthetics and the Transatlantic Book Trade, 1800–1850*. Philadelphia: University of Pennsylvania, 2015.

Riesman, David. *The Lonely Crowd: A Study of the Changing American Character*. In collaboration with Reuel Denney and Nathan Glazer. New Haven, CT: Yale University Press, 1950.

Robbins, Bruce. *The Servant's Hand: English Fiction from Below*. New York: Columbia University Press, 1986.

Roberts, Jennifer. "Certain Dark Rays of the Sunbeam." In *The Pre-Raphaelite Lens: British Photography and Painting, 1848–1875*, edited by Diane Waggoner, 60–69. Washington DC: National Gallery of Art, 2010.

——. *Transporting Visions: The Movement of Images in Early America*. Berkeley: University of California Press, 2014.

Robinson, David. *Buster Keaton*. London: Secker & Warburg; British Film Institute, 1969.

——. *From Peep Show to Palace: The Birth of American Film*. New York: Columbia University Press, 1996.

Robson, J. M. Textual introduction to *Collected Works of John Stuart Mill*. Vol. 18, lxxi–xcv. Edited by J. M. Robson. Toronto: University of Toronto Press, 1977.

Robson, J. M., and Jack Stillinger. Introduction to *Collected Works of John Stuart Mill*. Vol. 1, vi–liv. Edited by J. M. Robson.

Rose, Jonathan. *The Intellectual Life of the British Working Classes*. New Haven, CT: Yale University Press, 2010.

"The Royal Academy Exhibition." *Builder* (June 1, 1850): 255–56.

Ruskin, John. "Fiction, Fair and Foul." *Nineteenth Century* 10 (October 1881): 516–31.

Saint-Amour, Paul. *Tense Future: Modernism, Total War, Encyclopedic Form*. New York: Oxford University Press, 2015.

Saler, Michael. *As If: Modern Enchantment and the Literary Prehistory of Virtual Reality*. New York: Oxford University Press, 2012.

Sanders, Andrew. "Millais and Literature." In *John Everett Millais: Beyond the Pre-Raphaelite Brotherhood*, edited by Debra Mancoff, 69–94. New Haven, CT: Yale University Press, 2001.

Sanders, Valerie. "Mrs. Oliphant and Emotion." *Women's Writing* 6 (1999): 181–89.

Sandner. David. Introduction to *Fantastic Literature: A Critical Reader*, edited by David Sandner, 1–13. London: Praeger, 2004.

Sayeau, Michael. *Against the Event*. Oxford: Oxford University Press, 2013.

Schiller, Friedrich. *On the Naïve and Sentimental in Literature*. Translated and with an introduction by Helen Watanabe-O'Kelly. Manchester: Carcanet New Press, 1981.

Scott, Laurence. *The Four-Dimensional Human: Ways of Being in the Digital World*. London: Heinemann, 2015.

Scott, Walter. *Ivanhoe*. Edited with an introduction and notes by Ian Duncan. Oxford: Oxford University Press, 2008.

——. *Redgauntlet*. Edited by G. A. M. Wood with David Hewitt. Edinburgh: Edinburgh University Press, 1997.

——. "The Two Drovers." In *The Two Drovers and Other Stories*, edited by Graham Tulloch with an introduction by Lord David Cecil, 282–62. Oxford: Oxford University Press, 1987.

Shanley, Mary Lyndon. "Subjection of Women." In Skorupski, *Cambridge Companion to Mill*, 396–422. Cambridge: Cambridge University Press, 1998.

Shattock, Joanne. "The Making of a Novelist: Oliphant and John Blackwood at Work on *The Perpetual Curate*." In *Margaret Oliphant: Critical Essays on a Gentle Subversive*, edited by D. J. Trela, 113–23. Selinsgrove, PA: Susquehanna University Press, 1995.

Sherborne, Michael. *H. G. Wells: Another Kind of Life*. London: Peter Owen, 2010.

Sider, Justin. "Dramatic Monologue, Public Address, and the Ends of Character." *English Literary History* 83:4 (2016), 1135–58.

Simkin, Mike. "Birmingham and the Magic Lantern." In Crangle, Heard, and Van Dooren, *Realms of Light*, 77–85.

Skoblow, Jeffrey. *Paradise Dislocated: Morris, Politics, Art*. Charlottesville: University of Virginia Press, 1993.

Skorupski, John, ed. *The Cambridge Companion to Mill*. Cambridge: Cambridge University Press, 1998.

——. "The Philosophy of John Stuart Mill." *British Journal for the History of Philosophy* 15:1 (February 2007): 181–97.

Smalley, Donald. *Trollope: The Critical Heritage*. London: Routledge and Kegan Paul, 1969.

Smith, Jonathan. *Charles Darwin and Victorian Visual Culture*. Cambridge: Cambridge University Press, 2006.

Smith, Lester. "Entertainment and Amusement, Educations and Instruction: Lectures at the Royal Polytechnic Institution." In Crangle, Heard, and Van Dooren, *Realms of Light*, 138–45.

Smith, Lindsay. *Victorian Photography, Painting and Poetry: The Enigma of Visibility in Ruskin, Morris and the Pre-Raphaelites*. Cambridge: Cambridge University Press, 1995.

Smith, Michael T. "Notes on Buster Keaton's Motion." *Kinema* 38 (2012): 91–102.

Smith, Pamela. *The Body of the Artisan: Art and Experience in the Scientific Revolution.* Chicago: University of Chicago, 2004.

Soll, Jacob. *The Information Master: Jean-Baptiste Colbert's Secret State Intelligence System.* Ann Arbor: University of Michigan Press, 2009.

Stanksy, Peter. *William Morris.* Oxford: Oxford University Press, 1983.

Stevenson, R. L. *Letters: Volume Five.* Edited by Bradford Booth and Ernest Mehew. New Haven, CT: Yale University Press, 1995.

Stewart, David. *Romantic Magazines and Metropolitan Literary Culture.* New York: Palgrave Macmillan, 2011.

Strauven, Wanda, ed. *The Cinema of Attractions Reloaded.* Amsterdam: Amsterdam University Press, 2006.

Summers, David. *Real Spaces: World Art History and the Rise of Western Modernism.* New York: Phaidon, 2003.

Suvin, Darko. *The Metamorphosis of Science Fiction.* New Haven, CT: Yale University Press, 1979.

Sweet, Matthew. Introduction to *The Woman in White*, by Wilkie Collins, xiii–xxxiv. London: Penguin, 1999.

Swinburne, Algernon Charles. "Before the Mirror." In *Algernon Charles Swinburne: Major Poems and Selected Prose*, edited by Jerome McGann and Charles Sligh, 119. New Haven, CT: Yale University Press, 2004.

Tarde, Gabriel. *L'Opinion et la Foule.* [1901]. Paris: Alcan, 1904.

———. *Underground Man.* Translated by Cloudesley Brereton with a preface by H. G. Wells. London: Duckworth and Co., 1904.

Taylor, Charles. *A Secular Age.* Cambridge, MA: Harvard University Press, 2007.

Taylor, Joanna. "(Re-)Mapping the 'native vale': Sara Coleridge's *Phantasmion*." *Romanticism* 21:3 (2015): 265–79.

Theissen, Bianca. "Simultaneity: A Narrative Figure in Kleist." *MLN* 121 (2006): 514–21.

Thoreau, Henry David. "Walking." [*Atlantic*, June 1862]. In *Essays: A Fully Annotated Edition*, edited by Jeffrey S. Cramer, 243–80. New Haven, CT: Yale University Press, 2013.

Thurschwell, Pamela. "Henry James and Theodora Bosanquet." *Textual Practice* 13:1 (1999): 5–23.

Tickner, Lisa. "English Modernism in the Cultural Field." *English Art 1860–1914: Modern Artists and Identity*, edited by D. P. Corbett and Lara Perry, 13–30. New Brunswick, NJ: Rutgers University Press, 2001.

Tilly, Charles. *Popular Contention in Great Britain, 1758–1834.* Cambridge, MA: Harvard University Press, 1995.

Todorov, Tzvetan. *The Fantastic: A Structural Approach to a Literary Genre.* Translated from the French by Richard Howard. Ithaca, NY: Cornell University Press, 1975.

Tolkien, J. R. R. "On Fairy-Stories." In *Tree and Leaf*, 3–84. Boston: Houghton Mifflin, 1964.

Tolstoy, Leo. *Anna Karenina.* Translated by Richard Pevear and Larissa Volokhonsky. New York: Penguin, 2003.

Tribble, Lyn. "'When Every Noise Appalls Me': Sound and Fear in *Macbeth* and Akira Kurosawa's *Throne of Blood*." *Shakespeare* 1:1–2 (2005): 75–90.

Trollope, Anthony. *Barchester Towers*. Oxford: Oxford University Press, 2008.
———. *The Warden*. Oxford: Oxford University Press, 2008.
Trumpener, Katie. *Bardic Nationalism: The Romantic Novel and the British Empire*. Princeton, NJ: Princeton University Press, 1997.
Turner, Victor. *Forest of Symbols: Aspects of Ndembu Ritual*. Ithaca, NY: Cornell University Press, 1967.
Underwood, Ted. *Why Literary Periods Mattered: Historical Contrast and the Prestige of English Studies*. Stanford, CA: Stanford University Press, 2013.
Unwin, Timothy. *Jules Verne: Journeys in Writing*. Liverpool: Liverpool University Press, 2005.
Van Ghent, Dorothy. *Willa Cather*. Minneapolis: University of Minnesota Press, 1964.
Vincent, David. *Bread, Knowledge, and Freedom: A Study of Nineteenth-century Working Class Autobiography*. London: Europa Publications, 1981.
Waggoner, Diane, ed. *The Pre-Raphaelite Lens: British Photography and Painting, 1848–1875*. Washington DC: National Gallery of Art, 2010.
Walker, Emery. "Relation of Illustrations to Type." *American Bookmaker* 10:3 (March 1890): 60–61; 10:4 (April 1890): 91–92.
Warner, Sylvia Townsend. *Lolly Willowes; or, The Loving Huntsman*. New York: Viking Press, 1926.
Watt, Ian P. *The Rise of the Novel; Studies in Defoe, Richardson, and Fielding*. Berkeley: University of California Press, 1957.
Wells, H. G. "Argonauts of the Air." In *Thirty Strange Stories*, 66–85.
———. *Boon: The Mind of the Race*. London: T. F. Unwin, 1915.
———. "The Country of the Blind." In *Selected Short Stories*, 123–46. New York: Penguin, 1979.
———. *The Croquet Player*. New York: Viking Press, 1937.
———. "The Crystal Egg." In *Selected Stories of H. G. Wells*, edited and with an introduction by Ursula Le Guin, 64–80. New York: Modern Library, 2004.
———. "The Door in the Wall." In *The Door in the Wall, and Other Stories*. Illustrated with photogravures from photographs by Alvin Langdon Coburn, 5–24. New York: Mitchell Kennerley, 1911.
———. *Experiment in Autobiography*. New York: Macmillan, 1934.
———. *The History of Mr. Polly*. Boston: Houghton Mifflin, 1960.
———. "In the Abyss." In *Thirty Strange Stories*, 157–82.
———. *The Invisible Man*. Edited by Patrick Parrinder. London: Penguin Books, 2005.
———. "The New Accelerator." In *Selected Stories of H. G. Wells*, 80–93.
———. "An Outcast of the Islands." *Saturday Review* (May 16, 1895): 509.
———. "The Plattner Story." In *Thirty Strange Stories*, 34–65.
———. "The Remarkable Case of Davidson's Eyes." In *Thirty Strange Stories*, 291–306.
———. "A Slip under the Microscope." In *Thirty Strange Stories*, 216–46. London: Harper and Bros., 1898.
———. "The Star." In *Selected Stories of H. G. Wells*, 142–52.
———. "The Stolen Body." In *Selected Stories of H. G. Wells*, 94–112.
———. "The Story of the Late Mr. Elvesham." In *Thirty Strange Stories*, 86–113.

——. *The Time Machine*. New York: Henry Holt and Co., 1895.

Welsh, Alexander. "The Later Novels." In *The Cambridge Companion to George Eliot*, edited by George Levine, 57–75. Cambridge: Cambridge University Press, 2001.

West, Rebecca. *The Return of the Soldier*. New York: Doran, 1918.

Wharton, Edith. *House of Mirth*. New York: Charles Scribner's Sons, 1922.

Wickman, Matthew. "Of Tangled Webs and Busted Sets: Tropologies of Number and Shape in the Fiction of John Galt." In *Romantic Numbers*, edited by Maureen McLane. Romantic Circles Praxis Series. Set 1. College Park, MD: University Press of Maryland, 2013.

Wilde, Oscar. "The Critic as Artist; with Some Remarks upon the Importance of Doing Nothing." In *Intentions*, 93–217. Portland, ME: T. B. Mosher, 1904.

Williams, Jeffrey. "The Narrative Circle: The Interpolated Tales in *Joseph Andrews*." *Studies in the Novel* 30:4 (Winter 1998), 473–88.

Williams, Raymond. "The Bloomsbury Fraction." [1980]. In *The Raymond Williams Reader*, edited by John Higgins, 229–48. Oxford: Blackwell, 2001.

——. *The Country and the City*. Oxford: Oxford University Press, 1973.

——. *The English Novel: From Dickens to Lawrence*. London: Chatto and Windus, 1970.

——. *Marxism and Literature*. Oxford: Oxford University Press, 1977.

Williamson, Jamie. *The Evolution of Modern Fantasy: From Antiquarianism to the Ballantine Adult Fantasy Series*. New York: Palgrave Macmillan, 2015.

Winkler, Michael. "Naturalism." In *Princeton Encyclopedia of Poetry and Poetics*, edited by Roland Greene et al., 919–21. 4th ed. Princeton, NJ: Princeton University Press, 2012.

Winnicott. D. W. *Playing and Reality*. New York: Basic Books, 1971.

Wolfe, Gary K. "Fantasy from Dryden to Dunsany." In James and Mendlesohn, *Cambridge Companion to Fantasy Literature*, 7–20.

Woloch, Alex. *The One vs. the Many: Minor Characters and the Space of the Protagonist in the Novel*. Princeton, NJ: Princeton University Press, 2003.

Woolf, Virginia. "Mr. Bennett and Mrs. Brown." In *Selected Essays*, edited by David Bradshaw, 32–54. Oxford: Oxford University Press, 2008.

——. *Mrs. Dalloway*. New York: Harcourt, Brace and Co., 1925.

——. *To the Lighthouse*. Edited with an introduction and notes by David Bradshaw. Oxford: Oxford University Press, 2006.

Worth, Aaron. "Imperial Transmissions: H. G. Wells, 1897–1901." *Victorian Studies* 53:1 (Autumn 2010): 65–89.

Yeazell, Ruth. *Picture Titles: How and Why Western Paintings Acquired Their Names*. Princeton, NJ: Princeton University Press, 2015.

Yousef, Nancy. *Isolated Cases*. Ithaca, NY: Cornell University Press, 2004.

Zola, Emile. "The Experimental Novel." In *The Experimental Novel and Other Essays*. Translated by Belle Sherman, 1–54. New York: Haskell House, 1964.

Index

NOTE: Page numbers followed by *f* indicate a figure.

thoughts and intentions in, 141–44, 270n42, 270n46, 271n49; inward and public selves in, 134–41, 150–52, 273n67; in James, 123–24, 136–52, 198–200, 270n46, 271n49, 279n38; Norris's naturalism and, 198–206; Rancière on distribution of the sensible in, 122–25, 268n1, 269n5; shifting viewpoints in, 127–38
Experiment in Autobiography (Wells), 184

The Fantastic (Todorov), 278n18
fantasy (speculative) fiction, 188–95, 219; genealogy of, 191, 281nn68–69, 282nn72–73; of secondary worlds, 265n17; Wells's impact on, 177, 189–95, 277n8, 281nn63–65
Fantomina (Haywood), 22
Faulkner, William, 14
A Favorite Poet (Alma-Tadema), 92
Fawcett, Trevor, 159, 161
Ferdinand Lured by Ariel (Millais), 90–91
The Fermata (Baker), 182
Ferris, Ina, 30–31, 36, 242, 249n42, 251n60
fiction. *See* modernist fiction; provincial novels; short stories; Victorian realist novels
fictionality: episodic sequencing in, 11, 14–16, 21–22, 45–46, 246–47nn19–20; Gallagher on believability in, 11–14, 38, 102, 198, 246nn15–17; Gallagher on readerly embrace of artifice in, 14–15, 102, 214, 228, 257n57; indeterminate representations of pertinence in, 45–47, 151, 252n88; moderate modernism in, 13–14, 174, 177–91, 197–98, 208; moving center of consciousness in, 13; productive complementarity in, 12–13
Fielding, Henry, 43–44, 252n74
film. *See* Keaton, Buster; motion pictures
Film and Attraction (Gaudreault), 287n9
Filon, Augustin, 179, 280n51
Fitzgerald, F. Scott, 14, 199
Fitzgerald, Penelope, 120
Flammarion, Camille, 179
Flatland (Abbot), 112, 114, 180–81, 192
Flaubert, Gustave, 110, 231–32
Fleissner, Jennifer, 283n13

The Flight of Madeline and Porphyro (Hunt), 259n20
"Floor Scrapers" (Caillebotte), 78–79
Ford, Ford Madox, 177, 283n6; on doubled impressions in bright glass, 3–4, 7, 15, 23, 238, 290n2; on shell-shock, 282n75; subjectivist impressionistic fiction of, 281n63
Forster, E. M., 13, 189, 191–92
"For the Union Dead" (Lowell), 4
Foucault, Michel, 278n17, 290n3
The Four-Dimensional Human (L. Scott), 17
Francois, Anne-Lise, 263n2
Frankenstein (Shelley), 71
Fraser's sketches, 28, 29
Fried, Michael, 16, 78–79, 258n9
Frow, John, 246n16, 257n61, 270n42
The Frozen North (Keaton), 220
Frye, Northrop, 216
Fyfe, Aileen, 158, 274n13

Galison, Peter, 5, 67–68, 277n16, 279n49
Gallagher, Catherine, 141; on believability in fiction, 11–14, 38, 102, 198, 246nn15–17; on readerly embrace of artifice, 14–15, 102, 214, 228, 257n57
Galt, John, 7, 16, 20–21; experimental writing of, 28–29, 238, 249nn28–31, 249nn38–39; "The Mem" sketch of, 28–33, 36–38; short stories of, 37, 259n17
Gandhi, Mahatma, 153
Garbo, Greta, 287n9
Garcha, Amanpal, 33, 37, 250n51
Garland, Hamlin, 199
Garnett, David, 192, 282n74
Gaskell, Elizabeth, 16, 108–9, 111, 261n42
"The Gathering of the West" (Galt), 30
Gaudreault, Andre, 216–18, 220, 287n9, 288n19
The General (Keaton), 220, 225, 228–30
Gernsback, Hugo, 192
Gérôme, Jean-Leon, 92
Gibbs, A. Hamilton, 284n30
Gide, André, 22
Giebelhausen, Michaela, 261n42, 261n47, 261n50

Morgan, Daniel, 289n24

Morris, Jane, 153, 273n1

Morris, May, 154, 160–65, 172

Morris, William, 10–11, 132, 153–74, 258n10; epical and ornamental vision of, 167–74, 218, 276n34, 276n37; lantern lecture of, 168; magic lanterns and font design of, 132, 154–55, 157, 160–69, 218, 275n18, 275–76nn28–30; medieval inspirations of, 153–54, 157, 160–61, 166–69, 273n1, 273n3, 275n14; metaphor of magic lanterns of, 173–74; prose romances and poetry of, 154, 173–74, 191, 281nn68–69; socialist politics and slow print movement of, 153–54, 169–74, 273n2, 276nn40–41; Wells's debt to, 178. *See also* Kelmscott Press

motion pictures, 219–22, 286nn4–5; advent of talkies in, 286n6, 287n12; blanks and intertitles in, 232; burlesque comedy in, 220–25, 226–27f, 287n8, 287–88nn12–16; fashion films of, 220–22; Gaudreault on cultural series in, 216–18, 220, 287n9, 288n19; perceptual aspects of, 232–33; studio system of, 286n6, 287n12, 288n16. *See also* Keaton, Buster

Mourning Over the Dead Christ (Mantegna), 257n6

"Mr. Adamson of Laverhope" (Hogg), 25–26, 28

"Mr. Bennett and Mrs. Brown" (Woolf), 177, 277n12

"Mrs. Brumby" (Trollope), 39

Mrs. Dalloway (Woolf), 137

Mulready, William, 88–89

Multiplying Worlds (Otto), 245n3

Münsterberg, Hugo, 286n4

The Musicians (Caravaggio), 8–9, 8f, 238–39, plate 1

My Antonia (Cather), 205–8, 210

"Narrate or Describe?" (Lukacs), 200

Nash, Susie, 258n8

Natural History of Selbourne (White), 112

The Navigator (Keaton), 220

Nazar, Hina, 251n60, 253n5

Nead, Lynda, 276n41

Nelson, Robert, 159, 162, 169, 275n25

Nesbit, Edith, 282n71

"Nevsky Prospect" (Gogol), 37

"The New Accelerator" (Wells), 182–83, 187, 192, 279n42

News from Nowhere (Morris), 154

Nietzsche, Friedrich, 120

The Nigger of the Narcissus (Conrad), 4

Nightingale, Florence, 56, 254n22

Nobody's Story (Gallagher), 11–14

Norris, Frank, 13, 198–206; influence on Cather by, 199–202, 205–6, 212–13; reverie and reality in, 204

North, Michael, 211–12, 231

"The Nose" (Gogol), 37

"Note by William Morris on his Aims in Founding the Kelmscott Press" (Morris), 168–69

"Notes for *The Ivory Tower*" (James), 270n46

"Notes on Form in Art" (Eliot), 128

notes on the letter "h" (Morris), 162f

Not Under Forty (Cather), 199

"The Novel Démeublé" (Cather), 209

Objectivity (Daston and Galison), 5, 279n49

Oliphant, Margaret, 16, 108–9; confrontation with daily obligations in, 114–21, 133, 266–67nn46–53, 268nn60–61, 268n64; critique of Eliot by, 115–16, 266n49; irritation in, 115–18; James's praise of, 118–19, 268n58; published works of, 115, 266n45

Oliver Twist (Dickens), 40–41

Omega: The Last Days of the World (Flammarion), 179

O'Neill, Joseph, 193

One of Ours (Cather), 212

One Thousand and One Nights, 43, 251n65

The One vs. The Many (Woloch), 246n16, 269n3

One Week (Keaton), 219

"On Fairy-Stories" (Tolkien), 191

"On Flaubert's Style" (Proust), 231–32